Monet's Garden, France

Dedication
To the three women in my life, my wife Susan and daughters Julie and Lisa

Acknowledgement
I wish to thank my publisher Chuck Lesher and my editors Roy Sinclair, Kirstin Carlson, Nancy Archibald, Pam Anderson and Ken Middelton.

Note: All Photos in this book were taken by the author, David Archibald, unless otherwise specified.

Cover: On the trail to Hanging Lake Colorado

Back Cover: Sunset on the Adriatic

ISBN 978-1-938586-90-3

Published: 2020

Printed in the United States of America
Writers Cramp Publishing

editor@writerscramp.us

The views expressed in this work are those of the author and should never be construed as those of any other individual or organization unless explicitly specified.

Out My Door

Chapter 1: Family 1

 Family
 My Mother
 My Father
 The Bard of Casa Grande
 My Vagabond Year
 Susan's Childhood
 Teaching
 Retirement travel log – 30 Countries

Chapter 2: Mountains 25

 Charlie Rice
 Popocapatul, Mexico
 Kilimanjaro, Tanzania
 The Grand Canyon, Arizona
 Humphreys Peak, Arizona
 Mountains of Colorado

Chapter 3: Argentina, Uruguay, Chile 34

 South America

Chapter 4: New Zealand 38

 Seven Kiwi Cities in Sixteen Days

Chapter 5: Turkey 43

 Istanbul

Chapter 6: Norway, Finland, Russia 47

 Overseas Adventure Travel

Chapter 7: Home 51

 East Valley
 The Middleton Saga (starting in 1956)
 A progressive dinner in the Pueblo

Chapter 8: California 57

 San Diego
 San Diego: Thanksgiving
 Wedding in Malibu
 California Wine Country
 Six beds in twelve days, circling California
 A Tree House in Northern California
 San Diego, Our Second Home
 Another trip to the Bay Area, a week in 2019

Chapter 9: Toastmasters 74

 Park Central Toastmasters
 "Enthusiasm"
 "Toot Your Own Horn"
 "The Child Within Us"
 "Las Vegas"
 "The Color Green"
 Once In A Lifetim Experiences"
 "Your Lucky Penny – Who or What?"
 "Relationships"
 "Once In A Lifetime Experiences"
 "Ships In My Life"
 Clubbing With The Toastmasters
 "Mother's Day"
 Toastmaster's Pearls Of Wisdom
 Toastmaster Table Topics
 Jokes

Chapter 10: Running 82

 The Dam Run
 The Boston Marathon
 How many Wagner's have I coached?
 Reunion of Runners
 Centipedes
 Back to the life of a coach
 Dobson High School
 Kyle's senior year
 The Decathlon
 Retired as Coach
 Running A Handicapped Race

Chapter 11: Minnesota and Illinois 95

 Minneapolis
 Chicago

Chapter 12: Colorado 98

 Glenwood Springs
 Leety House
 Another Colorado visit
 Forest Fire

Chapter 13: Mexico 108

 Xcalak

Chapter 14: Advice 111

 Traveler or Tourist
 More Travel Insights

Chapter 15: England 113

The Land of Shakespeare
Ireland

Chapter 16: Alaska and Canada 119

Chapter 17: Peru 124

Puno
Machu Picchu

Chapter 18: Susan in France 129

Chapter 19: Phoenix 130

Papago Park
Lake Adventure
Traffic class
Music

Chapter 20: Profiles 136

Polly's Party
Dusty Everman
Mendoza Chronicles
Bruce Pierce
Laurie Coe
Gary Charlton
Roy Sinclair
Joe Reilly

Chapter 21: Spain and Portugal 145

Spain
Portugal
Island of Maderia

Chapter 22: Athletics 155

Proudest Athletic Achievement
Roy Sinclair
Ray Hayes
My Best Race
John Conant
Bob Anderson and Dave Stantus
David Santiago
Andy Carusetta
Wyatt Earp – Hawaii Ironman.
Bev and her bike
ASU Track meet – me and the mile run

Chapter 23: Southwest 161

Bryce, Zion, and Monument Valley
Room with a View – Oak Creek Canyon
A Step Back in Time: Bisbee
Another Trip to Bisbee.
Las Cruces, New Mexico
Trains

Chapter 24: The Adriatic 170

Adriatic Adventure
Highlights from my Journal...
A Toastmaster challenge

Chapter 25: Rotary 176

Rotary Club
Golf Tournament
Rotary Speaker
Flor DiBartolo and Havasupai
Four days at Havasu

Chapter 26: Politics 186

Politics with **Jennifer Samuels**

Chapter 27: Reunion 189

High School Reunion

Chapter 28: Diary 193

Dear Diary

Chapter 29: Denmark 196

Copenhagen

Chapter 30: Italy 200

Rome
Our Trip
Montecatini

OUT MY DOOR

A story told is a life lived - Anonymous

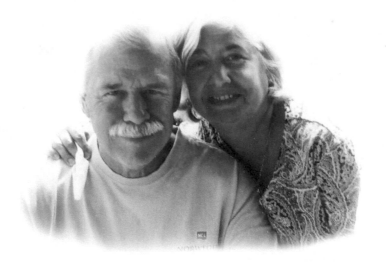

Introduction

Before I go out my door, we need to go inside and see who I am, a product of my parents and my wife. After realizing some of my make-up we can now go on a roller-coaster ride of adventure. My trail of travels has some ups and downs and unpredictable sharp turns, it lacks a smooth comfortable telling.

Perhaps you too have flown over the ocean to foreign lands, perhaps your story is similar. If so, get confirmation of the joy of discovery. If not you may be encouraged to try. To re-charge our batteries between trips I offer up my fourteen years as a Toastmaster, membership in Rotary and my life as an athlete. Come join us in our exciting adventure.

Chapter 1: Family

"The most important thing in the world is family and love." –John Wooden

Family

Have you ever felt like a celebrity? Good friends Bud and Sally live in Tucson. Since Susan and I live in Phoenix, we both decided it would be good to meet halfway for dinner. Hence Susan and I visited my old home town of Casa Grande. It was here I felt like a celebrity.

The fine restaurant we chose has some interesting history behind it. Mattie and Jean Vallette built an adobe home in Casa Grande in 1917. They spent much of their time collecting cacti, antiques and HoHoKam Indian artifacts. Lee and Annabell BeDillion bought the property in 1968. He was my shop teacher when I went to high school. My brother Bob married Nancy Vincent in the cactus garden (1972). Nancy's father Frank was my typing teacher in high school. Michael and Nancy Jackson fell in love with the garden which has many eight foot high skinny cacti in it, and bought the property in 1987. They turned it into a restaurant and kept the name BeDillion because that's what most of the locals were familiar with.

The owner, Michael Jackson (not the famous singer) resembled a hippie with long braided hair hanging down his back like a pony tail. When I introduced myself to him, he grinned and said, "Your mother was the best English teacher I ever had." I almost never visit Casa Grande so this was refreshing to converse with somebody I didn't know, but who had such high praise for my mother.

Sitting down to our fine dinner I heard in the background, "David Archibald is here". A short while later a man with a huge sweeping handlebar moustache come over. "I'm Bennie Crowe" he says. I vaguely remembered him as a year or two ahead of me and a member of the football team. He married Annalee BeDillion who played tennis with my brother Bob. They combined the men's and women's score to win the state championship, beating rival Bisbee. Bennie is now a justice of the peace and he too spoke eloquently about my mother.

Before dessert is served Louis Story comes to our table. I didn't know him in high school, but I knew of his sister Jerrilyn, who was a sophomore when I was a senior. She was royalty in our school year book and as I can recall she was, "hot." I was too shy to date her. Louis and his band were setting up in the garden outside. We were unaware of this Friday night entertainment. Louis said he got kicked out of high school, yet my mother tutored him so later when he was in college he could write a research paper. He was so grateful that she helped him even though he was not in her class. I asked him if Jerrilyn was here, and he replied, "She might show up later."

We found chairs in the garden and listened to Louis and his band perform. They played a nice variety. A woman approached our table and said, "I'm Jerrilyn." I hadn't seen her in fifty years. She was excited to see me and gave me a big hug. I felt like a celebrity. Yet, I wasn't. This time it was my

September 25, 2002

Dear Mrs. Archibald

After 40 years have passed and teaching thousands of students, I don't know if you'll remember me, but I graduated with Dave in 1963 and was in your senior English class. My name was Velma Rollins at that time. I've intended to write this letter for years but somehow always manage to find some way to fill up the hours of each day.

Many times through the years and most recently in talking with my children, the conversation has often come around to former teachers and the things we learned in school. Invariably I will think of you and how much I loved going to your class and how much I learned. You were the most outstanding and influential teacher I ever had. You prepared me for college, increased my vocabulary, taught me how to write term papers and actually enjoy doing the research, but most importantly, I think, gave me a love of reading that has not diminished to this day. There are so many words that I have read that were in our weekly vocabulary list, like tintinnabulation, coalesce, faux pas, and so many others that I would have had to stop and look up in the dictionary if it hadn't been for your lists. My daughter who recently graduated from ASU never had vocabulary words in school after the 6th grade. What a disservice those teachers have done to our current generation of students. I wish she could have had you as an English teacher.

Of all the classes and teachers I had in high school yours was the one I looked forward to the most. I couldn't wait to get to your classroom, and it was the last class of the day, so I know by that point I must have been tired and you as a teacher must have being feeling tired also, but it never showed. Your enthusiasm for English literature and sharing stories about English royalty was infectious and held me spellbound every day. It has opened worlds for me as nothing else has. You were terrific!

I hope all is well with you and you are enjoying life. Maybe you can convince Dave to pull out his old annual from 1963 and show you my picture if you can't remember me. But, I'll never forget you and your wonderful class. Thank you so much.

Most sincerely,

Velma Rollins Linley

father, the Presbyterian minister who was the star. "Your dad and I had such good talks…he was a great man". She and I then walked over to see her mother, who also gave me a big hug and was overjoyed at seeing an Archibald. The light was good here, and I asked if I could take Jerrilyn's picture. Secretly I wanted to compare it with the year book photo. At this moment a man approached and Jerrilyn said, "I want you to meet my husband."

I was so startled by the man's appearance I forgot his name, but I got my picture. Jerrilyn had a charming smile. Standing next to her is a man with long grey hair and beard of the same color reaching down to his chest. He could be a character in some movie. They seemed happy and later we saw them dancing to the music of Louis and his band.

There is no statue or commemorative plaque to my parents in the town, yet I was overwhelmed by the passion of people who fondly remembered them. "David Archibald is here" will forever be a message of love that I cherish for it tells of the lives my parents touched. I've included a letter as evidence of the strong feeling people had for my parents.

My Mother

My mother, Marcia, had a younger sister Jean and younger brother Richard Leety. Jean lives with her husband Art in west Phoenix. Susan and I never see them…well almost never. Richard and his wife Jean live in Colorado and we see them once or twice a year. Why is there such a discrepancy? They are vastly different people.

Growing up my aunt and uncle both loved athletics. But if you judge how they turned out

it seems they had little else in common. I grew up in Oklahoma and Arizona while they lived in Philadelphia. Therefore I only had brief glimpses of them. My mother and father drove back east every summer to visit their family. This was a three day drive when there were no interstate highways. An admirable effort when I look back on it. The physical toll was less daunting than the economic one. My parents weren't poor but we were barely lower middle class. A step above water for us was Kool aid. Soda pop was considered a luxury.

The trip east loomed big for me, I sort of saw it as the promised land. I was engrossed

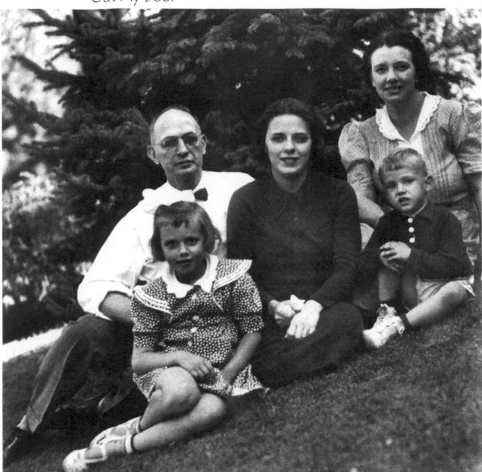

Leety family: Jean, Ralph, Marcia, Rich, Clara

in the totality of the east coast and played scant attention to Aunt Jean and Uncle Rich.

Jean and Richard continued their interests in athletics and became coaches. Jean and Art have two boys. Both Keith in Salt Lake City and Bruce in Phoenix are doctors. Rich decided not to have children and he and his wife Jean became a world travelers. His favorite place is Africa. He and Jean have been there over ten times. I know it's confusing, there are two Jeans in this story. One's in Colorado and the other in Phoenix.

If my father could drive two thousand miles to see his family it's about time I drove fifty miles to the other side of Phoenix to my mother's family.

My middle name is Ralph after my grandfather, who my mother adored. I feel blessed to honor his name because of all the stories my mother told me about him. Hopefully Jean Horwood, his middle

child, can tell me more about this great man.

Ralph grew up in Pittsburg with three brothers and a sister. The Leety quartet sang at all kinds of social functions. Ralph was the high tenor. He went to college at Carnegie Tech. The yearbook said this about his exploits as a member of the ice hockey team: "Leety at goal saved the day many times and his work was watched with interest by persons who declared he is the best goal tender Tech ever had." He also played basketball and in those days, only one person shot free-throws for the entire team and that was Ralph. On one occasion he got knocked out and they waited for him to regain consciousness so he could shoot the free throws.

At age twenty, Ralph met a seventeen year old beauty named Juniata. She studied piano and voice with private teachers. She and Ralph both loved music and often went to the theater. After four years

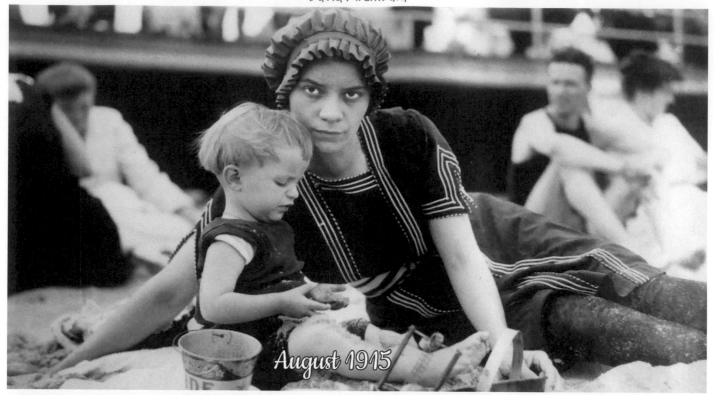

August 1915

My oldest picture is of my mother, Marcia, and grandmother, June, taken at the beach. June sadly died a year after this picture was taken. Obviously I never knew her but I did know how great her absence affected my mother.

of courtship they married. They then had my mother Marcia. When Marcia was three years old tragedy struck as her mother Juniata died. It was a simple operation to correct a thyroid problems, but the procedure got botched and she died. Years later, her sister Lucy told Marcia, "I am sure June and you were his whole life. I never knew a more devoted father than Ralph was to you. He took you on his yearly vacations, and it must have been hard to take care of such a tiny girl when traveling." Ralph worked for the real estate department of the Pennsylvania railroad and some of their trips included: Florida, New Orleans, and Glacier National Park.

When Marcia was fourteen Ralph married Clara who was 28. Ralph and Clara moved from Pittsburgh to Philadelphia. Here in 1930 they had Marcia's sister Jean and in 1934 brother Rich. Marcia went away to college and stories about Ralph can now be picked up by his daughter Jean Leety Horwood.

Typhoid fever or a similar disease caused Ralph a lot of trouble with his teeth. Because of his first

wife's death at the hands of an incompetent doctor Ralph did not trust doctors. Not wanting to be bothered with any more trips to the dentist he had all his teeth taken out. My mother told me this story and Jean confirmed it. It has always impressed me as to the depth of Ralph's courage.

Jean wasn't able to tell me much about Ralph. As a young girl she would walk down the block to meet him when he came home from work. Ralph would hoist her up on his back and carry her home. There is an awesome family picture of Ralph, his brothers, their wives, and children. Jean is up high resting on his shoulders.

I'm not sure what kind of insights I was going to get from Jean about Ralph's character. I got only a glimpse. She was more interested in talking about her grandchildren. Who can blame her? I kept a score card, listing the names of all seven. In the time allotted for our visit stories about two stood out.

Art and Jean taught at NorthWestern Nazarene College in Nampa Idaho. It's a fundamental Christian

school. When one of their sons got married the minister told them to not allow Satan in the bedroom. They also do not wear lipstick. This I can understand, but the former leaves me scratching my head.

Aaron, Bruce's oldest son graduated from West Point. He majored in engineering and is now stationed someplace in Missouri. His sister Taylor is a missionary to underdeveloped countries around the world. She's helped orphans in Central America, Mexico, Africa, and the Philippines. Her journals are filled with religious references. Missing were descriptions of the countries, and the circumstances she found herself in. I admired her courage and I'm sure her great grandfather Ralph would be proud of her.

Jean and Art were Physical Education teachers in college and coaches. Art took his soccer teams to play in New Zealand and later in Portugal. It seemed only fitting that we were watching the World Cup, host Brazil playing Croatia. He was able to provide very insightful commentary on the match. At last I was getting something of value. I missed on Ralph. I missed on Taylor, the missionary. But here was a connection. The speaker, Art and the audience, and I were in tune. My grandfather Ralph died in 1955 at the age of 67. Silently, somewhere he might be smiling.

Visiting Rich in Colorado, he says when he was growing up and wanted to do something, there would be a discussion with Ralph and Ralph always won. Ralph never threw Rich a bone, so after a while Rich stopped talking to his father. As a young man he says after a night of partying, the next morning Ralph would ask him if he wanted to play golf and hung over Rich would decline. He realizes now the error of his ways and admits Ralph was making an effort, yet he wishes earlier his father had thrown him a bone.

My Father

More on the celebrities of Casa Grande, my father and his many moves. Fairfax, Oklahoma; Busselton, New Jersey; Okmulgee, Oklahoma; Casa Grande, Arizona and Phoenix, Arizona

My father grew up in Philadelphia. When he was 31 years old he moved to Oklahoma. You may ask why? Nancy, his first wife had died. He decided to give up his career as a commercial artist and become a minister. To do this he needed a college degree and a job to support himself and Marcia, his new wife, my mother. And all of this took place under the umbrella of WWII.

The University of Tulsa is eighty miles away from Fairfax. He was a minister in this small town. They waived the requirement of him possessing a degree because ministers were in short supply. Because he was away at the college during the week, Marcia became very good friends with the Locketts

My father - Circa 1930's

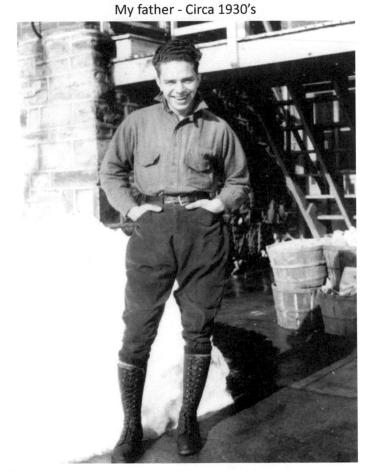

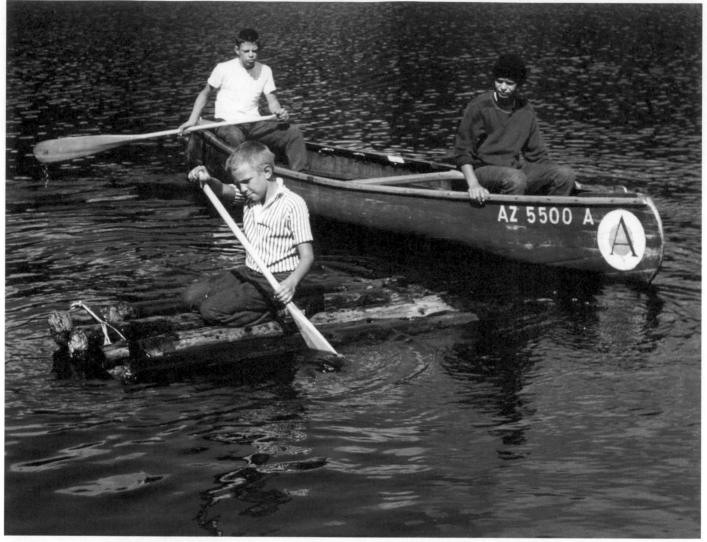

I am in the back of the canoe. My brother is in the front and my little brother is on the raft.

who lived across the street. Fairfax did not have a hospital, so in 1945, I was born on a snowy day in January, twenty miles away in Pawnee.

My earliest memories are from Fairfax. These memories were reinforced by my mother's stories of them. Once I climbed a chest of drawers in the Lockett house and cut my foot on the glass knobs. Another time I came running home with blood cascading down my face. My mother asked me, "What happened?" I replied, "She hit me." I had been playing with a girl three houses away from ours. "What with? "My mother asked. I replied "A knife." However, this incident did not hinder my interest in girls, just made me a bit cautious.

Father's next move was to Busselton, New

Jersey and Princeton. It was here he would get his ministerial degree. Once he saw a man with wild white hair strolling around campus. It was Albert Einstein. My brother Bob was born here. Perhaps he inherited some of the man's genius.

Many years later when I was married to Susan, she once remarked, "There are no religious symbols in your house, you would never know a minister lived here." One object from the Princeton period is a nice old fashioned captain's chair we have inherited.

My mother and father had enjoyed the people in Fairfax and after Princeton moved back to Oklahoma. Our second time in Fairfax, my brother Bruce was born. At age five I can vividly remember, early morning light reflecting on colorful jelly jars

resting on the window sill, and watching children outside walking up a hill. I asked, "Where are they going?" My mother replied, "To school, you'll get the chance next year." Before that happened we moved to Okmulgee.

My father was now a college graduate from the University of Tulsa and had his ministerial degree from Princeton. The Presbyterian Church in Okmulgee had a vacancy in their pulpit. Their search committee heard my father preach and offered him a job with more money. It was a step up for my father, a bigger town, a more prosperous church, and for us boys a spacious room all to ourselves on the second story of our house. We lived here for six years, until I was twelve years old. I could easily walk to Franklin school.

Football is a religion in Oklahoma. We had no face guards on our helmets. Making a tackle once I bit a hole in my tongue. Seeing some blood, the coach's comment, "Don't wipe it on your game jersey."

With his prestigious position as head of one of the city's important churches, my father got himself more involved in the community by joining Rotary. Now many years later his son has also become a member of this tremendous altruist organization. My father became president and attended national conventions. It was this expansive view of life that may have sparked his wanderlust. His view of religion was expanding beyond a literal interpretation of the bible. The conservative community of Okmulgee did not seem to fit. It was time for another move.

When I was told we were moving to Arizona I immediately went out and bought a large canteen. I thought of large sand dunes. Now living here for 67 years I understand many people's misconceptions about Arizona. Sure, it's hot, but it's a dry heat and we have air conditioning. I've visited the east many times and their horrible humidity is not something I want to live with during the summer. Then you have

a freezing winter where you have to shovel snow. Next ice is on the windshield of your car and you have to laboriously scrape it off. Yes, I am happy in Arizona. Before I forget, we also have no tornado alley, which destroys homes in Oklahoma.

My father's moves were not only physical, they were mental. He was drifting from his conservative roots and becoming more of a liberal. Collecting some of his sermons after his death, Kate his devoted church secretary, lovingly spoke to me about this. She said, "I know his mind was evolving and I often wonder where it would be now, with what is going on in society today."

Casa Grande, Arizona was a good place for a teenage boy to grow up. However, for my father it proved to be a struggle with the church community. I have emotional memories of his coming home after the governing body of the church, the session, had denied him a raise in salary. Ministers are not on the high end of society financially. With three boys and now daughter Beth of school age, my mother went to work. Her job as a high school English teacher was very satisfying. She didn't get much money but she got emotional pay-back as students loved her.

1956 to 1969 saw us in Casa Grande. The last six years saw me away in college and then the army. Therefore I was not privy to the strategy of my father's next move to Phoenix, yet I easily saw the results. He was happy. It was not necessarily having a swimming pool in the backyard and no financial worries, it was the members of the church. The gold band club, recently married young members in the church would come to his house. One guy remarked, "This church has got to be good when the minister offers you a glass of wine in his home." This never happened in Fairfax, Okmulgee, or Casa Grande. I guess alcohol led to sinful behavior, something a minister would be firmly against. The times, they were a changing.

When he retired, the church produced the "R

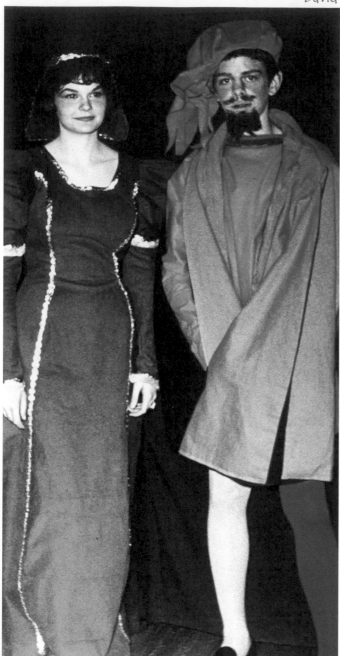

The Taming of the Shrew, Patty Cooper is
Katherine and I'm Petruchio
Casa Grande High School February 1962

The Bard of Casa Grande

What's it like to enter a room and meet people you don't know anymore, but are expected to recognize? It has been 54 years since I graduated from high school and faces change. My feelings were hurt a bit when people didn't recognize me. I wasn't a major player back then, but somewhat well-known because my mother was an English teacher at the school. But in reflection that shouldn't bother me. I'm a different person than way back then. In the same fashion when Enedina our host introduced somebody to me, a silent question lurked in the background, do you remember me? You do not want to disappoint anybody so you speak out, "Of course I remember you." Of the twenty some odd people in the room I only had to lie once. Everybody in the room was positive and up-beat.

I have fond feelings for my high school years and classmates. This is a long time to hold onto a memory of so many people. We had about 120 in our class. I recognized many I was close to in high school, but the majority of those at the luncheon were longtime residents of Casa Grande and not in my inner circle in the sixties. The successful people in our class had moved away to more productive environments out of state. Balentino, who was a teammate of mine on the JV basketball team, is a classic example. He was very successful with insurance in San Jose and he had just moved back to be near his extended family.

My athletic career saw me sitting on the bench at football and basketball games. I was small and slow. I tried hard but saw limited action. Traveling on the bus to away games throughout the state was fun. Eloy, Globe, San Manuel, and Nogales were small towns with dirt-like character populated by common folk. This wannabe athlete really made his mark in high school as a writer and actor. "Arch's Armchair View" appeared regularly in the "Cougar Growl" our student newspaper. My ascendancy on the stage is an intriguing story.

Event". It stood for his first name Richard and Retirement. It was planned in total secrecy. To see his face when he walked into the large room filled with over one hundred people is a priceless memory. Slowly walking about the room a big grin appeared on his face as he recognized not only members of the church in Phoenix, but good friends from Casa Grande and lo and behold his second son, Bob. He had come out from his home in Virginia for this big event honoring his father.

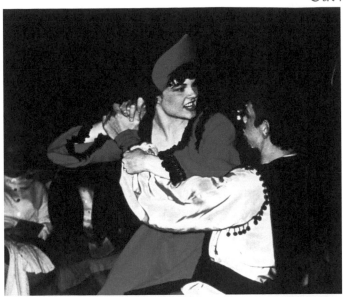

Katherine and Petruchio struggle

Jim Crouch was a senior and a year ahead of me. He was the most popular boy in school. Jim was Student Body President and star actor in school plays. I was in math class when David Hardaway, the drama teacher pulled me out of class. How busy was I the next two weeks? The policy at our high school stated that if you got married while a student you had to drop out. The shocking scandal at Casa Grande Union High School revealed that Jim had gotten a pom-pom girl Bev Kepheart pregnant. Their ensuing marriage meant that Jim could no longer play the lead in an upcoming Shakespearean play. I was cast in the play as Curtis, a slave. For some unknown reason I was the understudy to Petruchio, the lead, in "The Taming of the Shrew." I had won a freshman essay contest but I doubt this was the reason I was placed in this position. It was probably because my mother was a well-regarded senior English teacher. Mr. Hardaway explained all the work which would be required of me. They considered cancelling the play, but came up with this last ditch effort. Would I accept the challenge? I said yes and this changed my life.

As Curtis I had nine lines in the play. I now faced the daunting task of memorizing 157 lines as Petruchio. Complicating the situation was a fellow

actor. Playing the other lead role, that of Kate, was Patty Cooper. I had a big crush on her. One scene called for me to pick her up and carry her off the stage. In rehearsal Patty struggled so much to be in character as the feisty Kate I almost dropped her. They changed the scene to me dragging her off.

I would never have pulled this off if it had not been for the invaluable help my mother gave me. Her background was drama. She had taught this before becoming an English teacher. We practiced together a lot.

The foreword to the well-worn playbook says this about the play: "The Taming of the Shrew is one of the happiest of Shakespeare's comedies. It has romance, frolic and studied dramatic development in the main theme which, so delightfully seasoned with buoyant comedy, has a clear and disciplined life in the conflict of two real people."

Re-reading the playbook now, I can see several places where dialogue of my speeches was cut and shortened to make it easier for this novice actor. I'm sure somewhere in the play I got to kiss Kate, but overcome with so much on my mind it wasn't the pleasant experience of high passion it should have been.

Shakespearean English is tricky. The cadence to our modern ears seems a bit off. However, one of my speeches in the play reeks of high poetry. "Marry, so I mean, sweet Katharine in thy bed: and therefore setting all this chat aside, thus in plain terms: your father hath consented that you shall be my wife; your dowry 'greed on; and will you, nil you, I will marry you. Now Kate, I am a husband for your turn; for, by this light, whereby I see thy beauty, thy beauty that doth make me like thee well, Thou must be married to no man but me; For I am he am born to tame you Kate, and bring you from a wild Kate to a Kate conformable as other household Kates."

Re-examining my junior year in high school: it did not start out well. I had a minor injury to my knee

in football and when it healed, I quit the team. I got behind in Algebra II, couldn't understand it and was flunking. My father took me for a drive and a serious talk. Receiving some tutoring I managed slight improvement and got a D. Try-outs for my passion basketball saw me getting cut. Then BAM my success in the play. It sky-rocketed my self-esteem and filled me with confidence. For a while this made me a celebrity.

I was in five more plays. My senior year, another Shakespearean one, "The Comedy of Errors." As a history teacher at Coronado High School we were fortunate to have a talented theater teacher, Jim Newcomer. Every once in a while depending on who was available, he put on a student faculty play. I was Romeo Scragg, a very small role in the play, "Little Abner." In "Up the down staircase" my role increased as I was JJ McCabe, an assistant principal. After one performance the superintendent of the Scottsdale District came up to me afterwards with congratulations and a big smile. "You were so believable, I'd hire you in an instant."

My next play saw a major role, playing Juliet's father, in "Romeo and Juliet." For this part I grew a beard, so my youthful appearance would be transformed into that of an elderly gentleman. My last play was "The Crucible." This was a drama about the Salem witchcraft trials. I was one of the judges. No plays now on the horizon, yet Toastmasters is a micro theater that keeps me sharp and challenged.

Another memory of my high school years occurred when our football team traveled to Nogales for a game. This was during my senior year when I lifted weights in the summer, gained twenty pounds and made the varsity team. I remember the field was as hard as cement. I can't recall if we won or lost. Since we had a long bus ride home after we had showered the coach let us attend the dance in their gym for a while. I'm no gifted dancer and at that time in my life somewhat shy around girls. Somewhere in the recesses of my mind I found some courage and asked a girl to dance. I was shocked when she said "yes." I was not ready for this. After all why would she dance with somebody from the rival school, "the enemy?" Guess she was curious, or I might flatter myself and feel she was attracted to my good looks. I held her in my arms, very conscious of not getting too close. What we said to each other I don't remember, but the song captivated me. It struck a chord with where I was with my life at that particular time. A senior in high school with only vague plans of what was to happen next. What would college hold for me? The Vietnam War was dominating the news. Ah, the song and the enchanting seductive voice of Brenda Lee, "All alone am I, ever since your good-by, all alone with just the beat of my heart." Fifty three years later I still get choked up thinking about this.

My Vagabond Year

My life-long love of travel, now begins with my vagabond year, 1968. From my graduation in college until I was inducted into the army I was a nomad wandering the country. It started with my desire to leave the life I had been living in the town of Casa Grande Arizona. Growing up we had always taken a summer trip to visit our parent's home in Philadelphia. This instilled in me a fascination with "the East" and big city life, much different than a small town in the west. No longer having a student deferment, the draft was hanging over my head and the prospect of Vietnam.

I did not own a car so my travels were mooching rides with friends, going by train or by bus. Stan Penny also attended the University of Arizona and was driving home to Brooklyn. Our non-stop drive from Tucson to Brooklyn saw us taking turns at the wheel. It amazes me now how I felt comfortable enough and had enough trust in Stan that I was able

to sleep while he was driving. This is something I couldn't do now. We did, however, take a break and slept in a bed at my aunt and uncle's house in Indiana.

My stay in Brooklyn at Stan's house did not last long. His father did not approve of my interest in his daughter Leslie. Watching my limited finances I next found lodging at my aunt Dee's apartment in Manhattan. She had just recently divorced my uncle Rich and I felt a bit uneasy here. New York City is expensive and with a dwindling bank account and advice from Dee I took a long bus ride to Cape Cod and the town at the very tip, Provincetown.

Arriving in the evening in this New England town was dramatic. A person getting off the bus ahead of me was met by a friend outside dressed in a long black overcoat with a stylish hat. He was standing in the surrounding fog. It reminded me of the Pilgrims and I felt like a character in a movie. There was an aura of foreign suspense as to what would happen next.

Of course no one was waiting for me to get off the bus. Walking about town I saw a large building called the Atlantic house. Nobody was inside yet, but the bar attached to it had several people in it. Entering the bar it didn't really register with me that there were no girls present. Ordering a whiskey sour the man sitting next to me said, "I'm Paul, what's yours?" Something about his deep penetrating gaze into my eyes raised the hairs on the back of my neck. I quickly gathered my wits about me and said, "I'm David, where are the girls?"

My education at college didn't prepare me for this. Paul assumed I was playing hard to get. Then he couldn't believe I didn't know Provincetown was the gay capital of the east coast. I also sent off the wrong sign as I was wearing a shirt with a collar. I soon learned if you dressed well, it indicated you were gay. Those who dressed down, wearing sweat shirts, were straight.

Standing in line at a bank the next morning to cash some traveler's checks somebody told me Basil Santos just lost a dish washer and there might be a job for me there. With a college degree I was reduced to working at a restaurant washing dishes? 1968 was the height of the Vietnam War and healthy young men not in school were being drafted into the army to go overseas to fight and die. Classified IA employers knew what my future was and it wasn't with their company. So yes, I became a dish washer.

The camaraderie of the chefs, waiters, waitresses, and fellow dish washers at Basil's restaurant put me in a warm cocoon of friendships. After work we did a lot of things together. One of the highlights was "the blessing of the fleet." An array of fishing boats formed a long line and sailed by a pier where a Catholic priest waved a religious symbol, repeated a Latin phrase and blessed the boat. We then sailed away and had a party on the boat. It was tossed about as to who would climb the center mast and dive into the Atlantic Ocean. Watching a few others do this, I debated with myself. Is this something I really want to do? Encouraged by my new friends and with some alcoholic courage I climbed the swaying mast and pushed myself off, high in the air and made a fairly decent dive into the frigid ocean. Welcome to the clan, I was then blessed.

Washing dishes I got a good view of Margaret as she reached up a high counter to place her order for the cooks. In my opinion she was the best looking waitress. However, Margaret did have a boyfriend. Since I had arrived after the season had started, finding a room to live in was always a problem. I drifted from place to place. When Margaret had a fight with her boyfriend I was staying on her sofa for a couple of days until I could find a place. I was then changing shifts. I had just been promoted out of the kitchen to a more lucrative and higher status of being a waiter. Margaret said to me, "Let's go out and party!" Here I made one of the biggest mistakes of my life. I was dead tired and said no. The next day

Margaret matched up with one of the cooks and I was gone from the sofa, looking for another place to stay.

Only if I had said yes, life at Provincetown would have been set and so much sweeter. Then I met Ulla. It didn't turn my life around immediately but later became something special. There was a bar in town where it was acceptable for both gay and straight people. One evening a brother and sister were talking to another guy and I came over to sit by them. The guy was drunk and getting nowhere in his effort to pick up the girl. He shortly gave up and walked away. Ulla Schaffer lived in Germany and was visiting her brother who was attending Harvard. We made plans to meet at the beach the next day.

Lying on the fine soft sand the next day we talked and took pictures. Since she seemed interested and I did not want to disappoint her, I got her address in Germany. It didn't seem realistic that we would ever meet again, but then again, we both sensed a faint possibility magic might intervene. Six months later I was in Germany, a member of the US Army, and I used that address to write her a letter. She would probably have a boyfriend, but why not give it a try. Unlike my missed attempt with Margaret, this time I struck gold, Ulla was free and willing to meet.

Ulla Schafer was like a child in some ways, trapped in a gorgeous body. This was in part brought on by our language difficulty. She spoke halting English and I spoke almost no German. I always spoke slowly so she could understand, hence my memory of her like a child. Ulla was above all kind, and considerate. We'd meet about once a month in different parts of the country and it made my time in Germany a lot of fun.

Returning to Provincetown in 1968 I got "itchy feet" and decided to return to "the Big Apple." I was happy being a waiter but not having a regular place to stay was bothersome. Rooms available were for tourists. I couldn't afford tourist prices. I also felt New York City had something left for me. My hunch

was right, her name was Jennifer Reilly.

Somebody gave me a hint that a job at Kennedy Airport might be available. I acquired a room in a two story family house in Queens. It had a staircase on the side of the house up to the room so I didn't need to interfere with the family. My job at the airport saw me driving a truck to the many different terminals, picking up suitcases for people changing airlines and taking them to the correct terminal.

While my immediate family lived out west, I did have a few relatives in the east. I greatly admired my uncle Rich Leety. He was only ten years older than me and always seemed to be doing things in grand style. I gave him a call and he invited me over to Philadelphia. He and his new girlfriend Jean were going scuba diving and I could accompany them. I had to show up at his house early in the morning because they were going to drive to the Jersey shore and meet their diving buddies.

I took a train to Philadelphia and got off at the 69th street terminal. I knew the route to Ruskin Lane, the old brick row house my father grew up in. I also knew how to get from there to Wayne Avenue, the tree lined street where my mother grew up and her younger brother, my uncle Rich. But to walk in the dark from 69th street to Wayne Avenue I wasn't too sure of. I got lost. Panic settled in. I would miss the appointed time, the ride to the Jersey shore and a chance to meet Rich's new girlfriend. Somehow I guessed right on one street that lead to something familiar and made it to Wayne Avenue with five minutes to spare.

Being on a rocky boat and learning about scuba diving was fun. Returning to Philadelphia I had a good visit with Rich. In the evening he took me to Jean's apartment and for dinner we had lobster they had caught that day. Jean had been a science teacher and was now a counselor at the high school where Rich was a history teacher. They seemed nice together. Rich and Jean got married when I was in

Germany.

Back in New York, one night I went into the city and entered a crowded east side bar. You could almost smell the predatory atmosphere of people eyeing each other as to who they wanted to mate with. Many were dressed in fancy suits. The best I could offer was my worn corduroy coat. It must have had some charm because I met Jennifer.

To digress for a moment and put my romantic life in perspective I need to return to high school. Here I had a crush on Patty Cooper. She was polite and I got one date with her to the movies, but she wasn't really interested. In college I dated some but not much clicked. Up to this time in my life there had been no one you could call a girlfriend. Jennifer therefore was my first girlfriend. It was an education. I got entangled in a tumultuous relationship of highs and lows. One of the highs saw me with a partner who was an ardent lover.

Jennifer's family lived in the wealthy enclave of Garden City Long Island and she had an apartment in the city. We visited there often. She understood my precarious position of waiting for the army to snatch me up. There were subtle hints that after the military we'd marry and I would become a lawyer. I was on the edge about this and my true feelings for this spirited woman. We did, however, have a strong connection lasting two and a half years. One unsettling factor for Jennifer was my wanderlust. With the army about to nab me I got "itchy feet" and moved to San Francisco.

This time there was no cross continental car trip. I flew to Phoenix and touched base with my parents. The return of the wandering son was brief. Being a minister in a conservative small town of Casa Grande he had just gotten a church in northern Phoenix. This made him happy and for the first time I saw my parents drink wine with dinner. Of all my travels I always kept enough money in reserve for a bus ticket back home.

Arriving in the Bay area I had no job. Budgeting carefully at one point I was down to eating only one low-cost meal a day. Then I struck pay dirt and got the ole reliable job of washing dishes at a cafeteria. The hotel where I resided was located in a neighborhood of San Francisco called the tenderloin. The name fit the area. It was a bit seedy, and run-down, but it was cheap and fit my budget. One night I hovered between being awake and falling asleep. Hearing fire engines, a common occurrence in this neighborhood, I didn't think too much of it, probably far away. Yea, maybe I should check it out. Half asleep I stumbled to the window and much to my surprise saw a fire ladder come up towards me. My hotel was on fire. I quickly put on my pants and shoes. Racing down the stairs I had to hop over fire hoses two floors below me. Joining residents on the street we waited for an hour before we were allowed back in the hotel as the small fire was contained.

Jennifer's older brother was in the navy and she came to visit him and me in San Francisco. Much of our long distance relationship involved writing letters to one another. Our separation was awkward, but our feelings for each other were thus tantalizingly kept alive. We saw each other three other times after San Francisco before the big break-up. In the army I got leave for the Christmas vacation and flew not to Phoenix but New York and Jennifer. Stationed in the south before I went to Germany, Jennifer flew to Atlanta for a weekend to see me.

My vagabond year was not a calendar one as it ended in November. My corduroy jacket went into storage replaced by olive green fatigues of the army. Now I face two years with travel stops in: Fort Ord, California, Fort Benning, Georgia and two different sites in Germany.

While I was in Germany my parents went on their eastern trip to see relatives in Philadelphia and knowing of my relationship with Jennifer, had dinner with her in New York City. Wow! Did this make me

uncomfortable? Being diplomatic they of course never revealed to me their opinion of my judgement of a potential spouse. I later learned in one of her letters, that Jennifer was nervous in this meeting and drank too much.

Life in Germany was vastly different than the training I received in the United States. Luckily I escaped what I was trained for, the infantry, and became a court reporter. It was just like a regular job and a lot more interesting than washing dishes. I had fun cavorting around Europe with Ulla and writing letters to Jennifer. Being somewhat smart I never told Jennifer about Ulla.

Getting released from the army in Fort Dix, New Jersey I headed straight for New York City and Jennifer. The intellectual connection achieved in writing letters was not enough to keep us together. We had a big argument. That night I stormed out of her apartment and went to a bar. Inside you could just feel the predatory atmosphere of people sizing each other up. Seeing a beautiful woman in the corner I walked over. Here I met Susan Biggon by the cigarette machine.

She was looking in her purse. I asked her what she needed and she replied, "A nickel." I had the nickel and an hour or so later her phone number and a date that Friday. Thinking to walk her home, Susan remarked, "Oh I'm with Mark." I thought to myself, who in the heck is Mark and where has he been this last hour? Realizing I must put forth my best effort I brought flowers that Friday night. We ate in a French restaurant and saw a romantic movie set in Ireland. Our next date saw us walk across the Brooklyn Bridge. At this juncture we both knew we were in love. Who knew I would marry an anti-war protester from Brooklyn?

Where are they now, Stan Penny, Ulla Schafer, and Jennifer Reilly? I'm curious but don't know. Susan knows about one of her old boyfriends. She went with Steve in college for three years. Three times he broke

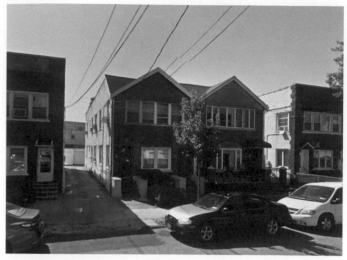

1416 Avenue R, Brooklyn, NY - Image Courtesy of Google

her heart. Then thirty years later, Steve called her. He was living in north Scottsdale and being a detective, looked up her married name. Steve's explanation as to why he broke up with her was, "he wasn't ready for a big time serious relationship." What would I say to Jennifer if I saw her today?

Susan's Childhood

My impetus for travel in retirement is Susan, my lovely wife of 48 years. Some background on her life.

Picture: Concrete sidewalks, asphalt streets, a house on 1416 Avenue R in Brooklyn and you need to escape the sweltering heat of the summer. Now imagine paths of green grass, tall trees providing welcoming shade and a pristine lake… this is camp for Susan Biggon.

Growing up encompasses a plethora of experiences. Life in Brooklyn where her great grandmother ran the household and her mother divorced her father when Susan was eight is one big chapter and summers at camp is another. The focus now centers on her camping stories.

The idea for this came from her step-father Gabe who entered her life at age twelve. He knew somebody whose child went there. It was relatively inexpensive and was a special time in her life molding her into the tremendous person she became. Starting

as a novice she climbed the ladder to become a counselor and taught swimming and tennis. Campers were given nicknames. A comic book "Archie" was popular. Since Susan had dark brown hair she received the nickname "Ronnie" after one of the brunette characters. Little did she realize later she would marry an "Archie." I never liked this nickname and preferred to have the runners I coached call me, "Arch."

The outhouse had five seats close together so young girls would talk. In the evening a bar of soap and the lake is where one got a refreshing bath. Hiking with a sleeping bag and gazing at the universe above, the pitch black sky and the thousand tiny white lights puts you in touch with nature. A lot different than life in Brooklyn.

Campers stayed for two weeks, however, Susan stayed for the whole summer. The big event took place the last day of camp when one camper was named, "an honor camper." A list of previous honor campers was prominently displayed for all to see during the two weeks. The suspense of who would be chosen was similar to the academy awards and the ceremony accompanying it was a highlight for all. In her third year of camp because she was a good leader, Susan, was so honored. She was presented with a big green candle. Then everybody went down to the lake and placed small candles in little paper boats that gently floated out onto the calm lake.

Thomas Patrick King an Irish Catholic from the Bronx also went to a summer camp that was on the opposite side of the lake from Susan's camp. At age fifteen Susan was a junior counselor working in the kitchen. Also at this time dances were held with the boy's camp across the lake. Tom walked across the floor and asked Susan to dance.

Thus sparked a romance that extended beyond the summer. He would travel from the Bronx to Brooklyn to take her out to dinner and the theater. "He liked me." They dated for three years and he took her to his senior prom. Tom was President of his class and this made for a memorable evening, yet they later drifted apart. They met four years later at a museum and found out they were different people than they were in high school.

Susan's parents met after WWII. Miriam always worked to help support the family. Teddy her father worked in the textile industry. Grandmother Rose had a weak heart and was physically unable to hold a job. Running the household was Henrietta, her great grandmother, who at age 14 had emigrated from Germany to Cleveland. A strong intelligent woman who was a great cook. When Susan was a teenager the pillar of her life, Henrietta, died. Rose had died a few years earlier. Susan's parents divorced when she was twelve. Gabe now entered Susan's life. Gabe was from Hungary, a land locked country. He first saw the ocean when he was 31 coming to American following WWII.

My parents on the left, Susan's parents on the right.

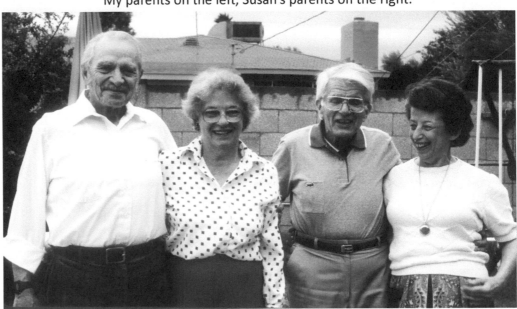

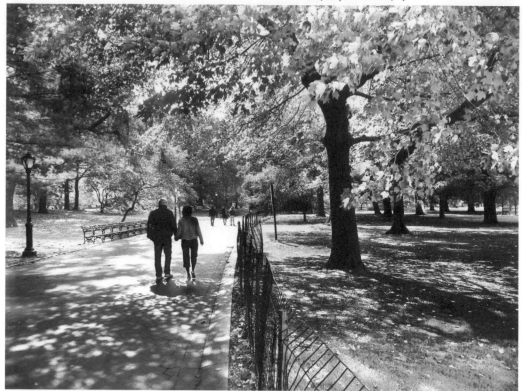

New York City - Central Park

neutral. The city was fought over by the Nazis and Russians during the winter. The house had broken windows and no heat. He had to stay in line for water and got only one minute each day to draw his ration. This was strictly enforced.

In January 1945 Gabe went to his hometown of Papa and stayed there until the end of the war in May. There he met up with Bandy and Denes. Since Denes was a communist, he decided to stay in Hungary. None of Gabe's family survived the war. Both of his parents were killed at Auschwitz. Gabe had a cousin in America and he and Bandy made plans to go to America.

Deciding to go to America and getting there in the middle of war-torn Europe was not easy. Gabe and Bandy spent over a year in Displaced Persons camps and tried to navigate their way to American occupied territory from the Russian zone. They traveled in railroad boxcars and before entering Salzburg were told to say nothing because they were traveling with false documentation. For example somebody had papers saying they were Belgium and were returning home. In reality they couldn't speak the language of the country from which they were supposed to come from. They stay a couple of months in Ulm and then went to Frankfurt. Looking back on this experience Bandy and Gabe can't seem to remember how they got food for three months. Yet they did, because they survived. At such times stress is just going to blot your memory of events. December 31st 1946 they departed Frankfurt for Bremern Haven. This German

Where were the men in Susan's life? She never knew her great grandfather Jacob Dub as he died before she was born. We do, however, have his scissors because he was a barber. Robert Sheer was a salesman and he died when Susan was one year old.

Gabe grew up in the town of Papa with Denes his cousin and their good friend Bandy, both who were ten years younger than him. Gabe's father ran a general store; Denes father was a lawyer; and Bandy's father bought and sold ox and beef. Upon completion of his schooling Gabe worked in the textile industry.

Living in Europe and being Jewish during WWII was dangerous. While Denes and Bandy survived in concentration camps, Gabe worked in a labor camp. In November 1944, Gabe possessing an identity card with a photograph and no religious identification, escaped from his labor camp. This happened during a changing of the guards. Hungarian guards were being replaced by German guards and knowing this would mean a concentration camp for him Gabe took a chance and ran away. He went to Budapest and a house protected by the Swedes, who were

port city according to Gabe was one of the coldest places on earth in 1947.

Bandy got an earlier ship a week ahead of Gabe. Gabe describes his three week ocean voyage as an ordeal – there were rough seas and almost everyone was seasick. They arrived in Bermuda where they recuperated, shaved and got cleaned up for their arrival in America.

Meeting Gabe as he got off the boat was his cousin Eva. Within a week of his arrival he got a job in the textile industry. It was easy to get a job after the war because everybody wanted things they had been deprived of during the war. Bandy's whose real name is

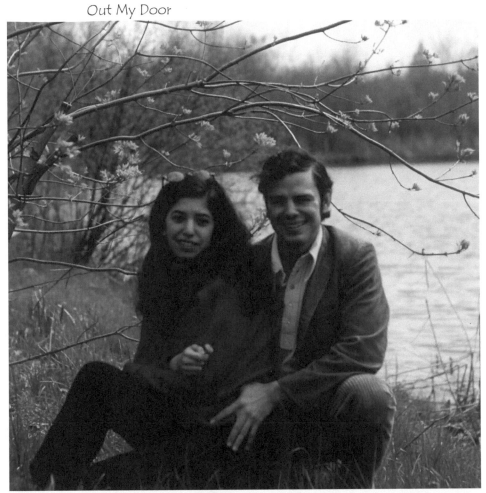

Susan and me a couple months before the wedding.

Andrew Laszlo became a successful Hollywood cinematographer. Denes Kardos after the war was in the Hungarian air force as a navigator. The quirks of communism produced strange results. Because Denes' father was a lawyer, he was thought not to be a good communist and so Denes was dismissed from the air force and returned to medical school. After the 1956 Hungarian revolution Denes immigrated to Israel and became a psychoanalyst. Denes died in the early 90's so I will have to talk to his son Michael to find out more of this fascinating story.

In 1960 Gabe married Miriam and they moved to avenue H. They had an apartment on the fourth floor. Here Susan had a separate space with two windows and was next to the kitchen. Nine years later after her junior year in college they moved to Manhattan, the east side, 72nd street and Third Avenue, apartment 2G. Unlike avenue H which had a stoop (elevated

steps leading to the front door) this building had a doorman and an elevator man. Welcome to the big city. It was a one bedroom apartment with a small kitchen and living room. At the end of the living room next to the kitchen Susan had a bed and almost zero space. With her approaching senior year at Long Island University the expectation was obvious she would be moving out into the world. This of course set the stage for me.

I was a bit unsure of myself when I first met Gabe in November 1970. He had a head full of white hair and a determined look about himself. Such was not the case with Miriam, Susan's mother. For my first date with Susan I brought flowers. Miriam seemed more impressed with this than did Susan. Looking at Miriam I said to myself this is what Susan will look like in thirty years as the sparkle in her eyes and smooth skin were attractive assets. I faced a daunting

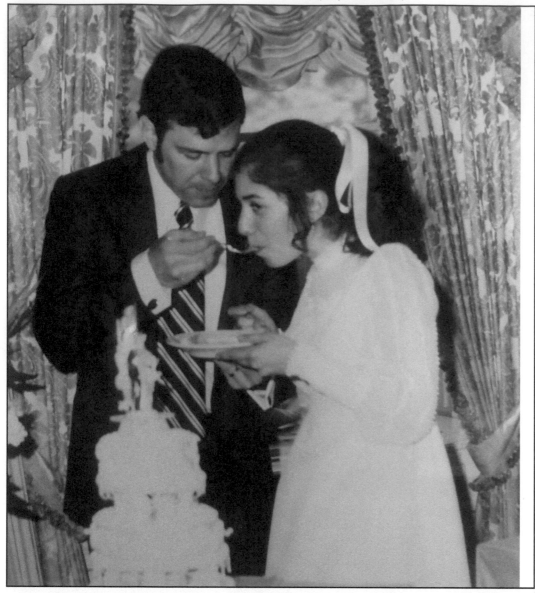

June 27, 1971 - Wedding cake, our first meal.

Of course Julie and Lisa could do no wrong. I on the other hand had to be extremely careful. Once when returning from a run in Central Park I ate a banana. Miriam screamed at me in front of everybody in their small apartment, "He ate the last banana!" Oh, what a horrible sin. I guess she was going to eat it.

Miriam fell down some stairs, had a stroke, lingered for three days and died at age 78. Ted had relocated to Georgia remarried Sadie, a true country gal and died at age 78. Gabe outlived them all. When Miriam was alive we enjoyed a holiday at Val David, a quaint village in the Laurencin Mountains above Montreal. When Miriam died we took him again to Val David. When the next year he wanted to go a third time, we had other plans and said no. Gabe did not like the word no, and we became estranged. He died alone except for a caregiver whom he left a considerable sum in his will. He was 90.

New York City vies with London and Paris as "grandest cities of the world." In my youth there was our annual trip east from our western home visiting Philadelphia. We probably took a side trip to New York, but it doesn't stick in my memory. Stan Penny brought me there after graduating from college in 1968. We drove from Tucson in three days. While Stan faded from the scene, my aunt Dee was a brief

task as Susan had only dated Jewish and Catholic boys. My father was a Presbyterian minister.

When Gabe first arrived in New York City he wondered why all American cars were yellow. There are, of course, a lot of taxis in the city. Gabe was very passionate about classical music. It was played so much in the small apartment it drove Susan crazy. To this day she shudders at the sound of violins. I like classical music, but I like Susan more so we do not play it our house.

Living in Arizona we often brought our daughters Julie and Lisa to New York City to see the awe inspiring sights of American's cultural capital and visit with their grandparents, Gabe and Miriam.

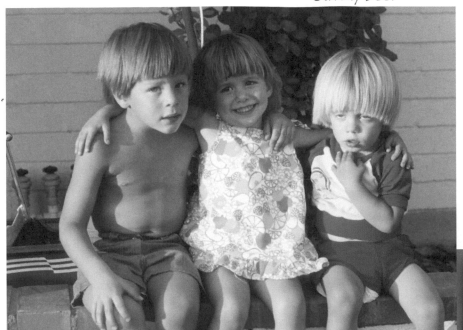

Cousins - Bobby, Julie, Brian

came from staying with Gabe and Miriam, Susan's parents in the East side of Manhattan. Seventy Second street and Third Avenue is an easy walk to Central Park and the Subway station at Sixty Eighth Street. Their small one bedroom apartment was on the second floor. Susan and I plus our two girls slept

Sisters - Julie, Lisa

touchstone to the city. A very successful advertising executive, she provided helpful insights to the local culture. My true teachers of life in the big city were my on again off again girlfriend Jennifer and, later, my wife Susan. I met both of them at different times in a bar.

New York has a lot of impressive architectural structures. High on the list is the Brooklyn Bridge. When it was built in the late 19th century it was the longest suspension bridge in the world. Massive grey brick towers at both ends support numerous cables holding up the curved roadway. However many are unaware of an upper deck for pedestrians and the lower for cars. On my second date with Susan we walked across the Brooklyn Bridge.

When we visit the city now, we stay with Willie and Daisy. He's a good friend from the army and they live in the Bronx. You can faintly hear the screeching sound of the subway three blocks away. Willie is passionately in love with the city. He drives with reckless abandon and has intimate knowledge of the city streets.

The majority of our knowledge of the city

My collection of family pictures is immense. However, a few stand out. The picture above of Susan and our girls is one I treasure. In 1981 for our tenth wedding anniversary Susan and I took a vacation to Hawaii. My parents watched our daughters. This was the first time we had been separated from them. The reunion of our family is well expressed in the photograph with smiles on everybody's face.

were away from the glamour and thrill of: Broadway, Wall Street, Fifth Avenue, and all the other attractions of America's largest city. Staten Island, however, was a good base when I ran the New York City marathon in 1984. Connecting Staten Island to Brooklyn is the very long Verrazano Narrows Bridge. With thousands of runners you can actually feel the bridge move a bit. The race continues and connects all the other boroughs of New York City. The finish line is in Central Park and I joyously reached it in three hours and twenty three minutes.

Patty was another college friend of Susan. She lives on ninety second street on the tenth floor. We stayed with her a few times when our girls were grown up and didn't accompany us. Her apartment complex had a doorman but unlike Gabe and Miriam's place did not have an elevator man. These simple tasks seem a touch overboard, but when you factor in they are also security, it makes sense.

While Susan grew up in Brooklyn I only truly lived there one year. Sixty Five Atlantic Avenue was on the edge of Brooklyn Heights. It was affordable as it was on a mercantile street and safe, because it was right next to an expensive fashionable brownstone neighborhood. It was also an easy walk to a subway station and a short commute to Manhattan and my job at Metropolitan Life Insurance Company.

It was here I saw my parents walking to our apartment a week before our wedding. Susan was

in the living room. Somewhat like camping.My father in the 1930's

A couple of times we stayed with Pocket and Mike on Staten Island. She and Susan are friends from their days in college. This is nothing like life in Manhattan. You're in a traditional suburb with trees, and sidewalks are absent of the crowds of Manhattan. A bonus was a picturesque lake a short walk down a sloping hill. Here we had a room to ourselves but

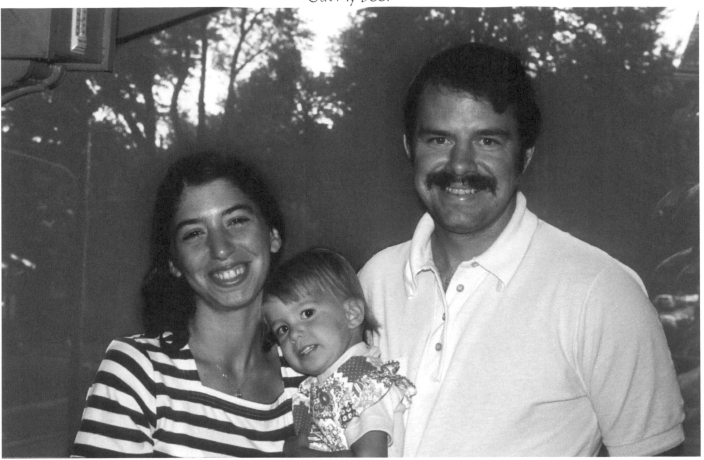

Susan and I with Julie at age two.

nervous, never having met them. My father was carrying a very large object wrapped in brown paper. He had made a copper tray designed with oak leaves and acorns, our wedding gift. The St Moritz Hotel on 59th street the southern boundary of Central Park was the location of our wedding, June 27 1971. My father presided and I felt everybody in attendance could see my leg shaking. The dinner after the ceremony saw us looking out below the hotel at a Gay Pride Parade. We spent the night at a suite in the hotel and the next day flew to St Martin for our honeymoon.

The second most recognizable symbol of our country is the Statue of Liberty. It stands on an island in New York's harbor. The number one symbol is the flag. In the fog of my mind we went to the crown on one of our eastern trips my parents took. As I've grown older there has developed a fear of heights. The express elevator to the top of the Empire State Building has never happened. Thus the towering skyscrapers of New York City are intimidating.

Part of the charm of New York City is how popular it is. How many TV shows and movies are shot there? How many books are set in New York City? Too many to count is my answer. Seeing a scene from a movie in London or Paris I can proudly say, "I've been there." This happens with greater frequency and impact when the landscape is New York City.

Our city of choice is now San Diego. Its beaches are better and less expensive. Even before our daughter Lisa moved there eight years ago, we made frequent visits to this California oasis. The year-round weather there is probably the best in the United States. An outstanding event happened when our girls were young and my parents rented a house right on the beach. My brothers were there and it was a grand event. Now our yearly Thanksgiving sees our daughter Julie fly down from San Francisco and we make the five and a half hour drive from Chandler. I'm not a surfer yet Susan and I love the ocean. The

Susan's father Ted, Julie, and Susan gazing into the flame

and could I also coach football? This resulted in a long distance phone call to Ed Anderson, the head football coach at Coronado. I told Ed I had played football in high school and felt confident I knew enough about the sport to coach it. I did a good sales job and got the job.

The enrollment of Coronado in 1974 was over three thousand students and they had just gotten off double sessions. This meant I was a floater, using a room of a teacher who had their planning period when the class I was to teach was scheduled. I had only two econ classes with the rest my more comfortable subject, American History. Fellow social studies teachers were of tremendous help for this rookie. Then a conflict emerged. Bill was retired military and his leadership style did not sit well with other teachers in the department. When talking to you, Bill moved very close to your face and this often made people uncomfortable. Two years earlier they tried to depose him as chairman, but he ruthlessly crushed it. This time they were more careful and enlisted my support. I owed my job to Bill, but agreed with them. When he was ousted, he stormed into a room I was in and shouted in my face, "How could you?" There was nothing I could say, so I remained silent and listened to him rant and rave. A tense situation I survived because I had the support of my fellow teachers.

For some people the subject of history is unappetizing and boring. Yet I loved it because it's just more than politics and war. It's culture, the totality

Teaching

A question we all eventually ask someone is, what do you do for a living? I was a high school history teacher and track coach. After thirty years, I retired and wanted to see if what we read in books about places is actually true and this became the inspiration for international travel.

First you may ask, How did I get my job at Coronado High School in Scottsdale? My uncle Rich and aunt Jean who lived outside Philadelphia were going to be traveling for the summer and offered to let Susan and myself to house sit for them. Their old house with thick white brick walls was built in 1790 and had a beautiful creek in the backyard.

Bill Sullivan was a member of my father's church in Phoenix and the social studies chairman for Coronado High School. Having a vacancy to fill he asked my father if I could teach economics? When he found out I could, he said there was one hitch,

smell, the sound of the crashing waves and all its majesty captivate us. Just sitting on the beach brings a sense of joy and peace.

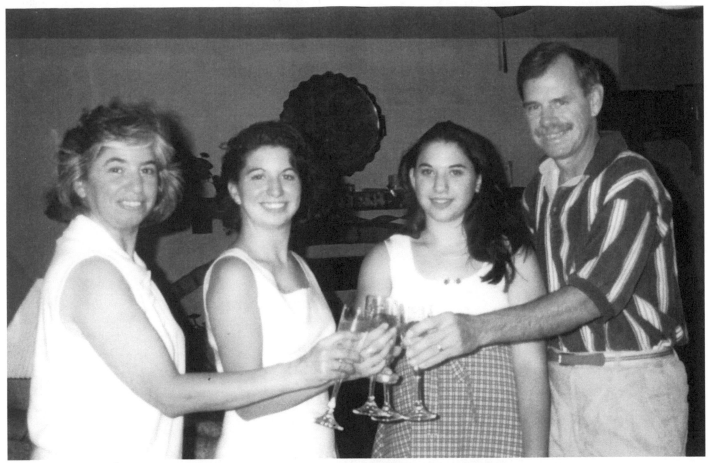

Susan, Julie, Lisa, and Myself. Kids are growing up.

of life or the essence of man. Yet it's everything you choose to study. For a teacher the presentation of the subject matter is vital. If done correctly with passion it can lead students to understand the many, many lessons that can guide them in their lives.

At Coronado there were four of us who taught American History. In my third year of teaching we came up with a creative way to teach the subject, the quad system. We divided American History into eight periods and had each of us teach two of them, so at the end of the year students would be exposed to four different viewpoints and personalities.

Davalene Niehaus taught the twenties and thirties, because she had lived through the depression and intimately knew the subject. She also taught the Jeffersonian and Jacksonian periods. Bill Kelly landed on the Normandy beaches after they were secure. Therefore, the subject of WWII was his along with a section on Arizona history. He grew up in the mining town of Ajo. Keith Plummer grew up in the

south and had a passion for the Civil War. He also taught the Industrial period that followed it. Being the youngest of the four, I was given the beginning: the Colonial and Revolutionary period. Being alive in the fifties and sixties, this was my other area of instruction.

A highlight was a slide show I created. All pictures of the fifties were in black and white, and with the sixties the shift was to color. I included the top two songs of the years to accompany the pictures. Getting the songs to match the image took a lot of experimentation but I was pleased with the end result. It was a fun way to teach. Of all the things I packed into the nine weeks, Vietnam got only a day or two because the subject was emotionally charged for me and I felt a lack of perspective as a historian. While I did not serve there, my two brothers did and I was sent to Germany. They survived, but Bob does not watch movies on the subject.

A safer subject was the geography of New York

City. With so many things to teach, I got to pick and choose, and this was fun. Our department chairman and the principals at Coronado trusted us and gave us a lot of freedom. I doubt this is the case today.

It's bittersweet when you retire. To leave something you love is sad, but money speaks volumes. In 2004 the Scottsdale District wanted to economize… get rid of teachers high on the pay scale and hire cheaper beginning teachers. Thus I was offered a package, whereby I could sit at home and make the same money if I was teaching. I lost my audience. Yet if you look closely something can

always turn up to take its place. Bill Trottier got me involved in Park Central Toastmasters Club. It's the second oldest in the valley and in my mind clearly the best in many ways. Public speaking can be frightening for most, but as a teacher it seemed second nature to me. However, when I spoke at Toastmasters I was told, "You're using your teacher voice, stop it, we're adults." I've made the adjustment in retirement and at Toastmasters.

GOOD LUCK
Mr Archibald

Retirement travel log – 30 Countries

- **1996: Julie moves to San Francisco**
- **2004: Lisa moves to San Diego**
- **2004: Retire after 30 yrs of teaching and climb Kilimanjaro**
- **2004: Mother dies (Marcia was 90 years old)**
- **2006: South America (Argentina, Uruguay, Chile)**
- **2007: Xcalak, Mexico**
- **2008: Hawaii and Maui**
- **2009: New Zealand (January)**
- **2009: England (December)**
- **2010: England, Netherlands, Belgium**
- **2010: Havasu Falls, Arizona**
- **2011: Turkey**
- **2012: Russia, Finland, Norway**
- **2013: Ireland**
- **2014: Alaska**
- **2015: British Columbia, Alberta, Canada**
- **2015: Peru**
- **2016: France (Susan, Linda, Sharon and Marilyn)**
- **2016: Spain, Morocco, Portugal**
- **2017: Adriatic cruise (five countries)**
- **2018: Denmark, Baltic cruise (six countries)**
- **2019: Italy - ten days**

Chapter 2: Mountains

"The mountains are calling and I must go." – John Muir

Charlie Rice

Reading about Mount Everest, the highest mountain, and those who climb it, I have no interest. Some respect, but not fully. You have to be rich to do it. It costs a lot of money and generally a good segment of time, two months or there about. Plus a lot of ego is involved. Reasonable mountains for me were: Mount Sopris, Colorado (elevation 13,000 ft); Popocapatul, Mexico (17,000 ft); and Mount Kilimanjaro, Tanzania (19,000 ft).

After achieving one of my running goals of breaking three hours for a marathon (sub seven minute mile pace) I decided to slow it down, see the scenery and climb mountains. At first glance not a smart decision for somebody who is afraid of heights. Some research informed me that not all mountains are sheer drop-offs, but just a general slope involving a hard hike. Yes, I can do this.

Mount Sopris is what you look at from the Leety house. It's far away across the valley but always in clear dramatic view. When my brother Bob visited we climbed it. The trail was not always easy to follow and often only marked by caroms, three rocks stacked together one on top of another. Afterwards we took a well-deserved soak in the Leety hot tub.

Gordon Foster was the impetus for me to climb five 14ers in Colorado. He was a fellow runner and a more accomplished camper and climber. Joining us were three of his friends who came out west from Maine. We would camp at the base of the mountain, start early so we could summit and descend before

Charlie Rice

afternoon storms and their dangerous lightning.

My next climbing partner was Charlie Rice. He looked like a character out of the Bible. Charlie had a full head of white hair and an equally eye-catching beard. With his wrinkled weather-beaten skin you might have been thinking you were talking to Moses. Charlie was certainly unique. He had a way of talking to people that you realized he was giving you his full attention as though you were the only person in the world.

I've known Charlie for over thirty years. He was a solid fixture in the running community, when I started competing in road races. Charlie ran every Fiesta Bowl marathon and in its last years a faint picture of him was superimposed on the application blank. Charlie achieved the awe-inspiring task of breaking the three hour time in the marathon before he broke forty minutes in the 10K. Most very good runners do it the other way around. Charlie died at

I'm above the clouds at the summit of Popo. Two English climbers are coming up behind me.

age 86 in January 2017 and his memorial service saw a reunion of many running legends in the valley.

Charlie also liked to climb mountains and hike. One woman runner at the service told me she saw Charlie at the bottom of the Grand Canyon with four woman hikers. She said, "You know Charlie was a ladies man." He did indeed have that magical charm.

He summited the tallest mountains in five continents and was a trekker on an Everest climb, reaching 21,000 feet. I had him come into my class a few times to show slides and tell stories of his Everest adventure. Charlie always hiked with a teddy bear he called, "Buddy." Before the lights went out in the room to show his pictures he said Buddy was afraid of the dark and would some girl hold on to him. Several hands flew in the air and Charlie, looking out for Buddy, would always pick the prettiest girl in class. Periodically Buddy appeared in the show: a Korean airline stewardess holding him; Buddy peers outside the window of a train; Buddy ridding atop a yak; and Buddy wearing ski goggles. Charlie was a retired elementary school teacher and he certainly knew how to hold a class's attention.

Popocapatul, Mexico

My understanding of Mexico was based on the tourist's border towns of Nogales, Juarez, and Tijuana. This false picture changed when, in 1992, Charlie took me and two other runners, Gordon and Bill, to Mexico to climb Popocatepetl. At elevation 17,887 feet it's the second highest in the country and always has snow on the upper reaches. To get a good feel for the country Charlie convinced us to take a bus. The drive from Nogales to Mexico City certainly changed my opinion of the geography and people of the country. It's not a brown desert like I thought, but lush green in many places. The bus made local stops. The 38 hours tested our endurance but gave us a good look at how the local people lived. Anytime

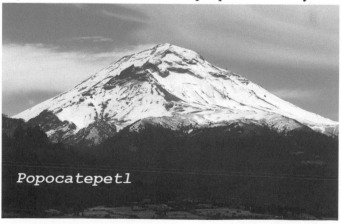

Popocatepetl

we had doubts Charlie reassured us because he had done this trip and climb before and was our trusted guide.

A rather plain cement building stood at the base of the mountain. It was here where we met a bunch of kids and some European climbers: a pair from Belgium and another pair from England. After a day of rest and orientation we got in our sleeping bags early to rest for the long day tomorrow. We started our climb with flashlights in the dark. The majestic array of stars was breath-taking. Ever so slowly light began to reveal a trail and the surrounding landscape. Colors and details emerged of bushes and off in the distance we saw another mountain. As I look back on this slowly developing light on our mountain climb it was indeed thrilling.

Eventually we reached a junction on the trail and snow. It was here we got separated. Earlier Charlie felt our pace was strong and not wanting to be a drag told us the direction and we'd meet up at the junction. At this resting place Bill lost his glasses. After several futile attempts we gave up the search and told Bill to wait for Charlie. Seeing the footprints of the Europeans in the snow it was easy for us to follow a path. We did encounter a brief white-out that caused us a bit of concern. Then, of all the unexpected things, a dog came out of nowhere and joined our climb upwards. Soon we passed the English and then joined the Belgians at the top. Gordon joined the Belgians to circle the cone of the sometimes active volcano that Popo is.

As they joined me at the summit, I gave the English hikers some aspirin, as they were exhausted, then started my descent. Way down the mountain I saw a lone figure struggling in an uneven manner. As I got closer I realized it was Bill. He was lost, and suffering from altitude sickness. Bill had not waited for Charlie and now was so overjoyed to see me. Together we made it down the mountain and joined Gordon and Charlie at the cement building where

it had all started. Looking back on this adventure, I probably saved Bill's life.

Kilimanjaro, Tanzania

Mount Kilimanjaro was different in many ways. You were not allowed to climb alone and it took nine days. Going with guides and porters helped the local economy and made the climb safer. After some research, Thomason Safari was the tour group I chose. They were excellent compared with other groups I encountered on the climb. The reason for nine days was to slowly acclimatize, allowing you to reach the summit. People who scheduled five days, often did not make it, as you can die from altitude sickness if you stubbornly refuse to give up. Local guides are very aware of this and strictly bring climbers down once they see the signs of altitude sickness. After all it's bad for business having Americans die. Even so, it happens.

Part of my research for Kilimanjaro was talking to a good friend who had already done it. Gary Carlton is married to Alyane who is Susan's cousin. While they live in Los Angles we have done several hikes together: Havasu Falls, and the Superstition Mountains in Arizona, and Palisade Glacier in California. His experience on Kilimanjaro was vastly different than mine.

For my trip, three black guides and twenty seven native porters took care of ten white rich Americans. The obvious racial divide made me a bit uncomfortable at first, like an evil imperialist, but I got over it. Guess I have lead a sheltered life. Strangers at first, our group blended well. I can remember the states, but not all of the occupations: California, Wyoming, Nebraska, Illinois, Washington DC, and Arizona; manager of a theater, Shepherd, lawyer, AFT agent, Department of Agriculture executive, and me a retired teacher. Everybody was with their spouse except a mother and her son who had just graduated from college, and two of us singles, me and George the Ag guy.

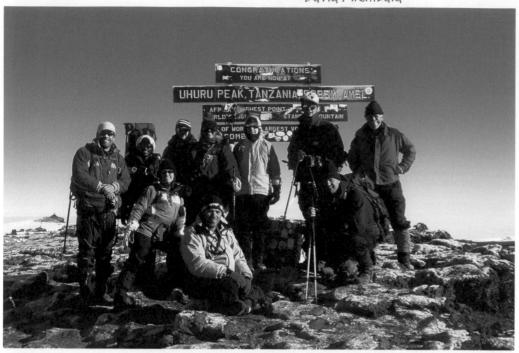
Summit on Kilimanjaro. I'm on the far right.

porters had tents set up and we ate well.

One of the highlights of the day for me was lunch. A table would be set up outside, just off the trail we were hiking on. It had a red table cloth and chairs. It was relaxing to get off your feet, sit in a chair, eat something interesting and look around at the awesome landscape.

An arduous climb is how Thomson's Safaris describes the non-technical ascent of Mount Kilimanjaro. Non-technical means you do not have to use ropes and make vertical climbs hanging on by your fingernails. I have no plans for such a climb. There was some risk in our climb because at times we had to scramble. We hiked with poles which give excellent support in balance and take the stress off your knees. We abandoned our poles and scrambled, reaching out with our arms and grabbing some rock and hoisting ourselves up on day four at the Barranco Wall and portions of the Western Breach on day seven. The basic way to climb a mountain is to gradually get acclimatized so you do not get altitude sickness. To be successful you do not race to the top in two or three days, but go slowly, slowly up the mountain.

While my group pretty much stayed together, Gary's group got strung out especially on Summit day. All of my group summited but four of Gary's group did not: a lawyer and his fashion conscious wife who wore a different climbing outfit every day; an eager beaver who had to be first at the day's destination every day and he then ran out of gas; and the fourth person Gary cannot remember. A sixty five year

Married for many years, Susan, while interested in Africa did not see herself climbing this mountain.

Gary's group was run by an outfit called Mountain Travel and was larger, with fifteen Americans and thirty five porters. He did the hike eleven years before I did mine. Gary's first day was a muddy hike thru the jungle. When I was in the same area they had made a new trail close by the old one and I had no mud. In addition to the mud Gary encountered on the first day he struggled and came close to hypothermia. Due to an upset stomach he ate very little breakfast. The porters were late and they had the lunches. Thus Gary missed lunch. He hiked in shorts and had a rain jacket. Gary was wet when they got to the camp. He was hungry, tired and cold. The porters had not arrived with the tents. People found a metal shelter thus ensuring their survival. Gary was shivering and miserable. Three and a half hours later the porters finally arrived.

My experience the first day was the complete opposite. The hike thru the jungle had no rain and was probably the best day of hiking I've ever had. The green jungle canopy was unlike anything in Arizona or California. Arriving at the camp our

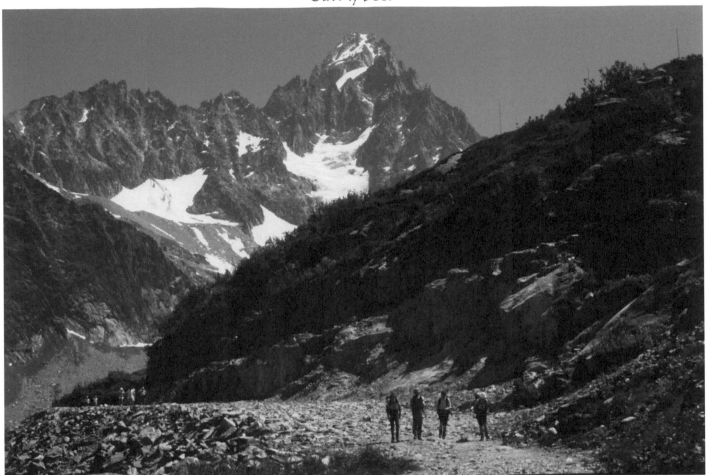

I took this photo while stationed in Germany and hiking in Switzerland. Note...I did not climb that mountain

old doctor was the first in his group to summit. The doctor was an ultra-marathoner, hence in excellent shape. Gary was second, and close behind was an older couple, then it was awhile before anyone else arrived.

We all summited together except George. He lagged behind us the last couple of days and one of the guides carried his small back pack. We waited at the summit for him and our group picture of ten happy climbers. How tough was it? I've done harder things as a runner. The camping was difficult for me. Not getting sick was important. The hiking was moderately strenuous. Overall it was a challenge that all ten of us met in our own ways.

After the mountain we went on Safari and saw the traditional animals of Africa, kind of like a victory lap. After roughing it on the mountain, being on the safari was pure luxury. Not having a shower for nine days and having dirt under my fingernails

had made me feel like a homeless person. But all this changed on safari as we stayed in very impressive four star lodges which are world famous. Somebody remarked to me on the outstanding accommodations and treatment we received on the safari said, "If Bill Gates was here, he would not be treated any different than we are."

If you're going to Africa some **Swahili** might be helpful. **Jambo** = hello; **Maauri** = good; beautiful = **Asante;** thank you = **Sana;** very much = **Twende; Polepole** = slowly; **Peepee** = candy; **Simba** = lion; **Twiga** = giraffe

I love this African proverb. Every morning in Africa, a gazelle wakes up. He knows it must run faster than the fastest lion or it will be killed…every morning a lion wakes up, it knows it must outrun the slowest gazelle or it will starve to death. It doesn't matter whether you are a lion or a gazelle…when the sun comes up, you'd better be running.

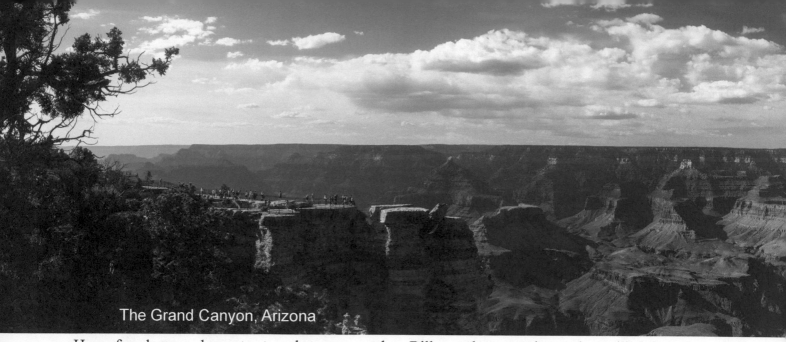

The Grand Canyon, Arizona

How far do you have to travel to see and experience one of the Seven Wonders of the World? An exhausting airline flight across the ocean you may think. No, it's in our backyard of Arizona. A former student teacher of mine Joe Reilly says, "The whole world comes here."

Four days and three nights of magical wonder… strenuous hiking, interesting people and the unexpected made this a memorable adventure. Our talented group was: Dick Watt, 72 years old and eleven previous trips; Bill Hegebush 63, five previous trips; and Joe is 51, our tenderfoot on his first hike to the bottom of the canyon. Each person brought something different to the team and we blended well together right from the start. Nobody knew everybody before the trip but we all had education in common. Dick was an elementary music teacher; Bill was an elementary school principal; I was a high school history teacher and Joe our only member who was not retired, is a middle school English teacher. I had the idea for the expedition, Dick was the leader, Bill set the pace and provided breaks on the hikes, and Joe who grew up on the east coast provided comic relief.

Our physical limits were severely tested, three of us wondering if we're going to make it: Dick whining about his hip, me with shaky knees on our descent, and Joe catching his breath on the climb to the top.

Bill was the exception and provided the calm subtle example that it was possible we could all make it.

The Grand Canyon defeated my digital camera. I tried different setting and none could capture the feeling of majestic space and the awesome shades of pink and red. Thousands of people there had cameras and I am sure many of them got great pictures. Sadly, I am not one of them.

We began our adventure taking a four hour drive north from Phoenix to Flagstaff, west to Williams and then north to the Grand Canyon. The difference in temperature provided some interesting clothing decisions. On the rim the high was 79 with a low of 42 and down at the bottom the high was 98 with a low of 66. The edge of the canyon saw a meeting of the United Nations. It was fun hearing different languages as people passed by and I sneaked a picture of a lady in a blue sari. Unfortunately I missed a shot of the Mennonites in their home-spun attire. Later we got our group picture taken by a woman from Spain.

Spending the night on the rim at a campground we saw an awesome view of the stars at night… white pin points of light in an endless pitch black sky. Getting a somewhat late start in the morning we went down the South Kaibab Trail, which was seven miles. Before beginning the hike there is a big warning sign. "For hikers entering the canyon from May to September it is critical to begin hiking well

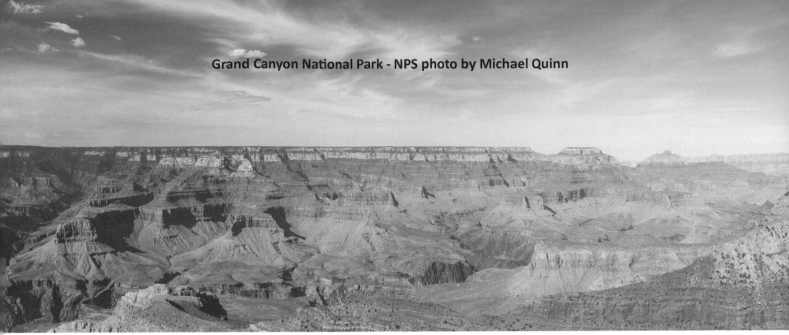

before dawn or in the late afternoon. Success depends upon staying off the trail between ten in the morning and three in the afternoon. Failure to arrive at Bright Angel Campground by ten in the morning during hot weather can result in ill health or even death; at the very least, it will be a miserable experience." Somewhat cocky, we didn't really follow the warning in the sign which we should have read the day before upon our arrival at the rim.

There is a grapevine of gossip on the trail. It was through this informal network we learned of a hiker in distress. Ahead of us was a woman from Minnesota who was in trouble. Arriving we found her supported by two friends who were trying to shade her from the hot sun and giving her sips of water. We stopped and we told a ranger was on the way. We later learned the ranger applied ice to her groin trying to lower her core body temperature and was hoping to walk her out in the late afternoon. I guess this didn't work out and we learned she was evacuated by helicopter. This happens about 300 times during the year.

Camping means you are carrying thirty to forty pounds on your back and this greatly increases the physical effort necessary to navigate the steep narrow switchback trails. We were advised to sleep in tents because of the ants, mice and squirrels that inhabit the well-used campgrounds. Dick and Bill slept in one man tents and Joe and I shared a very confining two man tent.

Arriving at the bottom of the canyon you come upon the mighty Colorado River, the source of water for several states. Finding a spot at the campground and taking off the heavy backpack was a relief. What was even more of a relief was stepping over and around slippery stones and lying down in Bright Angel creek and letting the cool water rush over my body. The Bright Angel creek flows into the Colorado River.

Joe and I had reservations for dinner at Phantom Ranch. It was a short slow walk from our campsite. The food was already laid out on the table. It was help yourself and pass the steak, potatoes, corn and salad to your neighbor. For the first part of the meal we were so tired we acted like zombies. Halfway through we slowly began to talk with those around us and we started to feel refreshed and civilized. Three interesting Germans sat to our right and to our left was a couple from San Diego.

The temperature at the bottom of the Grand Canyon is just like Phoenix in the summer, hot. Neither Joe nor I got much sleep that night as the tent resembled an oven. I even tried to sleep outside on the cement picnic table where there was a faint breeze but gave it up thinking I might roll off it when I went to sleep.

We all knew the next day was going to be easier

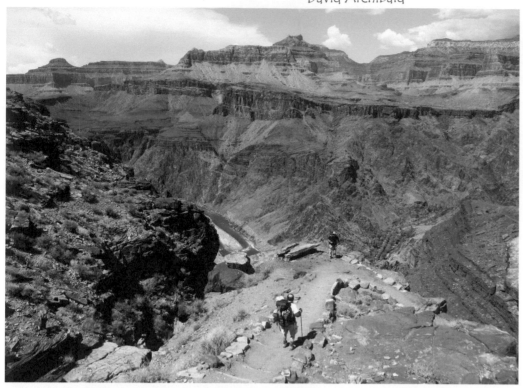

Hiking the Canyon

trees. We arrived at eleven o'clock in the morning and greatly enjoyed a leisurely afternoon of rest. I got my arm attended to by a very friendly park ranger. It was fun to talk to other hikers. You were seldom alone on this hike. Jan, a tall Polish Canadian with a bushy moustache was an impressive individual with a lot of hiking experience. We also met a girl from San Diego who had given her father a Christmas gift of a hike with him in the Grand Canyon. Close to our campsite was a water fountain and spigot, a common area where everybody not only drank water, but brushed their teeth, and washed their dishes, all the while chatting with other campers. It was all very peaceful, a friendly place with a mild climate that allowed a good rest before our climb out the next day. There was no oven-like heat and Joe and I slept well.

The ascent from Indian Gardens to the rim is broken up very well with rest stops, water and a rest room at three miles. It was still hard work but you had incentive. The stream was gone and it was an endless number of switchbacks. Hiking is not a race, you take your time and enjoy the majestic scenery.

Arriving at the rim was anticlimactic for me. I had hiked the Grand Canyon two other times so it was not a first time accomplishment. I took a book with me but never opened it. Reading is an escape and I wanted to drink in the present of where I was. The size and color of the Grand Canyon has a hypnotic quality that truly makes it a wonder of the world, but how many people in Arizona have ever been there?

than our long descent of yesterday. The hike was two miles shorter and the Bright Angel trail is more scenic than the South Kaibab as for the most part there is a rushing creek to accompany you. Bill and I felt going up is less stressful on your legs than going down, so our mind set was in the positive gear.

My run in with a mule was unexpected and happened so fast it's hard to piece together what really happened. We all had warnings that a mule train was coming and hugged the inside of the narrow trail and massive wall of rock. The mistake I made was trying to get a picture and leaning out a bit. Suddenly the protruding saddlebag a mule was carrying hit my backpack. I lost my balance and down I went. The mule train stopped. I saw hooves and legs, slowly regained an upright position and stood up. Lucky was I the mule did not step on me in the confined space and see me falling off the cliff to my death. I ended up with a scrape on my arm, which either Dick or Bill covered with a piece of cloth and wrapped it up with all-purpose duct tape.

Indian Gardens is the mid-point in the Bright Angel Trail. It is an oasis with giant cottonwood

Humphreys Peak, Arizona

Another adventure with Charlie took place in northern Arizona. Charlie's son Jonathan had open heart surgery when he was in the sixth grade and was now a sophomore at Northern Arizona University (NAU) in Flagstaff. Charlie convinced Steve and me to join him and his son on a climb of Mount Humphrey, Flagstaff's tallest mountain and the highest mountain in Arizona. Steve grew up on the east coast, was an accomplished runner and has done a 2:37 marathon. Even more impressive he took first place in the run up the Empire State

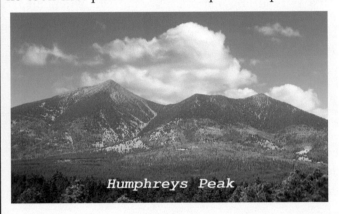

Humphreys Peak

Building. The four of us stayed together until above the tree line where it seemed to be an unspoken agreement to continue at our own pace. Who do you think reached the summit first? The first response would be Steve. But no, it was Jonathan. He lived at altitude in Flagstaff, whereas we had taken off early in the morning in Phoenix. Plus Jonathan's heart was not a factor having fully recovered many years ago. I was second because Steve was frustrated with the many false summits and not used to western mountains, being an easterner. The most experienced climber, but the oldest, was cheerful Charlie.

It was as a runner that I knew him best. Once, he joined my high school cross country team for a workout. Passing by a posh neighborhood in the Arcadia area, one house stood out as not belonging. The paint on the side of the house was peeling

and there were weeds in the yard. A few runners in the pack made some unkind comments about it. Hearing this, Charlie said, "Thanks for the run David, I'm going home now." He then went over to the house, stopped at the front door and turned around to look at us. The kids were mortified. With a big grin on his face Charlie jogged back to our group and we continued our run. Of course the house was not his. For a while you could have heard a pin drop it was so quiet. Charlie was indeed a bit of a prankster but above all he enjoyed being a teacher. He was one unique person who influenced many lives. I was blessed to have him as a friend.

Mountains of Colorado

There are many tall mountains in Colorado. Fifty four of them are called 14ers because of their altitude. In 1994 Gordon Foster and I along with some of his east coast friends climbed five of them: Mount Antero 14,269; Mount Princeton 14,197; Huron Peak 14,005; LaPlata Peak 14,336 and Missouri Mountain 14,067. In addition we saw a night time sky on Mesa Verde plateau filled with thousand brilliant white stars and we floated down the Arkansas River on a raft.

Pikes Peak is also a 14er but I didn't go to the summit in a normal way. It's famous because it's the first mountain pioneers saw moving west. I've taken the cable car to the top and driven in a car to the top. However the most arduous route to the top was a race, The Pikes Peak Ascent. In 1997 I ran then walked, then ran, then walked 13 miles with a time of 3 hours and 59 minutes. Close to the top Sue Berliner, a fellow Arizonian passed me. I struggled to stay with her but gasping for breath was unable to do so. Yet after crossing the finish line and standing atop this majestic peak I regained normal breathing and felt a rush of excitement and said to myself, "yea this is something special"

Chapter 3: Argentina, Uruguay, Chile

The world is a book and those who don't travel, read only one page

South America

For my South American adventure I traveled with Susan, my trusty intelligent wife. Traveling for three weeks, we encountered a variety of landscapes: the majestic shades of blue and green amid the Chilean fjords; the tall buildings and busy city streets of Buenos Aires and Santiago. However, what adds excitement to this scenery is sharing it with other people.

The chronology of our three week trip saw us three days in Buenos Aires; fourteen days aboard the Norwegian Crown and three days in Santiago. Our ports of call were: Montevideo, Uruguay; Puerto Madryn, Argentina; the Falkland Islands; Ushuaia, Argentina; Punta Arenas, Chile; Puerto Chacabuco, Chile; Puerto Montt, Chile; and Valparaiso, Chile. Both Buenos Aires and Santiago are very big cities with extensive and efficient subway systems. Buenos Aires is right next to the ocean and the river Plate, which is the widest river in the world. Santiago by contrast is inland, about a two hour drive from the ocean and is at the base of the Andes Mountains. Both countries killed off most of their native populations so they do not have the feel of a Mexico or Peru, but a decidedly European flavor.

Besides travel with Susan and myself are good friends Chip and Gail. Gail teaches Spanish at a Community College. Traveling with her provided us with a safety net, because if we ever wanted some insider information we had our own personal interpreter. She advised us that in some aspects of South American culture, rules and what you should expect are, "Only a Suggestion." Stop signs and traffic lights do not necessarily mean traffic halts… "it's only a suggestion." Sometimes when clearly ordering certain food which appears on the menu, the food appearing on the plate might be different. Again the motto down south applies for it is…"just a suggestion."

A big attraction on this trip was penguins. On our trip we saw them in three different ports of call. Outside Puerto Madryn, a big Welsh settlement, was a beach with thousands of penguins. In one small hilly area you almost stepped on them if you were not careful. They are one strange upright bird. They waddle but don't fly.

A strong part of the economy of both Argentina and Chile is their fine wine. On our shore excursions we were encouraged to visit wineries and enticed to buy their high quality and relatively low priced product. You could of course ship it home, but this was expensive. You could bring it aboard ship, but you then had to pay a $15 corking fee.

We met Phaedra on board and immediately bonded with this charming person of Greek ancestry. She lives in Tucson and also has an apartment in New York City, thus we have a few things in common. On this trip she is overcoming the death of her husband who died in the World Trade Center terrorist's attack of 9/11. We were shopping in the Falkland Islands and I told her my plans of smuggling a bottle of wine aboard. Phaedra smiled and said, "That's something

nothing to do with looks, but one's attitude. He was unabashedly pro American and had no feeling or understanding for the native culture of the ports of call our ship made. At a performance of a trio of South American singers on the ship, he walked out in the middle because they weren't singing in English. Why he was on the cruise became pretty transparent. He wasn't interested in South America. He was interested in spending time with his office manager away from the office.

Cruising on a ship you realize how big the ocean is. The ocean offers starting contrasts to someone living in the desert. It is colorful in a unique way. You get so many different shades of blue, sometimes differing shades of green and sometimes black and white. The ocean is powerful. The ocean can be unpredictable. The rhythm of the ocean can have a calming restful presence and then with little warning turn into a ferocious monster of huge crashing waves that terrify you. The ocean has also been a highway for much of history. It was the way to go from New York to San Francisco instead of covered wagon across the continent. The big hurdle for this ocean trip was rounding Cape Horn. We all silently anticipated the rough weather that is advertised. But this did not happen to us. Once we passed the Cape we expected a calm Pacific. We were in for a surprise. There were rough waves, a five on the international scale of one to nine. One is calm, eight is mountainous and nine is phenomenal. It only lasted for a day as we entered a maze of peninsulas and islands making up the Beagle channel and fjords of Chile. This was indeed majestic scenery which made you feel like an insignificant speck in a vast landscape of

my husband would do." Traveling alone she became good friends with a couple of Australian ladies and she later confided in me that Victoria thought I was "Dishy." It is always good to receive a nice compliment.

On traditional cruises you eat at a fixed time and always with the same people. Our cruise gave us a choice of 6 restaurants and a wide range of time of when to eat. This freestyle cruising meant the four of us, (Chip and Gail were included) always found different people sitting next to us at dinner. With over 900 passengers aboard for two weeks, the odds are sometimes you are going to have unfortunate dinner companions. This only happened once for us with a couple from New Jersey. He was a dentist and she was his officer manager. They were not married to one another and spoke of children they had from previous relationships. He was short, slightly pudgy, well dressed and while not unattractive, he admitted to being "An Ugly American." This of course has

changing shapes and color. After the violence of the crashing waves to be moving along so gently and seeing such picturesque land was truly magical.

Before we rounded the Cape, we met George and Wilma Fitzell. This unique couple were celebrating their 64th wedding anniversary. They met in the second grade but as Wilma said, "We didn't get serious until the tenth grade." They have more vitality and zest for living than couples twenty years younger. They are both eighty eight years old. George was in the Navy during WWII. His father sailed around

Susan is enjoying some chocolate in the ship's restaurant

Cape Horn in 1905 on a three masted sailing ship. Thus another event is commemorated on this trip, the 100th anniversary of a Fitzell family member going around Tierra Del Fuego and Cape Horn. George and Wilma were accorded the honor of joining the captain in the pilot house when we left the Atlantic Ocean and entered the Pacific.

We left the ship at the port city of Valparaiso and took a bus to the capital city of Santiago. Lunch saw us stopping at a citrus farm in the Malo valley. After a short walk by some lemon trees we encountered a large veranda with lot of tables set up, piled with food and wine. After I had been sitting down for perhaps five minutes, a luscious dark haired beauty appeared over my shoulder and bending down asked if I needed anything. I was quite shaken and replied, "No I don't think I do." Later during the meal she was part of the entertainment, playing the guitar as the owner of the farm and his daughter sang. I took pictures during the vacation but unfortunately the picture of Anna did not turn out. It was out of focus because my hand was shaking so much. I did manage

a conversation with Anna later and found out she had traveled to the United States and visited: Santa Barbara, Nashville and New York City. She liked New York City the best because it was so European.

It was also at the Citrus Farm where I met Ed and Keith. Both served in the Vietnam War but didn't know each other and thus were unaware of each other's experiences. I changed that after I had met each one of them individually apart from each other. You could say I am a "match maker." While I didn't go to Vietnam because my two brothers were there, the subject fascinates me. It's not much talked about, but it affected the lives of so many people.

Ed was a co-pilot and navigator flying a jet on a mission over a harbor in North Vietnam. A Sam missile hit their plane and he and the pilot ejected on opposite sides of the plane. Consequently they landed on different sides of a hill. The pilot was captured and endured eight years as a prisoner of war. Ed was wounded and managed to evade the enemy for four days, traveling 47 kilometers before he found friendly forces. After his release from captivity, the

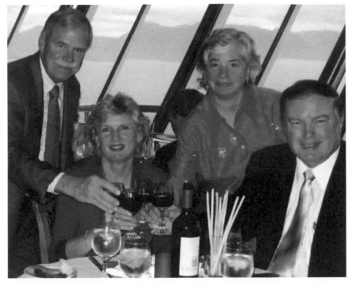

Susan and I are toasting with Chip and Gail Shay

pilot became an alcoholic and committed suicide four years later. After his service Ed had a career with the FBI and is now retired and living in San Diego.

Keith flew a propeller plane that spotted enemy activity. He didn't tell me much about his experiences, but enough for me to know he would enjoy meeting and talking to Ed. I then introduced them to each other and withdrew. Standing back away and using the zoom lenses on my camera I got a nice picture of two men engaged in meaningful conversation.

In Santiago we visited the home of the famous poet Pablo Neruda, a winner of the Nobel Prize. He actually had four houses and we visit one in the neighborhood of La Chascona. It was eccentric and filled with outlandish objects. The house was built for Neruda's mistress Matilde, a woman with short unruly hair. She eventually became his third wife. The objects that decorated the three level building reflected his interests. The lower portion was built like a ship as he loved the ocean. On the middle section was a painting of Matilde by Diego Rivera and in the curls of her red hair you can see a profile of Pablo Neruda.

The world is a small place. Coming home we were in the Los Angeles airport going from the terminal were Lan Chile arrived to the terminal Southwest uses when somebody in a crowd shouts, "Hey Mr.

Archibald." It was James O'Conner, a former student of mine in 1999. He had just gotten off a thirteen hour flight from Brisbane Australia and was taking our flight to Phoenix to attend a friend's wedding. We had a three hour layover and talked.

James played football at Northern Arizona University and graduated with a degree in business. He went to Alaska working as a set netter on Kodiak Island, fishing for salmon. James worked ten to twelve hours a day and lived in complete isolation with no TV and the nearest neighbor twenty miles away. He commented, "I got completely in touch with nature and myself." With his savings he went to Australia and Thailand for three months. He got certified as a scuba instructor in Thailand and was in the ring with a Thai kick boxer James knocked out in the third round. James also went rafting down a river in Thailand on a bamboo raft and rode an elephant in the jungle. I saw some of this on his digital camera. It was delightful to listen to his adventures and share his enthusiasm for world travel.

While the whole world was not on our trip it sure seemed like it. Nine hundred passengers were aboard the Norwegian Crown and came from twenty different countries. The five-hundred member crew saw fifty-three different nationalities. The close of a farewell show saw a sampling of different departments come on stage: receptionists, cabin stewards, and some I can't remember. The cooks with their tall white hats came on last and by this time everybody was singing "We are the World." I seldom cry. But here I did, because for fourteen days on the ocean everybody got along and it was so sweet.

"Macanudo" an Argentinean expression meaning very good or one hundred percent.

Chapter 4: New Zealand

"Say yes, and you'll figure it out afterwards." Tina Fey

Seven Kiwi Cities in Sixteen Days

After twelve hours flying over the Pacific Ocean we had a dramatic entry into New Zealand. It was early in the morning, we were among white clouds, blue grey sky and could see the yellow lights of Auckland below. When we landed you could see silver puddles of water from a recent rain on the black asphalt runway. We were tired but excited.

At the end of a long day Susan and I settled in our room. We then decided to take a walk down to the beach which was only a few blocks away. After looking at the ocean for a while, something catches our attention. There is a free standing shower and two girls are shampooing their hair. The tall blond in a red bikini becomes aware of our interest. She says something to her friend and laughs. Susan and I smile at each other and walking back to our room wondered what other delights New Zealand would have to offer us in the upcoming weeks.

We are in the small town of Piahia. The area is called "The Bay of Islands" and is in the north eastern portion of the North island of New Zealand. The area somewhat resembles Hawaii. It is where the first European settlement took place in the 17th century and was a stopping place for whalers who were sailing the Pacific Ocean. Across the bay from our town is Russell. The town there used to be called by its native Maori name, Kororareka. Because of the lawless activity of the sailors looking to relieve themselves of the confinement aboard ship for long

periods of time it was called, "The hell hole of the Pacific." There are no grungy wild-eyed sailors there now and it was a charming place to stroll around. We had an excellent dinner at the Duke of Marlborough restaurant overlooking the harbor. The sun was setting, and its glaring light made one shade one's eyes. We were getting acquainted with our fellow travelers and the food was very good.

I now think of our fellow travelers as our group: a cohesive unit gathering strength. There was a spirit of camaraderie not unlike an athletic team. Someone needs a band aid, or sun tan lotion, it's there. You

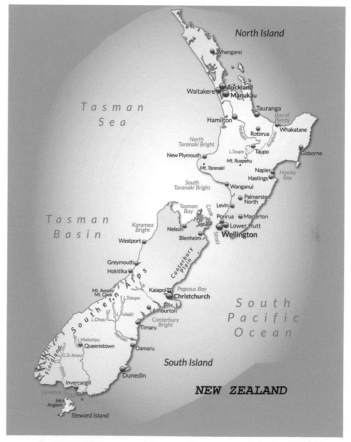

want a picture of you and your wife in front of a monument, someone is there to use your camera, line up the shot and snap the picture. Everybody brings something to the table. And then there is the comic relief, the lovable antics of Rick and Carol. We became an extended family and when gathered together after a walk through a city, we looked around and checked to see if we had everybody.

The real authority, the head counter, is our leader and guide, Gary. He was thirteen years younger than our youngest member, yet he commanded our attention and respect because he was very good at his job. We did not lose anybody during our sixteen days. Nobody got injured or sick. Beyond keeping us healthy Gary brought a wealth of knowledge and experience to the table. A native New Zealander he grew up on a farm near the city of Hamilton. Gary spent eight years as a guide in Europe before coming back to his native land and has been with Overseas Adventure Travel for four years. Every evening he would leave a handwritten one page explanation of the day's highlights and information of what to expect for the upcoming day. One member of our group was so impressed with his talent for diplomacy she suggested he enter the political field. He was indeed flexible, articulate and displayed good judgment.

The biggest city in the country is Auckland and it's on the North Island. It is called the city of sails. On a thirty foot yacht everybody got a chance to steer at the helm, a large sensitive circular wheel. After almost everybody had their moment of command Carol hesitated saying, "I do not want to be responsible for tipping the boat over. I only want to steer when it's level. Aboard a sailboat in the wind this is of course impossible, yet she did summon up some courage and gave it a successful try.

The city of Rotorua is in a geothermal area and heavily visited by Japanese tourists. An old gingerbread building is the most photographed structure in New Zealand. In the foreground of the building are lush, well-manicured lawns where lawn bowling was taking place with the participants dressed in English white. Very classic, but during the only rain we had the whole trip made taking pictures difficult. I am thankful it was sunny when we visited Milford Sound, "The eighth wonder of the world," later in our trip.

Our hotel was dangerously close to the geothermal activity. It was like having a chemistry set in your backyard. This would not have been allowed in the United States. From our third-story balcony we could have easily thrown a stone in the belching mud pots and the occasional erupting geyser was within two football fields. You somehow got used to the sulfur small and constant sound of a kettle, the nefarious mud pots.

The seven Kiwi cities merely served as a base for much of our adventures, so there is little I will relate about their urban landscape. It is primarily the outdoors which is celebrated on this trip. The Waihou Walkway was a meandering trail set in rolling hills following a crystal clear stream appearing blue green because of the minerals it contained. There was an occasional clump of trees you navigated thru and of course the New Zealand trademark: ferns all over the place. Our group separated on this three-mile hike. This hour hike was one of the best Susan and I have ever been on. It was breathtaking.

Following the morning's wander (Kiwi for hike or trek) we visited a Maori cultural center and I got to be a chief, one of the highlights of the New Zealand visit. How did I get to be chief? From an earlier Maori lecture I learned that touching noses twice brings attention to what is considered "the breath of life." The two previous Maori teachers were male, but this time we encountered a fetching female. Being a bold member of our group I walked up to greet her in the Maori fashion and that's how I got to be chief.

In a good sized hall, as chief, I had to stand in front of our group and other assembled tourists

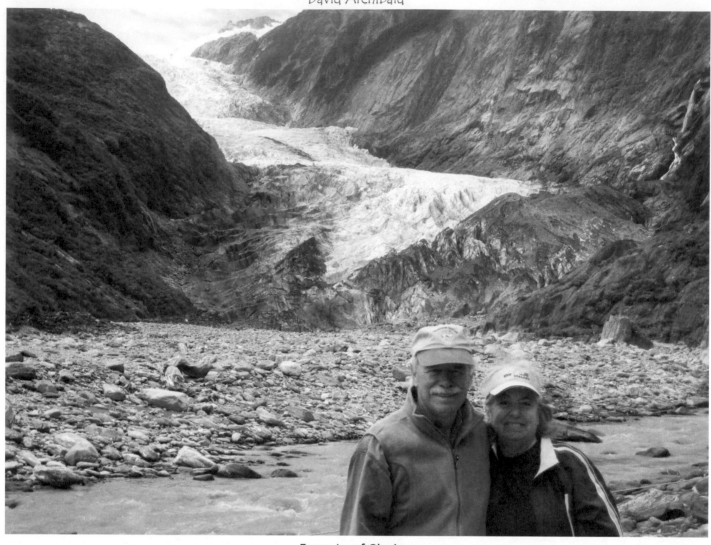

Franz Josef Glacier

and receive a token from other Maori after their threatening gestures to see if I and my tribe were worthy to enter their lodge. I performed flawlessly and we were allowed to enter. I wasn't so sure of myself later in the show when they asked male members of the audience to come forward on stage and dance the Haka, their war dance. As Susan knows, dancing is not my strong suit. With peer pressure propelling me forward I end up on stage with some young boys and teenagers. The dance involves lifting up your legs in a sideward fashion and then quickly pounding them down. At the same time you had to stick out your tongue, puffing out your face, protruding your eyeballs forward in a threatening manner. Pictures were passed around later on my comic effort.

We leave the three cities we have visited in the North Island to see four cities in the South Island. We will be lodged in New Zealand's premier resort, Millbrook, which has hosted many celebrities: Bill Clinton, Bill Gates and John Travolta. It was indeed first class. A charming feature was their indoor swimming pool. Swimming laps you look up and see wooden beams and off to the side glass windows and trees outside. On the deck inside are heaters and wicker furniture. While our trip took place in January, the seasons are reversed below the equator and its summer there. Even so I try to imagine swimming in the heated pool in winter and looking at the snow outside.

With Millbrook as our base we visit Milford Sound, as mentioned before one of the wonders of the world. It was our longest day of the vacation as we

left early and arrived home late, but it was well worth the long ride in the motor coach. Leaving the vehicle we boarded a medium size boat. Our two hour cruise sent us through spectacular scenery. Fjords exist in Norway but they do not have the temperate climate of New Zealand which produces greenery all around you. Tall very steep mountains some with snow on their top arise from the ocean. As our ship navigates through passages you see numerous waterfalls cascading down grey rock walls. The majestic power of nature is surely evident here.

A jet boat on the Dart River sounds thrilling. It was. Before boarding we were given long lightweight rain jackets and life vests. Once aboard it was high speed, sudden quick turns and high spray of cold water. You could see far away snow capped mountains. The jet boat traveled on a shallow river that slipped along a wide bed of white gravel-like rock. The special boat could travel on water as shallow as four inches. Sometimes it was a bouncy ride and as the boat thumped along the river you really couldn't concentrate on the vast scenery because you needed to anticipate the sudden turns. Fortunately the driver did stop now and then, so we could view the scenery. Our captain's most complex move was a three sixty and before he did this, he'd raise his arm and give a circular motion.

To visit Franz Josef Glacier we were issued hiking sticks for our jaunt to the glacier. First we walked in a temperate rain forest where we didn't need the sticks. Reaching a wide plateau of rocks, the sticks came in very handy in keeping your balance and preventing you from falling. We weren't able to get close enough to touch the wall of ice, but were close enough to hear the faint rushing sound of water melting underneath. Our guide did reach into the small stream and pulled out a small crystal-clear, solid chunk of ice and passed it around for pictures.

On the route to Greymouth we made a brief stop at the small town of Ross which has unique public toilets. You press a button and the door opens, then closes and music starts playing. You had ten minutes before the door automatically opened again. After using the toilet you had to wash your hands before the toilet would flush. Then you push a button, the music stops and the door opens.

The Cape Foulwind Walkway was an hour stroll of two miles looking down steep cliffs at the ocean below. Somewhere on this walk we encountered the pancake rocks. They are four stories high and stacked like pancakes, hence the name.

Entering our final Kiwi city, Christchurch I saw a white building with blue lettering which read, "Archibalds." It's a car dealership selling Land Rovers and Jaguars. I gave my card to one of the salesman and found out the original owner, Ray Archibald was in his nineties and in a rest home, but he would give the card to Ray's son, David.

Christchurch is a very walkable city and our hotel was in the center, near everything: Cathedral Square, the botanical gardens, restaurants and stores in which you could buy things to take home as proof you'd been to a foreign land. The Buskers Convention was in the city and crowds gathered around these vaudeville street performers. They displayed a lot of fun creativity.

For our last dinner Jerry, Karen and I put on a roast of our guide, Gary. It was entitled, "You know you are an outstanding Kiwi guide if…" We got some suggestions from other members of the group but most of the sixteen items were created by Jerry and me. We were sitting by the Avon River with a bottle of wine waiting for the girls to return from shopping and creative ideas just seemed to flow.

Listening to our group talk about their other world travels, Eric said, "I feel like a high school dropout now." Most of our veteran travelers felt Egypt doesn't put out the welcome mat. Its people assault you. They crowd around, trying to sell you things and begging you for money. Up close and

Footbridge over a New Zealand river

a streetcar. Getting off she asked young people for directions, figuring out they could speak English easier than old people.

Our fellow Arizonan Jay can easily lay claim to the title of "The King of World Travel." He had been everywhere. Sometimes things aren't as primitive as you might think. In a ten day cruise on the Amazon he would leave his clothes outside his room and the next day they would be clean.

Every time I travel I ask myself this question. Could I live here? For New Zealand the answer is a definite YES. But, it is so far away, from our daughters and longtime friends.

personal it often becomes difficult to move, but charge ahead you must. There was not a part of the globe that somebody in our group had not been to and it was fun listening to their stories.

Rick jokes about the ten-thousand dollar, red, winter jacket his wife Carol has. What he means is their trip to Antarctica cost that much and as part of the trip, you got to keep the winter parka they issue to you before you step on the continent.

To me the experienced traveler is one who packs light. They have clothing that is flexible for many occasions and can be worn more than two times. Of our group Joann won the award in this category. She has hiked over twenty national parks in the United States. She once stayed in a five star hotel in Charleston South Carolina. She discovered a whip and handcuffs underneath her bed. Reporting this fact to the management they gave her a hundred dollars off her room price. In Amsterdam Joann became separated from her group and got lost. It was a frightening experience, for she had nothing, no identification and no money. She sneaked aboard

You know you'd make a Kiwi Guide if…

- **You can explain the difference between a walk, stroll, tramp, trek, wander, hike and burn**
- **You can describe an outhouse to foreigners as an eco-friendly facility**
- **You prefer abalone shells to wallpaper for interior decorating**
- **You prefer white bait, venison and meat pies to filet mignon**
- **After three pints you can explain the mysterious rules of cricket**
- **You can convince landlubbers to steer a sailboat in a brisk wind**
- **You can hold eight cameras to take group pictures in front of a dramatic backdrop and can remember which button to push**

Chapter 5: Turkey

"The gladdest moment in human life, me thinks, is a departure into unknown lands." Sir Richard Burton

Istanbul

Istanbul conjures up exotic mysterious impressions: spice markets, belly dancers, ancient city streets, the dangerous Mideast. Walking on cobblestones, I think of people long ago on the same street. But then our tour guide, Ulas tells me the locals call them "The Albanian Stones." It seems twenty five years ago, Albanians would work for cheaper wages and were brought in to repair the streets. Guess I would not make a good archaeologist.

The Blue Mosque and the Hagia Sophia in Istanbul are historically correct and majestic in their entire splendor. Huge structures with several skinny minarets on the side standing a sentinel watch. It's humbling being inside and now I get the powerful feeling I'm in an impressive foreign land.

Geographically Istanbul straddles Europe and Asia. Culturally Turkey is also a mixture of both and while it is a Muslim country in the Mideast it is definitely not an Arabic country. Very few people practice the faith, yet the secular democratic government subsidizes the daily call for prayer over loud speakers. People are friendly and I feel safe. My preconceived idea of a barren land with crude dwellings is quickly shattered. You may think I am only referring to Istanbul, but the rest of the

Morning on the Turkish coast

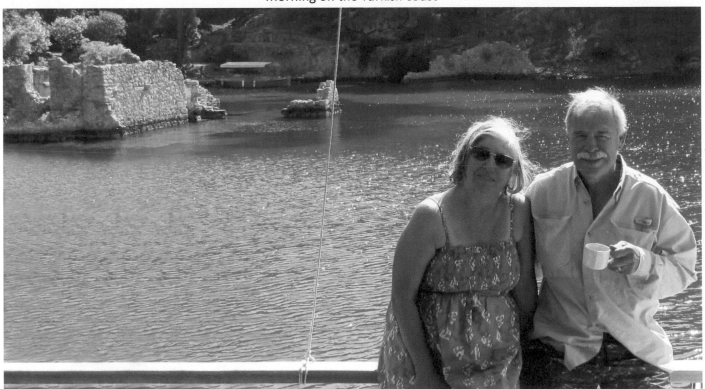

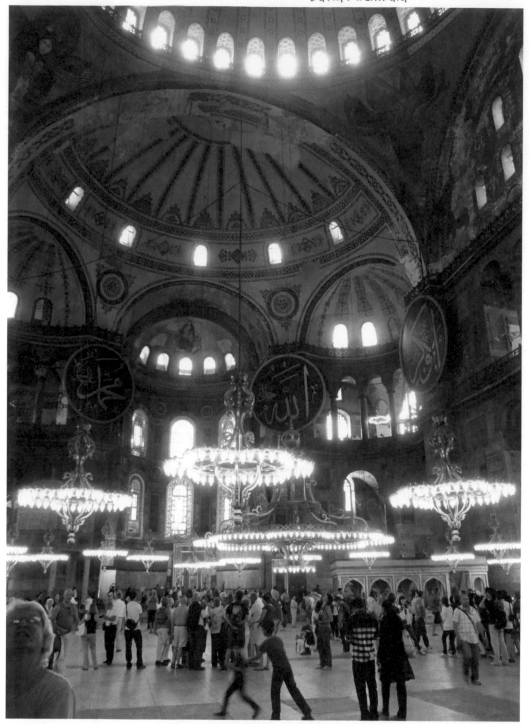

Hagia Sophia in Istanbul

(near Ephesus).

The people my wife Susan and I travel with make the trip just as enjoyable as the picturesque landscape and the rich history of the country. Ulas, our tour guide, is experienced, pleasant to be with and a good leader. We have a nice mix of humanity: couples from Boston, California, Virginia, Kentucky, and a mother and her fifteen year old son from South Carolina. Everybody makes contributions at one time or another and we evolve into a happy family.

Our breakfast at the Armada Hotel in Istanbul is stupendous. It is a buffet on the terrace above four stories up overlooking the water. I have never had walnuts as a choice for breakfast. You can squeeze your own freshly chilled oranges. Fruit, cheese, pastry, cereals, and an omelet makes selection of what you are to put on your plate difficult. I count six different kinds of cheese. You certainly didn't need to take vitamin pills with what was offered here. And there are tomatoes. For our whole trip, they are offered at every meal. An interesting omission are potatoes; the Turks seldom eat them.

"Sir I need your money," says a merchant outside his stall in the Grand Bazaar. Not being an

country is also clearly in the twentieth century and a fertile country. People live in eight-story apartment buildings and there is an abundance of trees.

Our trip with Overseas Adventure Travel is fourteen full days inside the country, two days of airlines getting there and coming home. While there fourteen Americans stayed in six different places in the country: Istanbul, Kayseri (Cappadocia), a village in central Turkey, Antalya, a yacht, and Kusadasi

Spices in a market place

carpet is not to be for the Archibalds.

After staying in fine hotels, our travel takes us to a small village and an overnight stay with a local family. This is a nice creative touch Overseas Adventure Travel has on all of its trips around the world. The people here are farmers, the village has about a hundred homes and half of the people own cows. Our host has a large three story house with bedrooms on each floor. We sleep in a plain functional room and share a toilet at the end of the hallway with others. We do not have TV. It is truly a humbling experience seeing how the locals live. Walking to the edge of town before dinner there is a beautiful picture of green plants with white flowers, then a field of yellow and in the background a white house with a red tiled roof. I get a beautiful picture of this idyllic scene. The white flowers are poppies. We were told the government controls this.

Our hotel in Antalya not only has TV but a complimentary wine opener. The Muslim faith prohibits alcohol but we find beer and wine readily available at restaurants and the local markets… but having a corkscrew in your room surprises me.

Antalya is a large city on the coast of the Mediterranean and a charming walkable city. It is here six of us go to a four hundred year old Turkish bath. We sit in a hot, domed room with a thick cloth wrapped around us and work up a big sweat to prepare us for the upcoming scrub. For the scrub you go to a side room and lay on a marble slab. The cloth rubbing over our bodies resembles a thin wash cloth with

experienced shopper like my wife, I am somewhat taken aback. His words must have been spurred on by my roving eye on his merchandize. I didn't give him any money. Other merchants try to engage you in conversation. Looking at our clothes, they think we are from California. I think about making some jokes about Hollywood, but decided against it and direct my effort towards taking pictures of people and window displays of spices offering a rainbow of colors, shiny pottery, colorful rugs and glittering jewelry.

Turkey is famous for its Persian carpets and we visited a weaving center. Such nimble fingers of the women and impressive strength in their hands. I wonder what they are thinking when they do this mindless repetitive work. The owner is an outstanding salesman, a friendly guide and one smooth operator. Of course if you buy, it's an investment and we'll ship if from here to your home. The carpets are indeed beautiful but Susan and I can't agree. What size? Is it for the floor or to be hung on the wall? What color? In the end we save a thousand dollars as a Persian

faint bristles. After our back and front are scrubbed we receive a foam soaping of both sides followed by copious splashes of water. Next we are wrapped in two towels and a third one circles our head like a turban. We now return to the reception area and are given apple tea and fifteen minutes allowing our skin to adjust and get ready for the last process. Another marble slab and an olive oil massage. The Turkish bath lasts an hour and a half and I walk back to the hotel in a light rain and feeling rejuvenated. This was one of the highlights of the trip, the other one awaits us. Four days on a yacht.

I'd never been on a yacht before. It was a wonderful experience, one I recommend for everybody. The Omar Kurt out of Bodrum is a hundred feet long and has eight cabins each with their own toilet and shower. The cook was marvelous. We had a moderate breakfast and then go ashore, hike for several miles and then meet the yacht at another cove. Onboard we then dove off into the ocean for a refreshing swim. While motoring to another cove lunch was served. The afternoon of serenity sees us reading a book with an occasional glance at the brilliant turquoise water and the rocky pine trees. Your mind wanders with the rippling sound of water lightly lapping alongside our boat. Is it time for another swim or not? Towards evening, sunlight highlights the ocean, dancing diamonds sparkling on the dark blue water and you get the feeling of living inside an impressionist painting.

The end of our journey offers striking contrasts as we stay in a very modern four star resort and visit Ephesus the largest preserved Roman ruin in the world. You can read about Ephesus in the Bible as Mary the mother of Jesus lived there.

Every room in the Charisma Deluxe Hotel faces the Aegean Sea. We are on the seventh floor. We open our sliding door and hear, see and smell the ocean. Swimming presents you with two choices, hotel's very large swimming pool or down the front stairs

A Turkish mother reads while her daughter listens.

and jumping into the vast ocean. I do both.

Ephesus at one time had a population of two hundred and fifty thousand people making it the largest city in the ancient Mediterranean world. It's the top tourist destination in Turkey and there are well over a hundred buses in the parking lot. A lot of marble surrounds you as you walk on the same street Caesar and Cleopatra walked on. The library and huge amphitheater stand as monuments to the ancient past and give one a reverence for life. The Romans were clever engineers. They had in place an underground gravity flowing system for their sewage. I get a good picture of easily identifiable holes of the public toilet. It's the same shape as today.

It's hard to sum up our Turkey adventure. We learned about many aspects of Turkish life and now when I listen to the world news, I pay particular attention to anything relating to Turkey. Just recently an NBA basketball player is leaving his team in New Jersey and joining one in Istanbul. Susan says now that we've been in so many mosques, our next vacation has to be Israel. Of course many in the Mideast call it by another name, "Occupied Palestine."

Chapter 6: Norway, Finland, Russia

Now some balance, from southern Europe to the North

Overseas Adventure Travel

Sixteen days saw us in a wide variety of locations. Overseas Adventure Travel had a pre-trip visit to Saint Petersburg, Russia which we took for four days. Next was the primary trip: two days in Helsinki, Finland; two days above the Arctic Circle in Ivalo, Finland; five days on a ship along the Norwegian coast; two days in Bergen, Norway; and twelve hours in Oslo, Norway getting ready for our long flight home.

Russia is so tied up with recent American history, the cold war, our enemy. It was with some fear and trepidation for me to set foot in this country. We've watched so many movies and I wondered, will I be safe in the year 2012? Yet this country held a fascination for Susan as her grandparents Joseph and Sara Biggon emigrated from Russia to the United States in the 1890's and Susan was keen to learn about the town they came from. We saw many impressive palaces comparable with anything we've seen in France. The lasting image I have is of golden gilded domes and statues.

Swan Lake, St Petersburg

We saw the ballet "Swan Lake." So many things came together, I sat entranced. The music by Tchaikovsky was a familiar piece for me, everything else was compelling: the set and costumes were dazzling; the athletic movement of the dancers left me in awe, such strength and flexibility. There were no spoken words and it was fun to figure out the plot of the story by the action you saw on stage. "Pass-see-ba" is thank you in Russian.

Finland is the coffee drinking capital of the world. With a population of only five million they drink more per capita than any other country. Helsinki is a charming city in the summer, a harbor with a lot of

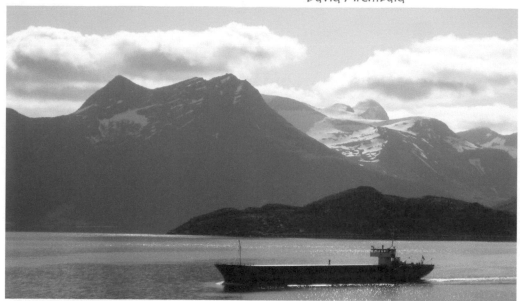
Ship in Norwegian fjord

and thus had time to fully appreciate the artic chill of the Ivalo River. Treading water and waiting, I gained a new appreciation of what really being cold was. Once on the dock I jumped up and down to get my blood stream working, let out a loud shout and felt invigorated. It was a natural thing to do after this dip into ice water that what I really needed was a good sauna. The Finns are famous for this treatment. A faint smell of birch wood permeates the air once inside and a languid feeling settles into my body. Numbness now creeps into my lips as I'm surrounded by a dry welcoming heat transporting me into a comfortable relaxed state.

greenery. It is difficult to imagine the winter with the brutal cold and only a few hours of daylight. They probably drink something stronger than coffee and say to each other, "keep-us" which is the English equivalent of "cheers".

Above the Arctic Circle is the town of Ivalo and a good size river of the same name. Here we learned about the Sami people and their Lapland culture. They are somewhat similar to Indians in America, number about 100 thousand and live in the northernmost regions of Finland, Sweden, and Norway. Reindeer are vital to their way of life and we got to see some of the attractive friendly animals up close (think Rudolph). We also got the opportunity to jump into the Ivalo River. There are 34 people in our tour group and only four got up the nerve to try this daring feat. One of the intrepid souls was me. Standing on a small dock jutting out into the water were Susanna, Neelima, Mattias (our guide) and myself. We looked at each other thinking. Are we crazy? Who was going to take the lead and go first? I seized the opportunity and made a mighty leap out into the deep river. It was of course shockingly cold. Others soon followed but did not jump out as far, so they got the first chance to climb up the ladder and escape the numbing temperature. Being a gentleman, I waited my turn

We board our ship in Kirkenes, Finland and proceed to Hammerfest, Norway, Europe's

Susan aboard a ship in Norwegian fjord

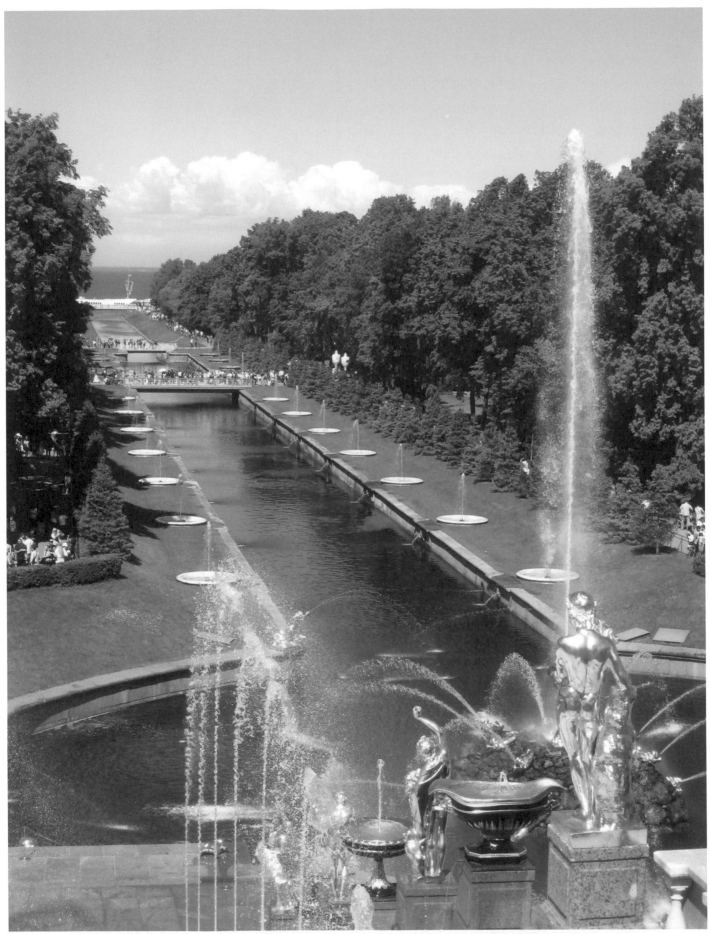

The Peterhof Palace is a series of palaces and gardens located in Petergof, Saint Petersburg, Russia, commissioned by Peter the Great as a direct response to the Palace of Versailles by Louis XIV of France.

northernmost city where the midnight sun shines from mid-May to late June (white nights). Our Hurtigruten Norweigan Coastal Voyage ship is called the Norkapp. It has a multi-purpose role: dropping off supplies at numerous towns; acts as a ferry with space for forty-five cars and a cruise ship with room for five hundred passengers. The Norkapp will make thirty-four stops as it travels down the coast of Norway at fifteen knots. On our five day journey we will go ashore on ten of those stops. Some of the stops are only fifteen minutes and others an hour and a half. Since it hugs the coast line going in and out of town harbors there was no rocking of the boat with high waves if were out on the ocean. We had spacious accommodations and very good food. The temperature our first day on deck was a comfortable 46 degrees.

The Hurtigruten advertised itself as, "The world's most beautiful voyage." And I heartily agree. The ride was smooth and the landscape stunning. High mountains sheltering towns and differing shades of blue…the sky, the water. At times the sun hits the water and the small rippling waves appear like dancing diamonds. In addition to the jaw-dropping scenery you got an overpowering feeling of space, a big depth of field. The suspense of what's ahead was dramatic because the landscape, while similar, offered subtle changes and when you walked around the deck what you saw before on one side wasn't there when you returned. I felt like I was in a movie spellbound by the hypnotic landscape.

"Berg" means mountains. Norway's second largest city, Bergan felt more like a town. It's in southern Norway and where we left the Norkapp. There are cobblestone streets, charming houses brilliantly painted with different colors and of course hills. To me it had a San Francisco feel to it. It rains 230 days of the year so quite naturally is very green. We were fortunate for our two days to be blessed with sunshine. We took a ride up a steep cog railway

Parade dancers in Helsinki, Finland

to be rewarded with a fantastic view of the harbor and the city below.

The Flam Railway highlighted our last full day of the vacation when it transported us high into the mountains, and through tunnels. The train whistled through curves and we turned our necks to capture the views before they disappeared. We saw cascading white waterfalls and distant green valleys below as we constantly climbed up and then rapidly descended.

Those who choose to travel with Overseas Adventure Travel are mostly like-minded people who share our curiosity about the world. It's a friendly crowd with diverse backgrounds. Never thought I'd be sitting at a table and having dinner with somebody who had belonged to the Hitler Youth. Growing up in pre-war Germany, when you became a teenager, he said, "You had no choice." And it was on this trip we met Bud and Sally, who we really bonded with. They live by East Falmouth on Cape Cod and for several years rented a house at the base of mountains in Tucson. We've since visited them in both places and still keep in touch.

Chapter 7: Home

We all need a break from travel, what's home like?

East Valley

We've lived in the East Valley of metropolitan Phoenix for fouty-six years: Scottsdale, Tempe, Mesa, and for the last twenty, Chandler. "But why Arizona? It's so hot," many people say. Any place you live there is a weather trade-off. We do not have the freezing cold of many places, no torrential rain of Seattle, no earthquakes of California, and no tornadoes of Oklahoma. It's also a dry heat, not the horrid humidity of Mississippi and Florida. It's where there was a job for me. It's affordable and a bartender in Pinetop told me why the letter "B" is so cool, it's between "A" and "C" air conditioning, which Arizona has in abundance.

Everybody has a home. What makes yours different? Some are spacious enough to have separate areas for a husband and a wife. These areas are not roped off yet they exist. My "man-cave" is the north east corner of our two story house. It's right next to the front door. Reading a book sitting in my recliner I can look up at a thirty foot ceiling. Two rooms upstairs sit above our three car garage. Periodically I gaze up at filtered light coming in from the windows and count myself lucky I live in such a magnificent house.

The neighborhood we live in is quiet. People mostly keep to themselves. With small back yards and a high cost of an HOA fee, there are almost no children screaming and running about. High volume traffic sound does not reach my ears.

Location, location is the mantra of real estate agents and we have it in spades. In twenty minutes we can be at the airport. An easy walk sees us at a supermarket. However, the gem is a park, one row of houses away from our front door. It is here our dog Luckie enjoys the highlight of her day, a walk in the park.

Some of our neighbors are snowbirds, living here only a part of the year. Arizona means their winter residence with the summer in either Chicago or Seattle. Then there is Rick who commutes once a week in a month to New York City. Our closest neighbor right next door is Pam. While not a snowbird she does occasionally visit the family

Our nearest neighbor, Pam Anderson

Our home in the Pueblo

"Hey could you keep the noise down a bit?" Not a good idea. Over the years our frosty relationship gradually improved and they were very friendly when several years later we visited their downtown Chandler Steakhouse.

When they moved out we were very nervous as to who the next occupants would be. Would they be considerate and not have their living room TV on too loud? Our worries came to naught as our new

home in Hawaii. We watch out for each other when either of us is on vacation. An added bonus sees Pam evaluate my toastmaster speeches and give helpful advice as to their improvement.

Physically our closest neighbor sees us almost sharing a west wall. Pam's house, number 50, is to the south of us across a narrow path. Jack's house, number 48, however, is right next to ours. We are number 49. When our house was built twenty years ago there was an expanse of open land surrounding us. Five years later a house was built right next to ours and we noticed a one foot gap between our bedroom wall and its living room wall. Built close together in clusters of four houses we sort of resemble condominiums.

Jack is not the first to occupy number 48, he's the third. The first were Ron and Lori. They had a party to celebrate moving into number 48. We were not invited and had never met them. The party must have been good because it was loud and lasted a long time. Finally, after much social confusion on my part, I went over to their back patio and introduced myself to a drunken Ron. It was past midnight and I wondered,

neighbors Howard and Tonya were wonderful. They became very good friends. Howard was a successful Seattle businessman who sold maritime supplies. Tonya, a Russian, is an erotic artist. Not only did we occasionally have dinner at each other's house, we visited them in their other home in Seattle. Sadly Tonya couldn't adjust to Arizona and after five years they sold number 48. We next welcomed Jack who is an international businessman from Belgium. Not the friendship of Howard and Tonya, but nothing like Ron and Lori. The TV sounds don't penetrate, and I water his orange tree when he's traveling. Jack's divorced and periodically sees his daughter who lives not far away. He recently got married to a woman from Zambia. We haven't met her yet.

Recently I joined a weekly Wednesday community lunch at our near-by watering hole, The Hungry Monk. The mainstays are: Troy who is 92, Bob 85, and Frank somewhere in his late 50's. The first week Greg and Mike joined us. The second week they were busy and Rick and Steve who live in Tempe were in attendance. Troy is a retired college administrator and a talented artist. He drives

a motorized wheelchair. Bob suffers from dementia. It's not severe yet but we have to watch him. Frank is a former Navy Seal and has been battling cancer for a couple of years. Not sure where I fit in with this group? The conversation is relaxed and lively. More on this group as I show up on a regular basis.

The next week mid-way through our meal, a chocolate Sundae is placed in front of Bob and he says, "Did I order this?" Sitting next to him, Troy says, "Yes you did Bob." Looking about the room at my friends, they smile and gently nod their heads. Everybody accepts Bob's condition. I know Troy has an upcoming birthday, he'll be 93, and he still has all of his mental faculties. I tell them my birthday is also approaching. Troy asks when, and I tell him it's the 28th. He looks at me in amazement and says, "That's my birthday too, of course in a different year.

The Middleton Saga (starting in 1956)

Good friends add to the quality of your life. Neighbors in the Pueblo are Ken and Sharon. He's run the same number of marathons as I, fourteen and we share a love of reading the same authors. Sharon and Susan are almost like sisters.

Sharon Middleton was a dancer from age thirteen to eighteen. During these five years she traveled in Colorado, where she grew up, and New Mexico, and Texas. She and her sister Marilyn performed in huge movie palaces just before movie premiers. These large theaters, popular in the thirties, forties, and fifties, disappeared in the sixties with the popularity of television. They danced in a chorus line of four to sixteen girls. This experience allowed Sharon to meet the Marx Brothers, Kate Smith, Robert Mitchum, and Jane Russell.

To put her and her husband Ken's life in perspective a short preview is necessary. Ken's best friend was dating Marilyn and this brought Ken and Sharon together. Sharon was seventeen and Ken twenty when they got married. They spent four years on a farm struggling to survive in harsh conditions. Later, ten years in Sun Valley Idaho where Ken was a banker. They left Sun Valley for the warmer weather of Phoenix. It was here we met them and they became our friends and neighbors. We visit their log cabin in the pines of Heber, Arizona elevation 6,600. feet

Living on a farm you never have a day off, those cows have got to be milked -all forty of them. Neither had any experience of what life would be like living and working on a farm, they were city folk growing up in Denver. Ken had held a variety of manual labor jobs ordinary teenagers had in a suburb of Denver.

One day Sharon's father was visiting and saw Ken return home from work in a rubber company. Ken was covered in black goo from his cooking of the rubber. In addition to being sticky dirty, he smelled. "This is no way to live your life," said Ken's father-in-law, "Why don't you two come work my eighty acre farm?" He did not live on the farm and it was unoccupied at the time. Little did they realize what they were getting into? In the 1950's most Americans viewed farm life thru rose: colored glasses and were shockingly unaware of the hard work and the wide variety of knowledge necessary to grow crops and care for animals.

Though tough, Ken says life on the farm was one of the best experiences of his life, "I learned a lot." Once an ornery cow had stepped on his foot and to get his foot free he gave a heavy blow on the cow's back and broke his arm. The consequence of this accident saw him milking the cows for three months with one arm. Normally the cows and Ken got along. They named the cows after their relatives. Ken doesn't remember which relative stepped on his toe. The cows liked music and when Ken would perform some dance steps, the cows would imitate him. The milking had to be done every day at the same time: seven in the morning and seven in the evening. First they expected to get fed. Then the process of attaching the four milking machines to their udders

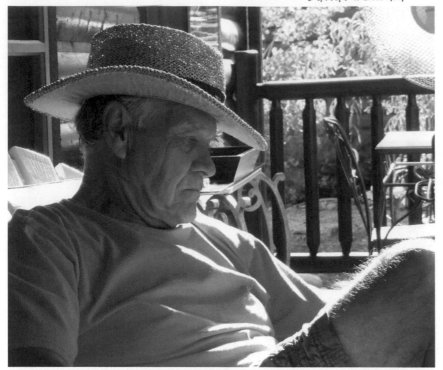

Ken in his backyard at Heber, Az.

beautiful women they ever knew.

Going to the outhouse Sharon often had to use a broom to beat off the chickens because they attacked her. In the spring every week Ken would kill the five most aggressive chickens and they would go four miles to town (Nampa) to put them into a freezer they rented. A sign outside the massive steel door proclaimed, "Hit with a mighty thrust," and Sharon often worried she would be trapped inside.

They raised a few pigs. Once, one grew so big and ornery that the pig dominated a yard outside the house. They weren't able to put a bucket over his head unlike the younger ones and take them to the pen where they would meet their demise. This corpulent, threatening pig lived on an eight foot high corn cob pile for weeks and weeks, getting fatter and fatter. If you tried to get him he chased you off. Ken and Sharon often had to scamper to their car. Being a danger to the family, they hired a man to come over and kill and slaughter the pig. He had to shoot him in between the eyes because a shot elsewhere would not be fatal to the monster. A true shot killed the pig, which weighed 400 pounds. A lot of bacon.

Winters saw work on the farm slow down. After milking the cows Ken went into town and hauled coal for cash from a railroad car and delivered this vital fuel to grateful residents of the town. Coming home in the evening he still had those cows to milk.

Sharon too had no down time. Once she remarked to me, "I can remember one time driving the tractor balancing one baby on my lap next to the other, and one in the hopper." Mark, Mike, and Mitch were all born on the farm, but since Ken and Sharon were only on the farm from 1957 to 1960 the boys don't remember much.

began. With forty cows putting the suction cups on and taking them off took some time. Lastly there was shovel work cleaning up the poop. It was about a three hour job. Every morning and evening it had to be done.

The trickiest task on the farm for Ken was irrigation. It didn't require brawn but brains. Every year it was a challenge to get the water to flow correctly down the rows. First you plowed the ground, getting the ground level enough for gravity to do its magic and get the water flowing just right. Ken grew the following crops: wheat, corn, alfalfa, barley, and clover seed. Knowing what to plant and when to plant was important. Ken found this information on the outhouse door. The former owner had all the planting information written there.

Neighbor Jack also gave great advice and helped Ken and Sharon with unpredictable problems. One day driving his tractor, Jack accidentally shot his right hand, losing four fingers but keeping his thumb. Ken says, "I would love to buy him a beer and find out why he was playing with a gun." Jack was married to Penny. Ken and Sharon say she was one of the most

After a heated argument with his father-in-law, Ken and Sharon left the farm. Ken had come to the enterprise with fifteen hundred dollars and despite prospects of success within reach, left the farm with fifteen hundred dollars.

Sun Valley, Idaho was the complete opposite of the farm for Ken," It was the most interesting and enjoyable time of my life." At seven thousand elevation, the ski resort attracted the rich and famous. In the spring the town had a population of five thousand. During the winter the town burst its seams often reaching fifty thousand. There were well educated ski bums and trust-funders with rich relatives. Famous families resided there: the Hemingway's, DuPont's and Kennedy clan. No paparazzi, everybody was the same, rich and poor were socially on the same level. Ken and Sharon loved the camaraderie and friendly spirit of the community.

Sharon became a nurse in Sun Valley. An interesting brilliant bi-polar patient was Tortoise. She and her boyfriend were nuts. Tortoise would come into the clinic and depending on which of her boyfriend's shoes she wore, gave Sharon a clue as to her behavior. They were size 13: white would indicate a good day, an angel; if she wore red: its off the wall; and wearing black: it's doom and gloom. In this last stage Sharon couldn't get her to talk. Once Tortoise was running naked on Warm Springs road in the snow and had to be put in a strait jacket.

Europeans visited Sun Valley in the winter and wore flashy fur coats. Supervising them in an exam room Sharon was shocked at how unhygienic Austrian women were. They had dirty finger nails and didn't shave their legs or arm pits. Sweating under their heavy furs they also smelled. Another different group were Cambodian refugees the Mormons were brining into the country. They ate a lot of strange fish which gave off an unpleasant odor.

Positive experiences saw her treating one nice woman, sort of on the hippie side, and later finding out it was the famous folk singer, Carol King. Once she saw someone waiting patiently in line to be treated for a minor skiing accident. Up close helping the doctor put in a few stitches by his eye brow Sharon realized it was Clint Eastwood.

Ken is now a banker, a far different occupation than farming. Unlike the farm you think he would have to wear a tie. This was true in Denver but not Sun Valley. Ten years in Sun Valley saw no bank robberies. There was only one way into and out of town. It would be hard to escape. Almost everybody was a trust funder, getting the equivalent of free money, so the motivation to rob a bank wasn't present.

Linda Carter who played "Wonder Woman" was one of Ken's customers. Another was Steve McQueen. When he insisted that he wanted to buy a used pick-up, not a new one, Ken helped finance the purchase, working with Steve's Los Angeles bank. Also in town was Dick Fosbery. For those unfamiliar with track history he was the athlete who revolutionized the high jump, clearing the bar by going over on his back. Before this there was the Western roll which sees you taking off your inside leg and hopefully clearing the bar by not touching it with your chest. Now everybody does "The Fosbery Flop," where the take-off is with your outer leg, twisting and arching your back over the bar.

It was here in Sun Valley Ken became a runner. Of course this would have been impossible on the farm. In 1977 he started with 10K's, races of six miles. Then without any serious training he ran his first marathon (twenty six miles) in a very respectable time of three hours and twenty minutes. To run a faster time he increased his training. Once running on a forested hill he encountered a bouncing bare breasted woman running down as he was going up. This was a lot better than meeting a bear. Though startled he kept his concentration and was able to finish his workout.

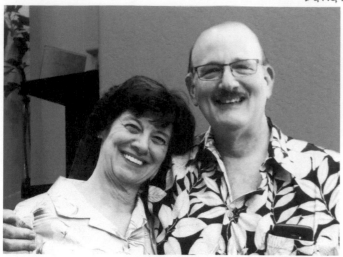

Henry and Maria

Like me Ken has also run the Boston marathon. Now in our seventies with creaky knees we no longer run marathons.

A progressive dinner in the Pueblo

The progressive dinner involved ten people, and five houses. The five couples all live in the Pueblo and it's an easy short walk to each of our houses. While we are neighbors who nod a greeting to one another many don't really know each other. The purpose of the dinner was to change that. Four couples are retired and two are snowbirds, living here only half of the year.

Being extroverts Susan and I know all the eight people and have been to their houses for dinner in the last two years. We are the instigators and planners for this social outing. The party begins at our house with appetizers, vegetables and cheese. Since everybody likes wine we tell people to bring their own wine glass so the various hosts don't have to do extra washing. Two requested a white, we had a Rhine and the rest faced with a choice of a zin and a cab, choose the cab.

The second house was Henry and Maria's. They are still employed being active lawyers, he's with various businesses while she handles divorces. Henry is also the president of our home owners association and fielded questions about our community. Entering

their house I heard ooh's and aah's as to how their house is decorated. This would be a common refrain for other houses we visited. Their assignment was salad and by now everybody was getting comfortable with each other.

The third house was David and Jan's. He's a retired engineer who worked for Boeing in Seattle. Here we had a white cold soup with a cucumber base. At each house I took a picture of the hosts. I'm happy to report nobody was camera shy. Perhaps this was due to the fact that we're on our third glass of wine.

Our fourth house was Marty and Diana's. Marty is a retired CPA, an avid hiker and artist. Sliders was on the menu. Small rolls filled with meat, mushroom, and other choices. You have to remember I'm now on my fourth glass of wine.

The fifth and final house belongs to Bob and Margo. On their second- story balcony is a white banner with a big blue "W". They are passionate Chicago Cubs fans and the banner signifies a win. Unless you've been living on a desert island you know the long-suffering fans have celebrated their baseball team finally winning the World Series. Their house abuts Arrowhead Park and we sat outside having dessert. Fortunately for me coffee was served.

Four and a half hours brought people together. We did talk about Trump but you could sense this was a divisive subject so we didn't stay there long. Talk about community improvements, finances, and plans Henry handled well. None of us have been divorced, a rarity in this age, we're all in our sixties or early seventies and we're all parents of grown children. Our community has a low-keyed atmosphere that encourages privacy, yet every once in a while it's nice to meet your neighbors and socialize.

Chapter 8: California

"We only have two kinds of weather in California, magnificent and unusual."
James M. Cain

San Diego

Some interesting facts about California. It has more people than Canada. If California was a separate country its economy would be the fifth largest in the world.

While we live in Chandler we also feel at home in California. Lisa our youngest daughter lives in San Diego and Julie lives in Berkeley.

Our daughter Lisa lives in San Diego and we visit for Thanksgiving. Our other daughter Julie flies down from Berkeley to complete our family reunion. Julie stays with Lisa who is two and a half miles from the ocean in Carmel Valley. Susan and I stay at the Del Mar Motel which is right on the beach. While the desert where we live in Arizona has its charms the ocean has a magical presence hard to describe.

Sitting on Lisa's balcony before our Thanksgiving feast I wonder if the salt taste in my mouth comes from my earlier swim in the ocean or from the margaritas we had last night at a fabulous Mexican restaurant. The other effect of my brief ocean swim is a mellow feeling in my calves and torso as a result of being pounded by ocean waves, somewhat similar to being in a gigantic Jacuzzi. Talking to a surfer before I made my mad dash into the surf I was told the temperature was sixty one degrees. This assured me I would not freeze to death swimming in the month of November.

Relaxing in our deck chairs ten feet from the ebb and flow of the ocean, I towel off and put on a warm sweat shirt and hat to watch the parade of people.

There is such a variety of people who pass by. A few are carrying surf boards, some are into their mode of jogging, others are walking their dogs, and some couples keep in step holding hands. One guy saw my red hat with the letter "A" and gave me a fist bump saying, "Bear down". This is the rallying cry of the University of Arizona and it was neat to so be recognized.

The day we arrived in the late afternoon the brilliant yellow sun slowly sinks down on the distant horizon. Up front the color of the ocean subtly changes to differing shades of blue, divided by the crashing white surf. The pink distant sky offers tantalizing hints of vibrant shocking reds. Time to take out my camera. To put a picture in perspective it helps to have some people in the foreground. Checking my camera from what I've just shot they appear as black silhouettes. I get four good pictures and later confer with Julie as we delete three to keep the best picture. I feel satisfied my artistic impulses have been taken care of. For the rest of the vacation I don't have to take any more pictures, because I have in my camera, the masterpiece.

The day after Thanksgiving I take a short run to Starbucks for the morning newspaper. With coffee and rolls and an informative read of the news, Susan and I are ready to start the day with a walk on the beach. I become fascinated with taking pictures of rocks on the sand. The smooth colorful circular and oblong rocks are randomly rolled on the beach by the pounding surf and are set in different patterns and

A Southern California beach

swirls of black and grey sand. They are commonplace here yet have an intriguing uniqueness that captures my imagination.

We meet Julie and Lisa for some shopping. I prefer to sit instead of walking the aisles. They do not need my help. Next it's off to a nail salon and a family pedicure. The girls get shades of red, but I can't decide on a color and just got mine buffed. We all enjoyed sitting in the massage chairs as we had our feet attended to.

Back at Lisa's condo she helps me and Susan understand "the cloud." I love my computer but don't fully understand it. Young people are smarter in this field. Some even four years old are well versed in our digital world. Lisa figures out how to put Susan's photos from her phone into the cloud and then to my computer. Susan has some excellent pictures. I now have on my computer a thirty seconds video she shot of flamenco dancers.

From travel discussions yesterday we now have agreed to a trip to Italy in either March or April. It's always helpful to have something to look forward to. Tomorrow the lure of the beach awaits before we drive back home. Now that our daughters are adults living away from home it's rare to see them.

Having the four of us together is special. Also special is being at the beach, everybody there is happy. This seems to be in stark contrast to the divisiveness prevalent in our country because of the heated presidential election. It's nice to notice there are no angry people on the beach.

It's also nice to notice we are only 370 miles from fresh fish and an ocean breeze. I'm proud of my daughter, Lisa, in many ways. She's good at her job being in administration for the American Lung Association. And she has a nice condo two and a half miles from the beach. While she can't see the ocean, Lisa gets the marine layer leaving her temperature a moderate 73 degrees when we arrive in late June after a six hour drive. I feel blessed being in her home for ten days while she's off to run a camp for asthmatic kids. Our excuse for being here is we are watching her elderly dog. Berkeley is fifteen years old.

Do we live through our children? Some do more than others. Being in Lisa's home gives us a wonderful feeling. Looking at the pictures on the wall, the books on her shelves all speak to her personality as an adult. She also has three things of my father's: a wine rack and table he made, plus a painting of a poem, "How Do I love thee" by Elizabeth Barrett Browning. I think to myself there goes a little bit of my father and me. And at this very moment my wife says to me, "Our other daughter, Julie, is flying home to Berkeley from Dublin." She had been visiting her English boyfriend.

Lisa's neighbors are Ron and Lori. I met them in the pool on our last visit in January. He has two jobs,

she has one, and with their busy schedules, finding a time to get together was somewhat challenging. We make a date for Sunday in LaJolla at the swank Georges restaurant overlooking the cove.

The day we arrived we did not immediately go to Lisa's condo, but instead went to the beach at Del Mar and just looked at the ocean. As many times we've been here and it's a lot, it's still a thrilling

Susan walks Berkeley and Luckie on the beach

sight. The ocean is wonderful therapy, mesmerizing and hypnotic. The next day I went for a swim and finally felt I was in California. The waves slamming into your body, the salt air, and when you get out the tinging feeling on your skin. Nirvana.

Everybody takes pictures. I take a lot. The key for me is editing. In the evening with a glass of wine I delete many that don't meet my high standards. I probably only save a quarter of the pictures taken during the day. Our first day here four made the cut, and the second day five survived. Our third day saw us go to little Italy in downtown San Diego and a farmer's market. It was a feast for my camera. Close-ups of green peppers, peaches, and three different kinds of berries became delicious images. We then went to Harbor Island. Here I was fortunate to watch another photographer shoot different people who were posing for her. She had a habit of bending down slightly with her butt sticking out and extending her arms somewhat as she was in action. The light was coming toward us so I only able to get the two figures in a silhouette, but set up against the grey skyline of the distant city and the brilliant blue water I got some artistic shots.

We spend many days at the beach. Going alone is one thing, but bringing our dog Luckie and Lisa's dog Berkeley is a production. Just getting them in and out of the car is a hassle. Monday we went alone to Torrey Pines beach. They watched us prepare our tote bag with sad eyes. The next day they put up a big fuss, whining and jumping up and down, "Take us, take us." So we did.

In the summer most beaches do not allow dogs. However the Del Mar beach does allow dogs in a certain area away from the masses of sun bathers and surfers. Finding a parking spot to be at the beach can be a challenge. My pride refuses to pay at a lot. On previous visits to San Diego we discovered a hill on a side street that normally has some unoccupied free spaces. Susan prefers to park closer at spaces that limit you to two hours. This particular trip to the beach we spied a surfer adjusting his board atop his car. We ask him if he was leaving or arriving, and as luck would have it, he was leaving.

Berkeley is a slow walker while Luckie tugs at the leash. I have collapsible cloth chairs slung over a shoulder, our tote in one hand and Luckie's leash in the other. Susan and Berkeley are out front scouting

suitable areas on the beach for our camp. Berkeley and Luckie seem to mostly ignore each other, but you can sometimes tell they do pay attention. They are medium size, with light tan coats, beautiful animals who often draw attention from other dog lovers. We often get stopped as others admire them and they can be classified as "chick magnets."

Our two hour trip to the beach was a success. The dogs got to walk along the smooth sand at the edge of the water. Susan had to admonish Luckie not to drink the salty ocean. I got to swim again. Our packed lunch included dog bones and we had a small cloth dish for their drinking water. Watching the waves with Susan and the dogs in the distance walking toward me, I fumble around for my camera. Extending my telephoto lenses to its maximum length I snap a representative photograph of Susan flanked by the two adventuresome dogs.

Sunday dinner with Ron and Lori got cancelled due to his bad back. He got better because he didn't go to work at his second job, moving crates of wine at a nearby supermarket. We got together Thursday for a glass of wine at their place. Actually we had more than one glass and conversation flowed easily over many topics. There was a lot of laughter present as we had many things in common and surprising twists pop up.

Ron and Lori are an unmarried couple living together. Lori's daughter is a senior in high school. She made a brief appearance. Ron has several daughters but none live at home. One of them is in a theater production, Dragon Two, performing in China. She plays the role of a Viking princess.

Gia a neighbor of theirs joined us. She was impressed that our 43rd wedding anniversary will be tomorrow. Gia is an airline stewardess and has been married for three years. When the talk turned to world travel I asked what her husband was doing and could he possible join us. She shrugged her shoulders with a sigh and lamely remarked, "He's watching TV."

Ron's hobby is scuba diving. He told some hair-raising stories of a dive off Cancun Mexico. Conflicting strong currents that were dangerous and a barracuda that surprised him swimming right past his face mask. They are such a fun couple we invited them to visit us this September when we will be in Colorado.

Our last day in San Diego was our anniversary, and Lisa's return from her sojourn as camp administrator. We took the dogs to Coronado Island. The leisurely stroll along a sidewalk next to the beach was enjoyable. Two times the dogs and I sat at a bench and Susan took to the beach where the dogs were not allowed. That evening we had dinner at the Fish Market restaurant. A couple our age sitting next to us were on a date as a result of computer matching. Susan remarked they didn't talk much, but they did agree to go to the beach afterwards.

When Lisa arrived home she said the camp was a success with no major emergencies for her to deal with. One day she was invited to dinner at one of the doctor's homes, who was an instructor at the camp. The camp was in the hills outside San Diego in the town of Julian. The home was a stunning mansion, set among towering trees. For dinner a huge lobster was on the menu. It was so big it would not fit in the big pot they had planned for. So here are three doctors, two who are surgeons debating how to cut up the lobster. It's not a human body they are familiar with that they can anesthetize. It's alive, large, with different parts squirming around. Everybody present laughed at the indecision of the surgeons. It was all in a good natured style because everybody ended up eating a fabulous meal.

Our San Diego vacation comes to an end. With Lisa's return, she wants her home back and I can't blame her. But who wants to drive six hours? We survive by breaking up the trip into six parts. Susan saves me by driving two of them. The hills outside San Diego maintain my attention for 100 miles.

Just outside El Centro Susan takes over until Yuma. Then it's my turn to drive the flat straight line of uninteresting desert in monotonous boredom. My savior is the music of Patsy Cline and the Beatles. Sixty miles outside of Gila Bend is Dateland and Susan's turn to steer the unending straight highway until Gila Bend. I consider Gila Bend to be almost home because the paralyzing straight line has vanished. We now have small rolling hills with Saguaro cactus.

Before we reach Maricopa I'm struck with the "Time Shift". Yesterday at this time we were walking the beach on Coronado Island. It was a cloudy balmy day in the low seventies. The sound of the crashing surf was the music we were listening to, not the Beatles. Now it's over one hundred degrees, but this doesn't faze us, because it's a dry heat and we're almost home.

San Diego: Thanksgiving

My favorite holiday for many reasons is Thanksgiving. I love the traditional food and family reunions. Plus there is little commercialization compared to other events. The selling of Christmas revolts me.

When Rich and Jean returned from their Italian trip I invited them to an "Archibald" traditional Thanksgiving at Lisa's place in San Diego. Julie flies down for this from Oakland. It has been some time since they have seen our two daughters, Lisa and Julie. Turns out it's been forty years since Rich and Jean have been to San Diego. You got to go for those opportunities when family can be together. This time of the year happens to be Rich's birthday, this year his 80th. He wasn't excited about this and adamantly told us not to make a big deal about it. We didn't but greatly enjoyed their company.

San Diego is almost our second home, we've been there so many times I often wonder why we don't live there. It has the ocean and arguably the best weather of any place in the United States. Then I'm brought back down to reality, it's expensive. Lisa affords it because we help her.

Our drive of 370 miles this time took five and a half hours. Susan and I rotated behind the wheel. Chandler to Gila Bend was mine: Susan does Gila Bend to Dateland; I then drive the flat boring stretch to Yuma; Susan gets to cross the border into California and goes to the first rest stop past El Centro; I do the rest which includes four thousand foot mountains outside San Diego. We forgot our tapes and listened to country western music on the radio. Some of the nasal twang had grade school logic: "We all want what we can't get." "Don't come with liquor on your breath and loving on your mind." Then there was Tom Hall's catchy song, "What I want is faster horses, younger women, and older whiskey."

We got a good rate at the Del Mar Motel which is right on the beach. If Rich and Jean had tried to fly they wouldn't have made it because the Denver airport had too much snow. They drove for two days to reach San Diego. Getting a bit confused and temporarily lost when they did arrive, I accompanied them to the nearest bar after they had checked into our motel. I had one beer … they had two.

Dinner that night was Italian. Everything ordered was shared with those around the table. Conversation easily flowed and brought a warm glow to my heart. Lisa explained her job with the American Lung Association. Julie talked of her life in the Bay area. When the check was presented, Rich reached for it, but Susan beat him to the piece of paper saying, "You can get the next meal." He got more than just the next meal.

The next day, the one before Thanksgiving, we spent at the beach. Jean and I braved the frigid temperatures and went into the ocean. It was fun bracing yourself for the pounding of the surf that hit you. Susan went on long walks looking for interesting shells. Rich was content sitting in a chair

and covering his legs with a towel to prevent sunburn.

Despite the fact I swam in the ocean I felt like a cripple during the vacation. The longest and biggest nerve in your body running from your lower back to your ankle is called the sciatica nerve. Since I acquired this affliction I've discovered it affects a lot of people. At first it was a sharp shooting pain, but this has disappeared to be a constant dull throbbing in my right shin. My only relief is not to walk and to sit down. Since the San Diego trip the sciatica pain is gone due to months of diligent therapy which included acupuncture.

Wedding in Malibu

California is more than just San Diego, we head for Los Angeles. LA Freeways, the world's largest other than somewhere in China. "Why don't you use cruise control?" You hit the freeway system and a sign says, "Los Angles 100 miles" and you think to yourself, "Oh my gosh!"

We're heading to Malibu which is on the coast so we've got a ways to go bumper to bumper with those crazy lane changing high speed California drivers, scariest part is when you come to a complete stop, "wow am I going to be rear ended?" Somehow we make it doing the 10, 57 north, the 210 which turns into the 134, and finally the 101.

Yet, Susan's caustic comments ring in my ears, "you don't merge right, you go too fast, you go too slow." At least we didn't encounter anybody with a gun. She replies "it's a miracle with the way you drive."

The wedding on the beach was great. The father of the bride is my good friend Gary who is married to Alayne, Susan's cousin. Gary went over the average of $33,000 for a wedding and spent $40,000 for a crowd of fifty. The Wedding ceremony and reception lasted five hours and I had my good share of wine and champagne. Fortunately the drive back to our Inn was less than a mile.

You know you're leaving LA when the lanes you are driving shrink to three. One redeeming feature of the LA freeways is they have an Archibald ave exit.

California Wine Country

To celebrate my sixty-ninth birthday Susan and I went on a wine tour in Santa Barbara, California. Our tour bus driver Tommie picked us up at nine thirty at the Lavender Inn. It was a clear sunny day and we looked forward to an enjoyable time because somebody else was doing the driving. At his next stop we met Brad and Terri. They were from Pennsylvania and had been married for forty-two years, the same as us. Terri had never seen the Pacific Ocean. They were teachers who ran a home schooling program. Both of us being teachers and approximately the same age we had a lot in common. Consequently we quickly bonded.

Tommie then pulled into a luxury resort up on a bluff overlooking the ocean. I took a picture of Terri with the crashing surf below. Asking Tommie the name of the resort, I quickly forgot what he said because he remarked it cost six hundred dollars a day to stay there. There we picked up three young blonde women. A guy with the top half of his wet suit off was there to say goodbye. Santa Barbara is home to a lot of rich movie stars. Exactly who were these women?

At the first of our four wineries we picked up a glass of wine in the tasting room and followed the vintner outside. Sometimes you might be asked, do you see the glass half empty or half full? On this tour we were not here to debate such deep philosophical questions. Our glass was neither, since we were here to taste, not get hammered and accordingly were given only sips in our glasses.

Our host had a pleasant, easy-going manner and fielded questions adroitly. Yet he, and the other three we were to visit, assaulted us with a multitude of adjectives describing the wine. I guess this was to help us distinguish one wine from another. The

West Coast Sunset.

noticed our attitude and smiled with a twinkle in his eye as he drove us to our third winery. Tommie, of course, drank the bottled water.

The Alma Rosa Winery is famous for its pinots. This is a variety of wine Susan and I like a lot. It was here we got to taste a wine named, "Two Sisters". The price tag of sixty dollars a bottle was too steep for us, even considering it was my birthday. Ordinarily we impose a ten dollar limit when buying wine. Early in the trip, Susan whispered to me, "I think here we should up the limit to twenty." While the cops were buying bottles left and right, we bought only one. We may have been hasty by buying a bottle at the first winery, but after a while it was very difficult to make decisions, so we didn't and just enjoyed the flow of easy conversation as we rated wine, from one to ten, avoiding the outlay of cash.

The bottle we bought was a 2012 Sauvignon Blanc from the Lincourt Vinyard, retail price of eighteen dollars. It is described as "being complex and concentrated with beautiful texture and balance." Now really what does that mean in layman's terms? Next the description gets a little more concrete and realistic, "Aromas of sweet honeysuckle are followed by a palate of bright grapefruit and citrus notes with a zippy, dry acidity."

The bottle that escaped us: a 2011 Pinot Noir – Mt Eden Clone – El Jabali Vineyard, Sta. Rita Hills, Price $45.00 "has a red currant, black pepper nose, soft and subtle forward fruit and an elegant, lingering finish.

Every once in a while I put my glass down and

supreme test is to have two glasses in front of you: sip one, swirl it around in your mouth, swallow, and repeat the process with the second glass. Then, can you tell the difference between the wine that costs ten dollars and the one that costs sixty?

What does it mean, when a wine is described as "full bodied"? I'm not sure, but could easily say the three blonds were.

After our second winery we were provided with a very good lunch. Here two things happened. The first was sandwiches, and we mistakenly didn't partake of the bottled water provided. The light and easy atmosphere occasionally punctuated with laughter that was already a part of our day, now increased. And the second thing that happened was very good. We learned more about the three blondes. They were police officers.

Jill, Heather, and Kristin said they got picked up at the resort because it was close to where one of them lived. They also wanted to fortify themselves with a substantial breakfast at the resort before undertaking the daunting task of keeping a clear head on a wine tour.

Our group of seven now got closer and a wonderful sense of camaraderie developed. Even Tommie

picked up my camera. Seven pictures survived my editorial cut, one which captured the three blonde's elbows on a counter and tilted wine glasses to their lips. I used my zoom lens to get this candid shot. Susan used her I-pad to get a nice picture of me standing in front of a rack of wine barrels. She e-mailed it to our daughters so they could share the experience of my birthday. No cake for this man, just another glass of wine.

After our fourth and last winery I turned around in my front seat and asked for a show of hands if they had a buzz. It was unanimous. We started out strangers, but now felt so close to each other we'd have no qualms about hosting each other at our homes.

Wine gets better with age, but if not cared for, turns into vinegar. People are the same, some turn cold, cranky and snarlous, yet others are mellow and warm…fun to be around. Approaching seventy I hope to be in the latter category…a person others smile at when they approach.

Six beds in twelve days, circling California

A familiar drive we probably make two times a year finds us on a grassy cliff overlooking Del Mar beach in San Diego … below us the hypnotic, calming effect of the ocean. However, after an hour gazing at the water Susan gets kissed by the sun with a mild burn.

On the five and a half hour ride across the desert I came up with a humorous toastmaster speech about bananas. It started off with a small tic in my brain that said, "How does a banana come from the jungle to the supermarket?" It's got to be shipped by plane, yet bananas are sold so cheap, how does this work? The highlight of the speech will be colorful adjectives used to describe a banana split. Anyway in my childhood eating a banana split on the fourth of July was one of the highlights of growing up in the Archibald household. More work needs to be done on this subject.

Lisa has lived in San Diego for twelve years, eight in her current condo. Monday she takes us to a fish dinner in Pacific beach. She accompanied us on our Peru trip. Since then she has been to Paris and most recently New York City. Also on the Peru trip were Fred and Pam. Fred grew up in the Point Loma area of San Diego and sailed across the Atlantic Ocean in a thirty-two foot boat with his wife, daughter and son (ages 9 and 7). Pam grew up in Boston and met Fred a few years ago after his first wife died. They are a neat couple.

A day with Fred and Pam begins with: lunch at Del Mar Heights; shopping at a gigantic Chinese supermarket (Ranch 99) ; Maritime Museum tour of two submarines: one American (Dolphin) which has a depth record, the other Russian, which during the Cuban missile crisis prevented nuclear war; and two tall sailing ships; cemetery where Pam's brother David Wax is buried, casualty of the Vietnam War, a pilot shot down in 1965; drive by Fred's old elementary school and house; traffic on freeway where Pam refers to those who cut in front of you as "schmucks." and then drinks at Lazy Dog in Mission Valley where Lisa works and picks us up.

Took a lot of pictures, those standing out: colorful bottles crowded together in an aisle in Chinese supermarket; from a porthole of the Star of India, a view of a Russian sub; looking up at rigging of a sailing ship; curled white rope on grey wooden deck; Fred at chart room in sub; Fred looking at gauge in sub; and white marble grave stones on a field of green grass.

We survive Los Angeles, a rite of passage for tourists visiting California. I lost track of the number of times we came to a complete stop and go, stop, and go, then crawl where somebody walking alongside would be keeping pace with you. Morro Bay offers a stunning view of the water, a beautiful resting place after the tension of the traffic in America's largest

metro area. I meet Mike a graduate of Stanford and he explains why he likes Morro Bay. It's a fun place in and of itself and is a base for going north to Big Sur and south to the beaches.

A little bit of me is in this Berkeley apartment of Julie, a jolt of awareness and wonderment as I sit on her sofa after a six hour ride from Morro Bay. We get this apartment because Julie is visiting England. It's an old building with the hum of traffic outside and the shade of trees blocking the sunlight thru the windows. Posters are on the walls, a wooden floor, and a careful eclectic selection of furniture. The apartment truly has character, with shelves built into the walls, black and white tile in the bathroom and a cast iron tub. I think Julie said the building was built in the 1930's and this accounts for the old fashioned windows and interior woodwork. A step back in time being here for four days.

Julie is at the edge of a very "posh" neighborhood, Russell Street. The iconic Claremont hotel rising eight stories sits on a hill two blocks away. It was built in 1915. Houses and mansions sit on either side of the street. Each building has its own distinct style that's impressive.

Saturday we should have realized others wanted to go to Muir Woods. A late start saw us facing three parking lots full and cars cruising inside for some spot to open up. Cars were also parking along the narrow road. We gave up and drove a twisted road sheltered by awe inspiring majestic trees to Stinson Beach. As beautiful as this drive was, it was fraught with danger. On this small road with blind curves bicyclists appeared on the right and to make room for them you risked a collision with periodic oncoming traffic. Fortunately we avoided an accident and were able to get a parking spot, it wasn't easy. Susan, Luckie and I enjoyed the fresh air, the crashing surf and the serenity the ocean gave us.

Waiting for a seat at an outdoor restaurant we struck up conversation with another couple who had a dog. Ming and Scott joined us at a table for lunch. They have been married for four months. She is from the Philippines and he is a former policeman from Virginia Beach and now works as a hot air balloon pilot. Ming and Scott met online and in the ebb and flow of conversation he remarked, "I gotta get it right because this is my third time." A physical fitness buff when on the police force he was able to bench press 450 and weighing 267 lbs run a 5:05 mile…wow, an unusual combination of athletic ability. Repeating this story later to a friend we question his fast time with his size, a bit unbelievable.

Susan enjoyed the ride along highway one, the high cliffs, and a dramatic steep drop down to the ocean. A touch scary for me so I kept my eyes intensely glued to the twisting road. We saw only a few bicyclists. Once on the Richmond Bridge I relaxed somewhat and even took a glance at the sailboats in the bay. Sunday a rest from driving. We live as Julie does, walk.

Monday was a day full of contrasts. We drove to Sacramento having lunch with my brother Richard and his significant other, Sue. It was good to touch base. Then a beautiful drive through Donner Pass to Reno, and Monty's. He was a runner and worked with slot machines. Monty and his wife Betty have a house on a hill overlooking the University of Nevada campus and stretching out beyond the sprawling city. Sitting on their well-designed deck and chatting with these good friends was enjoyable. That evening saw us in the Atlantis casino for a grand buffet dinner. We drank champagne in honor of our 45th wedding anniversary.

Tuesday they took us for a mile hike on the Mount Rose trail. I got some dramatic pictures of snow capped mountains and also Lake Tahoe. At an elevation of nine thousand feet we came across patches of snow and Luckie enjoyed romping about on this unusual surface. Next on our tour was the shore of Lake Tahoe and the ritzy neighborhood of

Incline Village. Their dog Harvey is a service dog and can accompany them almost anywhere. Monty spoke to the host and explained Luckie is a service dog in training, so the six of us got seated. The food at the Lone Eagle Grill matched the upscale environment. Also first class was the view of the lake. After lunch I went for a swim. It was cold but not overly so. Others were apprehensive but did manage to put their feet in. I think Susan slipped and got more into the Lake Tahoe experience.

Wednesday it's on the road again. Luckie usually responds very well to the command of "car". However, this time she ignored it, not want to leave her new friends. As parents we prevailed. Breakfast was at Heidi's in Carson City. Monty was there some time ago and his recommendation receives high marks from us. The road to Alpine Lake was challenging. It was very narrow with no center line strip. Because you were climbing or descending, curves were a constant presence. Fortunately no bicycles to contend with. However, we did run across a cyclist at Mosquito Lake and supplied him with water. He was so grateful.

Our cabin at Alpine Lake is set among gigantic fir trees with distinctive short branches. The lodge dates to 1927. After sitting beside the brilliant blue waters of the seven thousand elevation Mountain Lake for an hour or so we retired to the deck of our cabin and gazed upward at these spell-binding trees. We drank pear cider, nibbled at cheese, read our books, and totally took in this wonderful setting.

We are relaxed and comfortable here, yet the urge to go home is present. What's our personal paradise? A mountain lake where we are presently, or the ocean? Do we stay here, or push on the next day? Even though Susan tells me her view of paradise is our sofa/ TV room in our home, we decide to stay here, another day. She might go swimming or take a kayak out on the lake. Susan does neither preferring to walk Luckie on the trail around the lake. I take the customary plunge into the cold refreshing water of Alpine Lake. Susan records this event on her cell phone to send to our daughters. Two nights is better on a road trip because you get a better feel for the place and the people.

At Stinson beach I was impressed with the smell of the ocean. Here in the mountains I again sense a fragrance in the air. There is a difference between the two, difficult for me to describe, yet it reeks of freshness. Here there is no rush that I've felt earlier in our journey. This is indeed a calming change of pace, peaceful.

Tomorrow will be a long drive, much of it very scenic as we take in Yosemite, three high mountain passes, and go south on 395 in the Owens Valley with Barstow as a destination. On our deck Susan says "Give me more wine." I hesitate, she nudges me, "I'm on vacation." So I pour from the wine bottle. Normally it's me who has the extra glass.

Friday left me exhausted, six hundred miles and almost twelve hours required me to dip into reserves of driving concentration that I didn't know I possessed. Fortunately, listening to some classic rock and roll, feed my spirit and kept me alert and able to pass semi-trucks.

Susan also took turns at the wheel, and we stopped at Big Pine for lunch. Copper Top BBQ was, we discovered a nationally ranked restaurant. Susan agreed, telling me the ribs are some of the best she's ever had. The green chili with two types of beans and probably a secret sauce receives my praise.

The busiest travel days of the year are the Fourth of July weekend. Thirty seven million people travel, and we're on the road. Are we crazy? We were lucky today. A shower and TV news sees us not leaving our motel room. We're headed in directions others are not. Who wants to go to Phoenix in July?

- **378 miles to San Diego June 2016**
- **332 miles to Morro Bay**
- **261 miles to Berkeley**

- **244 miles to Reno**
- **107 miles to Alpine Lake**
- **607 miles to Needles**
- **272 miles to Chandler**

Total Miles 2, 200

A Tree House in Northern California

Julie, our daughter, has lived in the Bay Area for twenty years. She lives in Berkeley and walks one mile to work at a gift shop. The store is owned by Nathan who has a cottage up north and one of her perks is to use the hidden getaway in the towering redwoods.

Our two hour flight to Oakland brings us to the ocean and Julie. We lunch in Berkeley at Spengers which opened in 1892. The restaurant resembles the inside of a ship with ribbed walls and portholes for windows. Of course we ordered fish. Later in the day we drive to Nathan and Julie's store and meet her friend Jennie for dinner. Following Julie's advice I order a hamburger. It was good.

We spend the night at the Rose Garden Inn, a five minute walk from the University. It rained on and off the four days we visited California so we forgo an evening stroll to the campus. Susan watches TV and I read a book before falling asleep.

Driving north of the Bay Area we entered Sonoma wine country, one of the most well-known wine areas in the United States. The particular section we were riding in specializes in Pinot Noir, one of our favorite varieties. The winery where we chose to stop had a fee of twenty-

five dollars for a tasting. What the heck, might as well stop and give it a try. A pad of paper and a pen for your notes on the four choices was provided. As is normally the custom very small amounts of wine were poured in our glass. At times it's challenging to tell the differences in similar varieties of wine, but I amazed myself and made some notes of special qualities. We didn't leave with a forty dollar bottle, but a pen which I refer to as my twenty-five dollar pen. We made no more wine stops during our remaining three days.

We had passed Petaluma on the 101, took the exit for Route 116, and headed north towards Sebastopol, Guerneville, and our ultimate destination, Monte Rio. Can't remember now where the winery was where we stopped. The drizzle continued, but being from Arizona we gloried in it. Arriving in Monte Rio we crossed a bridge over the Russian River and in front of a fire house began our ascent up a steep one-lane road. What do we do if we encounter a car coming down? There were very few spots wide enough to allow two cars to pass. Backing up to get

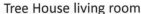
Tree House living room

The Tree House is up a narrow twisting road

to one would require a skilled driver. Fortunately I was not put to this test. With one easy to recognize left hand turn we made our way, but missed the next tricky one. I only had to back up a little and we finally arrived at Nathan's cottage.

The cottage is nestled among majestic giant redwood trees. The windows inside the two-level, six-room house vividly remind you that you're surrounded by greenery. Somewhat elevated, the cottage feels like you are living in a tree house. Reading the guest book there were numerous eloquent comments. "Breathtaking; clean, well lit, we're enamored with the surrounding hills; cozy fires at night, misty beautiful mornings; truly feels like a home; late afternoon soaks in the hot tub amidst the trees, so quiet here; and had most amazing honeymoon here."

Rain keeps us from canoeing on Russian River. However, we did drive to the coast and Goat Rock Beach. With a slight chill in the air and no sun we did not lie on the beach or swim in the ocean. Driving south on Route One we had lunch in Bodega Bay. You could go horseback riding on the beach here, but this is another activity we passed on, saving it for better weather and another trip.

Going back to the cottage I was again nervous driving up the one lane road with no shoulders, again wondering what to do if another car was to come

down. Fortunately this did not happen.

Our four days spent with Julie were refreshing. We bought her expensive boots, Susan got sandals and a dress, and I bought some hot socks with Shakespeare's face on them. Julie is a little bit of me and seeing how she lives is gratifying that a father raised her right.

San Diego, Our Second Home

San Diego, how many trips we've lost count? This one in 2018 sees us drive 370 miles to be by the ocean and our daughter Lisa. She has never met Mitch and Silvia. They moved from San Jose to the San Diego area last year. Mitch and Susan are cousins. The day after Christmas we plan to meet.

We break up the drive. I drive from Chandler to Gila Bend and we listen to news on the radio. Susan then drove to the Mohawk Rest Stop sixty miles outside of Yuma. With her at the wheel I read sections of the Sunday edition of the New York Times. Now that it's my turn to drive we can't get anything on the radio except Mexican stations so we listen to a disk featuring rock n'roll classics. "Devil with a blue dress on." and Jerry Lee Lewis with Great Balls of Fire: pounding the piano keys and screaming, "Good Golly Miss Molly." Just across the border into California are huge sand dunes and Susan's turn to drive. This time I read from the book section of the newspaper which reviews Michelle Obama's book, "Becoming." Our last switch of drivers occurs before we hit the mountains, going from sea level to four thousand feet… more rock n'roll. We arrive on the outskirts of San Diego and stop for lunch in La Mesa eating outdoors in a dog friendly area at a seafood restaurant named Anthony's.

California seems like another world. The vegetation is different, the freeways bigger, and it rains. It's fun to be here. Despite the chill outside of 59 degrees at 11:38 in the morning, Luckie and I checked the temperature in the swimming pool.

Lacking a thermometer, I used my feet to test the water and it was agreeable. I plan to swim when Lisa and Susan get back from the movies. They are seeing Mary Poppins.

Lisa makes a delicious baked brie appetizer. I restrain myself from a third selection to save for the upcoming dinner of a beef tenderloin, green beans and scalloped potatoes. I wonder could an appetizer also be a dessert. Both are scrumptious. My swim in the pool went well, loosening me up and was wonderfully refreshing.

We arrived on Monday, I wanted to go to the beach and gaze at the ocean, but was over-ruled. Tuesday was Christmas and opening of presents, again I wondered if the ocean was still there, but again am over-ruled. Wednesday Lisa has to work so Susan assures me we will spend time at the beach and view the majestic Pacific Ocean.

Tuesday over dinner we look ahead and discuss several different travel plans. Lisa is thinking of Maine in the spring. Our biggie would be in November to the Greek Isles and Israel. In between we're for sure going to the Bay Area to see Julie. Then there are the possibilities of Seattle where we know several people and the opposite direction the East Coast, Cape Cod and Nova Scotia. Too many choices, and we haven't factored in Colorado, where we always seem to go in the summer. It's good to expand your mind and think of the merits of each choice.

Wednesday, It's still there… an endless blue horizon with white crashing surf. The Ocean is just two miles from Lisa's condo and we were finally there. We spent an hour and a half at the beach. Parking spaces limit you to two hours. I got a couple from Chicago to take a picture of the three of us. Nothing quite like spending some time with the ocean, very relaxing.

Dinner in downtown with Mitch, Silvia, and their daughter Jackie renewed our acquaintance with distant relatives we seldom see. Unfortunately our daughter Lisa had a heavy day at work and was unable to meet people she has never seen. Mitch and Silvia live a bit north of San Diego in Fallbrook. Lisa works in the neighboring city Vista. Promises are made on both sides that she will come after work sometime to visit Mitch and Silvia in their beautiful home surrounded by charming hills and a golf course. The daughter Jackie lives in San Jose and was taking an airplane ride home. The son Adam like his father is talented and passionate about playing golf and I have invited Mitch to bring his son to Phoenix and play in our Rotary Golf Tournament in April. I do not need to write about the crazy twisting street of Rosencrantz we had to take to reach the restaurant. Trying to see street signs in the dark was frustrating, but we managed.

Thursday, "The water temperature is sixty degrees and I surf for two hours." So sayeth a fit young man at the D street cliff beach in Encinitas. Thursday late morning we drove along the coast and found decent parking to walk along the beach. Similar to yesterday we had a light lunch of fish and a crab cake. The Fish Shop is dog friendly on avenue I in Encinitas, and I highly recommend it. Tonight Lisa is taking us to her favorite Mexican restaurant, "Tony's Jacal

The restaurant doesn't take reservations and is crowded. Told we have an hour wait we head to the bar. In a corner table Lisa starts talking to a couple. It's her good friends Steve and Mary. Two kids move and make room for us then leave. Animated conversation starts. Steve is from Chicago and Mary from Nogales. Drinks and a cheese crisp arrive and surrounded by people talking the noise level resembles a festive party. Locals know this is the place to be and we feel welcomed. It's gratifying to see Lisa smile and engaged.

Over four days I have taken 35 pictures. In reality I've taken more, but editing them and deciding many are unworthy, they are deleted. What I'm to do with the 35? Perhaps a few will be added to my California

show which already has a lot (115). Some I will send to Julie and maybe one or two I will print, and maybe one will replace a picture I already have on my wall at home.

I have enjoyed swimming in Lisa's heated pool three of our four days. And of the four days I have enjoyed reading an awesome book on the Civil War through a viewpoint of diverse characters, "Jacob's Ladder" by Donald McCraig. Wonder if my attempted book is provocative enough to capture other's interest.

printed with their function. This is something you don't normally see.

Our daughter Julie joins us and after touring Telegraph Street we sit and eat some good hamburgers. The restaurant is at the southwest corner of Durant and Telegraph and we see an unusual thing. A silver two foot square metal box with an antenna sticking up is waiting to cross the intersection. It was a robot food delivery. Also somewhat unusual was getting wine poured from a spout when I went to the counter to get our order. .. but nothing really matches the robot.

Another trip to the Bay Area, a week in 2019

April 7 – 14…. We flew to Oakland, only an hour and a half, rented a car and stayed in three places.

Monday – 4:40 in the afternoon, relaxing in our room after a swim in our old hotel. The indoor pool is heated and in the middle it is twelve feet deep. I didn't have to wear a bathing cap as my hair wasn't long enough. The Berkeley City Club was only for women until 1962 when men were admitted. It was built in 1930 by the famous woman architect Julia Morgan. She also built the Hearst castle. Another guest in the hotel remarked to us, "I feel like I'm in a time warp." Helping putting her in this mood is the faucet handles in the bathroom which are

Heated indoor swimming pool at Berkeley City Club circa 1930

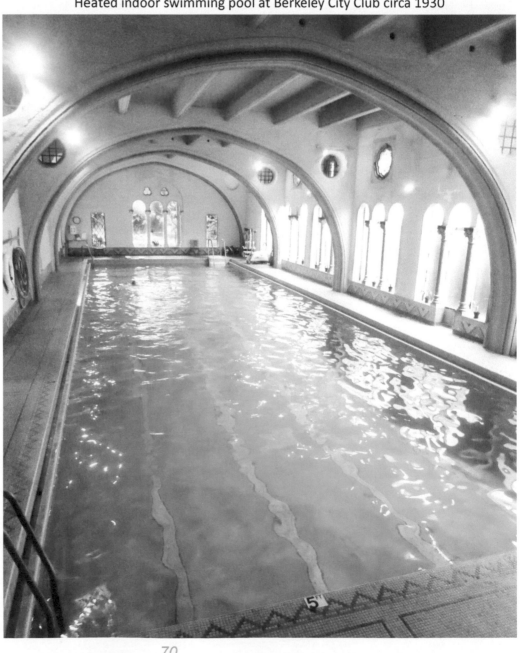

I took a lot of pictures during the week, 170 to be exact. This has been edited down to 56. While I have a nice shot of the indoor pool with its old-fashioned curved walls and ceiling, I failed to capture the fog on the Berkeley hills… and I wasn't quick enough to take a picture of the robot. Ah! The wonderment of discovery, life is indeed different here.

Tuesday: We're off to Sonoma county and Monte Rio. Traveling north I make a mistake when the freeway splits. Re-tracing our route we got stuck in a huge traffic jam just before the Richmond Bridge. With a change of drivers we're now traversing some twisting narrow roads and Julie hears a flapping noise. Susan pulls over to a fire station in the small town of Occidental. We get out of the car and discover our right rear tire is flat.

Knowing the lug nuts on the tire are so tight it takes a machine or a wrenched back to get them off, Susan calls AAA. It's an understandable hour for a man in a truck to arrive. He knew his job and changed the tire easily removing the lug nuts holding the tire with a machine looking like drill. Now I slowly drove with a donut, ie a small wheel, some twenty miles to the airport in Santa Rosa. This made me nervous, very cautious and moving slowly. At the airport we got another rental and were on our way to Nathan's cottage in Monte Rio. Before we arrive I wanted to visit a winery. Kobel had an easy sign to read on the road and we stopped there. Surprise, surprise they do not charge in the tasting room. They know if you stop, the chances of you buying something are very high. Yea, we bought a bottle of their champagne.

Before we arrive at the cottage we stop off for supplies in Guerneville. Nathan's cottage is on the side of a forested hillside. I've mentioned this before on our first visit, but it is spellbinding and so unique it deserves a re-telling. You climb up a small one lane road and worry about somebody coming downhill. Fortunately this didn't happen and I successfully made the correct left hand turns. The cottage is somewhat elevated and sits among towering redwood trees. It's like being in a tree house. We eat ham sandwiches and sip wine.

Wednesday: Being in this enchanted forest I wake up and look out the windows. There are fourteen of them in the master bedroom. I spy movement. No leaves are moving and then I understand what my eye has picked up, a butterfly.

What does Julie want to do today? After all, the primary purpose of our trip is to share quality time with our daughter. What does Susan want to do today? Julie gets her wish as we go to Guerneville to see the Armstrong Redwoods. Before the trees, we stop in town and she got a good cup of coffee and a biscuit. The trees are bigger than the ones around our cottage, but not by much. Susan got her wish and we drove along California State Route 1 and the ocean. We go north and visit Fort Ross, a Russian settlement in the 1830's. Lunch is at Jenner overlooking the Russian River and eating crab rolls. I got my wish yesterday, the visit to the winery.

Thursday – Back to the city today. Before we travel there we visit the Charles M Schultz museum. He's the author of the cartoon strip "Peanuts" with characters Charlie Brown, Lucy, and the dog Snoopy. It was impressive as the message is very human and positive. Julie got a cute picture of me sitting in a chair behind a sign which says, "Psychiatric Help, the Doctor is In." I have an impish grin on my face.

In the city we go shopping for Julie. It's competitive parking in the Trader Joe's lot. With some patience among the circling cars I find a spot before somebody grabs it. You got to be assertive in California. We rest in Julie's apartment and await our meeting tonight with Al and Paula.

We met Al and Paula on our Baltic Cruise this past summer. They live in near-by Walnut Creek. We are to meet them in downtown Berkeley. Again parking is a problem. We finally find a space and met them in a Café across from a museum where we are

I ponder the meaning of life

We sleep in a room full of books. Al and Paula are collectors. Paula has a collection of flamingos, Al a collection of Owls and all 40 of the Mr. Wiggily books. They are about a rabbit and one book was published in 1914. I think they are children's books. We're not serious collectors like them but still have a lot in common, a love of travel and two daughters who live in California.

Friday: We walk at Shell Ridge Recreation Area. This ground was saved by the city from a projected housing development. Green grass is everywhere as are clusters of big oak trees. The sunlight contrasts well with the trees and I am happy taking some serious pictures.

Having a room rent-free you feel obligated to treat your hosts to a lunch or dinner. We went out for lunch but had dinner at home. The lunch was at a nice Italian place, our treat. Their treat was a Jewish dinner at their home. This Friday meal is called a Shabbat. Candles are lit, a prayer said, the man breaks bread giving a small piece to each person, glasses are raised and a toast given. It was special.

Thursday we tried to get in touch with George and JoAnn Chimes, but were out of luck. I hadn't seen George since he and I worked at Metropolitan Life some 47 years ago. Every Christmas we'd receive a card from them and I would send one in return. This year the return address on their card did not read Queens, New York, but Walnut Creek, California. Two weeks before we talked on the phone and agreed to meet. Friday they had to babysit grandchildren, the reason for their move west. Tentatively we were to meet for lunch Saturday, but where? Not hearing from them Thursday stretched into Friday. Finally late at night George called.

Saturday: An aura of suspense hung over us in this quest to see people we haven't seen in ages. We drove to the Japanese restaurant and arrived early. George said they would be walking as they do not have a car and the restaurant is only 4 blocks from

to hear a lecture. The Mexican tacos and enchilada were excellent, unfortunately the lecture was too challenging for my feeble mind. The subject, "The Navel of the Dream, Freud's Jewish Languages."

Now driving becomes an issue. How to get to their home in the dark. I'm familiar with Ashby and the tunnel but directions on which exit to take on the freeway are at first confusing. The freeway divides and you need to be in the lane three taking the freeway to the left so when it establishes itself you are now in lane one, you can then make the first exit. I manage this and follow the directions Susan had into her phone and we successfully made it to Al and Paula's. Al brings out some port wine from Portugal and we all share a glass.

Houses in their neighborhood sell for a million and a half. Eichler is the noted architect responsible for the mid-century modern, post and beam flat-roof houses. While they are nice, I like ours in Chandler better. It is indeed a different world in California.

their apartment. We wait about fifteen minutes and then in the distance I see a tall man with his head hunched over walking with a woman…it's them.

Arriving back at Al's place they are eager to hear how our reunion went. Susan summed it up with two words, "They're quirky." We had lively conversation, catching up and enjoyed each other's company. I was impressed George remembered I was

Susan and Julie in the Redwood Forest

from Okmulgee, Oklahoma. When pressed what he did at Met Life, George couldn't remember as he was there only two years and treated it like an apprenticeship to the business world. George rose in the ranks of a big advertising company. They've been in Walnut Creek since September and are still adjusting to life in the area. He's writing a book with the premise WWI didn't happen and Andy Griffin is elected President.

George ran the New York City Marathon twice. The first time he struggled, finishing in four hours. The second time he got in with some Australian sheep herders. He didn't remember the last six miles and had to be given oxygen at the finish line. His time of 3:11 is an impressive one.

Al and Paula's youngest daughter Gayla is an athlete. She ran cross country in high school and now does cross-fit activities. When I asked Paula what her daughter's proudest athletic achievement was she texted Gayla who then sent a video. It showed her lifting a bar bell in a gym. The lift was a "snatch" where you in one motion hoist the weight over your head. Gayla is 52 years old and the weight she lifted was 168, and I'm impressed.

In the evening we go into downtown Berkeley and see Don Reed, a comedian. He's a very talented slender black man. His expressions and creativity were highly entertaining. He was so uninhibited. One particular act he introduced himself as an Olympic marathoner in slow motion being distracted by a pretty woman and losing the race… dramatic music then played, he flung his arms out at weird angles, raised his knee slowly and twisted his mouth in an agonizing shape…it was hilarious.

Sunday: We say goodbye to our wonderful hosts Al and Paula and drive into Berkeley and Julie's store where she works. We have plenty of time to chat but I get antsy wanting to finish up my California driving experience, get to the airport and return the rental. The flight home is crowded, every seat taken, and I end up sitting next to a pediatrician. I then learned more than I really need to know about "birthin babies."

The seven days in the Bay area confirmed the wisdom of Ben Franklin's observation, "**travel slows down time**." We did a lot, enjoyed the company of interesting people, and had fun with Julie.

Chapter 9: Toastmasters

Empowering individuals to become more effective communicators and leaders

Park Central Toastmasters

When I retired as a teacher I lost my audience. I picked one up when I joined Park Central Toastmasters, an international public speaking club. There are numerous clubs in Phoenix and I joined the best one. It's the second oldest and has tremendously talented people.

Much of the creativity of Toastmasters comes from the ideas different members of the club write up as the theme of the meeting they will be in charge of. Here are a few examples.

"The Color Green"

by James Mueller.

Here's the rhyme. Green, what does it mean? Green has always been my favorite color. I've been a fan of the Green Bay Packers for about 20 years of my life. My wife will tell you I'm not exactly a bastion of fashion. She dresses me, but I digress. If you were to look in my closet, you'd see fifteen different polo shirts. No fewer than seven are green. Verde is my second favorite Spanish word.

This week perform a social experiment. Ask a couple of people what comes to mind when they think of green. Is it money, the environment, or Kermit the Frog? No matter what, you'll have something ready to go if you get called on for table topics. This Tuesday come ready to share your thoughts on the color green and what it means to you.

"Toot Your Own Horn"

by Hannelore Neweke

As you all know usually we do not use our meetings to advertise our own businesses. But this Tuesday we are making an exception. If you have a function, please come prepared to toot your own horn. If it is not about your business, tell us something amazing about you.

Now I toot my own horn. My business name is Hama Wisdom and I bring thirty years of experience to my coaching sessions and healing work. My love of people and passion to help people lead me to become a Massage Therapist and an Energy Healer. I am also a natural teacher and therefore I was always teaching what I have learned in workshops and seminars. Over the years I added quite a variety of potent healing modalities to my toolbox, like Hypnotherapy and Theta Healing.

A year ago I was trained as a teacher, in the Art of Feminine Presence. I am now starting to offer introductory evenings, to be able to fill weekly Art of Feminine Presence Circle, Mini Workshops and Seminars. "We live in a male dominated society and women are taught to use their non-dominant masculine energy. This does not nurture women. Art of Feminine Presence, teaches women to enhance their feminine essence, to be powerful, be heard and seen and achieve whatever they want with ease and grace.

"The Child Within Us"

by Wyatt Earp

The child within us allows freedom and so we take liberties with the accepted norm. We have the freedom to flower. I have found I have enjoyed risking disapproval. Keep alive and well, the inner child energizes creativity. Not only do we think outside the box, but we give the box new shapes. The child within us is imagination – fresh and powerful, in the mind-set

Me, Grant Coldwell and Wyatt Earp at a speech contest. Wyatt is actually related to the historical gunfighter.

of this child we can live the lyrics of John Lennon's song "Imagine." There are no sacred cow or turf issues.

The child within us can be: nonproductive without guilt; doesn't care what time it is; and shows curiosity, wonder and delight. The child places the highest value on laughter and delights in love. Next Tuesday come prepared to revel in nonsense, giggles and those magic moments of thrilling or charmed discoveries that have been yours.

"Las Vegas"

by David Archibald

What comes to mind when you think of this city in the Nevada desert? Neon lights turning night into day. People wear sun glasses indoors and lingerie outdoors. There are pleasure palaces (giant hotels), breathtaking shows, cheap buffets, wedding chapels, Elvis impersonators, Liberace Museum, the occasional boxing match, and the list goes on to include all kinds of bizarre things. The foundation is of course, gambling. I am not a gambler, perhaps you are? Since I do not play around with lady luck, I have only been to Vegas twice.

My wife and I stayed at the Flamingo and enjoyed visiting Caesar's Palace. The art on the walls was impressive as were the creative fountains at the entrance. The Luxor had just been completed. Casinos seem to have a short shelf life as every once in a while you read about one being demolished (the Riviera) so a new up-scale one can replace it.

There is the licentious saying, "What happens in Vegas stays in Vegas." Come to our June 2nd meeting and share with us your memories of the unusual city.

"Enthusiasm"

by Bill Trottier.

The word enthusiasm originally meant inspiration or possession by a divine spirit. For example, an enthusiast might be a person possessed by Apollo or Dionysius. Derived from the Greek word, Entheois, it means the God within. The "iasm" at the end of the word could easily refer to a spiritual source of motivation as in "I am Spirit," or a natural source of motivation, as in "I am self-motivated.

Being in the flow is closely related to enthusiasm and describes the state of being totally immersed and focused on the activity at hand. Being in the flow brings with it a feeling of joy and at one-ness. Come prepared to share your most enthusiastic moments with all of us, whether they be at Park Central or in your own private life.

"Your Lucky Penny – Who or What?"

By Andrea Beaulieu

Andrea Beaulieu

When I was in kindergarten it was all about playing, napping and eating graham crackers. Those were the days! I do remember quite vividly one of my classmates – a girl named Penny. I would chase her around the classroom laughing and saying, "I want my lucky penny for a piece of candy!" At that time, you could put a penny in a gumball machine and get a gumball. She was my lucky penny. We both enjoyed the game.

Today, I have many lucky pennies – people I love to be around who bring out the best in me and I in them. Places I feel comfortable in like my cozy home where I get to refresh. Events and activities I participate in, like our very own Toastmasters Club, for good fun and speaking support with friends. All of these are wonderful sources of wealth and good fortune in my life. Who or what is your lucky penny?

"Relationships"

by Jack Levine.

Jack Levine

A philosopher once said – "When you're in a relationship and its good, even if nothing else in your life is right, you feel like your whole world is complete." Another said – "To the world you may be just one person, but to one person you may be the world."

We all recognize that our relationships are so terribly important to our lives in so many ways. There are many different types of relationships. There are family relationships, romantic relationships, business relationships and simply friendly or, unfriendly relationships. I am certain that no one in our Club is going to be at a loss for words to describe some relationships they have had with another person that has made a big difference in their lives, for better or worse.

Of course, over the years, I too have been toastmaster and have come up with themes.

"Once In A Lifetime Experiences"

by Cathy Eden

I like once in a lifetime experiences. Sometimes these are experiences that are so over whelming I realize I will not be back this way again. Examples would be standing on the Gaza border, another time running on the Great Wall of China. A different way of looking at this is experiences that are horrid and I do not want to experience this again. I have a list of once in a lifetime experiences. Some are people I hope to never have to talk with again because once was plenty. Having a garage sale is on my list never to do again. What is on your once in a lifetime experiences that is great or were pure terror. Tell us about them. Some will be husbands: maybe you don't want to do the third grade again. Drive in a snow or ice storm, have another baby. What is on your list of "Once in This Life Time?"

"Ships In My Life"

by David Archibald

In 1957 my family made a canoe, large enough for six people. It had its inception in our family bath tub as we soaked wood for the ribs of the vessel. Unlike my ancestors in the 18th century who crossed the Atlantic Ocean for two months or more in horrendous conditions I was only in modern comfortable state of the art ships for reasonable amounts of time. Some of those other boats in my life that reflect my exotic travels include: The Staten Island Ferry; a yacht on the Turquoise Coast of Turkey; a mail boat cruising the fjords of Norway; Milford Sound of New Zealand; a cruise ship rounding Cape Horn of South America; the inland passage of Alaska; and the Dolly of Canyon Lake. Come to our meeting and briefly tells us of one of your exciting voyages.

"Mother's Day"

by David Archibald

My wife left me and went to California. On a Thursday I took Susan to the airport and she flew to San Diego to meet our youngest daughter Lisa. Lisa's older sister Julie was flying in from San Francisco for Mother's Day. That weekend they celebrated by going to Disneyland. Why wasn't I invited? The group dynamics would have been different. Yeah I guess there is something different and unique about my personality.

This was not the first time in forty-six years Susan and I have been apart. In 2004 I went to Africa and climbed Mount Kilimanjaro, Susan elected to stay home. She wanted me to bring home a carved wooden giraffe, but the only thing I brought home was a sixteen day old beard. Just last year Susan went with Linda Moser to Paris and cruised the Seine River to Normandy, I stayed home and coached track. However, this was the first time Susan and the two girls have spent the weekend together without me. It worked out well, they had a great time, and I am happy for them. The little bickering between Julie and Lisa disappeared and they had a fabulous time with their mother.

For the very few in this room who have not been to Disneyland and a reminder for those who have been…some of the rides my three girls went on: The Haunted Mansion, the Jungle Cruise, and Pirates of the Caribbean. It's on this last one they learned how much a pirate has to pay to have two ears pierced…a buck'near. In the evening there is the magnificent electric light parade.

With all this freedom at home, what did I do? Really nothing out of the ordinary or extravagant. I do remember one evening making macaroni and cheese and adding sour cream, something I recommend to those of you who cook.

Back to Disneyland, I am not forgotten. Susan says, "What would your father think of this" or Lisa would say, "Do you think Daddy would like this?" They bought me an: "MMSD" Mickey Mouse Soap Dispenser.

What happens on Father's Day? … a card, a phone call, an email…but no Disneyland. One year they did sent me a cherry pie.

What's my call for action? As a result of your speech what do you want the audience to do? For those who are married or have significant others it's healthy to have some time apart from each other. You come to realize how important the other one is. And then there is the reunion, the joy of seeing each other again.

Clubbing With The Toastmasters

You know your function a month in advance and before each weekly meeting you are apprised of the theme of the meeting. With fifty some members in our club, once a year you get to be in charge of your own meeting. This means you are the Toastmaster. You choose a theme and write up 150 to 200 words about it for the newsletter that goes out four days before the meeting.

Various roles or functions are assigned for the meeting. Your job is to remind these people to

Veteran Toastmaster, fellow high school teacher, and great person, Vanessa Dehne

show up. In addition you prepare an agenda for the meeting, making thirty-five copies because this is the number which normally attend.

Of these eighteen adults only one failed to show-up. However, it was easy to get somebody else in the club to fill in. You also have to write up an introduction of yourself that the president of the club reads. The meeting went well as we heard some interesting stories about Las Vegas. However I should add this, "What happens in Park Central Toastmasters, stays in Park Central?"

My next speech at Toastmasters was entitled, "A Room with a View." My beginning starts out with the word, "Paradise" and to many people it has different meanings.

My speech is accompanied by a power point show of my pictures. For many years as a history teacher I had numerous slide shows, now in power point for adults. I have edited my show and, with thirty-two pictures I am haunted by fellow toastmaster Betsy's admonition that in my previous power point presentations I have had too many pictures. She's an artist and I respect her opinion. I think Betsy wants to linger on only a few pictures and have the audience at the end to be able to remember one or two. However, I want to tell a story and want pictures to flow and illustrate my theme. I delete four and now feel my 28 will be sufficient to achieve my goal and perhaps mollify Betsy. Her friend Donna is to be my evaluator. This will be interesting.

My speech went well. I saw the timer flash on the green light and knew where I was with my pictures and speech. Knowing I had a few more pictures and I had qualified time-wise I picked up my pace. I then saw the yellow light, the big warning before the red, and felt confident I would reach my close. A big applause greeted me as the last picture, one of Susan and myself appeared on the screen.

Sitting down I felt I had done well. In the final tabulation of the ballots of four speakers I finished in

second place. Hannelore Nweke, a recent immigrant from Austria spoke about her love of children and Dave Dickey, a retired Washington DC lawyer spoke about his travels in Central America. Harry Huffman won the best speaker award as he gave a flawless humorous speech about ballroom dancing. He's a veteran of our club and a very gifted storyteller. He has a good imagination and uses colorful descriptive words to paint vivid word pictures, so I did not feel bad finishing behind him.

Competition continues as a few weeks later I am an evaluator. I am assigned to speak about James Mueller's talk. He's a popular man in our club, because he is funny. Of the four evaluators I am the last to speak. I do not hide behind the podium and like the others I do not use notes. These three factors put me in good position with the voters. Now all I have to do is say some interesting things about James. This is easy because his talent is being unpredictable and I have only to point out a few of these areas to

ASU Professor Cathy Eden

Me, Grant, Jack, Joyce Buekers, Kelly Clough, Nikki Lanford

win, "Best Evaluator." It was not easy to stand out in front and rely on my sometimes faulty memory, but I did it. We have a talented club, and occasionally winning fills me with pride.

Toastmaster meeting sees Richard Gehrke with pictures of his vacations and interspersed into the show after seven pictures is a famous traveler quote, then more pictures and another quote. I have borrowed them for my travel show.

> *"The gladdest moment in human life, me thinks, is departure into unknown lands."*
> *Sir Richard Burton.*

> *"People don't take trips, trips take people."*
> *John Steinbeck.*

> *"Travel makes one modest, you see what a tiny place you occupy in the world."*
> *Gustave Flaubert.*

> *"Broad, wholesome, charitable views of men and things cannot be acquired by vegetating in one little corner of the earth all of one's lifetime." Mark Twain.*

Toastmaster's Pearls Of Wisdom

Contributions by members during the meeting. Jeff Harbeson,"Talking about death doesn't mean you're dead, just like talking about sex doesn't make you pregnant." Bill Trottier,"I was driving on a deserted country road and came to a stop sign, slowed down and looked both ways and drove on. Soon a police car stopped me and the cop said, "Did you stop at the sign?" Bill replied, "No but I slowed down and looked both ways," The cop then pulled out a big stick and began beating Bill on the head, and said, "Do you want me to slow down or stop?" Jack Lavine, "The best way to travel to Las Vegas is not by plane or car, it's by bus… it only cost thirty dollars one way and you get to watch a movie while you are a passenger."

Before the meeting started Joyce the Toastmaster said, "Grant wants to speak last" I looked at the agenda and seeing myself listed as the fourth speaker said, "Unless he has a good reason I want to remain last." The other two speakers Dick and Lee were

also very talented speakers so I didn't expect to win. I gave a speech about what's essential about Phoenix and the use of a golf seven iron towards the end of the speech sparked some excitement in the audience. Driving to the meeting I added a phrase that I believe resonated with the people, "Have pride in where you live." When the results of the voting were announced I won! I didn't get best speaker, Lee did, but received most improved. Grant gave a very clever speech about his first car a Volkswagen. I have so much respect for Grant's talent, he's the master of insightful and colorful descriptive adjectives. In my ballot I voted him best speaker and myself most improved. Surprise, surprise, and I believe I beat him because I spoke last and was most recent in people's minds.

It's always thrilling speaking for five minutes and standing in front of others towards the end and your close. There is a threatening moment of silence when you stop talking, tensely waiting approval from the audience and applause. We all seek approval and recognition. When I finish one speech I always think forward about what my next one will be about. Driving home from the meeting I discovered the answer, Bisbee. You don't have to go overseas to find charming historical places.

Toastmaster Table Topics

This is extemporaneous speaking. If you don't have a function and are part of the general audience you can be called on to answer a question on the theme of the meeting. When called on you have to think quickly on your feet. Last week I was in charge of Table Topics and called on five people. This week I did not have a function and got called on. The theme was "Rituals".

Fortunately I was given a easy question I could easily twist around. During the meeting I'd already thought of what to say if called upon… I responded, "My early morning ritual is making the coffee, but who really is responsible, the man or the woman? The answer is in the Bible, it's Hebrews." The room erupted with laughter, so much I had to pause awhile to resume speaking as the green light wasn't on yet. Continuing, "My evening ritual is to brush my teeth after dinner and do my plank." Earlier Hannelore and Vanessa spoke of the importance of breathing and having a strong stomach… so this just set up my talk. To the surprise of many I then went down on the floor resting on my elbows and showing a flat back… the correct posture for a plank. Needless to say I won best table topics speech.

Jokes

Of the many different functions at a toastmasters meeting the one I find most tedious is that of "ah counter" marking down the useless utterances at the end of sentences. It requires so much concentration. My most enjoyable function is "joke master" Here are some cute, perhaps funny one liners.

Did you hear about the cartoonist found dead in his home…details are sketchy.

How do prisoners communicate to each other, they use cell phones.

An invisible man married an invisible woman, the kids are nothing to look at either.

Recently I read a book on the history of glue, couldn't put it down.

Whoever named it necking is a poor judge of anatomy –Groucho Marx

What did the mountain climber name his son? Cliff

Singing in the shower can be fun until you get shampoo in you mouth then it becomes a soap opera.

What did one eye say to the other? Something smells between us

There is a vegetable band in southern Arizona, lettuce turnips da beats.

There is a reason the letter "B" is so cool, it between "A" and "C" air conditioning

Chapter 10: Running

Exercise is vitally important to a healthy life.

To make running interesting there is sport, which adds the element of competition. Two good friends are passionate about two, which I only have a passing interest in: Bob Anderson plays golf and Roy Sinclair follows soccer. I got my job as a teacher not because I was knowledgeable about social studies but convinced Ed Anderson, the head football coach, that I could coach his sport. Jim Ryder, the head track coach, was impressed with what happened with the freshmen football team I was coaching and in spring hired me to be the freshmen track coach. I've stayed with track for 42 years. I left football after four seasons and picked up cross country, a nonviolent sport.

Every athletic endeavor involves running, yet it is often seen as punishment. "You're late, run two laps" is often the refrain you hear from coaches. With this mind set, it is difficult to recruit students to track. Those who are fast have no problem because they want to brag about their talent. Some recruits are not hesitant to put forth the work to improve and get faster. However, you need to give them constant reinforcement. I often tell students it's not always first place that's important, it's the fact that you improved and ran a faster time.

High school track has 17 events and there's always a place for you on the team. Explosive leg power means you could be a sprinter. With a patient mind set and inbred work ethic you can be a distance runner. What's left? The 800, two laps around the track, is not a scary distance to some and it's not a sprint. Of course to get good in this event I trick them and after gaining their confidence have them run a race under 800, the 400 and a race over 800, the mile. Then there are two relays open to them, the 4 by 400 and the 4 by 800. Finally we have five events available to the hesitant athlete: the 400, the 800, the mile, and two relays.

To relieve tension which might be present, I posted this humorous listing for my athletes to read. The ten signs you're not going to win the state championship:

10. *You only come to practice for the team photo*
9. *You're a sprinter and you don't know where the start of the 200 is*
8. *You high jump in hiking boots*
7. *You're a distance runner and get lapped in the two mile…by girls*
6. *The high jumpers are going higher than you are in the pole vault*
5. *It's the last meet of the year and you still don't know the order of events*
4. *Mesa has three freshmen faster than you*
3. *You are failing earth science*
2. *You have a dance concert that night*
1. *You didn't make it at the Last Chance Meet*

The Dam Run

When I'd go off campus with distance runners and during cross country season I would never run with them. Following Jim's advice, I would ride a bicycle. This way I could talk to the runners and not be out of breath. I could also speed up to be with our

I 'm running with some tired runners
as we finish the Dam Run

Souvenir T-shirt of the big event

faster ones and then drop back to be with the slower ones. The one exception to this policy was "The Dam Run", which we did one week before our first cross country meet. Pima road is at the edge of Scottsdale and the beginning of the Indian Reservation. It was here on a canal we'd start our trek along the canal to Granite Reef Dam some ten miles away. A pick-up truck would be in the rear carrying water and tired runners. Every two miles we would stop to gather people together and drink water. During "The Dam Run" I would run with the slower kids. The fast ones didn't need my attention. The finish line was the Granite Reef Dam. Here were waiting parents with fruit and donuts and rides home. It became a grand tradition every year and

we got a few neighboring schools to join us on, "The Dam Run."

In the last twenty or thirty years road racing has gained in popularity. When I started in the eighties very few women ran a 10K. Now half the field are women. However the most popular distance has shrunk to 5k. The lure of a marathon has captured the attention of many and swarms of people jog this classic distance. This has put the stamp of approval on running and today it is not seen as punishment, but a badge of honor.

The Boston Marathon

It lives up to its reputation. If you play baseball, you want to be in the World Series. If you are a

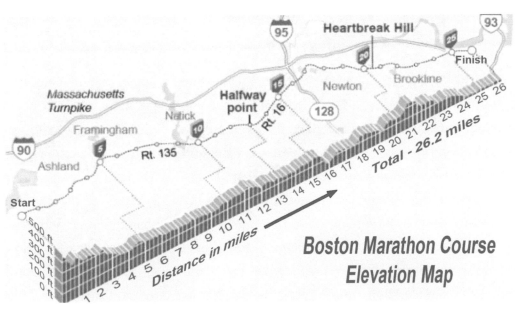

**Boston Marathon Course
Elevation Map**

I'm breathing hard finishing a 10K road race

along the twenty-six mile course from Hopkinton to downtown Boston. Other marathons such as Los Angeles, New York and London have more people so what makes this marathon special? The tradition. Mine was the 99th running of the race. It is run on Patriots Day, a holiday in the state of Massachusetts commemorating the first battle of the American Revolutionary War. You also have to qualify by running a marathon in a certain time based on your age. Not everybody can run Boston. The designated time represents what only ten percent of those in the age brackets can run. A sign in the Elliott Lounge, a famous bar for runners, describes the event as a "Moving Carnival." There is a feeling you are in a festival, not merely a race, but a human celebration of life. Everybody feels good.

musician, you want to play in Carnegie Hall; and if you have two lungs and two legs and you enjoy running you want to be in the Boston Marathon. It's the most famous race, a Mecca for runners from all over the world. Having climbed Mount Kilimanjaro and running the Boston Marathon are two of my signature claims to fame.

What makes it so great? The people. There are a lot of them and they are very supportive. Over four thousand volunteers and a million and a half spectators

My decision to go was prompted by the fact a runner I train with on Monday night, Ron Santa Maria had a hotel reservation in Boston and was going to do the race. He said he would be willing to share the room with me, so I decided to go. Why wait until next year and do the 100th anniversary when I already had run a qualifying race in Tucson and was in good shape now? Carpe Diem, seize the day, take

advantage of present opportunities.

When Susan dropped me off at the airport she said, "Well you can talk about running for three days now and people will listen." For three days there were many who listened. During the time I was in Boston there emerged an Arizona group which: went to dinner, toured the huge expo, and saw an afternoon movie. A sense of camaraderie developed that heightened the positive atmosphere which prevailed that weekend in Boston. Our group included: a welder, a physical therapist, a manager of CIM systems, a CPA, a publisher of a running magazine, a hot dog man, and me a high school history teacher and track coach.

A noon start made for different strategies by just about every runner you talked to. A big question was, do you eat that morning and if so, what? I didn't eat and it didn't seem to affect my race…but then everybody is different and what works for one might not for another. The late start was also relaxing because no one was really in a hurry; a mellow mood existed. Ron and I went down at nine o'clock just in front of our hotel to see a long line of yellow school buses lined up. The hour ride to the start saw strangers from all over dressed somewhat alike with a common purpose. It was fun talking to your neighbor sitting next to you and sharing stories. Our pre-race activity once we arrived was sitting on a nice lawn in front of a school with the temperature in the low fifties and the sun out.

The start is very carefully monitored by a lot of volunteers in distinctive jackets. I went to my assigned slot well in the rear. I wasn't running for a fast time as I had already achieved that in previous marathons. This was my fourteenth and I want to savor the experience and not push the pace. Five helicopters flying overhead made a lot of noise. Ten thousand runners lined up on a two lane street made for a very crowded pack of humanity anxious to unleash all their stored up energy, but prevented by masses of bodies in front of them. With a cannon or gun, I'm not sure which, we pressed forward but couldn't run. We did move, and in about two and a half minutes we came to the starting line and saw the dignitaries, but we still couldn't run until about another two minutes or so. Finally we were able to slowly jog. Picking open spaces and sometimes the side of the road I began to feel better about my progress. My first mile was 10:30 and my second a more respectable 6:40. At mile three I was able to settle into a seven minute pace and not have to use the side of the road or worry too much about hitting somebody.

Sheri LaFon and Jenny Palmer, 1990 Coronado Track state champions, here finish together at Scottsdale City Meet

Somebody remarked there are very few dead spots during the Boston Marathon and they were speaking of crowd support. It was fantastic. At times there were clumps of people scattered here and there and in the middle of towns ropes held back huge screaming crowds. It carried you along. The four famous hills from mile 16 to 21 (the last is called Heartbreak) really weren't tough for this Arizona runner, just something you did. They may have broken others but not me. Coming into the city of Boston you run alongside trolley tracks and become very aware of the mile markers and the tall buildings looming ahead. The finality of finishing entered my mind and eased the last miles on my tired body.

After you finish they keep you walking, give you a medal, a small bottle of water and have a silver plastic-like blanket draped over you. Then a bottle of juice is offered, a donut and a sandwich. I drank the liquid and took only one bite of the donut. I was tired but feeling pretty good having taken Gatorade at almost all of the aid stations. Another runner remarked to me, "I'm so low on energy, dirt would have looked good." Since our hotel was close by, only one thought was really on my mind, get to the Jacuzzi. It was crowded when I arrived, but they made room for me and it felt so good. Five of us went out for seafood in the evening and basked in our accomplishments. Although some were disappointed in their times we were all finishers in the Boston Marathon. Ron broke three hours and was timed at 2:51 while I was more pedestrian with 3:24. I was not one of those disappointed as it was a great experience.

How many Wagner's have I coached?

Kathleen and Ed Wagner had sixteen children. All of them went to Coronado High School. Michael was the oldest and in school before I was coaching. Patrick was next and on my freshman football team. Laurie was on our state championship cross country

Brigette Beracy with daughter Chloe

team in 1979. The meet was in Fountain Hills. It rained and she fell, but she got up and finished the race. A freshman Linda Retzlaff was normally our sixth runner, however on that day she passed Laurie and became our fifth scoring runner. In another season when I'm state meet director, Carl fights during the race with a Westwood runner. They were on wrestling teams and the previous season had some unresolved issues. Both got disqualified.

The youngest of the clan, Aimee, had her two sisters Anne and Sara on the team so I'm coaching three Wagner's at the end. Sarah is now coaching at

Arcadia. In between the beginning and end I had: Margaret, Nick, Matt and Joe, not sure of the order. Rose ran at Coronado when I did some coaching at Arcadia for a short interval before returning to Coronado. Mary, Beth, and Theresa were on the swim team which competed at the same time as cross country, so I didn't coach them. Another Wagner played volleyball which I didn't coach. If the math is correct there are six I didn't coach, so the correct answer is ten. Sara helped me out with this history as we walked a cross country course. She has three daughters who are now in college and doesn't plan to try and match her parents in child rearing.

I coached thirty years in the Scottsdale School District: four years freshmen football, twenty-six years cross country (State Champions '78 & '79), and thirty years track (State Champions '79 & '90). I continued coaching track for another twelve years in various east valley high schools. Many stories, yet the Wagner's remain unique.

Reunion of Runners

The Scottsdale City Cross Country meet sees me gossiping with three former coaches: Doug Holland, Ed Thompson, and John Prather. I asked them what athletic feat they felt most proud of. John ran on the ASU track team. His event was the demanding 3000 meter steeplechase. Ed played college football at

Brandy Pierce, Me, Beth Beracy

Wooster. He was a running back. Doug ran every day for 35 years until he had an emergency appendectomy. The bond you develop with fellow coaches is deep. We all encountered the same difficulties and joys of the sport we love.

The next day is a high school reunion. I'm preparing myself for the question, "Do you remember me?" Sometimes I actually do, but mostly no. I just don't keep in contact with many former students. The Beracy's are an exception, there are four I coached. Two of them, Bridgett and Beth came to the reunion. While it's easy to recognize Bridgett and Beth as I see them once or twice a year such was not the case with others.

I can also recognize the Wagners. Their faces have certain characteristics that helped me recognize Rose without any prodding. Nathan Hubble and Ian Gaffney, however, stumped me, and required the comment, "Help me out here, your name please?" It had been thirty years and a teenage face bears little resemblance to that of a mature man. The voice, however, didn't change much as the conversation ensued. I didn't talk much with Nathan but did remember this tall man was once a high jumper on our track team. Ian works for the post office delivering mail. He fondly remember his greatest athletic achievement. As a sophomore he won the JV city championship in cross country. It was fun to see him smile as he described the tactics of the race. Another person I haven't seen in thirty years is Carla Jackson. She won the 1500 meters at the National Junior College Championship. Her time of 4:39 is the equivalent a 4:59 mile.

Bridgett then told us on a canal run in Scottsdale early in the morning she was startled to see a beaver. Not to be outdone Doug who lives in Tucson told us on a trail run he encountered a mountain lion. He raised his arms to make himself bigger than he was and shouted in a loud voice. At first this did not impress the lion, but eventually he turned around and

let Doug finish his run wondering if they would meet up again.

Beth is going through a divorce and said it's working out reasonably well. There are no children involved. Bridgett coaches middle school cross country and works at a restaurant in downtown Scottsdale. It's only open for breakfast and lunch. She said they make a very good Monte Cristo Sandwich. This now means I have two good reasons for going there.

The reunion also included fellow coach Jerry Smith. We often competed with each other for athletes as his basketball season happened at the same time as my track season. Despite this rivalry we respected each other and got along well. We've both aged well and blended in with the chatting boisterous crowd.

Centipedes

I enjoyed running and racing, but did it with adults my own age. In a road race the top three in each age group get an award and we would compete for these prizes. When not racing we'd go on a long run together and a wonderful camaraderie developed.

A popular road race, The New Times Phoenix 10K, offer a prize for the best dressed costume. Some good running friends with an engineering background convinced me to partake in this endeavor. For several years with different costumes we always won the prize. Our costumes were centipedes where each runner was somehow attached to each other. Different people participated over the years but the primary organizers were Chuck Sorenson and Brent Pinder. We had six creative ideas and it was a lot of fun. The friendship of those who participated was uplifting. We were all well-known in the running community and got high fives and smiles when we saw our other running friends.

Our first centipede had only five participants. In addition to Chuck, Brent and myself, Dennis Keogh and Billy Wise made up the team. We were convicts, dressed in black and white stripped outfits carrying a plastic ball and chain connecting each other. Later centipedes involved more people and daringly creative costumes. The convicts was our fastest centipede as we finished in a most respectable time of 44:50. Ten of us were in the "Hula Girls." We wore long hair wigs, grass skirts, and plastic butts. It was exhilarating to be a wild woman running the streets of Phoenix. We were not as fast as the convicts and finished in 54:40.

The Dragon was our most popular centipede as we did this one three different times. The last time it had 18 people and our first mile split was 10:30. The youngest person in the group was 26 and the oldest 63. Your head was in a hole in the cloth representing the skin of the dragon. You could not see your feet when running. A strange sensation.

Some of the centipedes saw us cheat and cut the course because of the difficulty. The Circus train had us holding onto PVC pipes supporting large cardboard boxes that had at one time held refrigerators, but we painted them to resemble a circus train. Bridgett was a giraffe, Dennis a gorilla and I was an elephant. Brent and Chuck were in a costume of a horse in the front pulling the train. Brent had his arms on Chuck's back and they had to move together in lock step. They couldn't keep this up for six miles so we cut the course to make the finish line. The Upside down Cheerleaders also was overly ambitious. Imagine running six miles with your arms raised to resemble legs and your hands holding shoes.

Our sixth centipede saw us dressed up as baseball players holding up with sticks a huge paper mache bat. The baseball bat required us to rent a U-haul trailer to transport the two halves to the staging area where we connected them. We didn't cut the course with this costume but the slight wind made us holding the sticks to the bat a bit tricky. Our finish time was not important, we cared more about the expressions we saw on spectator's faces.

Back to the life of a coach

Retiring as a teacher and coach at Coronado high school and getting a nice fat pension I was not ready to finish my coaching career. Coaching track at Seton Catholic was somewhat different than at a public school in Scottsdale. For one thing it was a lot closer to where I lived, just a mile and a half away. Students have uniforms and you have to apply to get into the school, so discipline on the surface was seldom a problem. Now let's take a peek behind the scenes of "a surreal bus ride."

We have track meets in the middle of the week and travel by bus to the site of competition. With seventy on the track team we filled up two buses. Parents who support their kids usually take them home and the return ride is on one bus with about fifteen athletes. Going to the west side of town proved to be a different story in many unexpected ways. West Phoenix to me is like a foreign country. I seldom go there and often get lost. Listening to the news, the crimes reported always seem to take place in west Phoenix.

A track meet lasts about three and a half hours. Much of this time was spent sitting on metal bleachers. They did an excellent job of reflecting the Arizona sun. I survived the intensity of this oven-like heat by drinking copious amounts of water and watching kids in shorts run around an oval. Following our normal procedure upon arrival at the track meet we had released the second bus. Few parents had decided to travel the distance to the west side of town. At the end of the track meet I ambled down from the bleachers to the infield and the scorer's table. As usual it was three frustrated people surrounded by a chaos of event sheets, filling in columns, adding numbers and trying to find out who won the meet. Mary Jane, our faithful parents volunteer says she'll figure it out and give us a phone call.

The evening sky is turning grey and the stadium is empty as I walk to the bus. You don't want to leave anybody behind, so the coach is always the last person to get on the bus. The door is opened and I find the bus is full. It seems all fifty seven seats are occupied. There is one empty seat in the front and I tell Tom, our head coach to take it. I walk down the crowded aisle of noisy adolescents, hurdling knees, dodging elbows and find a seat in the rear of the bus. I sit next to Theresa, our top discus thrower. She is listening to her I-pad, so conversation is not an option. Even if it had been, I didn't want to compete with the noise level surrounding me.

There is laughter of a party in progress. It's the end of the track season. Energetic conversation produces a euphoric atmosphere. Two girls behind me sing songs. To a sixty four year old man it borders on chaos, but normal behavior for athletic teenagers. Then Tom's voice from a microphone changes the mood in the bus…"The driver says we are emitting smoke out the rear and we will be making an unscheduled stop to fix the problem. Those of you with cell phones who have contacted your parents to pick you up at school, please call them and tell them we will be delayed about fifteen minutes."

Our speed decreases and after a while we exit the safe, friendly freeway and enter south Phoenix. Not a good neighborhood to be in at night. Faith in our bus driver is not strong as earlier while taking us to the school in west Phoenix he had driven by the school and didn't realize his mistake for several blocks. The atmosphere in the bus has changed to one of fear and uncertainty. The air-conditioning has been turned off. We are hot, sweaty, and seem to be suffocating, trapped in a prison. We creep along side streets with abandoned warehouses. Just before stop signs, an ear piercing sound of screeching metal on metal increases our nervous tension as the driver applies brakes to our wounded vehicle.

What more torture awaits us? Young imaginative minds seize on possible dire consequences of horror

movies they have seen. A girl across the aisle from me shouts, "I don't want to die on a bus!" The lights have been turned off. Suddenly I look up and see two or three arms in the air waving their lit up cell phones. Others join in and it becomes electronic fire flies at night. The dark mood has lifted, we crawl into a huge bus barn and safety.

Entering the relief bus, there is a welcoming rush of cool air. This time I get to sit up front with my fellow coaches. As we pull into the safety of our campus there is a sense of urgency among many on the bus. With the door of the bus open, there is a stampede of young bodies with bursting bladders rushing off. Riding a bus shouldn't be comparable to the anxiety of flying in an airplane, but for me it is now on an equal footing.

Dobson High School

I got my job at Dobson High School because Gretchen Susan's workout trainer also coaches swimming at Dobson. She told me they needed a track coach and I applied. George, a longtime member of the coaching community, remembered me from previous seasons and hired me. I coached there for three years and could write another book about the people and the drama which surrounds high school and being an athlete. Instead I will focus on the highlight of the season, the state meet.

Kyle Brost, a junior, was our only athlete competing. When we arrived at the stadium it was packed. It was the gathering of the United Nations of Arizona. Everybody was there. Walking to the entrance you could tell by the buses in the parking lot: Nogales, Safford, Prescott, Yuma, Paradise Valley, Sedona Red Rock, and the list goes on.

Track is an oval with most everybody gathered around the finish line to watch an exciting close race. However, six of the seventeen events are contested on the field: two throws, the shot put and discus; and four jumps, the high jump, long jump, pole vault,

and the triple jump. Generally these events don't get much attention, yet at the state meet they did. The stadium was packed so Susan and I hung on a fence 200 meters from the finish line as the best place to watch Kyle compete in the triple jump.

With such a big extravaganza the state meet is held over three days. During the first day Kyle was in the long jump and the high jump. In the long jump he has a propensity for jumping beyond the takeoff board. Track terminology calls this a "scratch" and this is not a desired habit as your jump is not recorded and thus does not count. Of his three events, the long jump is not his strong suit. He scratched on all three of his attempts.

Kyle feels better about the high jump and in a field of 26 athletes he placed fourth. His leap and clearance of 6'4" earned him a spot on the podium, recognition from the announcer, and a medal. Looking ahead to the final day of the meet Kyle felt confident about the triple jump because he was ranked second in the event. However, lurking in the back of our minds was his inconsistency in his approach and the possibility of scratching.

A sign with moveable numbers posted the jump of each competitor for the audience. Kyle's parents stood right next to us to watch this drama unfold. Competitors get three jumps and then the field of 26 is narrowed down to 9 and they get three more jumps in "finals." Eight of the twenty six jumpers were entered with marks in the 44 foot range. Kyle and Conner Watson of Desert Vista were next with marks of 45 feet. Kyle's first jump brought shouts of joy from his parents as he soared 45'10", a personal best for him. Conner then jumped and scratched. Kyle then jumped 46'10" and 46'3". Conner did get a legal jump and entered finals, but his jumps didn't match Kyle's. A jump in the preliminary round carries over, so we were feeling pretty confident. Yet we knew somebody who had entered in the 44 foot area or Conner could "pop" one in the finals and put

Kyle's position in danger.

Kyle scratched on his first jump in finals. Nobody was coming close to Kyle's earlier mark so we relaxed a bit. He then rose to the occasion the state meet often provides and leaped 47'1". Seeing the mark posted on the board, his father jumped high in the air, but not as far as his son. For his sixth and final jump Kyle scratched, but by this time Conner and the rest of the competitors weren't close.

I did not see Kyle's final jump because Susan and I were walking fast to the finish line and the podium so I could take a picture of Dobson's state champion. Track indeed provides some rich experiences. Kyle is a junior and plays football. I hope and pray he doesn't break a leg and jeopardize his senior year in track.

Kyle's senior year

The state meet saw us finish in 13th place beating all Mesa schools, except Mountain View, which was only three points ahead of us in 11th place. I was a bit surprised we finished ahead of Red Mountain (17th) because in a dual meet they slaughtered us. Different factors are in play at state as you need a couple of premier athletes to score points. In a regular meet you need only good athletes and depth. Dobson has Kyle Brost and he is a superior jumper. Last year he won the triple jump and placed third in the high jump.

This year presented unique challenges, and dramatic suspense. Kyle jumped an inch farther than last year in the triple jump, but two other jumpers managed better marks. The high jump was easier for a spectator to watch. Instead of flying sand marking their jump, you had a bar that either remained on the standards or fell on the mat. Not only were Kyle's parents sitting next to me in the stands but his grandparents were also keenly watching Kyle and other jumpers. Johanna, his jump coach was allowed on the field. Opening height was 5'10 but Kyle passed until the bar reached 6'2. By this time many

of the 24 athletes had accumulated three misses and were out of the event. He missed on his first attempt but easily sailed over the bar on his second try.

With the bar at 6'6 four jumpers remained, Kyle being one of them. He is now guaranteed a medal and a spot on the podium in front of the huge crowd. Since he has fewer misses he might even be in first place. Two guys miss at this height but Kyle and a Desert Vista jumper clear it. Now the bar is set at 6'8, an inch above Kyle's personal best. On his second attempt Kyle clears it and we jump off our seats and scream with joy. On his third and last attempt the Desert Vista guy is also successful. The tension mounts. Now at 6'9 Kyle has the height on his second try but narrowly knocks the bar off. His third try is not even close as he twisted his ankle making the turn on his approach in the previous jump. Desert Vista is now up with his third and final attempt, if he misses Kyle is the state champion. He makes it. So Kyle is second, but he jumps personal bests in both the triple jump and high jump and in my mind is a true champion.

The thrill of coaching is similar to seeing your own children learn and grow. Their achievements become an extension of yourself and fill you with pride.

The Decathlon

It takes place a week after the state meet. One of the captains on our track team was Juba McClay. Research of Dobson history reveals that nobody has ever competed in the decathlon. This year we have four doing this daunting testing of ten athletic skills. It's a two day affair and at the end of the first day Juba is among the leaders. There are 56 boys in the competition. Joining Juba are Michael Chafin and Desmond Kumi. Taija Wilder joins ten others in the girl's portion.

Juba was impressive in the opening event, finishing fourth in the 100 meters. His specialty is the

Kyle in the high jump

I saw all four runners in the 400 but quickly left after the last one finished. Coming on Saturday it will be interesting to see where Juba is ranked in the standings. Juba is a senior while Mike is a sophomore and Desmond a junior. Desmond is frustrated as he is not doing better and Mike is gaining valuable experience. They both ran almost identical times in the 400. Taija looked good early in the race but ran out of gas at the end. I told her mother she really hadn't done much running in the last two weeks. You need an awful lot of practice to do well here.

The schedule of events at first glance is a bit confusing, even for a knowledgeable track coach. Each of the two days starts with a running event and ends with a running event, sandwiched in between are three field events. With such large numbers it helps that the host school has two high jump pits, two pole vault pits, two long jump pits, and two throwing rings (shot and discus).

Day two is long. It starts at 3:45 with the high hurdles and ends at 11:45 as the last runner finishes the 1500 meter run. The second day is not kind to Juba, he struggles with the discus and javelin, but bounces back in the pole vault, clearing a personal best of 9'6. Coach Farlow does a masterful job helping our three vaulters. Entering the final event Juba is in 11th place overall. He runs a determined race and finishes in 9th place (5, 211 points).

"The kiss of death" visits Desmond in the discus. He fouls on his first throw, stepping out of the ring incorrectly. On his second, he employs the spin and

long jump and here he finished first by one inch. You want to avoid the "kiss of death" not getting a mark in one of the ten events and therefore zero points. This happens if you throw out of the sector, scratch by going over the long jump board or fail to clear opening height. You get three tries in each field event except the high jump and pole vault, where you get more attempts as the bar is raised providing you clear the previous height.

The shot put saw Juba within the sector chalk marks with okay throws. In the high jump he cleared 5'10, a personal best. This mark puts him up with the leaders as only three people cleared 6 feet. The last event of the first day was the 400, an event well-tailored to his skills.

It's a long six hour day for spectators, coaches, and athletes. Because fatigue can be a factor, the rules stipulate a half hour break at the end of each event. Johanna, our jump coach competed in the multi events when she was in high school and college, so she was the "coach-in-charge". I helped time and coached Taija in the discus and pole vault.

Juba

Retired as Coach

I now volunteer to help out at track meets. This particular home meet at Dobson, it was judging a spear throwing contest. Little bit of history here, in ancient times a javelin was called a spear. It was a long-shafted weapon with a sharp point for thrusting or throwing. My first task was to call out the marks on the javelin efforts. Last year I was out in the field retrieving the spent javelins and putting

it goes out-of-bounds. For the pressure-packed third throw it narrowly lands outside the flagged area. Zero points for him. Others suffer a similar fate in different events and surprisingly the final standings place him 37 (3,908 points) out of 56 who started.

Mike has his sights set on the seldom-participated event as it appears only as an "exhibition" in track meets…the javelin. He breaks the school record. In the 1500 running in a separate heat from Juba, Mike betters Juba's time. Mike finishes 33rd (4,302 points). Taija has to jump behind the board in the long jump to avoid "the kiss of death" and is proud to finish the ten events.

- 100
- Long Jump
- Shot Put
- High Jump
- 400
- High Hurdles
- Discus
- Pole Vault
- Javelin
- 1500

Our four athletes did many things they have never done in track meets. It's a great accomplishment they'll cherish.

the tape where the javelin stuck on the field or on the divot they had made. The obvious danger made me and everybody else involved extra cautious. This year I convinced two others to this task so all I had to do was bend down at the take-off mark, read the numbers on the stretched tape measure and call off the mark to Johanna who wrote it down on her clip board. Finishing this event I then helped with hurdle movement, and then helped arranged the finishers of the mile in the correct order as they made their final sprint to the finish line. I then wandered over to the pole vault where Juba was. I coached him his junior year and now he is a sophomore in college. It was fun touching bases. Juba was a talented sprinter and jumper in high school. He is now in the decathlon, ten events. In high school he never pole vaulted, except in the decathlon, but now clears thirteen feet, a great accomplishment.

Later in the season there is another home track meet at Dobson. Arriving I help set the hurdles at the correct height for the girls and place them on the

THERE'S A RISK OF INJURY IN EVERY SPORT.

CORONADO CROSS COUNTRY

NIGHTMARE ON OAK STREET

Student art-work - Coronado High School is located on Oak Street in Scottsdale"

Running A Handicapped Race

The title sounds like it's for cripples, but it's not. Normally everybody starts a race at the same time. However, in this format you start at different times depending upon your age and sex. When you register you are given the time you are allowed to start this three mile race. It is based upon the national record for your age group. Nobody starts at the beginning and then after a few minutes old ladies and six year old children get to run. The last person who gets to run is a 27 year old male.

Fin	S	Age	Time	Hdcp	Net
1. Matt Pepak	M	23	29"08	13:50	15:18
2. Brent Pinder	M	58	29:11	9:43	19:28
3. David Archibald	M	54	29:18	10:52	18:26
4. Chuck Sorensen	M	55	29:43	10:29	19:14
5. Sandy Jensen	F	48	29:57	8:22	21:35
6. Gary Grierson	M	47	30:16	11:58	18:18
7. Bill Sayers	M	47	30:19	11:58	18:21
8. Roy Sinclair	M	52	30:21	11:03	19:18
9. Ross Dowland	M	43	30:46	12:39	18:07
10 Tom Ford	M	57	30:50	9:55	20:55

Final results of handicapped race

small yellow triangles on the track. Like last time I then work with the javelin. A throw of a hundred and fifty feet will automatically qualify you for the state meet. It's a mighty heave as most of the athletes have measured throws of sixty feet or so. Surprise, surprise Skyline has two athletes who manage beautiful form and technique and throw it in the magical area. I then join the timing crew and am assigned lane six. Half way through the meet the open 400 is run, a demanding race. Ivan is now a senior and I coached him when he was a freshman. It was fun seeing him take control of the race and heading down the final straight-away confidently in first place. While he wasn't in lane six, I glanced at my watch and saw 52 seconds, an impressive time. It was fun being "Coach" again even though I'm now retired.

The race was held at Papago Park and you ran along a canal. It's an out and back course so you are chasing those ahead of you and when you make the turn around you glance over your shoulder and see who is chasing you. Middle age men usually do fairly well with this format. Once I even won the race, taking first place, but have lost the race results. However, look at the chart for a race I did well in and you can see how the race is run.

Chapter 11: Minnesota and Illinois

With the end of track season, travel season opens up.

Minneapolis

Susan didn't want to go to Minneapolis. Our daughters weren't invited as the bride didn't want to invite her cousins and desired a small event. To travel a long way for just two days to an unappealing location didn't sit well with Susan. She called the city, "Minnehopeless".

I wanted to go because it was a rare opportunity for a family gathering. The last time my two brothers and sister and I had been together was eleven years ago at our mother's funeral. I prevailed.

Brother Bob was generous and paid for Richard and Beth's airline tickets. He also rented a house as a base of operations and was a fine host in countless ways. Friday's dinner was outside in a fine restaurant. It provided a relaxed setting to meet and get to know the bride's side of the family. In addition it's been awhile since we've seen Brian, his sister Emily; Ben, her husband, and their two young sons, Henry and Walter. They live on the east coast and we live on the west coast.

Good decisions continued Saturday with the site for the wedding. A balcony on the eighth floor of the Walker museum, with a dining area right next to it. Twenty one people were in attendance. We were not the only people who traveled a considerable distance with the following locations represented: San Diego, Sacramento, Phoenix, Colorado, Virginia, Washington D.C., and Boston.

The famous work of art in the museum was in the sculpture garden. It's a very large spoon (5, 800 pounds) with a cherry (1,200 pounds) at the tip where a fountain of water spurts out. There was construction in this area and this was one of the reasons we didn't see it. The other was why was it important art?

Clan Archibald: Richard, Beth, Bob, David

What's the significance or message to the viewer? I asked two people who worked in the museum and they couldn't give me an answer. Perhaps "google" can provide some thoughtful insight. It doesn't. Two weeks later at a party, Gail Shay's sister Gainer provided me with an answer I can live with. The spoon is commonplace, but with a cherry makes you think of an ice cream Sunday and pleasure.

One answer came from my good friend, Bruce Pierce, a native son of the north-star state. Thirty five years ago New York City coined the term, "The Big Apple" to describe their city. In response to this, the city fathers of Minneapolis sough a similar trademark calling themselves the Minni apple. Then the big spoon was given to the city. The tip of the spoon according to Bruce actually contains a crab apple, which often resembles a cherry. Susan is dubious of this explanation.

The major highlight of the festivities, in my mind, were three-year old Henry and eight-month old Walter. They were dressed in blue and white seersucker suits with blue bow-ties. Henry ran and pranced about, while Walter crawled. However, their mother Emily hit a profound high note when she gave a toast at the dinner. "My brother, Brian, received the nickname, 'stone-faced' in high school, as he never cracked a smile. I knew Ginger had won over his heart when in her presence he would laugh."

Chicago

An excellent travel planner, Susan prolonged our trip with a train ride to Chicago and a visit with Steve and Lindsy Castro. They were runners of mine at Coronado High School. We went to their wedding thirteen years ago. We haven't seen them since, but always get a Christmas card and recently an invitation to visit. They had moved from an apartment in a rough section of town to a house in a safe tree-lined street in North Chicago.

Like our visit to Minneapolis, our stay in Chicago was a reunion, but different in many ways. "We'll take you out to dinner, Sunday" said Susan. "Oh, no," said Lindsy, "Steve wants to cook for you." Little did we realize that Steve is a gourmet executive chef. Wow were we in for a treat, tender meat with thin noodles and a spicy tomato sauce.

Monday morning saw Steve off to work early at six and the three of us up at a leisurely eight thirty. Lindsey had taken off work to guide us on a tour of downtown Chicago. I drink coffee from a mug with The Beatles on it. Abbey Road album rests nearby on a bookshelf. Later I count five books on the subject. Lindsy and I share more than just the love of running. We both love the Beatles. When I taught world history I spent an entire day on them because they were so creative. History is more than just the study of presidents and wars, music is important.

The canyon of skyscrapers on the Chicago River cruise made the passengers in the boat crank their necks up at the ridiculously tall buildings. Being afraid of heights and avoiding taking express elevators to threatening heights, this was a good way for me to appreciate their beauty and the skill that went into their construction. The Chicago "bean" was a large orb of stainless steel and glass that gave amusing mirror images of the people looking at it and the surrounding skyline of tall buildings. This far surpasses the Minneapolis spoon. Continuing our tour we walked, took easy-friendly Uber, and the blue-line subway route.

I took a lot of pictures. Forty two survived my first edit. A sunny day and fascinating subjects caught my eye: a stunning TV anchorwoman surrounded by a camera man and another holding an umbrella; of course from different angles, the many tall buildings; a man dressed as a gorilla jumping up and down lip-synching "La Bamba" did not survive the editing process as I couldn't get him in focus. Then in a crowded subway to snap a picture of four

young women in animated conversation just didn't seem possible without appearing to be some kind of pervert. You miss out on some but several pictures from Monday are very good and possibly one will get enlarged and displayed as art on our wall back home.

How do you travel in big foreign city without a car? In Minneapolis we took the light rail, a taxi, and walked. Yes, Minneapolis is in the United States, but for us it was different and unknown. It's on the Mississippi River, but I was never close enough to get a decent picture of it. Figuring out which light

The Bean: Its official name is Cloud Gate and it is a public sculpture by Indian-born British artist Sir Anish Kapoor. It is the centerpiece of AT&T Plaza at Millennium Park in the Loop community area of Chicago. The sculpture and AT&T Plaza are located on top of Park Grill, between the Chase Promenade and McCormick Tribune Plaza & Ice Rink. Constructed between 2004 and 2006, the sculpture is nicknamed The Bean because of its shape, a name Kapoor initially disliked, but later grew fond of. Made up of 168 stainless steel plates welded together, its highly polished exterior has no visible seams. **The Bean** measures 33 by 66 by 42 feet, and weighs 110 tons.

rail stop would put us close to our hotel saw us talk to a local who guided us in the right direction. The taxi ride to the "get acquainted" dinner saw us put faith in a driver who was a recent immigrant from West Africa. It caused a few anxious moments but turned out all right. The next day the hotel clerk gave us good directions for our mile walk to the wedding location, the Walker museum. It was a very agreeable sunny day and strolling along in green Loring Park in no particular hurry was very enjoyable.

In Chicago I felt like royalty when we used Uber, it was so practical and easy. A car arrived in five minutes or so, no money changed hands as the ride was charged to Lindsy's account, and we had entertaining conversations with the drivers: a Pakistani, two Mexicans, and two native to Chicago.

We rode in comfort and the drivers, using GPS knew where they were going as we did not, relying on our trusted guide Lindsy. The stress and tension of trying to make sense of a strange city to us was gratefully absent and we enjoyed the passing scenery in style befitting a king.

Our trip back east was significant in that it provided us with beautiful, scenic, new environments: Minneapolis and Chicago. It also allowed us to touch base with people we don't normally see, our biological family, and the friendship with former athletes.

Chapter 12: Colorado

If San Diego is our second home, Colorado is our third.

Glenwood Springs

My uncle Rich would see a cruise ship as torture. He and his wife Jean, do not like to be part of crowds, prefer making decisions on their own, and avoid regulated excursions. They live in Colorado and starting in 1978 we have visited regularly. We have house-sat for them several times when they go on their international adventures. They live in the country, an area called Missouri Heights, overlooking the Roaring Fork Valley and Mount Sopris. This is in a forty mile corridor between Glenwood Springs and Aspen.

To get to this paradise you have two choices, drive up the eastern edge of Utah to Colorado or up the western edge of New Mexico. Both routes are approximately 700 miles which sees us break it up by staying overnight at the half-way point and making it a comfortable two-day drive. The New Mexico route is 45 miles shorter.

When we have not house-sat for them we've rented a house in Glenwood Springs for a month or two (elevation 5,763). 910 Pitkin Ave is on a tree-lined street where most of the houses have porches. It was built in 1887 and is only one block from the main drag of the downtown area. Edwin S. Hughes and his wife Helen built the house. He had a successful retail and wholesale liquor business. Edwin also bottled and sold Yampah Springs water as a cure for almost every ailment.

Carolyn Kauffman owns the house now, and it is amusing to read our comments in her guest book.

July-August 2010 *Awesome…we loved eating outside and reading in the cool shade of the lush garden. Easy walking distance to the joys of the town was great. I made thirty-three trips to the pool. Friendly neighbors.*

August 30th 2011 *Our second residency. Love the yard, reading and entertaining outside. Because of the location so many activities, really feel like a resident of Glenwood Springs. Carolyn you are an outstanding landlady and it's a joy to be a part of your life.*

July 30th 2012 *This is our 3rd summer. We love your house, beautiful garden, the neighbors we've met and the small town character of Glenwood.*

The house is an easy walk to a bridge over the Colorado River to Glenwood Hot Springs." Measuring 405 feet long this is the world's largest known outdoor thermal pool. The pool's mineral-rich waters come from Yampah Springs, once considered sacred by the Ute Indians (Yampah means "big medicine") It contains a children's pool, lap lanes, a diving board and two water-slides. A smaller therapy pool is maintained at 104 degrees.

A popular hike ten miles east of Glenwood Springs is Hanging Lake. It is so popular in the summer you need a reservation to make the 1.7 mile hike.

We've had several friends visit us in Glenwood: Chip & Gail of the book club; Joe & Marcia and Jared & Melia who are fellow teachers; and my brother Bob

910 Pitcan Ave, Glenwood Springs

their spirit of adventure they traveled to Vietnam. Here they got separated riding bicycles, his wife got hit by a scooter and she was killed. Not wanting to be alone, some months later he met Kay who was working out at South Mountain Park in Phoenix. She's a former nun and triathlon athlete. They married and visited us in Glenwood.

During their visit to Glenwood we took them to a concert in Aspen. On the drive home I saw

and his wife Nancy. It was during Bob's visit, he and I climbed Mount Sopris, the dominant feature of the Roaring Fork Valley. However, the most fascinating couple to visit us in Glenwood were Lyle and Kay.

I first met Lyle when I went to Colorado to run the Pikes Peak Ascent. He's lead an interesting life. At age fifty he decided to run a marathon in all fifty states. There's a club for this which he joined and achieved this unusual goal. He and his first wife were world travelers and Lyle has shown me a list of the numerous subways they have traveled on. After thirty years of marriage his wife got sick. Visiting her in the hospital for a month he met another couple in the same circumstances, but for them it was the husband dying. When their spouses died Lyle and the woman who had become friends during this ordeal decided to marry. Their children and grandchildren protested. So Lyle made a list of the things they had in common: both had 401K's, both liked strawberries, both had been to Russia, but were not communists, and so on. The protest disappeared and they married. True to

a bundle of fur racing across the road ahead. Going fifty miles an hour, anticipating a collision I quickly decided not to slam on the brakes thinking this would cause a tragic accident, instead swerved slightly and felt a small shock to the car. Still in control I saw a wide space up ahead and pulled off to inspect the damage. Another car which had been behind me also pulled over. The guy excitedly jumped out and shouted, "I saw the whole thing and the bear is okay." I thought this a bit strange and examined our car, which had a hardly noticeable small dent in the left rear panel. Years later when we sold the car, the salesman noticed the small dent and asked us about it. We replied, "We were hit by a bear!"

Unfortunately the owner of the house in Glenwood, found somebody who would rent it for the entire year, thus leaving the Archibalds who would only rent for the summer out of luck. We of course were saved because we could always house sit for the Leety's.

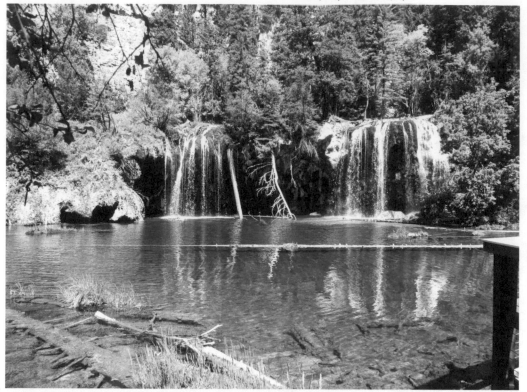

Hanging Lake

Leety House

Sitting at an elevation of 7,300 feet, the Leety location is awesome, commanding a view I never get tired of looking at. The fresh air gives clarity and stillness. Nature is in sharp focus. Colors are mesmerizing: a mixture of greens, blues, greys, browns, with hints of yellow. Looking out the living room window the view is framed by aspen trees. It gives me a wonderful feeling of distance and space. You see a few houses but it's basically fields sloping downward stretching out forever. Peace and serenity prevail.

Driving to the Roaring Fork Valley and Glenwood sees us stopping halfway at different places: Bluff or Moab Utah; Gallup New Mexico; and Durango Colorado. Another stop is just north of Cortez Colorado at friends Dave and Sharon Erb's house which sits just above the West Fork of the Dolores River.

The small valley of the West Fork sits at an elevation of 8,200 and boasts an exclusive resort, Dutton. Lodging at this pristine location runs 400 dollars a night. Five buildings with rusted brownish metal roofs are clustered together reminding one that it used to be a mining camp in the 19th century. Famous outlaws Butch Cassidy and the Sundance Kid stopped there for fresh horses after robbing the bank at Telluride. It was briefly a nudist camp in the 20th century. Cristal, a German CEO billionaire, now owns Dutton. He is very environmentally conscientious and strives diligently to retain the mystic charm in this mountain valley. We, of course, did not stay at the resort and partake a dip in the hot springs. Dave and Sharon's house and gracious hospitality were enough for us. But taking a peek at the surrounding neighborhood was enlightening.

People in Colorado love dogs and enjoy cycling. I often joke about a border crossing into the state where you are asked if you have a dog or a bike. If the answer is no, you are turned away. At the Redstone art show before you entered the white tented area, off to the side on the grass was an area, with a sign that read, "Dog Parking ." A silver rod was stuck into the grass with an attached leash for you to secure your dog. A bowl of water was nearby to keep him happy. Going to the Maroon Bells, ten miles outside of Aspen, there were more bicyclists on the road than there were cars. The winding-narrow road presented a challenge. To pass the bicyclists and give them a wide berth you had make sure you did not get hit by an oncoming car. I managed to get into the swing of things successfully, kept a keen eye on any oncoming

vehicular traffic, and at the same time gave the bike riders plenty of space.

Living in Rich and Jean's house was wonderful. The view from their house is overwhelming. I've already mentioned it, but more needs to be said because it was the dominant theme of our Colorado vacation. Imagine looking out a low flying airplane at the scenery below, that's how we felt looking down at the landscape of the Roaring Fork Valley, green fields with a smattering of trees and an occasional house. We're up high enough to be level with clouds we see on the other side of the valley. The houses seem small, resembling those you find in the game of Monopoly. The distant blue- grey mountains are overpowering. The Leety house is surrounded by shimmering aspen leaves that make their own special music when the wind blows. Most of the time there is silence and privacy which gave us a unique sense of freedom.

Those who grew up and live in the city will never see the stars as clear as we saw them. At nine o'clock in the evening we would often sit in their Jacuzzi on the lower wooden deck. Its pitch black outside. Warm water envelops us and pulsating jets massage our backs. We look up and are assaulted by a brilliant array of tiny white lights. I felt surprised as if receiving a gift. Everywhere you looked, the sky was full of stars, filling me with a profound sense of reverence.

"Growing up in Brooklyn we didn't have deer on our front lawn," Susan comments to me one morning. She is excited about this event and so is our dog Luckie as she barks at these bigger four leg creatures she has not seen before. With her I-Pad Susan takes a good number of pictures to capture this. The deer visit almost every day. I have a more laid back attitude growing up in the west, telling Susan I already have several good pictures of the deer. Still, it is a neat feature of living in the Leety house out in the country.

It's September 12th and my camera awaits the riot of color, fall leaves becoming golden yellow and bright red. I have tons of Colorado pictures in the summer from previous visits, but none in the fall. One of my pleasures in life is taking pictures, but here I have to restrain myself, be patient and wait for nature to take its course. Fortunately other subjects present themselves as this area of Colorado is a photographer's paradise. The early morning light and the setting sun present awesome shots from the Leety house looking down at the valley and the sloping distant mountains. Still, I look forward to the leaves, hopefully they will turn before we go back to Phoenix at the end of the month.

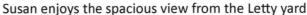

Susan enjoys the spacious view from the Letty yard

101

A special Colorado event was the National Sheepdog Trials held at a ranch just two miles from the Leety home. What made this enjoyable was the uniqueness of the event for us, and talking to Bill Wilder one of the handlers. I had met Bill on one of my bicycle jaunts a day before the trials started. Now a third day into the trials it was fun to renew our relationship. Bill and I had a good deal in common because we were both coaches. Yet Bill was able to tell me about two areas of his life that I found fascinating.

Bill was a talented volleyball player who subsequently became a high school coach of the sport. My sport, track, and his have the vertical leap in common. In track it's the long and high jump where leg explosion is critical and for volleyball, the players need to be able to leap as high as the net to spike the ball. We discussed this common overlapping ground and more, before moving onto his current job and his hobby.

Geese can be a problem for golf courses as they daily poop two pounds of unwanted waste. Bill has contracts with eight courses where he patrols on the courses with his dogs to scare away the geese and their potential land mines. Of course he has to keep a sharp eye on the players to timely release his dogs to chase the geese without interrupting play. Somebody once told me golf is not a sport because players are allowed to smoke and drink.

I know a little bit about golf but was a complete novice when it came to the sheepdog trials. It was so much fun having a color commentator standing right next to me explaining the competition. There are five sheep, a dog and his handler on a wide open field. The dog has to herd the sheep through four gates and then into a closed pen. The handler stands off to the side and communicates with his dog with a high pitched whistle and when the sheep and dog are closer with verbal commands. There is a fifteen minute time limit in which this has to be done and the

dog cannot touch or bite the sheep. The sheep see the dog as a predator and this fear factor usually allows the dog to move the sheep in the right direction. However, every once in a while the sheep rise up and challenge the dog. This turns into a staring contest which is fascinating to watch.

Like any sporting event, knowing the basics is one thing, but understanding the subtleties of it are something else. It was fun listening to Bill explain the finer points of strategy and get an insider's view. Judges score the contest between sheep and dog and Bill told me some of the little things they look for. Bill and his dog, Russell, competed earlier in the trials and did not advance to this, the semifinals. Meeting Bill and the ease with which we talked was one of the highlights of the Colorado trip.

Our dog, Luckie, does not have a pedigree like the border collies who competed in the trials. She is a mutt. Instead of chasing sheep, Luckie is a "chick magnet". Because she's beautiful, attracting the attention of other people is effortless. I guess this speaks volumes about inter-racial breeding. In addition to her golden coat, Luckie is friendly. She doesn't bark or bite. We receive comments on her demeanor and her flirtatious eyes. Luckie responds to three commands: "Car" "Cookie" and "Stop". Susan and I are working on teaching her a fourth command, "Come" but so far are having little luck. Luckie is indeed a smart, independent character, but not ready for the sheep dog trials.

On the mountain we were alone and felt isolated. Four miles of meandering roads exist until we reach the highway. It's another four miles until we reach the town of Carbondale. It's peaceful having such privacy. However, towards the end of our stay we had two dinners in a row. Friday we joined Michelle and Roger, former Peace Corps workers, who, like us, are avid travelers. Saturday it was David and Roz Leety. David is a distant cousin and Roz is part of a hiking group Susan belonged to when we were here

three summers in a row.

We met Michelle and Roger at an Indian restaurant in Carbondale. She is a teacher (empowerment coach and communication consultant) and he is an accountant. They are fun to talk to, as like us they had recently visited Ireland. When I mentioned how I was going to celebrate my upcoming seventieth birthday in January, Michelle asked me what the date was. I told her the 28th and she excitedly blurted out, "Oh my gosh, mine is the 29th!" Of course she is younger than me and will only be forty-seven. The next day we met them in Glenwood Springs for, "Rally the Valley". Michelle and Roger are both Rotarians and this service club sponsored the fund raiser for a local hospital. The event was a four mile walk. We took Luckie with us on the sunny day and did half of the walk, resting at the first water stop and talking to an Irishman who had lived in Argentina until his late twenties.

That evening we had dinner at David and Roz's beautiful house overlooking the Roaring Fork River. Roz served stuffed Cornish game hen, an excellent meal. David shares my interest in family history and we discussed a 1937 photograph of nineteen Leety members. I need to warn you, the twisting trail of genealogy, like the Aspen ski slopes, can throw you off course. Our grandfathers were brothers. David's father, John, born in 1910, was the son of Harry. Harry's brother Ralph, was the father of my mother Marcia, born in 1914. David told me his father and my mother being close in age were good friends growing up. David is eight years older than me and was able to identify fifteen of the nineteen people in the photograph. I hope you didn't crash into a family tree.

Rich Leety, for whom we are house sitting, is my mother's younger brother, and is two years older than David Leety. So, I was surprised David Leety identified himself as being in the picture at the age of two, yet Rich Leety being older was not in the picture. If alive, more relatives in the Leety clan need to be consulted. In fairness to David Leety, he said he's seen pictures of himself at an early age and thus recognizes himself as a two year old in the picture. History is not an easy subject, somewhat a mystery the further you look back in time, and fun to search for answers. People's memories are not always accurate.

Neighbor Dave Briscow who lives across the street came over to borrow a vacuum cleaner. He has just started a new job, relief for Haitian orphans. A wealthy woman from Aspen has been doing this for some time and she is excited about this noble venture. This was the first contact we had with somebody in the neighborhood. On the other hand, our curious Luckie has been visited several times by neighboring dogs.

One morning, Susan asked me, "What are we going to do today?" This implied to me we might drive someplace. I replied, "We don't have to go anywhere, the show is here." It had rained early in the morning and shifting clouds and peak-a-boo sunlight dominated the lush landscape. She looked at me and nodded her head in agreement.

- **Dark Star Safari, Overland from Cairo to Cape Town by Paul Theroux**
- **Passionate Nomad, The Life of Freya Stark by Jane Fletcher Geniesse**

Above are two books that entertained me when I was outside viewing the mountains. I'd read a bit, then look up and enjoy the view and get recharged as to where I was, reemerging into exciting tales of overseas travel. This was very relaxing. I'm realizing the dream of every over-worked teacher who never got to read for leisure.

There is travel and then there is living in one place for a month or so. Both are different. For one you live out of a suitcase and are on the move almost every day. You are greeted with something new, and at the end of the day there is a sense of exhaustion.

The other sees you settling in and living like the locals, getting a perspective that allows you to think about the place you are visiting and how it compares to your home.

Now we are on the way home. Thunder cracks outside, but we have found refugee and are safe and cozy at Ken and Sharon Middleton's cabin in Heber, Arizona (north of more well-known Payson.) Susan was stretched out on the sofa, exhausted from our long drive from the Leety house in Colorado.

Our drive homeward was a dramatic adventure with varied landscapes. We had traversed the western edge of Colorado. The beginning of our trip was the safe yet scenic interstate highway alongside the famous Colorado River. Our route then dramatically shifted to a smaller road and we entered a valley with huge silver grey mountains, in my imagination Yosemite. Later we entered another valley with high red rock and a small stream. The theme of red continued, but in a different hue of color and shape as we drove the eastern edge of Arizona and the Navajo reservation. We made the eleven hour drive, in seven shifts, alternating at the wheel. Towards the end of the long day we needed rock n roll music to maintain our concentration on the road and traffic. Rain added to our fatigue while the windshield wipers seemed to keep time with Patsy Cline and then the Beatles. We safely arrived in the Middleton cabin. It was indeed restful to hear the sound of water on the roof and know that our ride tomorrow would be a much easier one, a shorter distance, one we can easily manage.

It's good to visit and get a different view of life. It's also comforting to come home to the familiar.

Another Colorado visit

Exiting the freeway at Glenwood Springs we take Route 82 to Carbondale. A couple of miles later we hit the light at Catherine's store and head up the hill to Missouri Heights and the Leety house, elevation 7,300 feet.

Rich and Jean travel the world. Before retirement he taught world history. They are presently in Alaska for I believe the first time. They have never been to Hawaii. They had said they will go when they are old. He's 81 and she's 78 so while the majority of us think this is old, to them it's not. They have been to Africa twelve times and plan next January a trip to Ethiopia. What's the fascination? Perhaps the answer can be found in a book I'm reading, "Walking the Nile" by Levison Wood. It's from Rich's library and he highly recommended it.

Sunday we spend a day in Aspen, which is only 30 minutes away. It's a wonderful walkable town with a lot to see. We're going to the outdoor classical music performance at four o'clock. We've been before with Rich and Jean and it's a laid-back experience. Before the concert we have brunch where our dog Luckie can sit outside with us as we eat. We find a small crowded restaurant and with not too long a wait, a table becomes available. The eggs benedict with crab meat was superb. With time to kill we window shop and sit on a bench and watch the passing crowd, very relaxing.

Finding a good parking spot at the concert site so you can avoid the rush afterwards means you have to arrive early. The site is a huge white rounded dome building surrounded by lush green grass and aspen trees. The tall structure has very large open slats so those outside can hear the music. Those inside pay, those outside sit on lawn chairs, sip wine, eat cheese, read a book or newspaper and listen to the music. It became very crowded and I counted fourteen very obedient dogs sitting by their masters.

Before the four o'clock show we walked in on a special percussion performance. Drums of all sorts were at different locations outside. A moderate crowd stood and sat in silence to hear the sound of a tiny cymbal, very impressive.

The four o'clock performance with a full orchestra was excellent. I so enjoyed the demeanor

of everybody. So many people jammed together and they cooperated with silence. This is in marked contrast with crowds at sporting events. But to be fair it's something vastly different.

Intermission offers a time for people to talk. Most everybody knows their neighbors. These concerts have been a mainstay in Aspen culture since 1950. The gentleman sitting next to me was interesting. His grandfather ran the Hotel Jerome in the early part of the twentieth century. This is an iconic building in Aspen. His father then took over from his grandfather. The man I talked to lived there until he was seven years old. Now in his seventies he takes care of houses for those who are only part time residents in Aspen.

Life is not perfect and I messed up. My driver's license expired and I was unaware of this fact. Trying to buy marijuana, which is legal in Colorado and I was asked to show some ID. I displayed my driver's license. "Sorry, not valid, it expired in 2015" said the salesperson. "But you can see that's a picture of me?" I replied. "We have to go by the letter of the law" he countered. The clerk would not budge and I sadly left the store wondering, do I look like a narc? Are they thinking I'm some federal agent checking up on them?

Early Monday morning we awoke with thunder, lightning and rain. We were startled the lightning was so close to the house. Luckie was more than startled, she was frightened. Today we stay inside and watch the Olympics. They are held in the beautiful city of Rio. This city in Brazil has some compelling landscape of sheer mountain cliffs set among beaches and the ocean.

Jeff Farlow is coming today. We'll pick him up at the Shell station at Catherine's store. It's a bit confusing to give directions up the hill and necessary turns on the roads with three different street names. He's never been to Colorado before so this will be a treat for him. Jeff is a Coronado alumni. I coached him in the pole vault in 1983 and got him a job coaching this event at both Seton and Dobson.

Thursday, Jeff's third day is Tri-City as we visit Carbondale, Redstone and Glenwood Springs. These towns close to us in Missouri Heights are more down to earth than the affluent ski-resort of Aspen. Visiting a hot spring on the edge of the Crystal River we see a number of cars parked on the side of the road. Looking down at the river and rocks laid out in a circle to capture the hot water there are lots of people down there. Jeff navigates the steep cliff and goes to investigate. Then Susan and I smell a distinctive aroma wafting up. Upon his return Jeff confirms it, marijuana.

Sunday is another day watching the Olympics. The coverage is excellent with keen insight of commentators, human interest stories and showing the joy of the athletes. This seems contagious and inspires such a positive outlook. Perhaps it will bring the people of the world closer together.

For two days the car does not move, we just enjoy where we are. Then we break up our solitude and go out to dinner in Carbondale. Driving home at nine o'clock at night, its pitch black. There are no street lamps on this twisting mountain road. Fortunately the road is well known to me in the daylight, yet it requires my utmost concentration at night.

We broke up the ride home. Two hundred and fifty two miles and six hours to Dolores and the Erb's cabin at 8,200 elevation. Dave and Sharon Erb invite their neighbors Jerry and Cricket over to share dinner with us. They were both principals of schools in Tucson. Jerry was a body builder and competed in the Mr. Arizona contest. Cricket is writing her fourth book. They made for lively company that evening.

The next day four hundred and sixty miles and eight hours home via, Shiprock New Mexico, and Payson. I edit my 75 pictures down to 50. In addition to the pictures, we also came home with Colorado peaches and corn.

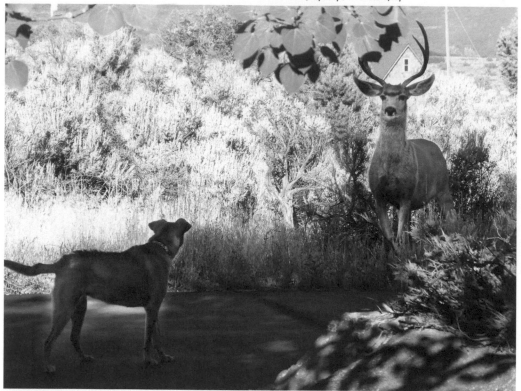
Luckie in a stand-off

Forest Fire

"We've been evicted." Jean Leety tells us. We've been planning on visiting her and Rich in Colorado. In addition to San Diego, we feel like this is our second home. The cool mountains beckon us from the furnace heat of central Arizona. Forest fires had forced Rich and Jean to leave their house. A more appropriate term would be "evacuated." Patience prevailed and five days later the situation was minimally under control, they're back in their house and our jaunt to Missouri Heights above Carbondale, Colorado is underway.

We break up the long drive by staying at Ken and Sharon's in Heber Arizona. Then it's on to the Indian Reservations in north-eastern Arizona and up the eastern edge of Utah. Gotta drive beyond Bluff, perhaps staying at Blanding or Monticello or depending upon our endurance pushing it onto Moab. Then up to the interstate, Grand Junction in Colorado and alongside the Colorado River to Glenwood Springs and we're an easy thirty minutes away from Rich and Jean's in Missouri Heights. We're there

to enjoy their wonderful company and celebrate Jean's 80th birthday.

Mileage is 147 to Heber Arizona; 371 to Moab Utah and 225 to Missouri Heights. The elevation there is 7,300 overlooking the Roaring Fork Valley and situated between the town of Glenwood Springs and Aspen. The temperature is very comfortable in the seventies. At the end of our long day's drive to Moab we stayed in a nice motel where I had a relaxing swim, drank some wine reading a book while Susan napped, and later walked to a nearby barbeque restaurant. It was a most enjoyable way to finish a day on the road.

Fire, how do you describe it? A threat to life and property. Unpredictable as to the direction it takes and where is it safe? We watch from the steps of Rich and Jean's house. Five miles away are puffs of dangerous smoke on Basalt Mountain. July 3 to the 21st and the fire continues. Ten yards away we watch a deer briefly stare at us, and then scamper off. Binoculars aid us watching helicopters dump their supply of water vainly in an attempt to put out the fire and the rising smoke. Are we safe? Yes as long as the wind which fuels the fire blows in the right direction away from us. The solution, a heavy rain for an hour or so will do so much more than two helicopters. Who knows what will happen. Rich says it could go on for a month and the area of Basalt Mountain contains no homes. He doesn't seem worried.

To escape the drama of the fire we go to Aspen for theater. First it's the rock musical, "Godspell"

and the next day, a comic opera, "The Barber of Seville". Both were enjoyable, uninterrupted entertainment without commercials which drive me crazy on TV.

It was at the opera I met Rauol during intermission. I enjoy meeting strangers, and perhaps this sets me off from a majority of people. His son was playing one of the leads, the suitor who wore different disguises. After comfortable discourse we exchanged jokes about food. Mine is about a honeymoon diet, "lettuce alone, no dressing." His involved a girlfriend meeting her boyfriend who was a produce manager at a grocery store, " I cantaloupe with you tonight, my celery is too low."

To give Rich and Jean a break we spent two days at Steamboat Springs. Curvy roads and through small towns saw 135 miles to Steamboat pass by in a relaxed charming manner. At varying speeds this took two and a half hours. Susan had done her research and we settled into the Steamboat Grand. It's a very impressive ski lodge in an area called Mountain Village two miles from the city. We very much enjoyed the massive swimming pool.

Fish Creek Falls, Colorado

"Pay it forward" was the word of a hiker who gave me five dollars for our parking permit at Fish Creek Falls. A plastic credit card was of no use and we had only a twenty dollar bill. I was so impressed with the generosity. After a short walk among pleasant greenery on the overlook trail we were rewarded with a majestic view of the long white water of the distant plunging waterfall surrounded by giant trees. I took several pictures.

Our trip had some symmetry to it. In ten days we slept in four states: Heber Arizona; Moab Utah; Missouri Heights & Steamboat Springs Colorado; and Gallup New Mexico. We drove roughly 700 miles to Missouri Heights. Going there was along the eastern edge of Utah and returning home along the western edge of New Mexico. The New Mexico route was 45 miles shorter.

Our last night in Heber saw us sitting on their back porch with wine and cheese and witnessing rolling thunder, frightening lightning strikes, all combined with refreshing rain. Ken and Sharon's son Mike entertained us with stories of being a chef in Hawaii for four years. His specialty is Italian dishes.

The final leg of the trip saw us reacquainting ourselves with our beloved saguaro cactus as we descended into the Phoenix metropolitan area. It's nice to visit but oh so comfortable to be home.

Chapter 13: Mexico

Xcalak, an isolated part of the world

Xcalak

Very few people know about the little fishing village of Xcalak, Mexico. My uncle Rich and aunt Jean share our love of travel, yet we'd never made a trip together. This changed when they convinced us to share their love of this part of Mexico. The village has a population of two hundred. Dirt roads with pot holes dot the landscape taking you back in time. They have as many scooters as there are cars. To get there we flew into Cancun, often called the Mexican Riviera. This is in south east Mexico on the Yucatan peninsula. Tis the hot spot for young people and cruise lines. We then took a five hour ride south to Xacalak, which is just five kilometers from the border of Belize.

What do you mean when you say something is rustic? Primitive or uncivilized perhaps. In this part of the world Susan defined the word as a place without television. Well, we did have indoor plumbing and electricity. For me, it means at cocktail hour I drink my wine in a paper cup instead of a wine glass.

If you want to put a more positive spin on the subject you might say a rustic place is pristine, calling attention to the glory of nature. In this humid location, mosquitoes become our closest companions. On the edge of town is the resort Costa de Cocos and this is where we stayed. Here you see the stunning beauty of coconut and palm trees, a white sand beach and the constantly changing color of the ocean… differing shades of blue.

What is commonplace here, in Phoenix is exotic. At the base of the lighthouse in town was a pile of about fifteen conch shells, apparently just abandoned. Back home they would probably sell for ten dollars apiece. The town has two bars and one restaurant. People appear content. Dogs are laid back and in one yard we saw a raccoon tied up. I saw two young boys walking down the dirt road and

Jean and Rich Leety

the older boy had his arm around the shoulder of the younger one.

Costa de Cocos is a collection of sixteen huts and one central structure. That building served as a bar/restaurant and headquarters. The huts are octagons with palm tree roofs. There is no air conditioning in keeping with the rustic charm of the place but they do have ceiling fans. It fulfills the basic need for shelter. They serve very good food: pancakes and fruit

The pier and a fast approaching storm

for breakfast; fish tacos for lunch; and for dinner we almost always choose fish. How often are you going to get lobster on your pizza? The dinner was always a four course meal and included an interesting soup.

In addition to the overwhelming tropical beauty there is the friendly low-keyed atmosphere of the people. This place does not attract your average person. Serious fly fishermen come here to enjoy their passion. There is no loud blaring music coming from the huts. Instead you find people lying on beach chairs reading a favorite book. Occasionally they glance up at the brilliant colors of the ocean. They are taking a break from their morning of fly fishing on the flats or snorkeling around the reefs.

Pescado is Spanish for fish. "Forty feet, eleven o'clock, strip, strip (pull line in); cast again thirty feet, ten o'clock" says Fernando, the guide. We're fishing for tarpon in a large lagoon. We are not deep sea fishing but rather hunting for marine life in the flats. Besides having good instincts and keen eyesight, our guide Fernando is also a gondolier, polling us along the shallow water. A huge coral reef a half-mile out

protected us from the pounding surf. To get to our location we had skipped along with the motor at full throttle. The entrance to the lagoon was through a maze of mangrove. Every once in a while you had to duck under a protruding limb of leafy green. I felt like I was in a movie.

Fishing requires an infinite amount of patience. It's also calm and peaceful. Rich is the fisherman, and I am just a photojournalist. There are long periods of searching for signs of fish. When sighted there are a few whipping sounds of Rich's line moving in long arcs from his tall rod. This happens a number of times until there is some serious action… a quick flash of white amid the water and carefully the prize is hauled in. Two fish manage to escape, but Rich does set the hook well on two others. Tarpon are not good eating so it's catch and release. The same is true for the eight bone fish Rich caught. I do, however, have a nice picture of a twenty inch silver fish and a grinning Rich.

After fishing in the lagoon we change locations and seek the elusive permit fish. The sun beats down

on us, intensified by the reflection of endless water. At times it feels like we are baking in an oven. With long sleeve shirts and hats which cover not only our heads but also necks and ears, we are well protected from the elements. A good pair of sunglasses shades our eyes. A hypnotic atmosphere develops for our seemingly fruitless search. Then, sixty feet away, at nine o'clock, we see several fins break the surface. There is calm water; steady polling by Fernando; a moving school of permit fish; and desperate casts from a tired Rich. This resembles a tense dramatic dance. At times we seem close to them, but find ourselves tantalizing beyond a good cast of them. Often such is the fate of fisherman. There are countless stories of the one that got away.

A day later, I again go out with Rich. After three hours of stalking the slippery creatures we catch a 27 inch barracuda. There was no catch and release this time. That night we ate him.

It seems you are always in for a surprise when you travel and meet different people. Two French couples didn't say much, but they did smile when we waved at them. A Swedish couple saw the man out fishing all day while his wife Margaret read a book on a lounge chair. I thought we'd gotten to know her pretty well after a couple of days. But I was wrong. When I askeda her how she met her husband, Margaret said, "Oh you Americans hardly know anybody and you ask such personal questions." One evening at the bar a young couple sat next to us and the man was rapidly speaking Spanish to the bartender. Turns out he was from Spain and his beautiful girl friend was from Brazil. I politely inquired if I could take their picture and they agreed. I showed it to them on my digital camera and before my aunt Jean and I had finished our first beer, another appeared beside it. We looked at the bartender and he nodded to the Spaniard who had bought us a free round. I was touched and in my limited halting Spanish thanked him.

I went snorkeling a few times. However, it did not compare with a previous vacation on the island of Bora Bora. The colors of the coral and variety of the fish there were amazing there. A big part of any vacation is the people you share it. This trip to Xcalak was unique because of Rich and Jean. Susan and I admire them so much. Being in this isolated part of the world where they go so often was indeed very special.

Our guide displays a barracuda that Rich had caught

Chapter 14: Advice

What is the difference between a traveler and a tourist?

Traveler or Tourist

Driving to Prescott, we got delayed with a huge traffic jam on the 101, finally unclogged from the mass of cars Susan says to me, "I'm hungry, so we can either stop at Rock Springs or McDonalds at Cordes Junction." I replied, "Well one's a traveler stop and the other is a tourist destination" We chose Rock Springs and ordered two-gun chili and a take home pie for our friends in Prescott. A big mac at McDonalds would have been a tourist stop. Depending on the circumstances we're a bit of both when we go overseas. We try to take the high road of being a traveler but there are times we cross the line and are tourists.

To differentiate between a traveler and a tourist I will touch on the following areas: clothes you wear; how you speak; what you eat; picture taking; and pick-pockets.

How do you dress? A tourists will wear shorts where almost nobody in the land he is visiting will be seen with bare legs. A loud Hawaiian shirt is optional. A traveler will attempt to blend in. In Ireland as a traveler I wore a plain brown jacket and one of their distinctive cloth caps.

How do your talk? The tourists says, "I thought everybody speaks English." The traveler tries to learn a few words to show he cares about their culture. "Bon dee ah" Portuguese for hello. "Nas tro via" is a Russian toast. "F harry stowe" is Greek for thank you. "An dee amo" Italian for lets go. "Ove Waugh" French for good-bye.

What do you eat? Guinea pigs are popular pets in Peru. They are also considered a delicacy's at the dinner table. The traveler of course will take small bites. In Europe when a waiter asks what you'll have to drink, the tourist's replies, "I'll have a coke." The traveler will ask what kind of wine they have.

How do you remember this vacation? Asian tourists march about in large packs waving their selfie sticks crowding around a famous landmark. The traveler uses their zoom lens and tries to capture local people doing average things like sweeping a cobblestone street, and sipping coffee in an outdoor café.

Beware of pick pockets is a common refrain of tour guides. Thieves overseas are clever. In Turkey a couple in our tour group were walking down a narrow street one night in Istanbul. A group of women in native dress were walking toward them. A car came by and swerved towards the side walk. Bill then felt a hand on his hip. He quickly brought his arm down and brushed it away. The car stopped ahead of Bill and his wife and the women pick-pocketers ran to it and hopped in. Thieves work in pairs and have been known to use cute babies to distract your attention. I learned a valuable lesson from a fellow traveler in New Zealand. John kept small bills in his wallet and his credit card in his sock.

Both travelers and tourists are concerned about safety. It is always an issue when you leave home. Is it safe to drink the water? Beware of eating a salad because the lettuce would be washed in the local

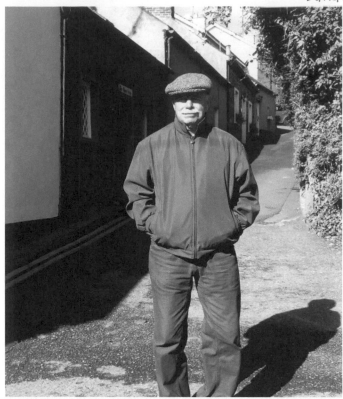

Do I look like a native?

England. Here they drive on the left side of the road. This takes some getting used to mind set of constantly reminding yourself of this difference every time you get in your car to drive. Daughter Lisa joined us on our Peru trip where we chewed coca leaves to avoid altitude sickness.

Who are you going to meet? The Hurtigruten is a mail boat/ supply ship stopping intermediately along the Norwegian coast. Traveling with a group of forty, all sorts of personalities emerge. The winner for us was Bud and Sally. The four of us just "clicked "together. They live in Cape Cod, Massachusetts and spend the spring in Tucson. After our Norwegian travels we've visited them in both of their American homes. On subsequent international trips we are always looking for a Bud and Sally type.

Bud and Sally met in college. Brown University is part of the Ivy League offering a broad liberal arts program. Sally was president of the Brown alumni club in the Cape Cod area. Bud was an engineer who once worked on a project in Russia for several months. He's a runner who has done the famous Falmouth Road race several times. Like us they have daughters. We share a common interest of so many things. Bud and Sally exuded New England charm.

Jim and Karen in Spain came close to being a Bud & Sally type. Karen is a very talented artist and Jim was an airline pilot, who had a quiet demeanor. Art and Paula on our Baltic cruise also rise to this high standard of agreeable companionship.

Of course the easiest way to travel with people is to start off with those you already know. Good friends Chip and Gail have been with us on four trips: Hawaii, Costa Rica, Argentina/Chile, and Turkey. Chip is an architect. Gail taught Spanish, which on two of our trips was invaluable. She also shares my passion for photography. We often discuss composition of various pictures and share the joy of getting that special shot which captures the essence of where we were visiting.

water. There is always a risk in life, we just try and minimize it. It's a beautiful world out there full of charming people. We are all travelers, when you step out of your neighborhood think and be aware of your new environment, smile and enjoy the world.

More Travel Insights

How to do it (and who will you meet?) First you have to fly in an airplane. If possible avoid the center row of five seats. If you're lucky an obese person will not sit next to you and take up half of your seat. Avoiding this is preferable to having a crying baby next to you. But I joke, these scenarios rarely take place. To calm your fear of flying it's safer statistically than driving a car. Last, if you can afford it, fly business class, there's more leg room.

Who do you share the international travel with? On our first two trips to Europe we were with my wife's parents. Gabe was a Hungarian and was very helpful as an interpreter. It was a good bonding experience for Susan to share this adventure with her mother. Later we traveled with our daughter Julie in

Chapter 15: England

To travel hopefully is a better thing than to arrive - Robert Louis Stevenson

The Land of Shakespeare

We've taken three trips to England and on our first trip in July 1996 we used the "thumb" method. Of course in this country they do not drive on the wrong side of the road, it's a different side of the road and it takes some getting used to. Mentally every time you get behind the wheel you have to remind yourself, stay on the left side. Plotting our trip we put our thumb on the map and drove no further. Lining up Bed & Breakfast homes we'd arrive early in the afternoon and get to chat with the owners as to the hidden charms of their neighborhood. Then we'd explore, confident this inside information would give us a rare view the ordinary tourist would miss. The next morning after a leisurely, delicious breakfast we're off. There's no rush with this method and taking your time is important when you're on vacation.

We went up the east side of England all the way up north to Scotland and the Isle of Skye. Going south on the west side of England we passed through the lake district, ended up in Wales and turned in our rental car in London.

We had a memorable dinner in a lodge. It just seemed so British. The owner who served us wore a tie as did the two gentlemen. Sadly I was undressed as I had not brought a tie on this vacation. We were a comfortable group of six around the table. One couple featured a gentleman who was a resident of the Isle of Man in England, yet lived much of his life in the West Indies. His wife was a member of the diplomatic corps. The other couple could have come

straight out of the movies, the man was a dead ringer for the actor Lee Marvin. Afterwards we nicknamed his wife, "The Duchess" for the way she acted. It was a fabulous, uninhibited flowing conversation from some real characters. After dinner we retired to the parlor for coffee and more talk now that we knew each other. We went to our room at eleven thirty refreshed with this highly entertaining evening.

You look for the unique on vacation, but I could have never dreamed up playing Rugby in Wales. Checking into our B&B in the early afternoon I told the owner I was a runner and for tomorrow's early morning run did not want to be locked out. He said he was the manager of the local rugby club and would I want to come to practice. I said yes, not really knowing what I'd get myself into. It was great. After we took a short drive to the field, he said the lads are going to warm up with a run through town. This was of course easy, putting myself in the middle of the pack. Jogging in town we occasionally received cheers and comments from the locals. Being a part of this made me feel special. On the field the manager said, "Well since you're a track coach, perhaps you'd like to lead the lads through some drills." This was fun as I knew what I was doing, but when later they asked me to join in on the scrimmage, I hesitated. "Oh no, we don't play tackle now, just two hand touch." Ruby is akin to football so I wasn't totally lost when I reluctantly decided to participate. After fifteen minutes or so of a lot of lateral movement, I felt I had fulfilled my participation quota and retired

Traveling the Streets of London

with guide book plans our next day. Her goal is to avoid the rain and have us visit the National Portrait Gallery.

After our stay in London we decide to go to Canterbury. We could go by train but decide to rent a car. Traveling the tube (ie subway) it stopped because of some problem up ahead. We then had to walk a half mile to get a bus which would take us to the airport. We arrived at the airport later than planned to get our rental

to the side lines. My t-shirt was soaked in sweat and I felt like I' had a real taste of Welsh culture.

Our second and third trip to England took place because of our daughter Julie. She led a successful life of a shoe buyer for a Department Store Chair which had five stores. Julie wanted more out of life and applied to the London School of Fashion and got accepted. We visited her in the winter of 2009 and the summer of 2010.

Our lodging in London was in Bloomsbury neighborhood. Looking thru a window outside our room we can see Cartwright Gardens. Our small hotel is a four story building with creaky floors revealing its age and you can hear people above when they walk around…a groan of the building. We meet Julie at a pub with hamburgers and cider and catch up with her life in England. Our second day in country we go to a Toastmaster meeting. It's in the evening high up in a modern skyscraper but we overlook the Thames River the Tower Bridge. Because it's a small group I get to participate. Susan is impressed because at this Toastmaster meeting they serve wine. Susan

car. Before we get to Canterbury we had planned a visit to Leeds Castle. It was well worth the stop, high ancient stone walls behind a moat, but it put us out on the road later in the day. Now it's getting dark, a drizzle rain and the road signs hard to read. When you come to a traffic circle where do you exit became a problem for me. Are we on the right road I ask Susan? She doesn't know and we exchanged harsh words. I think we might be lost, but drive on. Atmosphere inside the car becomes tense. Luckily we arrive in town and fortunately find a police station. We ask for directions to our B&B. "No problem you can't miss it, it's off the ring road," says an officer. Well its pitch black with road signs unintelligible and this does not help. Naturally Julie is stressed out at this point driving with her parents and cry's out, "Let me out of the car, I will walk." Somehow I kept her in the car and after several mistakes on streets we found the B&B. This was the most frustrated I've ever become in world travels and looking back somewhat dangerous. It's also something Julie remembers very well. I know there is a God because I didn't have an

accident on the road.

The Canterbury cathedral is a classic Gothic building, you feel a sense of space and reverence when you enter as you tilt your head upward to see the ribs of the church on the side walls, rising high up. You feel a sense of awe. It was well worth the arduous journey in the dark and rain and uncertainty of the driver. Canterbury is in eastern England and we turn around the next day driving to central south England and the town of Brighton. We walked their famous pier and Julie left us to take the train to London and her classes at the Fashion Institute. We're now off to Bath.

Finding our B&B in Bath again somewhat of a mystery, but not anywhere near the level of getting to Canterbury. By happenstance we stumble upon it, clear street signs were helpful. Tour of ancient Roman baths excellent and afterwards we shared some fish and chips, a typical English meal. Our B&B was charming and the host very helpful offering advice as to where we might go.

We drive in some fog back to London and stay at the Grand Strathmore Hotel, Kensington borough and nearby Embassy row. We are only a short walk to Hyde Park. It was here during WWII they grew potatoes, but now have beautiful flower arrangements, ponds and weeping willow trees. Back in our room after dinner Julie help me edit my English pictures.

Our next trip to England was not too far away, just six months later and we are again in England visiting our

daughter. This time we use England as a base and using the Chunnel, an underground tunnel across the English Channel, go to the Netherlands and Belgium. No driving a car, we use trains. Our itinerary: two nights London; three in Amsterdam; three in Bruges; and five in London.

We get an "Oyster card" to make for easy payment on public transportation. Amused at clever announcements at tube stations, "mind the gap," referring to the space between the train and the platform. A day after our arrival we take Bus 73 which is a Piccadilly Line to Cockfosters to meet Julie at York pub. This is our fifth European trip having gone twice before with Gabe and Miriam to Hungary, northern Italy and France.

On the way to Amsterdam we first had to stop and change trains. You have to pay to use the toilet at the train station and we had no local coin. I hurriedly ran outside the station and ran into a bar where I was fortunate to find a restroom, called a WC or water closet in Europe. Hint it helps to have local money.

In the 17th century Amsterdam was the richest

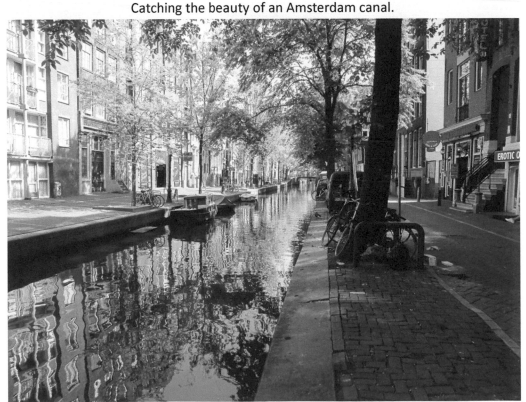
Catching the beauty of an Amsterdam canal.

city in the world, the cradle of capitalism. Today it has more bicycles in any city I've visited. You need to be careful walking the sidewalks and crossing streets because they are smaller than a car, make no noise and travel at impressive speeds. Our hotel was close to the Van Gogh museum which we toured. They have 160 canals and we took a canal boat tour of the city.

Waiting at the train station for our train to Bruges we talked to a very pleasant man from Israel. Aboard the smooth train ride I write in my journal like an impressionist painter. We pass patchwork fields of different crops marked vividly by various shades of green. This is in sharp contrast when we see a cluster of white cows. The sky is a murky white greyish blue. We then pass villages of reddish orange brick houses. I imagine what it would be like to live there? How would my talent match up with a suitable job to sustain myself?

Bruges is an ancient city of canals with 80 bridges. Its narrow twisting cobblestone streets mandate sturdy shoes not our sandals we used in Amsterdam. Bruges has 135 breweries, and is famous for its waffles and chocolate. We visited Sedert brewery which was established in 1856. Standing atop the five story building I got a good picture of the city.

On the train again, back to London, at the third stop outside Bruges a crowd of rowdy teenagers got on. If I was an elderly person I would be frightened. After a while they got off and soon twenty energetic squawking school kids possibly in the fifth grade ran on. They probably had too much sugar and made too much noise. If I was an elderly person I would probably be annoyed.

Our fourth hotel on this trip and we're moving up. Room 202 is on the third floor, no more street level like the first two. We're on Montague Street, just off Russel Square and by the British Museum. Here we find success breaking the British reserve with a couple sitting next to us at breakfast. At the

beginning you don't talk for a good long decent amount of time and then open up with charming friendly conversation.

Allen is Julie's boyfriend and after hearing so much about him we finally get to meet him. He's a nice guy. Julie has good taste. He was an engineer who had worked for Rolls Royce but now is into the computer field. Allen does not have a driver's license. I guess this is common because they have good public transportation. I politely say little and concentrate on my poor listening skills. Allen is from Liverpool. Susan has no trouble understanding him, despite his accent, but I'm at a loss. Sadly they broke up after being together for several years.

London has an outstanding reputation for good theater. We saw the musical Jersey Boys. It's about Jerry Vale and the Four Seasons... "You're just so good to be true, I can't take my eyes off of you, your like heaven to touch, the sign of you just makes me weep, I can't take my eyes off of you." It was a big ornate classical theater. The singers were awesome and this was certainly one of the highlights of our trip. I get misty eyed now just thinking about it.

The biggest sporting spectacle on the planet is the World Cup. TV news reports husbands are out of control, domestic violence increases and passion rises as people watch football. In America it's called soccer. We accompany Julie to one of her favorite pubs to watch England play America. Also joining us are Julie's good friends Mark, a wild eyed Welshman and his wife Emma. They have visited the United States, and liked Los Vegas. Mark said it gave him a buz. Inside the pub there was an international crowd, sitting nearby were Spanish and Italians and in the next room I talked to a Scotsman. Mostly absent were rapid English fans. England was favored but the match ended in a draw, a tie. The controversial play saw the English goal keeper, Robert Green, make a calamitous error... he let a ball slip thru his hands for a goal by America. This in soccer parlance

is called "a howler" a mistake by the goal keeper. Yet to the British it went beyond that, you'd thought the world was going to end… they were so consumed with grief.

Kew Gardens was big and impressive with lots of green grass, and trees. I love taking pictures of flowers, but have to admit many of Julie's pictures were better than mine. It was a nice visit here to escape the intensity of the world cup.

Our last breakfast in England saw us talking with two English ladies about their trip to America. They marveled at the red rocks of the west and formations in Bryce Canyon and the room they stayed in was so spacious…"you could swing a cat around." England does have a quirky culture even though they speak the same language.

Ireland

I didn't want to go, movies on the country show rock walls, green grass but not trees. Susan read a magazine about a fairy-tale castle and said to herself, "We've got to go and see if it's real." She's a persuasive person and Kylemore Abbey is just as impressive as the magazine portrayed it. And I was wrong, Ireland has trees.

Kylemore had three different identities: It was a hunting, fishing lodge 1853 to 1862; a fairy-tale castle owned by Mitchell Henry until 1903; and finally an abbey in 1920. It's a misnomer to call it a castle because it was never for military defense. Here there is an aura of peace, tranquility, a sense

of spiritualness, and a place of repose. It sits on the edge of a lake back-dropped with a misty hill and forest. Words cannot describe the dramatic beauty. My camera could not because the day we visited it was over-cast. However, the life of Mitchell Henry, is a compelling story of this magical place in Eastern Ireland.

Mitchell was a successful medical surgeon in London. His father was a rich merchant, but raised his son to be always aware of the dignity of labor. On his honeymoon Mitchell took his wife Margaret to the area of Connemara and the lodge at Kylemore. Connemara was recovering from the Great Famine. The region steeped in poverty, had already lost one third of its population through starvation, fever, and emigration. Mitchell decided to buy the lodge, re-built it for his family, expand the estate, and raise the standards of living of the locals. He accomplished all of this for the love of his wife and his desire to help others.

Pivotal to Mitchell's success as a landlord was his choice of steward. He appointed Archibald

Irish tunnel of green

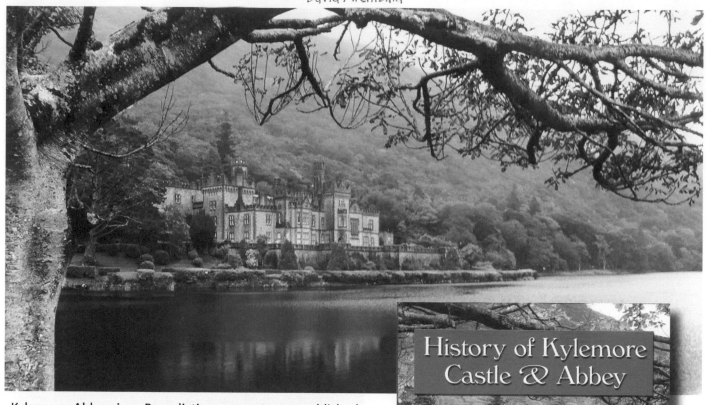

Kylemore Abbey is a Benedictine monastery established in 1920 on the grounds of Kylemore Castle, in Connemara, County Galway, Ireland. The abbey was founded by Benedictine nuns who fled Belgium during World War I. Susan and I were there in the summer of 2010. A foggy and overcast day but beautiful.

Macalister. Every assistance was given to help the tenants improve their holdings. The principal crop was still the potato, but many tenants had a run of mountain on which to keep sheep and cattle.

The castle had seventy rooms and all modern conveniences were added: such as indoor plumbing, gas lighting and service lifts to the upper floors. In addition to a gun room there was a fully furnished Turkish bath. There were twenty nine horses on the estate. One mile from the castle there was a six acre walled garden. There were twenty-one wooden-framed glasshouses or hothouses. They were filled with exotic fruits and plants for domestic consumption but were also used for experimental purposes. Visitors all agreed the beauty of the flower beds with rich emerald green of the grass invest the whole scene with an inexpressible charm.

Our trip to Ireland included many other thrilling experiences such as a very windy day atop the Cliffs of Moher. It was so strong (90 mph) one member of our tour group was knocked down by the wind and broke her arm getting off the bus. We divided our vacation into going with a tour for a week and the second week traveling alone, staying in various B&B's. It was all very charming and only rained one day, but the supreme highlight was Kylemore Abbey. For more read the book, "History of Kylemore Castle & Abbey" by Kathleen Villiers-Tuthill.

Chapter 16: Alaska and Canada

Anticipation is many times just as big a reward as the trip itself.

Thirteen years ago we flew to Alaska and traveled by car to Seward and Homer on the Kenai Peninsula. We then made the big trip to Mount Denali and got to see it in all its pristine snowcapped glory. We were lucky because many times it's covered by fog, disappointing those who've come to see it. This time we cruised along the coast and saw Ketchikan and Juneau. Susan had arranged an excursion for me to go salmon fishing. Months before this trip she had been shopping for just the right cloths to wear aboard our luxurious cruise ship. Looking forward to this vacation added some excitement to the adventure travel can bring.

Before we got on the cruise we spent two days in San Jose with Susan's cousin Mitch. He took us to Pebble Beach because golf is his hobby and he wanted to show off one of the world's most famous courses. It hugs the rocky picturesque coast with the crashing surf and unique Cyprus trees. We then spent two days at the Cornell d' France in San Francisco. Here Julie took us on interesting walks about the city. A high point was the Mission District and the alley that was covered in spray painted street art. Beautiful bold colors and creative designs were present.

The day we were to get on the ship saw us take, "The Trek." The walk from our hotel at Nob Hill to the Ferry Building was all downhill. Ordinarily an easy jaunt, but pulling two suitcases which were on small wheels and carrying two bags it wasn't easy. Then it was a long flat stretch from the Ferry Building to Pier 35. After a while Susan pointed out to me our huge ship in the distance. With a few rest breaks and this as motivation we finished "The Trek." On this two hour walk we saw a visual feast of people: those in suits, other tourists, homeless people, and runners. It was a bit of a challenge and I was proud of Susan.

The last day of the cruise I was in the steam room and the guy across from me was in deep thought. I asked him what was on his mind. He said, "Tomorrow… when I return to the real world… this has been an artificial heaven." For eleven days life was easy. You didn't have to make up your bed and when you finished dinner it wasn't necessary to wait around to pay the bill.

Two thousand and six hundred people were aboard the cruise ship and we were overwhelmed with an amazing number of activities. Trying to do them all in eleven days was impossible, even keeping pace was exhausting. But here's a list of some we did: presentations on upcoming ports of call; photography seminar; art auction; cooking class; jewelry demonstration; Iditarod lecture; talent show; numerous musicals with skillful chorography of the dancers and dazzling costumes; Jacuzzi and swim in one of the three pools, while at sea; listening to piano melodies by an Irish singer and hypnosis demonstration by a comedian with ten people selected at random from the audience.

At a wine tasting class we learned what "legs" are. Holding up a glass of wine to the light, tilting it to one side and then realigning the glass you can see some dripping inside the glass. This dripping in the

wine world is called "legs" and observing it closely you can discern the alcohol content of the wine. The more leg the more buzz you can receive.

Every morning just outside your door was the ship's newsletter, the Princess Patter. It listed the time and place of all the activities. The cruise company has to appeal to a wide audience. Here's a list of some meaningless activities we didn't do. Pain solutions with acupuncture and Chinese medicine; Spelling bee; Play croquet; Zumba fitness; Table tennis tournament; Martini demonstration; Ballroom dancing class; Non-surgical face lift class; Disco inferno hour; Bible study; Basketball shoot out; Scrabble; Vodka tasting; Knitters and needle workers get-together; Friends of Dr. Bob & Bill (alcoholic anonymous); Seminar on the secrets to a flatter stomach; British style pub lunch; Wet, wild & wacky pool games; Where in the world trivia; Ice carving demonstration; Bean bag battle; Free footprint analysis; and Paper airplane contest.

Staff present on the ship numbered one thousand and one hundred. They came from forty different countries. The Philippines clearly outnumbered everybody, as six hundred were aboard.

Our room was awesome. We had a great view of the ocean from our balcony. Much of the time we were content to stay in our room and be mesmerized by the color and the rhythm of the vast sea.

Nobody starves aboard a cruise ship. The choices of where to eat were numerous. Most were a part of the cost of your trip so no money changed hands. But there were specialty restaurants where you had to show your cruise card and paid extra. A few people we talked to said the food wasn't any betters there. The selection of food and the amount you could eat was staggering. The many fat people on the ship got more so. We tried to watch what we ate but many times it was difficult, oh what the heck we were on vacation!

We made four stops on land, three cities: Ketchikan, Juneau, and Victoria (Canada) and one village, Icy Straight Point. It was in Ketchikan I went out in a small boat with eight other people.

When was the last time you went fishing? On one of our many family vacations I vaguely remember a high cliff and a bend in the stream down below. It was a rough climb down to the stream and I did not enjoy getting the hook out of the fishes' mouth. I was ten years old. This time it was much different and not what I anticipated.

Deep sea fishing has been a long held dream. I'm in a chair struggling for an hour or so battling a huge fish that occasional jumps up out of the water.

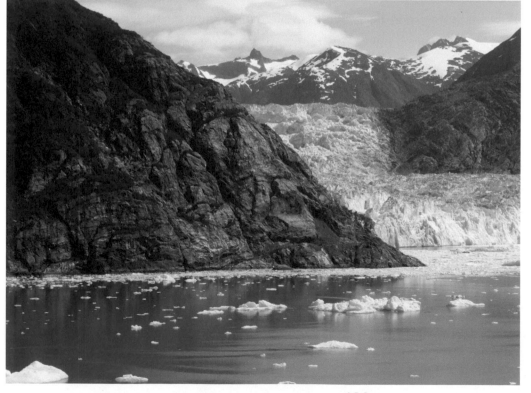
One of many glaciers we seen

This did not happen for me in the waters of Ketchikan.

The two person crew, a husband and his wife, had the six of us draw a card. This determined the order of who was fishing first. They, not us, put out five lines at different depths: seventy to one hundred feet. The first person up, then watched the lines to see which one would bend first. Metallic lures were used as bait. I caught two pink salmon of respectable size, but

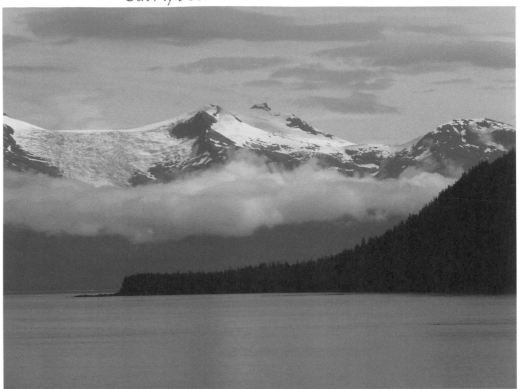

Low hanging clouds in an fjord

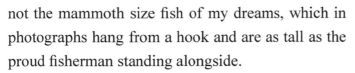

not the mammoth size fish of my dreams, which in photographs hang from a hook and are as tall as the proud fisherman standing alongside.

You could have your fish freeze dried and shipped home or put on the ship and eaten the next day. I chose the latter as it was cheaper, more immediate and could be shared by others. At the dining table the next night I was hailed as a hero, but I certainly didn't feel like one. The effort to catch it wasn't much, but I did enjoy the four hours spent out in the bay. A husband, a wife, their two sons (an 8th grader and a junior in high school) and Piero, a middle aged South African they were my fellow fishermen. It was fun talking to them and the owners of the boat.

For me, not much can be said about Alaskan cities we visited. They all seem to cater to the huge cruise ships and the hordes of tourists who come ashore to buy souvenir T-shirts and jewelry. However, with some reflection each Alaskan city did have some unique charm as both Ketchikan and Juneau are on narrow strips of land with high mountains at their backside. Juneau is the only state capitol that cannot

be reach by road. Airplane and boat are the only method of transportation to get there.

Tracy Arm fjord was Alaska at its finest… towering cliffs of solid granite with patches of green vegetation and long skinny waterfalls sneaking down from the top…raw unpolished beauty…an oculant overload (visual). At the end of the fjord the ship had to turn around to get out and we had plenty of time to view a glacier. It was greyish white on top with a magical blue glare inside the solid ice. The unique color is compared to a gem in Afghanistan called, Lapis Lazuli. That afternoon spent in the fjord was one of the highlights of the trip for me. It put me in a thoughtful, relaxed mood enjoying the grandeur of nature. My pictures do not do it justice.

Getting up close to Alaska happened at Icy Straight Point. It was an abandoned fishing cannery turned into a tourist spot…hiking trails, beach, cafes, and shops. Susan and I chose not to ride the sky high zip line which took you speeding along above the tips of the tall forest. Instead we walked along the rocky beach and in a forest trail. Here I did manage

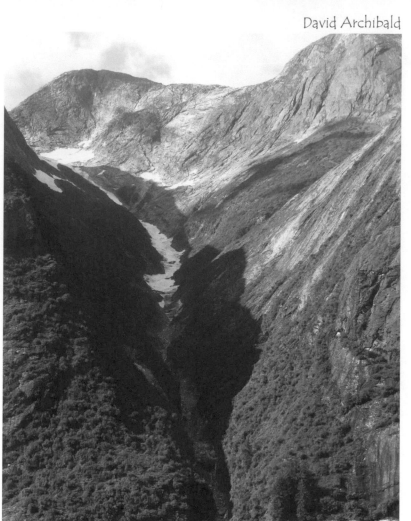

Awe inspiring nature

to get some good pictures.

I got some more good pictures in Victoria, Canada. Hanging flower pots displayed some brilliant colors. We of course shopped and Susan brought some nice ear rings from a street vendor. Visiting the huge opulent Victorian hotel, The Empress, gave us a glimpse of high fashion. The afternoon tea wasn't possible for us because we only had the morning to visit. I wish we could have spent more time in this charming city.

While this trip is advertised as visiting Alaska. You really only scratch the surface. The majority of your time was spent on the spacious ship with fifteen decks and meeting some interesting people. Susan was on the look-out for a "Bud and Sally type". We bonded with this fun couple on our Norwegian coast

cruise. Afterwards we've kept in touch, visiting their winter home in Tucson and their permanent home in Falmouth on Cape Cod. One couple came close to the "Bud and Sally" type.

A couple we bonded with were Al and Linda. Being New Yorkers who had lived their professional lives on the east side of Manhattan, we had a lot in common. They presently live in Las Vegas. She was in charge of cultural affairs for New York museums. Al was a maritime lawyer.

The ship had a talent show and I wanted to participate. Al had taught a class on comedy, and was a big help with my efforts in the talent show. This was my creative effort along with three other comedians. There were also three dance groups, one singer, and one yo-yo expert who happened to be a superintendent of schools someplace. The three judges liked my colorful Tommy Bahama shirt and complemented me on my stage presence. John, another comedian took home first place. He had a smooth delivery and had subtle references to sex in a senior's retirement community. I told four mildly amusing jokes that got good laughs; but next time I'm going to slide in some sly sexual references.

One day shopping aboard the ship, Susan met Janet. She was on a "Cruise from Hell." Janet was with her boyfriend of only six months. All they did was argue. One day she was locked out on their balcony for two hours.

While most of the passengers were from the Bay area, many were from different countries around the world. Usually we shared the elevator with other people. The elevators we rode, went from deck five to deck fourteen or you could take the stairs. We did both. The standard comment when meeting somebody was, "Where are you from?" On one

elevator ride, a man with a streak of yellow in the middle of his brown hair, replied to my question, "Singapore." I said, "Its quiet a dynamic city." He said, "Yes, it's Los Angles, without crime." He then got off at the next stop the elevator made. A woman next to me who had heard our conversation had a horrified look on her face and said to me, "Yes and they whip people who chew bubble gum."

The farewell message from Vincenzo Lubrano, the ship's captain, "Hope you've had a wonderful journey and were able to escape completely during your cruise."

There were countless things we enjoyed about this vacation. For eleven days we didn't have to pack and unpack our suitcase, the routine we follow on the majority of our trips. Everything seemed to be taken care of. People on board were having a good time with an activity on board to please just about anyone. Food was plentiful and to our taste buds, very good. As a result people were in a positive friendly mood and I enjoyed meeting a wide variety. However, the lasting image I take away from this adventure was our room. It was a haven of serenity, and privacy. The spacious room had a large glass window/ sliding door so you could view the ocean lying on your bed. Plus we had an awesome balcony we could easily step out onto and enjoy the ocean. Many times we had lunch there with a glass of wine and we were in our own special world.

When I told a friend of mine of I was going to visit the Canadian Rocky Mountains, he commented on driving in the area, "My jaw dropped down to the steering wheel looking at the magnificent mountains. My neck was sore the next couple of days."

We started off traveling by railroad, leaving Vancouver and two days later arriving in Jasper. Here we traveled in the traditional manner, by car, stopping where ever we felt like it. The train was very relaxing as we were almost watching a movie, the changing stunning landscape was breathtaking. The motion of the train was special with its one rhythm. Add in the sounds of the wheels on the iron road and this transported you back in time. Remember this was the supreme mode of transportation, for almost seventy years, thus you were put in touch with history.

Canada doesn't feel like a foreign country. It resembles Colorado and Alaska. Yet there are small differences. One that caught my eye, was no guard rails on some of the treacherous but well maintained roads. The beer is just as good, but, of course goes by different names. Distances are measured in kilometers not miles. And presently their dollar is cheaper than ours.

What's the most scenic drive you have ever taken? For me it's the Canadian Rocky Mountains – Jasper to Lake Louise. Why…good road, mountains galore, and rivers meandering alongside the highway. Signs alerting you to stop and see a water falls or hike onto a glacier. Colors, green, green, shades of blue of mountains stretching above the tree line, turquoise water in lakes, and every once in a while the sun peaked through and thrown some yellow light on the landscape. The finish line was a luxurious resort at Lake Louise; Susan gets lost in our bath room as we are up graded to a suite. View from our third floor window is of a pale blue lake and distant white glacier surrounded by gigantic mountains, just stunning.

Rest stop magic

Chapter 17: Peru

Land of the Inca Empire

Puno

In a small covered two-wheeled cart propelled by a man peddling a bicycle, Susan A. says to me, "This is as close to Asia as we'll ever get." We're at the end of our vacation in Puno, Peru, elevation 12,500 feet, cruising the town to stop and look at a local market. Puno is in the southern part of the country next to Lake Titicaca, the largest high elevation lake in the world. This was just one of many adventures we had in our fifteen day visit to this under-developed country, full of fantastic landscape and intriguing history.

Peru has a population of thirty million people. Of that number, ten million live in the coastal city of Lima and it's here our travels began. Lima is overcast much of the time, so I was frustrated to get any good pictures of urban life. Saturday our bus dropped us off in mid-town. After visiting a museum and an impressive old church, Henry, our experienced guide took us to lunch in Chinatown. Crossing one crowded street, He remarks, "Welcome to the jungle." In a mass of people it's not easy to keep the group in sight. Being in the rear I could always look ahead and see our tallest person. Charles (Tennessee) is a cattle rancher and stands 6'3". Christine (Florida) was the only one in our group of fifteen who spoke passable Spanish. Ordering took some time, but the food was good.

Taking an express bus-tram back to our hotel was high drama. We're in a strange foreign city packed tightly together, separated from Henry, and unsure of our exit. Jammed together it was difficult for people to get on and off at the various stations. Somehow word got passed around as to the name of the station where we are to exit. Squeezed in from all sides I had to fight for position before we arrived at the station. "Whoosh," the doors open, and lowering my shoulder, I managed to get out. I looked around at my fellow American travelers and on all their faces was a look of amazement and relief that they had escaped and not been trapped to ride on to the next stop and faced with the problem of finding their way to our hotel, if they remember the name of it.

We fly from Lima to Cusco and go by bus to a

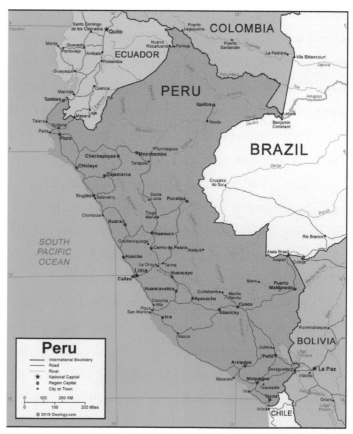

lower elevation, the Sacred Valley and the town of Urubamba. Henry has the driver pull off to the side of the road for a photo opportunity of the stunning valley below and the Urubamba River. Earlier he had purchased some Coca leaves and were instructed to chew them. This was to help us adjust to the altitude. You put a bunch under your lip and chew like tobacco, being careful not to swallow any. Having never chewed tobacco, this was a novel experience for me. After ten minutes or so my right cheek did get numb and I felt it was now acceptable to spit the substance out. Susan A., our daughter Lisa, who was also part of the trip, and I never had any problems with the altitude, but a few others did. Foremost among them was the other Susan R., who was hospitalized one day in Cusco, but bounced back to complete the trip.

We float down the Urubamba River in rubber rafts that hold up to six. This hour long trip of four miles was very relaxing. We silently floated on this gentle river with an occasional rapid of class one category. The river runs through towering mountains of different shades of brown, gray, and green.

Our hotel is set among exotic vegetation and offers a wide variety of food in our buffet breakfast. Here, I hear Fred's (San Diego) story of sailing across the Atlantic Ocean in 1977. His wife and two small children accompany him in his thirty-five foot sailboat. Fred spent thirteen days going from Florida to Bermuda, then eighteen days to the Azores Island, and finally thirteen days to the Straits of Gibraltar and the Mediterranean Sea. My fellow travelers are indeed fascinating people and the camaraderie our group develops was one of the highlights of the vacation.

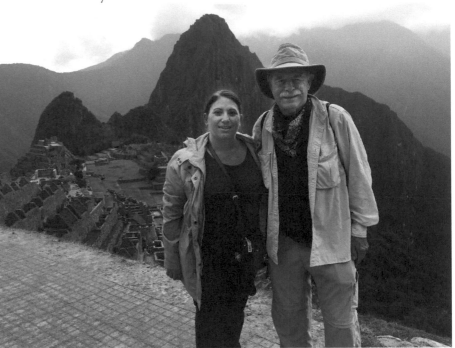

Lisa and I at Machu Picchu. It was quite a journey to get here. Not for the fainthearted.

Machu Picchu

The mountain top city of Machu Picchu is the magnet that draws tourists to Peru. It is in some respects the Eiffel Tower of South America. Tourism is the fourth largest industry in Peru. To get to Machu Picchu you have to go by train as there is no road or airport.

The train ride of twenty six miles took an hour and a half. It moved from a high plateau area to dense jungle. The narrow gauge rail line took us through an imposing canyon with vertical cliffs, a rushing river, and tall trees with dense green vines surrounding them. It was amazing.

The ancient Inca city is three switch back miles above the modern tourist friendly town of Machu Picchu. Three thousand people visit each day transported up by thirty-two buses. Previously, we had visited other Inca ruins and were already impressed by the skill of their engineers in arranging huge stones together without mortar. Machu Picchu was never discovered by the conquering Spanish. It was opened to tourist in 1955 and has become a mecca for South America. With its impressive stone

The Incas were some of the best masons in the world. Their structures were built with a technique called ashlar (stones that are cut to fit together without mortar) so well that not even a knife blade can fit in between stones. To stop the city from sliding down the side of the mountain the Inca people also built over 600 terraces and controlled the flow of rain through the city.

construction Machu Picchu sits atop a mountain surrounded by skinny mountain peaks and a lush green jungle below. It left its mark on us with bothersome insect bites that lingered for the rest of

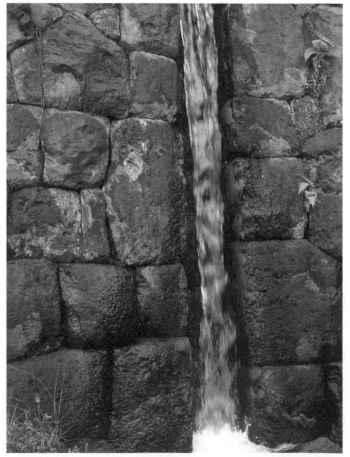

our time in Peru.

Most of our group were in our sixties. Tom (New Jersey) at 79 was our oldest and for a former college linebacker at North Carolina State did very well on our strenuous hikes up un-even stone steps. Lisa was clearly the youngest and hearing her laughter at dinner, I was proud she fit in so well with the group.

I had never visited a foreign country that so vibrantly displayed color in their dress. Susan A.

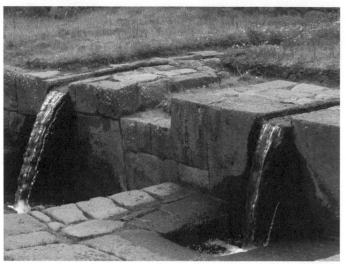

returned home with some striking textiles of bold colors. I also bought a multi-colored netted wool hat. When traveling you are always confronted with the problem of what to take and what to leave out. If awards were given to the best dressed traveler, Jim (Colorado) would have won the award hands down. Like me, he is a member of Toastmasters and he gave me the acceptable colors a presenter should wear: Brown is a poor choice, color of mother earth, monks wear it; Red is strength, force, courage, can be interpreted as anger; Yellow is joy and happiness, excitement, color of breakfast rooms; Green is new beginnings; Black is authority, bankers, lawyers, too much turns people off as seen as being a parent; White is truth, innocence, poor presenter, weak, no strength; Grey neutral, safe; and the winner is Blue, most powerful for men, truth, peace, honesty.

Henry's hometown is Cusco and it sits in a bowl of what used to be a lake a long ago. It was surrounded by mountains. The elevation here is 10,900 and the

hotels have oxygen tanks in the lobby.

After Mexico, Peru ranks second in the world in the amount of silver mined. Henry takes us to a designer jewelry store. They had a nice bench in a small court yard that I took advantage of while Gail (New Jersey) a nurse, Joyce (Tennessee) a psychologist, my Susan A., and Lisa bought: rings, necklaces, and ear-rings. That evening at dinner we listened to a very talented flute player, who overwhelmed me with what I believed to be, "The Sound of Silence "but is eerily similar to a Peruvian song about a Condor.

On an eight hour bus ride from Cusco to Puno and Lake Titicaca I find out Peggy (Colorado) worked in the White House during the Nixon years and then with the National Parks. She's one of the few people who's ever heard of Okmulgee, Oklahoma, where I grew up until age twelve and moved to Arizona.

Not everybody speaks Spanish in Peru. We learned "wall,leakie" which is the language of an indigenous people who live on the shores of Lake Titicaca. It translates to, "I'm Okay." The lake is an impressive body of bright deep blue water, 126 miles long and 40 miles wide depending on which tour guide you talk to.

Lake day saw us on a forty foot boat visiting a floating reed island and then spending two hours motoring to an island that has three thousand

Alpaca, signature animal of Peru

inhabitants. The small floating reed island had five families totaling twenty-two people. Susan says walking on it was kind of like being on a trampoline. The root of the reed acts like a cork, then reeds are placed on top in a crisscross fashion. They had solar panels for electricity and surprisingly, their TV's worked.

The Island of Taquile rises up prominently in Lake Titicaca and saw us hike up a very steep stone path to a half way point where we had lunch. The view was spectacular as we could see the snowcapped mountains of Bolivia far away on the other side of the lake. We then had another grueling uphill climb to reach the top of the island. Meanwhile our boat had to move to the other end of the island and we had a two mile hike to reach it. Fortunately it was on level ground with a gentle downgrade. When you take into account the altitude of 12,500, it was a strenuous day for Susan A; the breathtaking landscape was worth it.

Susan A. was an excellent shopper on our trip. It is not really my style, though I was jealous of the floppy hat Joy (Florida) had purchased. She graciously offered to buy another one and I was able to purchase the coveted hat from her. I continued my custom of buying a soccer jersey from any foreign country I visited.

Our last day in Peru saw us back in Lima, and it was game day, Peru vs Colombia and I wore my

Peru is famous for its textiles

soccer jersey. Little did I realize what I was getting myself into?

Susan decided to skip watching the match in a bar with the locals. Kathleen (Montana) joined me and Henry for a look at the festivities and excitement. Five blocks from our hotel was John Kennedy Park and on a side street there was a crowd of people. On the edge of the crowd a TV reporter was interviewing a girl in a yellow jersey, the color of Colombia. I quickly jump in behind the girl, waved my arms, and scurried away. Kathleen laughed and told me I'd just "photo bombed" the couple, or more correctly "video bombed" them.

Rounding a corner were more people and a couple of television crews. Henry recognized two famous sports reporters who were interviewing each other and moved in position to get a picture of them. I followed suit. Suddenly I felt a tap on my shoulder and a microphone thrust in my face. Another TV crew had spun into action and I was their subject because I was wearing the colors of Peru. If I confessed to being an American tourist, I think they would have found

I'm interviewed on national TV

somebody else to interview. I motioned Henry over, but he wanted my camera and chose to stay close by but away from the action. The interviewer had by now collared a Colombian fan and was going to interview both of us. "Who was my favorite player?" Henry whispered to me a name which I repeated. Then the focus was on the Columbian supporter, a girl in the yellow jersey and I got a moment to enjoy being on national TV. "Why did I like the player?" I needed no help from Henry on this and in my rudimentary Spanish replied, "**Est muy fuerta**" which I think means "he is very strong." The next question was beyond my skill and I had lost track of Henry. "What is Peru's strategy in the upcoming match?" Being confused, I slowly gathered my wits and let out a resounding shout, "**Viva Peru!**" This was greeted with a round of applause and thus ended my fleeting moment of fame.

The match was close, the beer good, but Peru lost two to zero.

Promises were made to share pictures when we get home. Pam (San Diego) and Fred are extending their adventure going to Ecuador and the Amazon. Since they live relatively close and we bonded with them I'm sure we'll meet up and hear about the great river.

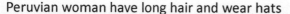
Peruvian woman have long hair and wear hats

Chapter 18: Susan in France

Don't replicate your life, when you travel, seek out something different from where you live.

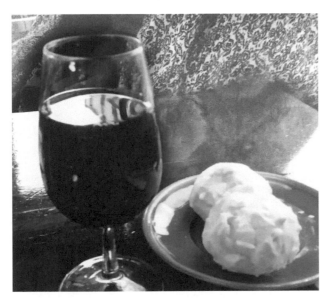

Susan goes to France for ten days and I stay home and coach track. She goes with Linda Mosier, a fellow Toastmaster and two sisters Sharon and Marilyn. A fear of a terrorists attack is absent because French security is on high alert. The only mishaps occur when Linda loses one of her contact lenses and Susan has one of her capped teeth fall out. This later mishap has Susan and Linda laughing so hard Linda pees in her pants.

For one reason or another Susan ends up as the only one who drank wine and took pictures. She has some good photos. The trip features a seven day river cruise on the Seine River to the coast of Normandy and back to Paris. They stop along the way in towns where French impressionist painters did their work.

Instead of a blow by blow narrative I will list in no particular order some of the highlights. Superior French cuisine: Eating from a large chunk of cheese when sipping wine, fabulous pastry, delicious fish

soup, and when your glass of wine is half empty on the ship, it gets refilled. Linda and Susan both feel the spirit of Van Gogh when they visit his room in Auvers. Awesome poppy flowers Susan captures in several pictures. The sisters tour the Eiffel Tower. Lots of Japanese tourists. The French people contrary to popular reputation are very helpful. Linda and Susan are successful shoppers: among the many items, Linda buys an expensive dress and two pairs of shoes, Susan buys two purses. The sisters marvel at the outstanding first class service on the ship. On the coast Susan and Linda rent a car for the day. Visiting a Gothic cathedral, Linda, an opera singer, bursts into song. The sisters are impressed by the beauty and strength of her voice. On the eight hour flight home Susan watches six movies.

Glad I'm here

Chapter 19: Phoenix

Papago - An archaic term for Tohono O'odham people

Papago Park

Parks are places where people enjoy nature and have fun. For most people running is punishment, but for me it's a sense of freedom and fun. I've run a lot of road races. The only one in which I won outright, not just in my age group, but captured first place in the entire race, happened in Papago Park. Towards the end of the race I could see no one ahead of me and worried if anybody was strong enough to catch me. Seeing the finish line I felt of surge of energy and confidence, a wonderful feeling as I sprinted towards glory.

The race was not a traditional one where everybody starts at the same time. It was a handicapped race. Starting times were staggered based on your gender and age. An elderly woman started first, then a very young child. Your start time was written on your bib, mine was eight minutes and something. The times were based on the national record for your age group. A 27 year old man would be the last to start. Theoretically everybody would finish at the same time. Of course some run faster than others so this did not happen. On this day I ran fast, passing a lot of runners and keenly aware some fast guys were chasing me. I won.

As a coach, I have organized many races. The biggest one, a state cross country meet, happened in Papago Park. Having good help was vital. Compiling the results, Curtis Bluth, a former runner, noticed a mistake. So just before we passed out mimeographed

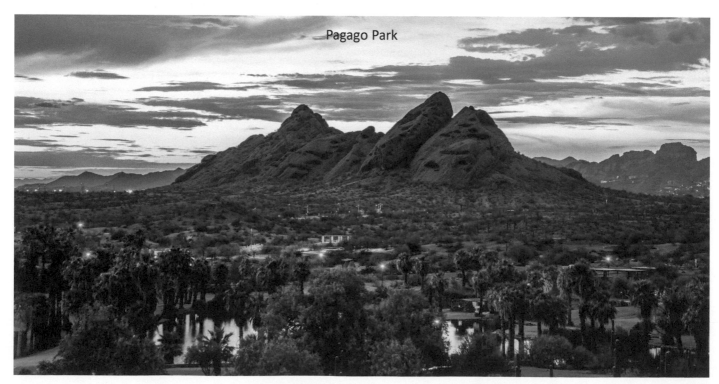
Pagago Park

sheets, Curtis made necessary changes on the master and cranked out newer pages. I took the earlier versions and stashed them in the trunk of my car, grateful not to be embarrassed.

The park is in the northern edge of Tempe, just a few blocks from Scottsdale. It's not far from eastern Phoenix. The park has hard reddish brown dirt with a scattering of tall palm trees. A canal with a constant flow of water meanders thru the park. In the middle are tall red rounded buttes about forty feet high. During WWII it was the site of a prisoner of war camp for German submariners.

February 14th, 2015 Susan and I went to a live performance on radio in the Arizona Historical Museum at Papago Park. The play was entitled "Escape from Papago Park." It was Arizona statehood day, Valentine's Day, and the 70th anniversary of the escape.

Close to a half a million prisoners of war were scattered in camps throughout the country. Therein lie many intriguing stories. One of the most striking occurred in Tennessee where three German prisoners escaped. They came to a mountain cabin and while trying to get a pump started for water, encountered a "grannie". She told them to "git". Unschooled in the ways of mountain folk, they paid no attention. A few moments later she aimed and fired, killing one almost instantly. When a deputy sheriff informed the old lady that she had killed an escaped German prisoner of war, she was horror-stricken and burst into tears. She sobbed that she would never have fired if she had known the men were Germans. Well, the deputy asked, "What in thunder do you think you were aiming at?" She replied, "Why I thought they was Yankees!"

There were many camps in Arizona. Not all of them contained Germans. Often prisoners were taken out of the camps to work on farms. Some American officers in Florence were concerned about their Italian prisoners and wondered if they had a bunch of homosexuals. The remarked to one another, "Normal men just don't sing opera as they pick cotton." Besides Italians, Japanese Americans were housed in, "relocation camps." So far my research has not found any amusing incidents. For the most part, there was fear in the country because there were a lot of the enemies in the camps. Ben Tyler, the author of the play, made history relevant by asking this question… "How would you feel about having over three-thousand members of the terrorists' organization Al Quada or Isis residing in Phoenix today?

Life in the camp was good, though the Germans complained. The beer was served cold. The white bread had too much air in it. They preferred black bread. However, they all liked American corn flakes. Another plus was every once in a while they got to see an American movie. So why escape? It was a soldier's duty.

In the fall of 1944 they started work on a tunnel. To hide the extra dirt they put it on a volleyball court. Looking at maps they knew a river was nearby so they built a collapsible boat they were able to squeeze thru the tunnel. Construction took one hundred days and the tunnel stretched 178 feet to freedom.

With the Americans celebrating Christmas, twenty five Germans escaped Papago Park in the rain. Many were shortly captured.

Mark Reinhard and Heinrich Palmer traveled nine days and were within thirty miles of the Mexican border before they were captured. The night before their capture sleeping on the desert floor they got awoken by thirty wild horses galloping nearby. A Papago Indian spotted them the next day and informed a customs official who took them into custody.

No water, just mud for the three who had constructed the boat. Today the Gila River doesn't exist. Signs on bridges signify its lost presence. They cross sandy washes marking the shadow of Arizona's history as it was dammed up into lakes. During

McDowell murals in downtown Phoenix

remained free the longest of the escapees. Late in January, he was wandering around in Phoenix and asked someone where Van Buren Street was. Since he was standing on it, the citizen became suspicious. What sealed his fate was his German accent. The next day, January 28, 1945 Kurt was captured. On that same day, far away in Oklahoma a great man was born, David Archibald. Was there anything momentous that happened the day you were born?

WWII, the dams weren't constructed and the Gila was intermittent in its flow. The German prisoners had to abandon their crude craft and in a day or so were captured.

Two other prisoners were captured outside Casa Grande. They were tired and hungry. They surrendered to Newt Cooper. He became the father of Patty Cooper. Patty and I went to school together. In Shakespeare's The Taming of the Shrew, she was the wild woman Katherine and I was the resourceful Petruchio. I had a big crush on her, but it only resulted in one date. It's odd, but I still remember the dark blue dress with white dots that she wore that night.

More personal connection to Papago Park remains. The leader of the escape was Kurt Wattenberg. He was 42 years old and stood 6'3. Kurt

Lake Adventure

We were stranded in the dark at Saguaro Lake with a wounded pick-up truck. A wrench and a screw driver had been unable to coax life into an impotent starter.

Earlier, the afternoon and evening were everything you could ask for… an escape from the furnace of the big city to the refreshing water of a large lake. Here were the stunning landscape of towering cliffs and the majestic cactus for which the lake is named. We arrived in the middle of the week and avoided the upcoming crushing crowds of the fourth of July. We almost had the lake to ourselves, with only an occasional motor boat in the area.

Jeff Farlow, my coaching compatriot, is a time tested veteran of the lake experience. He's on his fourth boat and is a very competent mechanic and navigator. Katelynne, his girlfriend, had just moved to Arizona from Florida, and he was eager to teach her to water ski. She was on the lookout for gators until Jeff reassured her, unlike Florida, Arizona had none.

It was a get acquainted time for Susan and me with Katelynne, who was a Canadian until the age of twenty two. She left Florida in June and drove non-stop across the continent with two dogs. A mutual friend had set her and Jeff up, but other than Jeff she didn't know anybody in Arizona. We were eager to change that. She's a nurse and we put her in touch with our good friend Megan. She helps place people

Our local basketball team

Curtis Bluth is water skiing with Four Peaks in the background.

in the health care industry. No results yet as they are playing phone tag, where one is in, the other is not.

First in the water were Susan and myself. We just swam around a bit, nothing fancy. After getting instructions from Jeff, Katelynne was next. She was to lie flat on a board that the boat was pulling and then rise up to her knees. She fell a couple of times, but then got her balance, keeping her elbows in like Jeff had suggested.

Jeff, of course, was the grand champion, skiing on one ski. Being pulled by the boat and in its wake, he would steer himself off to the side, skimming on the flat surface of the water. Jeff then made a sharp turn coming back and jumping in the air over the boat's wake.

Naturally I tried to get an action packed picture of Jeff's heroics. With the thump, thumping of the boat pounding up and down, the turns the driver Katelynne was making, and the turns Jeff was making, photography was challenging. I took about fifteen pictures. Two turned out well. His jumping in the air was fuzzy and out of focus, but the two I saved show him in a relaxed stance with the white wake of the boat on blue water, and the golden setting sun on the reddish brown rock walls in the distance.

Exhausted from water aerobatics, we found a secluded beach to rest. Jeff cooked hamburgers on his portable grill and with glasses of wine we watched darkness slowly descending on the lake.

The ride back to the marina was one of the most breath taking experiences of my life. It was unique, like being in a movie or a dream. Susan and I were up front, reclining on very comfortable cushions. Wind was caressing our faces. Looking ahead it was almost totally black. You could barely see the lake and the outline of rugged rock walls that bordered it. If it had been up to me to navigate the twists and turns of the lake and get us home, we would have been in big trouble. However, Jeff grew up on the lake and he had my utmost confidence. Rushing swiftly thru the black of night, the only sound was the boat lightly kissing the flat water. The adventure was surreal.

The marina was well lighted. It seemed like it was taking Jeff forever to get the truck and boat trailer down to the ramp where we were sitting with the boat. Finally he arrived and said, "We've got issues…the car won't start." It's late at night, we're miles away from home, isolated, and what do we do? A call was made to triple A, for emergency car service. Thirty minutes to an hour we were told. Time seemed to drag. Yet help was on the way. To pass the time, we tilted our heads upward to contemplate the awesome night sky and the brilliant stars that dominated the celestial landscape. More stars were visible out here than in our home in Chandler. It settled one's mind to see something more powerful than our meager selfish concerns of getting home.

We were lucky there was cell phone reception and no "dead zone" in this section north east of Phoenix. We were also fortunate, that during the monsoon season we missed the giant thunderstorm that hit the valley the next day.

In addition to the tow truck, Jeff was able to get a friend to come to our rescue. Brian had a ball joint on the back of his pick-up and was able to hook up to the trailer and get the boat. Susan and I rode with Triple A and Jeff's wounded pick-up truck. All together, we were stuck at the lake for three hours. There was nothing Katelynne, Susan or I could do, but just

accept the situation. I commended their attitude and everything worked out because Jeff is a smart man in emergencies.

Traffic class

I got a speeding ticket and had a four hour traffic class to attend. Robert Molina was the man in charge. An impressive Indian dressed in all black he did a good job of running the class for twenty people who did not want to be there. From the beginning it was a "scared straight" approach. He asked if anybody had been shot. A man sitting in the front row raised his hand, "I was in a restaurant when a man shot his wife." Robert then pointed out 400 to 500 people come to Arizona each day. He said, "If you think traffic is bad now, it's going to get even worse." A frightening statistic, four people die every day on Arizona roads. Another startling statistic, Robert pointed out 38% of vehicles have no insurance and a large percentage who do, have poor insurance. Arizona used to be number one in the nation for running red lights and stop signs, but now is number two behind Florida.

Also sitting in the front row was Stephanie. She had long brown curly hair and a very colorful tattoo on her right arm. She felt she had to talk all the time. What came out of her mouth was so stupid, often the audience would laugh. At one point, the discussion was about traffic cameras. Stephanie raised her hand and said, "Who's this big brother people are talking about?" While I couldn't stand many of her inane comments, this one broke me up and I laughed with the others.

Is he going to let us out early? This was the often unspoken mood in the room. When Robert felt he was losing his audience he had a long pause, gave a very good malevolent stare and then said, "Now people." True to his job, we stayed the full four hours. Most people in the room probably felt that if Stephanie had shut up we would have gotten out earlier. I certainly had that feeling. At one point, I felt

like reaching forward and putting my hands around her throat to silence her.

We all have our flaws and most everybody has their own story of traffic class. Somebody I talked to went on father's day. They watch a 20 minute gory film of head-on crashes. Then the instructor said he was a father. There were sons and daughters in the class who probably wanted to enjoy the day and he then dismissed them. My traffic class did bring home the point that I need to be more alert and aware when driving, be defensive and watch out for the crazy guy out there.

Traffic class injected some humility in me and made me think of this short poem I shared with athletes I've coached.

> *Fame is a vapor*
> *Popularity an accident*
> *Riches take wings*
> *Those who cheer you today*
> *Will curse you tomorrow*
> *One thing endures . . . character*

Music

We visit MIM, Musical Instrument Museum, in north Phoenix. It was awesome. I've been to a lot of museums in my life, but this was by far the most creative and well thought out. The museum stressed music of the world. Before we toured the exhibits we sat outside and listened to Stilicho: five guys playing Irish music…banjo, bass, guitar, accordion, harmonica, and a flute accompanied their songs.

After the hour concert we went inside and entered the Mechanical Music gallery. You stood in front of the exhibit and with the head set you received when you entered, heard the music. Old fashioned music boxes and the spinning gears that produced the sound were fascinating. Then we entered the Experience Gallery. It was hands on friendly, you could pound a drum or pluck the strings of a harp.

For lunch we again sat outside and listened to another Irish group. The gal who played the fiddle

I'm checking out the gong. The Musical Instrument Museum displays more than 7,000 instruments collected from around 200 of the world's countries and territories. Most displays are enhanced by state-of-the-art audio and video technologies that allow guests to see the instruments, hear their sounds, and observe them being played in their original contexts—performances that are often as spectacular as the instruments themselves. What's more, all guests are invited to play instruments from around the world in the Experience Gallery. They can also see instruments from music icons such as Elvis Presley, Johnny Cash, Pablo Casals, Buddy Rich, "King" Sunny Adé, Clara Rockmore, Maroon 5, and many more in the Artist Gallery. https://mim.org/

was excellent, hitting the fast pitched notes with charming rhythm. Inside we toured the Artist Gallery. Here John Lennon sang "Imagine." A screen had pictures of different people from around the world. I took pictures of Elvis Presley and Roy Orbison. Then we went to the gift shop and bought some Central American dolls for our daughters.

We spent four hours at MIM and it was overwhelming, sensory overload. There was so much to see and the exhibits themselves took time to really appreciate their unusual quality. MIM is also very user friendly towards children. I only had a glimpse of their activity, but like us they were captivated being there. It will certainly require a second visit.

Violinist from Montenegro

I've been to the Louvre in Paris; the Hermitage in St Petersburg, Russia; and the British Museum in London. To my mind MIM ranks right up there. You don't have to go overseas to see great creativity.

Chapter 20: Profiles

Profiles of People I've Met

Polly's Party

As a social studies teacher of thirty years, I reveled in the study of people and their places in society.

Saturday June 14, 2014 Susan and I were invited to Polly's 60th birthday party. Our first house in Tempe 1974 – 1981, saw Polly as our good neighbor. We lived in the south west corner of Mesa 1982 – 1998 and now reside in Chandler. However, we have kept in touch with Polly. She and Oren had four sons. They got divorced and she eventually married Vaughn Adams, a smart, compassionate man. The party was midday in an upscale Scottsdale restaurant, where we were given a private room.

Entering a separate room in the restaurant we encountered a crowd of happy people and six tables. A few were sitting down but most were standing in animated conversation. Many were holding wine glasses with orange juice and champagne. Not sure where to sit, I figured out the table that still had empty wine glasses on it was the one not taken. Pretty smart of me, huh? We knew a few people there, but hadn't seen many of them in quite some time. Two of Polly's sisters were former students of mine thirty years ago. Our daughters had played with their sons, but I struggled to recognize them. As fate would have it, our table offered some charming personalities and some titillating conversation.

Little did I realize the person sitting opposite me in the round table was my polar opposite? Terry was a conservative Republican and I'm a liberal

Democrat. Terry and his wife Patty are connected to Polly and Vaughn because they have a summer house right next to each other. This is in cool northern climate, northeast of Payson, the pines of Arizona. In the evening they often get together, share a bottle of wine, look at the brilliant stars in the black night and talk about life's adventures. Our amicable differences were not apparent at first but slowly exposed themselves.

The first connection made at our table was nursing. Chris, one of Polly's sons, was studying to be a nurse, and Patty, Terry's wife, was one. While I'm concerned about my health, my attention was diverted from most of this conversation by the pastries on the center of the round table. The chocolate croissant was very good.

Now that the ice was broken, another connection surfaced. Chris's partner, Rich was from New York, where Susan grew up. In addition, he worked for Metropolitan Life Insurance Company. He was familiar with One Madison Avenue, where I had worked for one year (1971). His second job was a "Go-Go Boy". A fascinating story of gay life in the big city was that occasionally he and his friends would fly to Reykjavik Iceland for the weekend. Rich said they had the most beautiful people.

Rich and Chris live in Tucson. Chris has not been to Polly's house in the pines in ten years. It's taken some time and emotional anguish for deeply religious Vaughn and Polly to come to terms with Chris's sexual orientation. The fact that he and Rich

are here at Polly's party sitting a table away speaks volumes. If Terry and Patty had any reaction sitting next to a gay couple, I missed it.

Terry told me he had been the head of the prison system for the state of Arizona. A very impressive undertaking. I told him it was possibly similar to being in charge of an aircraft carrier. Both are host to self-sustaining good size towns of five thousand. He chuckled and agreed with me.

A recent editorial in the New York Times, "End Mass Incarceration Now" (May 25th 2014), stressed that American prison population is "the world's biggest...More than half of state prisoners are serving time for nonviolent crimes. One in every nine are serving life sentences – nearly a third of them without the possibility of parole. After prison, people are sent back to the impoverished places they came from and are blocked from re-entering society." One of many possible solutions offered was to "rate prisons on their success in keeping former inmates from returning: as many as two-thirds currently do."

I didn't have the Times article on me to show Terry, but I asked him if he was aware of my Toastmaster friend Sue Ellen Allen. He said he was. However, he had not read her book, The Slumber Party From Hell. Terry mentioned another advocate of prison reform, James Ham. From his description, he sounds like a very interesting individual. Guess I'll have to check him out.

Sue Ellen and her husband David embezzled money from people who were buying high-end jewelry. They fled to Portugal because of her failing health and came back to the United States. They served seven years in prison. Her organization, Gina's Team is named after her roommate who died of leukemia in prison. The Team promotes education and self-sufficiency for the incarcerated. Another goal is to help inmates prepare for a smooth reentry upon release. In Toastmasters Sue Ellen is a clever and talented speaker. While I agree with her that prison reform is very important, I'm saddened she shows no remorse for her crime.

Terry laments the popularity of rap music and some of its crude language. Motown is more his style. He seems to feel this is a major cause for the decline in morality and hence a rise in crime. Well, he's got a point; but I think our criminal justice system is warehousing people. It's not coming even close to rehabilitation. Terry and I really didn't have the time, nor was it the place, to cover many of the issues that face prisons. I'll probably not change his mind, but he did seem like a reasonable person. There is always a sliver of a chance my point of view might linger in his sub conscious mind. Terry did think marijuana would get decriminalized.

I loved the diverse personalities at our table and the easy flow of conversation. It was spontaneous, respectful, and fun. Polly had surrounded herself with thirty-five radiant people. While we nodded at some and had snippets of talk with some, the hour with our table of six was priceless.

Dusty Everman

Two of the last three years of his life, I coached with Dusty. He was a giant in the field of Arizona track coaches. He died at the age of 78 and I expected that at his funeral there would be a reunion of athletes and coaches. I was not disappointed.

Dusty graduated from Snowflake, played football at NAU, taught math and coached cross country and track throughout the state. The title of coach covers a wide range of responsibilities and we all have our strengths and weaknesses. Over the years Dusty's social skills deteriorated. He talked too much. Dusty had a wealth of knowledge but after a while, he would lose his audience. He would make references to Edwin Moses and Mossy Cade, famous hurdlers, and I could see in the eyes of most of the athletes that they didn't know these people and couldn't care less. Dusty was the most knowledgeable coach I've every

Me & Dusty

known when it came to the mechanics of hurdling and sprinting, yet he had difficulty imparting this wisdom to the average athlete. Still, for some, who understood him better than others, he was of invaluable help in making them better athletes.

Those in attendance at the funeral all realized how unique Dusty was. No one understood this better than Betsy. They met at a Gideon Prayer breakfast and got married a month later. Entering his marriage at age 75 also made him distinctive from the vast majority of humanity.

Entering the church, I saw Dave Shapiro sitting in the back and walked over to sit with him. Dave, in addition to being the state meet director for track, also runs the biggest early-season meet, the Chandler Invitational. The budget for the Chandler meet is forty four thousand dollars. Soon the Westwood coach James Smith joined us. Westwood was one of the many schools Dusty was identified with. James also holds a big track meet, the Hohokam Invitational. I was sitting in between them and enjoyed the flow of conversation back and forth from these two talented coaches and meet directors. This was an inside look

at all the details that go into running a huge track meet. It was a conversation I'm sure Dusty would have enjoyed.

The pastor opened up the floor for those who wanted to come forward and share their memories of Dusty. There were many touching stories and tears. One man in a suit came forward and when he spoke, a faint inkling of familiarity stirred in my mind as he talked of his success as a hurdler at ASU. I asked Dave who he was. Dave said, "He's one of yours, John Lenstrom." Wow! I can remember when he first came out for track at Coronado High School.

After John led our team to the state championship in 1979, I lost contact with him. Now, 37 years later, I certainly wanted to talk to him. Outside the church I got my opportunity. I was wearing a tie that had a bunch of distance runners on it. I complimented Jon on his tie which pictured several track events. "Do you mind if I take a picture of it?" I asked John. "Sure" replied John. Much to my surprise, he then took the tie off and gave it to me. Somebody standing close by said, "Why don't I take a picture of you two?" After the picture I tried to return the tie to John, but he wouldn't take it, saying, "It's a gift." Many think a funeral is sad, and it has that element. Yet for many in attendance it's also a good reunion. We are the sum of all the people we have met.

Mendoza Chronicles

Sitting at a large track meet involving 34 teams can become tiresome. Every once in a while an athlete of mine will race, followed by a never-ending stream of other races which barely register a blip on the radar of my consciousness. Fortunately I get to gossip and chat with a friend and fellow coach, Ed Mendoza. He's a 1976 Olympian and in 1983 placed fourth in the Boston Marathon with a time of 2:10.07.

Growing up in San Diego he was once running in a ravine and thought he heard loud wasps overhead. Ed then realized someone up on a hill was shooting

Dave Barney and Ed Mendoza

at him. He picked up his pace and managed to escape. Later a police investigation revealed spent shells on the hill, so it was not his imagination. They told him a week earlier they had found the body of a woman who had been shot in the area. Ed avoided this locale in later training runs. He ran a nine minute two mile in high school and received an athletic scholarship at the University of Arizona in Tucson.

Going on a long run you need to be prepared. Normally you take care of business in the bathroom before going on a jaunt in the desert. Just in case, Ed sometimes carried a small section of toilet paper. Steve joined him on one of his runs and half way thru said, "Ed I got to go, what should I do?" Ed pointed to some near-by bushes and handed him the toilet paper. Soon Ed heard screams and saw his friend with his shorts half way down, stumbling out of the bushes. Ed went over and saw a rattlesnake with a rabbit ensnared in its mouth. Imagine being bit in the ass. The rabbit probably saved the friend's life.

Ed once ran a marathon in Hawaii. He was the pre-race favorite having run a 2:14. Half way through the race he hit the wall. The humidity was just too

much for somebody who trained in the dry desert of Arizona. Somebody passed him and he started to walk. After a mile or so a woman came up on him and he asked her if she minded him pacing her the rest of the way. Keeping company for several miles and getting close to the finish line he heard another woman coming close to them. Should he sprint and beat her to the finish line? No, not the gentlemanly thing to do. So the next day, much to Ed's embarrassment, a picture appears in the newspaper with the headline, "Grandmother beats pre-race favorite and sets world record." The woman was 39 years old and ran a 2:37 marathon.

Ed competed in the Montreal Olympics. I eagerly await the next long track meet to hear stories about this adventure in Canada because one his teammates was Bruce Jenner.

Bruce Pierce

Every week I receive a one-page typed letter from Bruce. He likes to write. Bruce has an entertaining, creative streak that holds my attention. But to write to me, of all people, once a week, seemed a bit unusual. So why? Perhaps he writes to other people? He obviously has a lot of free time to engage in his hobby. While I now seldom see him I consider him a good friend because of this letter-writing connection and the fact I coached his step-son, Jason Evans.

Bruce's recent missive is about rich and poor people. Bruce quote author Raymond Chandler, "They say the rich can always protect themselves and in their world it's always summer. But I've lived with them and they are bored and lonely." Bruce rattles on with cunning logic and concludes with, "Don't pity the poor; it's the well-heeled who deserve your sympathy. With great opulence comes great responsibility."

Bruce has self-published several books. They are mysteries and somewhat fit his personality. They can be found at the Poison Pen bookstore in Scottsdale.

Jason Evans was a runner on my Coronado High School cross country team. His mother Sherry closely followed her son's exploits and was a very good booster to our program. Bruce was a substitute teacher and an avid runner. I introduced the two and they subsequently married. Bruce is eternally grateful.

At one time a minister and later a prison guard, Bruce has had a wide variety of jobs. This unique, quirky, loveable person once put himself on a diet of just ice cream. He is a true Renaissance man. He even once worked as a nurse for a while and this medical background is perhaps the impetus for his unusual diet. Then again you're never sure what to believe with Bruce.

High school can be a turbulent time in people's lives. While not a super-star, Jason was a good runner on our cross country team. In my forties I was a respectable runner. Bruce ran in a couple of the marathons I competed in and Jason ran in a few road races of a shorter distance. Should I let Jason beat me to boost his confidence? I did not and this might be one of the reason Jason doesn't like me now. He went on to college and became a veterinarian. Despite Jason's feeling toward me this is not an impediment to my relationship with Bruce.

Laurie Coe

It's not often in my life a woman who's not my wife will say to me, "I love you." Laurie Coe, who is a member of Toastmasters said this to me. Of course I was flattered. One of my jobs at Rotary was arranging speakers. Laurie agreed to speak to them about being a hippie in San Francisco.

John Conant, a recent dinner guest at our home, when asked if he knew any hippies replied, "Yes my sister was one." I then asked him what this meant. He said, "She was a free spirit." Kicking this subject around for a few days I found myself visiting Troy, a former neighbor now in a health care facility. I

Linda Moser and Laurie Coe

sought his opinion on the subject. He's 93 years old and retains a lot of wisdom. He was once the chief of staff for the President of Arizona State University. "No, David, I'm not a free spirit, as I've been very regimented in my life."

Laurie's father was a conscientious objector during WWII, but he still served in the medical corps. He saw action in: D-Day; the Battle of the Bulge; and the liberation of concentration camps. A fascinating background that may have pushed Laurie into the counter-culture.

She grew up in Long Island, New York. Her college boyfriend persuaded her to come west to San Francisco. This adventure in life was initiated by a long train ride across our country. The first winter spent in the commune saw them freeze as they collected wood that didn't burn well; it was green. Laurie took care of the goats. To reach their pasture she had to pass thru the home of the commune's chickens. She said they had way too many chickens. Questions abound in my mind about: drugs, outlandish clothing, and sustainability of the commune. Where did they get money? Did they actively protest against the Vietnam War? Did they embrace free love? Living in Scottsdale, Laurie often visits the Bay Area and

the commune stills exists. Yet, like all things, it must have gone through changes. What have they been?

In 1968 Laurie gave birth to her son in a commune. The commune north of San Francisco was named Table Mountain Ranch, and was near the town of Albion. This was the first birth at the commune and others, hearing of this success, came to have their children born there. She named her son "River." Laurie is a Toastmaster friend who I have invited to speak at Rotary. It will be interesting to see how the members react. Most have an engineering background which hints at a conservative political stance which is in stark contrast to the liberal attitude of hippies.

Laurie left the commune and came to Arizona in the late seventies. She worked at a hospital giving massages. While there, she met Senator John Rhodes. She sheepishly confessed to me she was once a Republican. She will probably hold back other secrets when addressing the Rotarians. I look forward to the drama of her speech.

Now, here is my after action report. We reviewed her notes before the meeting. Laurie had prepared six pages, single spaced. Her life as a hippie and how she arrived at this lifestyle is a big subject. She had way too much information for the time allotted to her. I crossed out some information that was not germane to the nuts and bolts of being a hippie and hoped for the best.

As members slowly drifted into the room and started to gossip, Laurie over-heard about Ken and Skip's big party last Saturday. "Wow," said Laurie "I know Skip and Ken and always see them as a couple, so at first I didn't recognize Ken." Rotary business is the first part of our meeting and then our speaker gets the stage. We had a good deal to talk about leaving Laurie fifteen minutes. Our meeting ended at one but went over a bit as her speech lasted twenty-two minutes. I helped her out with a few questions so she could gracefully close. It's a dynamic topic

everybody enjoyed. Harry came up and told her it was one of the best speeches we'd recently had. Michelle, another member was so impressed she and Laurie chatted for twenty minutes.

Laurie's "old man" was Allen Cohen, a poet. He was also the founder of the San Francisco Oracle newspaper. Allen was not into drugs. The only time he shot-up, it was unknowingly with a dirty needle. Allen got infected and died as a result. Laurie was with him for six years; Stan for twelve; Terry for seven; and her current relationship with Chris is now at thirteen years. Chris is 16 years younger than Laurie. I'm still vague on the subject of what it's like to be a hippie. Hopefully I can get a copy of Laurie's notes to flesh out this interesting story. I'm sure the commune had a creative name. Tell me about the other people who were in the commune. What were their talents and personalities? Did anybody get arrested?

The hippie life style or counter culture is a fascinating subject I'm open to learning more about. Joyce, another Toastmaster friend, recently told me the color of my aura…the energy field emitting from your head that some people can see, but most cannot. Mine's blue with some white. So what does this mean?

Gary Charlton

Gary was a high school teacher of Calculus and Environmental Science for thirty eight years in the Los Angeles area. He also coached basketball. Outside of school he was a hiker and birder. Gary's most successful season as a coach was in 1999 when San Dimas went 29 and 3 and was Southern Section Division Three Champions and one game from playing in the state championship.

We've hiked Mount Whitney and the Palisade Glacier in California. In Arizona we've done the Superstition Mountains and Havasupai Falls. Gary is also an official in the Sierra Club. He had one

particular hike which stands out in Alaska above the Arctic Circle. I did not go on this one. This arduous boggy hike of thirteen days was completed with two friends Brian and Bruno. They went through mountain passes of the Brooks Range with snow peaks of nine thousand feet and finished at the village of Kaktouik, population 290. One of the dangerous things was crossing rivers waist deep. On one occasion they locked arms because of the strong current. Gary has also hiked the Alps in Europe.

Accompanying his love of the outdoors is Gary's love of birds. Just in his neighborhood are: hooded yellow orioles; California towhees; mocking birds; and two types of hummingbirds, Allens and Annas. In Peru he has spotted 400 different species. Traveling to Ecuador he spotted the rare, Banded Ground Cuckoo. A local guide said he had not seen that bird in ten years. At Madeira Canyon in Southern Arizona he has seen the rare Aztec Thrush, eating choke cherries. Then in downtown LA, a bird from Siberia was located. A Red Flanked Blue Tail, drew such interest that crowd control was necessary. Who knew such passion existed for our feathered friends.

Roy Sinclair

I first met Roy at the finish of a race in Scottsdale. After the raced and a drink of water runners talk to each other. Roy approached me, found out we were in the same age group and thus began a long lasting friendship. I've never beaten Roy in a race. He doesn't like the word, "beaten" and says "Sometimes you finish ahead of me."

Roy is an immigrant from South Africa. It took him ten years from his date of application to be accepted into the United States. This coincided with Nelson Mandela's rise to the Presidency in 1994. There are many categories for immigrants to be placed in. If Roy was a heart surgeon or some such needed occupation, his waiting time would have been shorter.

The Junior Chamber of Commerce ("Jaycees") is an organization focused on business interests for people under age forty. As a member and senior officer in the banking field Roy had traveled the world and been to America on several occasions. He also attended Jaycees world conventions in: Osaka Japan; Taipei, Taiwan; and Montreal, Canada.

His brother Sandy had entered the U.S. on a student visa in 1958 in order to become a missionary. Later in the mission field, traveling to Zimbabwe, he and Roy visited an extremely remote area that makes Arizona's Navajo Reservation look like New York City. Here in 1971 they encountered two elderly native women who had never in their life seen a white man.

Sandy's life as a missionary crashed when he and his wife divorced in Phoenix on November 3, 1982. A strange quirk of fate saw Roy divorced on that same date in Johannesburg. Sandy's church would not allow a divorced person to be a religious leader so he turned his efforts into becoming a wedding photographer. Later at the urging of Cathy, his second wife, Sandy entered the nursing profession.

Roy's close relationship with his brother is one of the three reason he came to the United States. Reason number two was Katie, his daughter. Roy's ex-wife had married an American and now lived in the United States with Katie. Reason number three was the changing political climate in his native land. With a strong mind, loads of patience, and a firm resolve to better his life after ten years of waiting, Roy achieved his goal and in 1994 arrived in Phoenix. His hobby as a runner saw him welcomed into the running community. He's been of invaluable help in editing this book and catching my mistakes.

Joe Reilly

To keep my hand in the mix I teach once a semester in Joe Reilly's class. I have been doing this for 12 years. It's fun. No grading of papers and

Joe and Marcia Reilly: Besides being a teacher, Joe is a civil war re-enactor. Here he stands with his wife Marcia

preparing lesson plans for the next day, because I wouldn't be there. It's a one shot deal. He was my excellent student teacher in 1998 and we've kept in contact.

Teaching certainly keeps you on your toes. The energy and curiosity in the room is electric as I enter to teacher at Joe's school. Subjects are my recent international trips and the importance of public speaking. The trips are explained in pictures I have taken displayed via power point and my projector. "Off the beaten path" was the title for photographs of Croatia and its neighbors. Students asked interesting and unpredictable questions. One requiring some thought was, "What inspired you to travel?" Collecting myself I replied, "My parents traveled every summer from their home in Oklahoma to visit their parents in Pennsylvania and, of course, took me and my brothers." Reaching the age of twenty I extended travel to crossing the ocean. It's not cheap, but fortunately I have a wife who is smarter than

myself. To date we've been to thirty-three foreign countries."

I then jump to a different subject. Many in the room don't understand why my public speaking club is called Toastmasters. When somebody gives a good speech, those in the audience raise their glasses and give a toast in recognition of the person's good talk. Toast in this context has nothing to do with burnt bread. I asked students to stand if a parent's job required them to speak to others. Since Joe teaches at the Mesa Academy, which enrolls only elite students, many stood. By contrast almost nobody had a father who was a truck driver.

September 20th 2018 brought another visit to Joe's school. Before the visit I think to myself that being on stage for fifty minutes in a classroom is different than five to seven minutes when I face my Toastmaster club. The extra time relaxes me and I can think better on my feet. A crowded classroom of kids is not as intimidating as a room full of fellow adults.

Three classes of fourth graders ask me to explain what Rotary is. I then show pictures of the leadership camp for high school students in Heber Arizona. Twelve foreign exchange students are interacting with sixty high schools students from throughout the state. The Rotary club I'm in has missed out recently on sponsoring an exchange student. However, we got our act together and this year are sponsoring Flor, a 17-year-old from Argentina.

Flor had to give a speech to our Rotary club. I asked Joe's students what they though she should speak on. Then I challenged them to think about being an exchange student themselves. They are in a foreign country and are to speak to a Rotary club in Italy. What would the Italians want to hear? The inescapable logic is… Arizona. Thus Flor will probably tell my fellow Rotarians what life is like in Argentina.

This then sets the stage for my power point

presentation on the geography, history and culture of Arizona. After the three classes of fourth graders Joe's schedule gives us a break. I needed it. My throat is sore as I'm not used to talking so much. Teaching involves your total concentration on so many levels. It does take a physical toll.

Joe's last class is full of bigger kids, eighth graders. They've been at the school for five years and being top dogs they have a different sort of superior attitude compared with the fourth graders. Here my subject shifts to exotic Kilimanjaro.

To introduce the subject I have a copy of five lines from the Julie Andrew's song, in the movie, "The Sound of Music." Entering the room the students hear an instrumental rendition of the song. They sense something is up with the guest speaker. I have Joe select a few brash boys to sing the five lines. "Climb every mountain, ford every stream, follow every rainbow, until you find your dream." On the last two words the four boys drop to their knees and spread their arms out. The class erupts with applause and with this grand introduction, I am up on stage.

A key component of any Toastmaster speech is a call for action. "Give blood" or "go vote" are examples. Our Toastmaster club came up with an acronym, W i i f m, pronounced "whip it" which means, what's in it for me. You can't just stand up there jabbering about how great you are, you need to touch the audience. I'm confident that with the fourth graders I've achieved this. I've increased their knowledge of the state they live in, and prodded them to think about being a foreign exchange student.

For the eighth graders my power point explained I was a runner. When I couldn't run any faster in races, I turned to hiking and climbing mountains. Local peaks included Humphrey in Flagstaff, numerous ones in Colorado, and Popo in Mexico. I provided this as background to my dream of eventually going to Africa for Kilimanjaro. At the close of my speech I said, "I realize Kilimanjaro is out of your reach now.

It's expensive, and high school and college expenses are more important. Taking a bus ride deep into Mexico to climb Popo is also out of reach. But going to Flagstaff or running in a race are within reach.

Ever mindful of how important Joe's principal thinks Toastmaster skills are Joe had prepped his students with forms to evaluate me as a speaker. Reading their comments is fun.

"I loved the entire speech/pictures. Loved the topics because it is so relatable."

"I like how he explains words we might not know."

"I liked the maps… cool quiz"

"Very interesting to learn about our state. I loved how clearly he spoke."

"Pauses are good, keep me on the edge of my seat. Could speak with a little more enthusiasm."

"Quiet in the beginning but gradually got louder, nice pictures, lots of information, kind of slow but good pauses."

"Like how he asked questions… loved the puns."

"You kept control of the class."

"Gives students a chance to do things he does."

"Very cool pictures of water, the waterfalls are very pretty. Rotary is a cool idea."

"I would like to know the difficulties and problems that you/the group had."

Chapter 21: Spain and Portugal

*"For my part, I travel not to go anywhere, but to go. I travel for travel's sake.
The great affair is to move." – Robert Louis Stevenson*

Spain

Much of our life is governed by habit, which does not involve any thinking. Periodically we need to plan ahead and have creative choices. Do I need a jacket for a trip across the Atlantic Ocean? Living in Arizona we often don't think about packing a jacket when traveling, because we seldom use them. Visiting Spain in 2016, it probably has a similar climate. We've been checking the temperatures in the newspaper almost daily. It's not the dead of winter for our vacation, only October. Anyway I'm packing one in the bottom of my suitcase.

We are given a list of the 38 other people with whom we'll be sharing this adventure. Two stand out because they are from Prescott and will also be sharing the post trip extension to Madeira. Learning all the names of our fellow travelers will be a daunting task for me, but at the start I will be

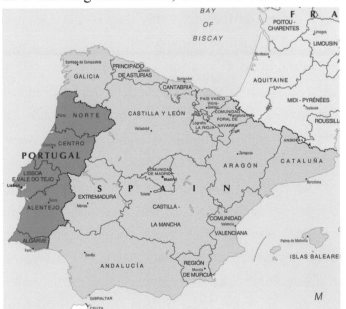

trying to place the face with the name for Kathleen and Marcia, fellow Arizonians. While our itinerary sees us visiting Spain, Morocco, Portugal and the island of Madeira my next Toastmaster speech will probably only focus on one of these destinations.

At the end of our trip Filipa, our talented program director, told our group of forty travelers what a perfect world would consist of: the police would be English, the cooks French, the mechanics Germans, the organizers Swiss, and the lovers Italians. The other side of the coin is a nightmare with the cooks being English, the mechanics French, the police Germans, the lovers Swiss, and the organizers Italians. A creative twist that brought chuckles to her appreciative audience.

Moving through crowds it was easy to see Filipa because she was six feet tall. In addition to Filipa, at each city we visited, there were local guides. All of them were very good, except Ramon in Malaga who was horrible. He was in dire need of Toastmaster training.

The beginning of our trip was Sunday, October 9th, 2016 in Madrid, Spain. This capital city is the second highest in Europe and sits in the center of the Iberian Peninsula. In roughly three weeks, we will visit eight Spanish cities, one in Morocco, and four in Portugal. This will prove to be a daunting task requiring a good amount of physical endurance putting up with countless bus drives and somewhat strenuous walking. It all proves to be a wonderful adventure we share with forty fellow Americans,

perhaps too many people. I come home with 360 pictures. I edit them to a show of Spain (100 pictures) and one of Portugal (70 pictures).

Madrid has an excellent very modern airport requiring us to walk a lot to retrieve our luggage and meet our guide. We are groggy, like stumbling drunks, yet the walk is actually somewhat beneficial as we have endured a two hour flight from Phoenix to Dallas and then a monster nine

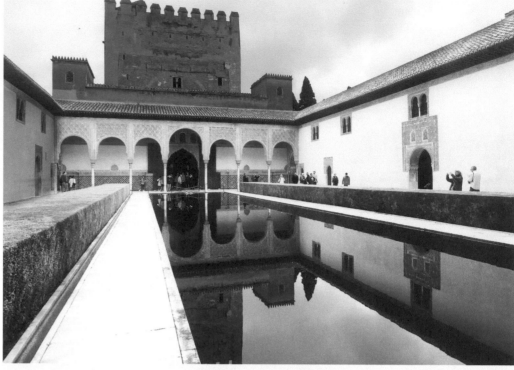

Court in the Alhambra

hours across the Atlantic Ocean to Madrid. You have got to be tough to be a traveler or are we tourists? More on this subject later.

Arriving in the morning and after brief orientation, we are given free time to acclimatize and adjust our bodies to the eight hour time difference. Leaving a supermarket in the evening I find myself climbing up some marble- like steps. I was wearing my sandals, carrying too much stuff and not holding onto the hand railing. Without any warning, I suddenly slip and fall. I'm embarrassed but not hurt. Unfortunately the bottle of wine did not survive. For the rest of the trip I carefully watch my step and avoid another possible mishap. I'm acting like an old man, feeble and forgetful, yet I resist this image and don't feel like one.

We were warned about pickpockets and do not fall victim to the clever Spanish thieves that prey on tourists. Only one of our group suffered this fate. Judy, who just got married for the first time at age 60, got her pocket picked. Her husband Bob did not get his pocket picked but did get bumped by a scooter

crossing a street. He was not hurt but said he had a big purple bruise on his thigh for the rest of the trip, a small Spanish souvenir. However, it must be mentioned that for the entire trip, we found the local people to be friendly and interesting.

Monday we have a bus tour of the city. Afterwards we meet Karen and Jim for lunch. She is an artist and he's a retired airline pilot. They live in Alabama on a farm and in La Jolla California. We gradually meet others. Of the forty, only thirteen are men and I try and learn their names first, establishing a sort of brotherhood. It's in this quest I bond with Gary because we both were stationed in Germany in the late sixties. He was in a tank company. Later in the trip I dance with his wife Shirley in Malaga. A musician has a small camera crew filming some candid shots of people to promote his new song. We are given headsets to hear the music and I do my best impersonation of a flamenco dancer. Also in our group are Kathleen and Marcia. In her youth Kathleen hitch-hiked across the United States twice and now rides her horse Prince George in Prescott

Yes it did rain in Spain

Americans allied with communists supporting the Republicans vs the Nationalists supported by Nazi Germany and the Italians. The Nationalist leader Franco won and became a dictator ruling the country until 1975. I see politics and history blended together, as bad as Trump is he's probably not a Nazi.

Wednesday we travel to Toledo for the day but will find our hotel later in Granada. It rains. No sun, no good pictures except inside the oldest Jewish synagogue in Spain. We have dinner with Tom and Barbara. To me his voice, looks and mannerism are like the actor Tommy Lee Jones who starred in the movie, The Fugitive. Susan disagrees and thinks he resembles Bernie Sanders. Despite his appearance we think Tom is a conservative Republican. We stay clear of politics and have a good dinner with them in Granada.

The number one tourist attraction in Spain is the Alhambra. The sprawling Moorish complex is on a hilltop overlooking the city of Granada. The maze of palaces, courtyards and fountains was built in the thirteenth century to resemble paradise on earth. It was also a fortress, a little town in itself, at one time hosting an army of forty thousand. Needless to say, very big. Our tour was booked three months in advance. We bring our rain gear but fortunately it only turns into an overcast day. Even without sun I get some good pictures. The winner is of a tower seen in a long narrow reflecting pool. At the end of our fascinating visit, Lucia our local guide, tells us we have walked two miles. It didn't seem like two

Valley. Group dynamics in play here are fascinating to see develop.

The famous museum in Madrid is the Prado. It's very big and we were tired. We did spend some time trying to locate Hieronymus Bosch's masterpiece, the Garden of Earthly Delights. Along the way to this work of art we did glance at a few other paintings that take your breath away, but my memory is foggy to recall who painted what. There was a sizable crowd around the Bosch work. Here's what the guide book says, "It depicts earthly paradise on the left-hand panel and hell on the right. The center panel features the Garden of earthly delights, a world given over to pleasure and sin, especially lust, painted with meticulous realism." Sadly I got no pictures. Unfortunately, photography inside the museum was not allowed.

Rumor had it that those involved in the pre-trip to Barcelona are Trump supporters… ugh. Tuesday Filipa gave us a very even-handed discussion about the Spanish Civil War that tore the country apart in the thirties. Atrocities on both sides.

147

miles because at every turn, you gazed at the intricate cursive designs on the walls and around a corner you looked down at a lush green garden.

Fortunately, there is a limit placed on the number of people who can visit the Alhambra each day. Eight thousand seems like a lot, but it is a big place and during our time there, the crowds were not massive. Later in a visit to a church in Lisbon we did have a problem with a press of people in a narrow hallway. People from two gigantic cruise ships were there. You couldn't move forward or backwards, trapped for an unreasonable amount of time with panic setting in. Filipa to the rescue, shouting at somebody and somehow gradually the mass of humanity began to crawl forward. It does help to speak the local language.

At breakfast we meet a "pepper pot". Hathi escaped Vietnam in 1972 just before the war ended. She's rich, a bit aggressive and very animated. Hathi lives part of the time in Vermont and the winters in Florida. She occasionally sees her second husband as he spends time hunting in his ranch in South Dakota. At 62 she is the second youngest woman in our group. That honor belongs to Christine who is 37. She is traveling with her parents. Christine lives with them in Long Island and commutes to work in downtown Manhattan. I got along with both of them but spent better time with Christine lining up photo shoots with different backgrounds of historical places we were visiting. Of the thirteen men I turn out to be the youngest at age 71. Ralph was in second place at age 73.

Cordoba is our next day trip and at the end of the day we'll be in Torremolinos and the Mediterranean Sea. Cordoba was once the largest city in the world shipping olive oil and other products to distant lands. Its ancient mosque called the Mezquita is the third largest in the world. It contains 850 soaring red stripped colored granite and marble arches. I asked somebody to take a picture of Susan and me outside

Stain glass windows in Gothic churches are stunning features throughout Europe

in the courtyard filled with numerous orange trees. The picture turned out but I was not happy with the composition, we're centered and too far away.

Torremolinos is a tourist mecca for the English. No ancient history here, just fields of sugar cane until the English discovered the balmy weather and the beach. Then a boom of high rise hotels started popping up. Spain has a population of 47 million with 72 million visiting this country each year. Escaping their inhospitable winters are citizens of England and Sweden. We luck out and get an awesome room at the Hotel Don Pedro on the third floor with a nice size balcony overlooking an inviting swimming pool, palm trees and a tiny peek at the ocean. Susan is in her element here walking along the beach at dusk, picking up a shell here and there. Gary and Shirley join us on our balcony later as we share a bottle of wine, sandwiches, and good company. They live in the Bay area and he's a retired middle school

counselor.

Morocco is not too far away and the continent of Africa beckons us to visit for the day. Most of us think Gibraltar is at the tip of Spain, but it's not. It's just a bit east of Tarifa which at the tip. Its here in Tarifa we take the one-hour ferry ride across the straits of Gibraltar to Tangier and Africa. High on a hill in a parking lot we ride camels. You sit up high and just as you're getting used to the swinging gait, the ride of 12 strides comes to an abrupt end. The handler obviously sees another tourist waving money in their hand eager to get their chance to have their picture taken atop the queen of the desert. I get a great picture of Dennis and Jim waving their arms high in the air sitting together atop a camel.

We walk the narrow twisting pedestrian streets with houses almost touching each other making it impossible for cars to drive. Susan gets a good picture of a vegetable market. We have a fantastic lunch in an opulent hotel. Continuing our single file stroll behind our local guide, street vendors follow alongside peddling their wares: tiles, cloth, and jewelry. Susan buys a small leather camel.

Not all of our group went on the excursion to Tangier. You need to pace yourself on this type of trip. One can't do everything and rest is an important element of travel. Tom who accompanied us on this adventure said to me when we got back to our hotel, "I've never run a marathon but I feel like I've run one now." Ken didn't go and the next day I asked him how he spent his day. He grinned and told me he and his wife Barbie walked west along the beach to the next nearby town. It was a nude beach. Not everybody shed their swim suits, but Ken showed me a picture of a woman who did. It was an impressive shot. While I admire naked women, I'm glad we went to Africa.

Malaga is a short drive east of Torremolinos and our next visit. This is Picasso's birthplace and a popular winter holiday site for the 19th Century wealthy. Those planning these trips can't always anticipate what's going to happen in local areas. Our visit was on a Sunday and we got to witness a religious parade. The street was packed. We stood in back of the crowd and craned our necks to see a large heavy float with the statue of a saint carried on the shoulders of twenty men. Blocked by so many people, I couldn't get a picture of the float. However, I was able to use my zoom lense and capture the solemn face of a man with white hair and his shoulder supporting the float. A much younger man right behind him also had a serious face. They seemed to be in a trance.

We next drove to a small village and had a home-hosted lunch. Due to the size of our group, it was divided up, going to different houses. Angelines was the only local who spoke no English. Susan and I volunteered to go there and we were joined by Ken and Barbie; Linda and Bob. After a warm greeting, Angelines took great pleasure in showing us her home. Then she had us sit at a table and retired

Cordoba mosque/cathedral

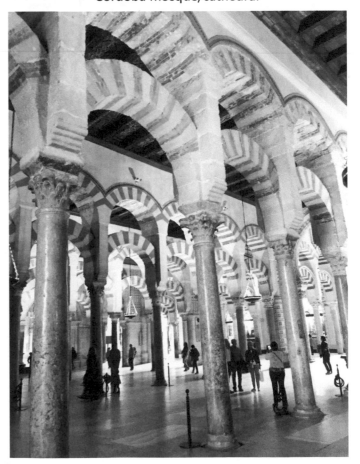

to the kitchen. At the end of the meal, Angelines joined us for coffee. Susan had taught in a Hispanic neighborhood in West Phoenix and together we were able to remember many words. With a friendly atmosphere, a good meal and a couple glasses of wine, everybody connected in a very nice manner. It was humbling to see a different culture on an intimate level.

Seville is our next hotel stay. On our way there, outside of Ronda, we visited a bull ranch. In Susan's opinion, some of the trip highlights were here and later at a horse farm. Rafael gave up a successful construction company at age 30 to become a matador and later started this bull ranch to supply animals for this well-known pastime of Spain. It's rather a late age to start this dangerous activity but he talks to us after our tour and is very charming and personable in replying to our questions. Something most of us are unaware of is that 70% of Spain is not in favor of bullfighting, thinking it barbaric.

Dinner that evening had Susan retiring to our room while I stayed up and chatted with Gary, Dennis, and Jim. Dennis has run 50 marathons and just recently retired as a lawyer. He lives in the Bay Area with his partner Jim. Jim has walked the Camino de Santiago in northern Spain and Portugal.

Susan and I remind ourselves this is not a vacation but a trip which is a test of one's stamina and endurance. Our constant bus rides fortunately are broken up every two hours with bathroom breaks. Then there is the continual packing and unpacking of our suitcases. We look forward to the post-trip extension, the island of Madeira where we will stay for five days and have more free time to ourselves. This will be more like a vacation.

Tuesday I start the day off with a small cup of expresso to supplement my well-chosen breakfast items displayed in our buffet. Migual is our local tour guide for Seville. The last one we had in Ronda was Ramon. Susan was aghast at Ramon's constant repetition of needless verbiage. On the other hand, Migual is informative, relaxed, confident and has a keen sense of humor. At one stop where we are gathering together after a long walk, he looks around counting heads, and says, "Oh well we do not have everybody, we can pick up a few from another group."

The old town of the city is packed with tourists. For the first time, I dress like one and wear shorts so I can blend in with the crowd. On the steps of an historic plaza we take our obligatory group picture. At my suggestion we take three: first all forty of us;

Castle at entrance to Lisbon's harbor

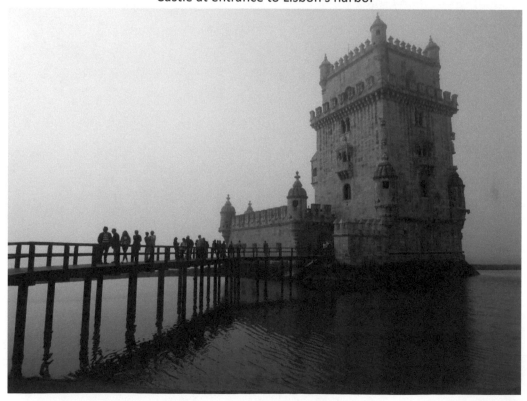

second, the twenty seven women; and finally the minority shot, thirteen men. I try to help moving some around so we can see everybody's face. Some are hesitant, I suspect they're not listening, caught up in their own thoughts of the tour today. Maybe it's my authoritarian coaches' voice that turns off adults. Finally, a few short people move so their faces are not blocked and all the three pictures are fine.

We visit the Santa Maria church where Christopher Columbus is buried. I finally get a decent shot of rich-multi colorful stained glass windows. Bright light from outside challenges my camera. However, today the God of light is with me and quickly checking my digital camera, lo and behold, I have a good picture. We retire to our room for a siesta, resting up for tonight's flamenco show. Who knows maybe I'll get asked to dance?

The soul of Spain at eye level, the awesome flamenco show is, to me, one of the trip's major highlights. Somehow we get seats in the first row at eye level with the raised stage. What a view, up close and personal… the flashing skirts, loud pounding feet, twirling bodies with outstretched hands and twisting fingers, the clicking sounds of castanets all accompanied by piano like guitar music and two operatic singers. It all blended together in my mind, excellently choreographed. I recognized some of the music coming from the opera "Carmen." Imagine those courtside of an NBA basketball game and a player leaps into the stands to catch a loose ball colliding with a spectator.

I mentioned this possibility to Kathleen who was sitting next to me when the male superstar was strutting about the stage and coming dangerously close. Spellbound, she replied, "If this happens I might take him home with me."

Portugal

We were unexpectedly stopped at the border entering Portugal. Our passports were checked. However, they spent more time examining the driver's log book. Seems they are required by law to stop every two hours for a break.

Portugal is the world's number one supplier of cork. While the landscape is not new compared to Spain, we now have a new language, sounding somewhat like an eastern European one. Yet some words are similar to the land we just left. "Bon de ah" is the greeting you give someone in the morning. If somebody does something nice for you the reply is "obrigado" thank you.

Double it and add thirty is the calculation necessary to find out what the temperature is.

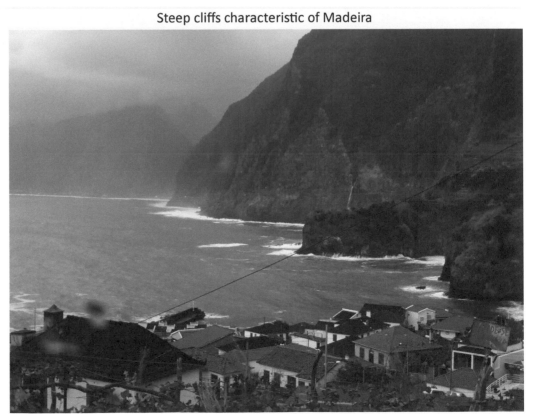

Steep cliffs characteristic of Madeira

151

Normally our trip saw us in the seventies and I only used my jacket when it rained, yet on the high point on the island of Madeira at five thousand feet it was nice to have my jacket with me.

Lisbon is a fascinating city built on seven hills with an excellent ocean harbor. We arrived in the evening, walking the area next to our hotel, so we would not get lost at night. Karen joins us, as Jim decided a good bath in the hotel room was more desirable. The girls decided on ice cream because the store Susan spotted had been recommended by one of our friends. A sign inside told us they also had stores in New York, London, and Paris. It was delicious ice cream. Of stronger interest to me was the shine on the pedestrian walk way caught from the lights above, reflecting on the marble-like surface of a black and white tile pattern. So far during the trip I have not gotten any good city night time shots. This changed in Lisbon.

The next day Filipa took us on the official city tour. Susan was able to spot some people that would make an interesting study. Ever the unobtrusive spy, I crouched somewhat hidden behind a wall or some such cover and using my zoom lens captured a man getting his shoes shined and an artist intent on sketching a nearby historic building. I searched for a couple at a sidewalk café sipping coffee and intensely looking at each other, but couldn't find such a scene. It's supposed to be a romantic city, so in the following days I continued my search.

Dinner that night saw us sitting next to three women from Pismo Beach California. They had some problems getting to Spain. They flew LA to Phoenix and arrived late due to some mechanical problems. They missed their connecting flight to Philly and had to spend 9 hours in the Phoenix airport. Also at the dinner was Filipa's husband and their two children. He was fascinating, a journalist and business consultant. Throughout our tour I've gotten to know Filipa very well and it's comforting

to know she's married to a smart man.

Sintra is an easy pleasant drive outside Lisbon in the hills. According to our guide book, "the well-traveled English poet Lord Byron called the town 'the most beautiful in the world." Our daughter Julie visited Portugal last year and we can compare notes when we see her in San Diego this Thanksgiving. Speaking to her on the phone she agreed with Lord Byron. I sent her a good picture of Susan standing at the bottom of a narrow hilly street and Julie excitingly said, "I've been on that exact street!"

Island of Maderia

Saturday, the next day we fly 600 miles to Madeira. It is the same latitude as San Diego but of course on the other side of the globe. Filipa our tremendous guide and program director leaves us. Her job at this point is finished and 17 of us are on the post trip extension. She really connected with everybody, knowing all 40 of us by our first names the very first day. I captured her charming smile and personality in two pictures which I will send her. On one bus ride she reminded everybody before we left the hotel, "Now did you check your room and remember to bring everything?" Once she had a tour from Brazil and as she asked them the same question, two people said they forgot to check under their bed. For some reason they weren't able to use credit cards and stashed their cash under the bed for safe keeping. Of course the ever diligent Filipa called the hotel and the money was waiting for them at their next destination.

The island of Madeira is 34 miles long and 14 miles wide, and due to the many steep hills has 198 tunnels. Our local guide Maria comments, "And that includes the old ones." The island has over 80 inches of rain a year, and you can understand why Madeira has a microclimate. This means the weather is very unpredictable.

Many on the island could not find work and

immigrated to Hawaii bringing with them a small guitar called Braguinha. The Hawaiians call this instrument a Ukulele. Life on the island took a dramatic change in 1964 when an airport was established and tourists discovered this wonderful place, and it received the nicknamed "The Floating Garden of the Atlantic". Our guide said, "This is to Europe what Hawaii is to Americans".

We were on the seventh floor and for some reason the height did not bother me. Our hotel overlooked the Atlantic Ocean and had a big swimming pool I used. Getting on the elevator one day we joined two beautiful young women. I sensed they were English. They seemed startled and looked at us, unsure who we were. Normally you would use the Portuguese greeting of "Bon de ah". However, I somewhat surprised them and said, "Hello" paused and remarked, "English is the second language here." They smiled and laughed.

While there are an untold number of churches in Spain and Portugal there are also countless numbers of statues of topless women. The capital city of Funchal in Madeira has a very striking one in the center of downtown. It was raining and we were in a moving bus. I wish a picture was possible yet it wasn't to happen. I wasn't able to find out what she stands for, but I can only guess it's to honor the thousands of British tourists which are the backbone of the economy on the island. Unlike other statues I saw on the trip, she proudly displayed erect nipples.

Breakfast here had a chef who made an omelet to your suggestions as to ingredients. This was something the other good hotels hadn't offered. It being Sunday, champagne was also offered. Ah the good life. Today Susan had the day all to herself as I joined the group and toured the west side of the island. It was good to have some time apart.

Unlike the sunny day of our arrival on Saturday, today it periodically rained. We saw the second highest sea cliff in the world and many of the island

A worker cuts out a pattern at a lace factory

tunnels. I was impressed as to how green the island is and covered with tall lush trees giving me the feeling we're in a jungle. At one of our stops at a small local café we were served the popular local drink, "Poncha". It was made fresh, right in front of us. A girl squeezed fresh orange juice, lemon juice, added honey, rum, and crushed ice. It tasted good and had a bit of a kick to it.

Dinner saw us joined by the two Prescott women, Kathleen and Marcia. We had pasta and suffered thru some very loud familiar American music. Still it was a great day, more of a vacation than an arduous trip of go-go, we were used to for the last two weeks. Our air-conditioning is too cold and too loud, so we turned it off and opened up the balcony. This brought in gentle comfortable air and the sound of car tires splashing on water. A gentle sound easy to fall asleep to.

Monday, 17 of us board a small van and proceed to a city tour of Funchal, and intermittent rain. A covered market has colorful displays of fruit and on another floor fish are being sliced into smaller portions. We also visited an embroidery shop where high end cloth is prepared with delicate stiches. We didn't buy anything. It reminded Susan of her grandmother's cross stitched table cloth that we have. That evening we again dine with our Prescott friends. This time in a nice Italian restaurant with no

distracting loud music.

Tuesday brings Susan along for a tour of the east side of the island. Today there is no rain. We ascend to the second highest peak on the island and I'm glad to have my jacket. Lunch was in a beautiful garden restaurant. We had a private room at the top and delicious fish.

Wednesday no tour, and the rain returned. When it stopped we did some local shopping, Susan bought a cork purse and I bought a maroon cork belt. Naturally when cork is mentioned you first think of an inflexible stopper on a wine bottle. However, as we have learned, cork can be somewhat soft and plenty pliable.

Thursday was a long day flying home on three different planes. Friday jet lag strikes and we recover from a wonderful adventure packed with a ton of experiences. I now think of a speech for Toastmasters on the difference between a traveler and a tourist… any suggestions?

We ate well during this vacation. Upon returning home, a test of my blood sugar reveals my health did not suffer from the meals there. The virtue of a Mediterranean diet I suppose. I can't remember all the sumptuous breakfasts and fine dining we had, but two soups stand out: a creamy garlic one and a wild variety of herbs in a tomato soup.

Ken and Barbie are from Tucson and at the close of the tour they did not go with us to the island of Madeira nor did they fly home, they spent four days alone without a guide exploring Lisbon. We caught up with them in the airport when both of us were flying back to the United States. Barbie graciously gave Susan some medication for her cold. They also told us about a fabulous fish restaurant in Lisbon, "Re ba door." It's been in existence since 1947, an important recommendation since restaurants don't have a long life expectancy. Good advice since Julie or us may return to this charming city.

I make mention of my passion for photography and I received some glowing compliments from my fellow travelers, but Susan also has some excellent pictures. It doesn't seem fair that a phone which also has a camera can take a picture to the equal or better than a regular camera, yet it happens. The other factor in play is the eye of the photographer. Many times Susan saw something I overlooked. Reviewing the many pictures 19 of them are rare unique glimpses of our exciting travels. Besides her phone she also used her e-pad. It warms my heart we have such a beautiful record of our trip that covered so much. The close of the trip ought to include the financial record, it reveals the following: $10,000 to Grand Circle which includes air fare; $200 for tips; and $600 for meals and gifts.

A post script: No mere tourist was Washington Irving who in 1829 was a resident of the Alhambra. Fascinated with its mystical charm he wrote a bestselling book, Tales of the Alhambra. I quote his lyrical prose. "I have sat for hours at my window, inhaling the wetness of the garden, and musing on the chequered fortunes of those whose history is dimly shadowed out in the elegant memorials around. Sometimes I have issued forth at midnight, when everything was quiet and have wandered over the whole building. Who can do justice to a moonlight night in such a climate and in such peace! The temperature of an Andalusian midnight in summer is perfectly ethereal. We seem lifted up into a purer atmosphere; there is a serenity of soul, a buoyancy of spirits, an elasticity of frame that renders mere existence enjoyment."

Chapter 22: Athletics

As a coach, I admire athletic achievement.

Proudest Athletic Achievement

The Olympics and the World Cup capture the attention of the world. As individuals we may not be world-class athletes but, in our own way have experienced memorable moments of personal athletic success.

Roy Sinclair

A question I often put to my friends is: "What's your proudest athletic achievement?" Roy Sinclair's answer harkens back to his native land, South Africa. His answer might be a race he's done in America, yet I think it might be a race that Americans are largely unaware of, which in his country was run on a national holiday. "I didn't think it was possible to

Roy, John, Elaine, Diana

get so tired," says Roy recalling his first Comrades Marathon. It's not really a marathon – it's more than two in a row, covering 56 miles. Comrades has the same stature in South Africa as the Boston race has in America, long standing traditions and huge crowds supporting the runners.

When Roy realized that within a fast walk he could get in under the mandatory cut-off time of eleven hours, he wondered why a guy with a TV camera on a motor bike was focused on him. A glance to his right revealed a legendary runner, Wally Hayward. In the thirties he had won the race every time he ran it. Now at age eighty Wally was running it for the last time. Roy's work-mates had already finished and were in the therapy room receiving a well-deserved massage and shouted out, "Look there's Roy on national TV!" Fifteen minutes of TV coverage made his mates jealous. One remarked, "I've run it over ten times and have never been on TV, and here's Roy running it for the first time. There is no justice."

Ray Hayes

Ray, my fellow coach at Dobson High School, spoke with pride of running a 2:26 marathon at Chicago. Running alongside him was the world's number one woman runner, Rosa Mota. They finished in separate chutes.

Not everybody responding to my question of what's your greatest athletic achievement talks about running. A track coach told me when he was playing high school basketball, he blocked a shot by

Ray Allen. For those unfamiliar with professional basketball, Ray Allen became a very talented player in the NBA.

My Best Race

Running the Boston Marathon and climbing Mount Kilimanjaro sound impressive to the average person. I've done both, but they are not the high point of my athletic achievement. Breaking three hours in a marathon was the hard- earned goal I cherish most. If you're not in the running community, this is not really meaningful. The time you run in a race is often more important than where you finish or who you beat. Most people can understand the time it takes to run a mile. So your pace per mile might make sense. My first marathon from Carefree to Scottsdale saw me finish with a 3:27. My pace per mile was 7:55.

I improved my time the next couple of times, but it wasn't until I ran the Sacramento International Marathon that I achieved praise and recognition from my fellow runners. It was there I joined an elite group that have broken three hours in this demanding race. The race started at Folsom prison and finished at the capitol building in Sacramento. My training in preparation was demanding as I logged 60 miles a week for two months. The weather was very good for running a marathon, it was cold, forty-two degrees at the start and forty nine degrees at the finish. My pace per mile was 6:45. Besides the joy of looking at the clock which read 2:57.47, the next best thing at the finish line, was the hot tomato soup. It was delicious, of course, you had to run twenty six miles to really appreciate it. Thus, at age forty I had achieved my greatest athletic accomplishment.

John Conant

A fellow runner who I often competed with in road races, as we were in the same age bracket, was John Conant. John in 2015 at the age of 71 hiked the Appalachian Trail. He hiked through fourteen eastern states starting April 28 and finishing September 1st. Those four months resulted in 124 days of hiking a half marathon of thirteen miles each day. There were only twenty-three days it did not rain. So much of the trail was rocks that he went through five pairs of shoes. He fell a few times and broke two different toes on his left foot and suffered a hernia.

John was accompanied by a friend for the first

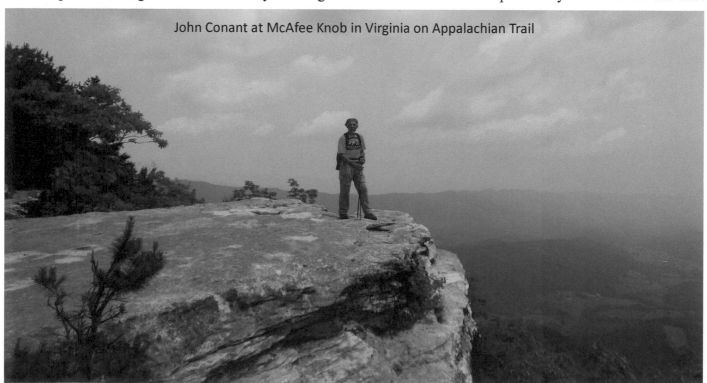

John Conant at McAfee Knob in Virginia on Appalachian Trail

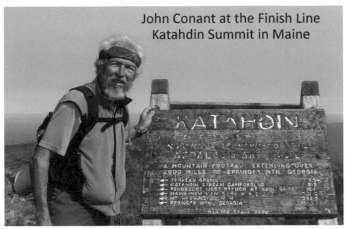

John Conant at the Finish Line
Katahdin Summit in Maine

month and met a lot of German hikers along the way. His wife, Dianna, and their trusty dog were his support crew meeting up with him every five days. This allowed him to sleep in their trailer, but generally he slept on the ground in his tent. John avoided the shelters in the National Parks because they were very crowded and had mice scurrying about at night. Bear and snakes were also hiking the trail. On one occasion John was five feet from a bear. Lucky for him, they passed each other in peace.

John started in the south and hiked north. The first state, Georgia was horrible. There were no switchbacks going up mountains and there were fields of poison ivy next to the trail. He encountered few flat areas in the entire hike as it was rocks and more rocks. It also rained a lot. The last state, Maine, John felt was very difficult as the mountains were higher. Once he looked at himself in the mirror and was shocked at his appearance. John lost forty pounds. He said he was just skin and bones resembling a survivor of a concentration camp during WWII. He ate a lot, but was burning up the fuel every day. To me this is an outstanding athletic accomplishment, requiring tremendous mental fortitude.

Bob Anderson and Dave Stantus

Besides my friends in the running community I often join my neighbors on a Wednesday for lunch at our local watering hole, The Hungry Monk. It's a short walk from our community. Pushed with a little prodding from me, two of them told stories of their greatest athletic accomplishment.

Bob Anderson is a golfer and within a six month span made two hole-in-ones. On the Scottsdale Silverado course hole number two at 150 yards Bob wasn't able to see the ball go into the hole because it was hidden by a sand trap. He used a six iron. Bob was ecstatic and on hole number five he made an eagle. Using a nine iron, his second shot traveled 120 yards. His final score that day was a 76, par being 70.

His second fantastic shot was six months later, when he again achieved a hole-in-one. Again he couldn't see the ball go into the hole because it was an elevated green.

Dave Stantus played baseball at Gonzaga University. They were playing in-state rival Washington State, rated number one in the nation at that time. Gonzaga was ahead by one run in the bottom of the ninth inning. With two outs Washington State had the bases loaded and was threatening to win the game. Dave was playing right field. The count on the batter was at three balls and two strikes. Dave sensed what was going to happen and started running even before the batter hit the ball. It was a "wounded duck" up in the air over the infield and sinking fast. Dave dove head first with his arm stretched out, caught the ball and ended up with grass in his face. He then said, "The whole team carried me off the field."

David Santiago

David's pool service takes care of the pool in our complex. We enjoy talking when our paths cross because he is a gifted athlete. He long jumped 21 feet in high school and afterwards has run a 10K in an impressive time of 30:12. Looking at a pace chart this indicates an average of 4:55 per mile. David is a member of the Seventh Day Adventist religion and has never taken a drop of alcohol in his life. He also observes Saturday as a day of worship and as a consequence, could not participate in the state track

Bob with prized photograph of Earnie Banks and Willie Mays at an All Star game

meet his senior year. He was frustrated by this and on his own, ran an 800 in 1:49. This impressive time would have won at the state meet.

Andy Carusetta

A Coronado connection is Andy Carusetta. Generally when somebody graduates you lose contact with them. I periodically kept in contact with Jennifer, but lost Andy, who graduated in 1993. Twenty five years later I was told he was coaching cross country at Arcadia High School with Sarah Wagner, another Coronado runner from the past. The years changes faces somewhat and being told by an Arcadia runner, "Oh there is Coach Andy" I did not recognize him. We embraced, and he was happy to see me. He's married and works in the insurance industry. As we talk I slowly recognized his voice.

In high school Andy placed second in the state meet in the two-mile. His sophomore year running for a junior college in an Invitational at Arizona State University he was right with the guy who beat him at state and on the last lap of the 3,000 meter steeplechase, he cleared the last barrier with better hurdle form and took first place. He raised some eyebrows as it was a bit unusual for a junior college runner to beat division one college runners. He got a scholarship to Arizona State and this paid for his education after his two years at the junior college.

A while ago I made a tape explaining cross country for the average person and it features an interview with the Olympian Lois Thompson (1968 Mexico City). There is footage of the city meet in El Dorado Park and the Division meet in Papago Park. In both races Andy took first place. It was in Papago Park I recently met Andy. I made a copy of the tape for him so he can show his current runners what he looked like in high school.

Wyatt Earp – Hawaii Ironman.

Wyatt grew up in Indiana and swam in college at Indiana University. He did the 200 individual medley, which includes the four basic strokes: butterfly, back, breast, and freestyle. When he occasionally swam the 50 free he could do it without taking a breath. After two years he got an offer of a full scholarship from BYU and never having been west transferred schools.

After a successful collegian, national and global swimming career Wyatt began competing in triathlons and came upon the biggest adventure in his life.

Competing in a triathlon in Bermuda he crashed on his bicycle injuring his ankle. He'd been accepted through the lottery for the Hawaii Ironman and figured the ensuing four months would allow him enough time to recover from his injury. He admits now this was a mistake and he paid for it in Hawaii. The final miles of the triathlon take place on King Kamehameha highway, a barren lava coated area, hotter than hell with waves of heat even at night. Runners had lights and all Wyatt could see ahead was a chain of luminaires like a snake. It was surrealistically quiet, the silence only broken by the sound of shuffling feet. As the sun had set, so had Wyatt's morale. He saw another competitor also walking and looking at his watch. Wyatt asked him why he was doing this because they were so far behind and getting a good time had long passed. His

companion was from New Zealand and told Wyatt he'd gotten married the day before and then said to Wyatt, "My connubial mate is waiting at the finish line and I'm late for dinner."

Turning off the highway onto Aliki Drive less than a mile from the finish Wyatt was greeted with floodlights, the overwhelming fragrance of tropical flowers, and what seemed like thousands of cheering people. His spirits soared with appreciation.

The cut off time in the race is sixteen hours, and Wyatt struggled with his legs going to putty to finish in fourteen hours. Collapsing at the finish the stragglers are rescued by "catchers" who hold you up by your armpits and take you over to the massage area. Wyatt clearly remembers Bernt, a German who gave him a massage telling Wyatt he was doing it so Wyatt could walk the next day. What amazed Wyatt was there was a story swirling around about a conversation an American had with a New Zealand runner. The story had spread and beaten him to the finish line. Hobbling about the area in awkward steps, Wyatt could hear the announcer say, "In sight we have our oldest triathlete." There was a tremendous roar from the crowd and the seventy-year- old man just made it in under the 16 hour standard. Wyatt approached the man and said, "You were cutting it pretty close." The man replied, "Well I just wanted to get the most out of my entry fee." A year later Wyatt qualified in a triathlon for the Ironman and in better condition improved his time by several hours.

Bev and her bike

Recently divorced in 1984 and unemployed Bev decided to do the Great Arizona Bike Tour. Its 517 miles from up north in the Grand Canyon to Nogales Mexico. To truly understand this adventure one needs some understanding of the geography in Arizona. To put it simply the 300 riders are going from the mountains to the desert. They are going to peddle 38 to 85 miles a day, and on the average go

David Frome has run the Boston Marathon, Bev Burns has run many marathons but tells her story of a memorable bike ride

60 miles. Bev's goal is to reach the camp site before dark and not have to ride one of the five sag wagons. Her brother promises to pick her up if this proves to be too difficult. The ride took place in October.

Packing her duffel bag for necessary items Bev is in a hurry to get from her home in north Phoenix to Sky Harbor Airport where the tour starts, bussing the riders up north to the Grand Canyon. Arriving, she realizes she's forgotten the front wheel of her bike. A friend rushes back home and gets the wheel and returns before the buses depart. Everybody now knows her as "the lady missing one wheel."

Getting acquainted with everyone she met, Gurnelle, a retired postal worker. Gurnelle has reservations in the various hotels they will be arriving at, but has planned to sleep out in the open when camping. Bev and her work out a deal, that she can sleep in Bev's tent and when in a hotel they will share a room. Gurnelle is in her seventies and has legs like Lance Armstrong. Knowing Bev is hesitant about the ride, Gurnelle offers this advice, "Charge the hill."

The day's first ride is from the Grand Canyon to the Cameron Trading Post. Then it's on to Sunset Crater and torrential rain at night. Four inches of water got inside their tent. Next they pass Flagstaff and camp in the Verde Valley. It was here Bev says, "I ate twice my weight of beef stew, and corn bread." At Payson she makes a phone call and finds out she got the job she had applied for. It required a teaching certificate and a masters in counseling all which she had. The job title was "Sex Equity Specialist" and Bev wasn't really sure what this entailed. Turns out she was to check equal employment practices of different schools and companies.

Passing through Globe and before spending the night in Florence they stopped by the road to get out of a rain squall and huddled together under large mesquite trees. Happy to be out of the mountains and ride on flat surfaces she was amazed that she found herself talking to a strange man about how sore her but was. They then spent the night in Marana, just outside Tucson.

It was in Tucson she made arrangements with her ex-husband to have him and her two daughters, Cindy seven and Stephanie three meet her. Bev says they waved at each other, and she briefly stopped but then had to start riding not to get too far behind the group.

The last night in Tubac was a happy one because the final days ride in the morning to Nogales Mexico was the shortest, only 38 miles. She ate a steak as large as a phone book. She was giddy with joy and relief she hadn't fallen and didn't have to ride the sag wagons. Going to her tent she saw grassy daddy long leg spider's eerily beautiful sitting around the tent. Normally afraid of spiders she felt so good it didn't really bother her, but still she quickly un-zipped the tent and got inside.

After a brief stop across the border in Mexico, buses drove everybody back to where they started, Sky Harbor Airport in Phoenix. Since this boost in her confidence Bev has run many marathons and done Rim to Rim in the Grand Canyon, three times (23.9 miles).

ASU Track meet – me and the mile run

People ask me if I still run. I tell them yes, but at age 74 with creaky knees I'm slow. As Chuck Sorenson says we're just ahead of the turtle. Running on grass in our near-by greenbelt helps my arthritic joints. I travel about a mile and a half five times a week and most importantly work up a good sweat. Occasionally, my mind drifts back eons ago to when I was faster. I never ran in college or even well in high school. However, at age 47 running in a master's event in a college meet at ASU I realized my dream of breaking five minutes in a mile run.

There were about eight of us middle aged men who stepped on the track in the middle of this college meet. I felt honored to be a part of this. Having raced against Chuck in countless road races, I knew him to be a rabbit, taking off at the start like there is no tomorrow. Beating him was not important to me, but getting my over-all time was. To break five, I needed to average just under 75 seconds a lap. Chuck flew by the first lap in 70 seconds with me just behind him. When he slowed just a bit I moved ahead and heard the announcer say, "Now taking the lead David Archibald." Wow, I was energized. At the 800 mark two men just powered by me, but I paid it no mind as I kept to my steady pace. With 200 meters left, David Lieberman made his move. It wasn't much, but I couldn't hold him off. Now with only the straight away in front of me, I struggled to breathe and told myself come on you can do it. My legs were so tight I almost fell down but did manage to cross the finish line upright. It really wasn't a mile, but 1500 meters and my time of 4:38 translates to a 4:59 mile time. My throat was so raw from forcing air into my lungs it hurt for two days, but I had a warm glow inside having accomplished my goal.

Chapter 23: Southwest

"Far better it is to dare mighty things even though checked by failure than to take rank with those poor souls who neither enjoy much nor suffer much because they live in the gray twilight that knows not victory nor defeat."
Theodore Roosevelt

Bryce, Zion, and Monument Valley

The opening of my toastmaster speech. "Many in this room have been to Bryce and Zion, for those this presentation will be a celebration. For those who have not been to this south Utah paradise it will be a motivation to visit."

Zion is a refuge or sanctuary. It's the one we visit first because it's closer to the Arizona border. It's a mystery because to me no other place is like it. A river running through a canyon with towering screaming verticality of red rock walls. Bryce is further north and has the higher elevation of eight thousand but has no water. The rainbow of colors is similar to the Grand Canyon, but it is not as deep or big. Both places were fun to visit and I shake my head we have not done this earlier.

We travel with our Prescott friends Chip and Gail. Snow is on the ground in Bryce. It's fun sharing the

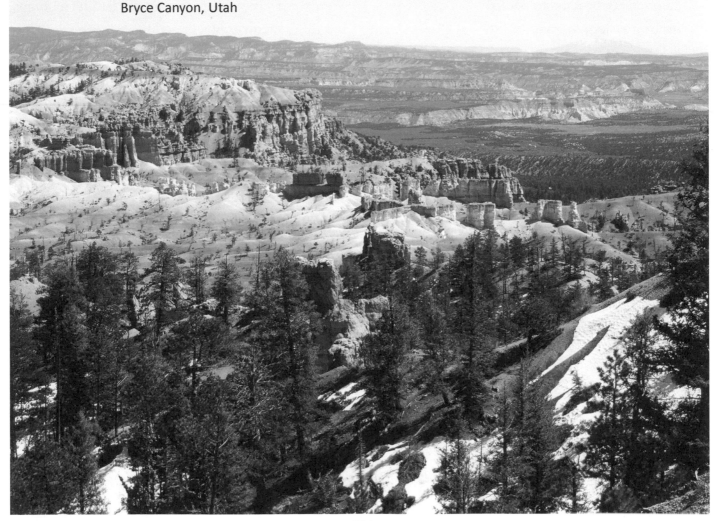

Bryce Canyon, Utah

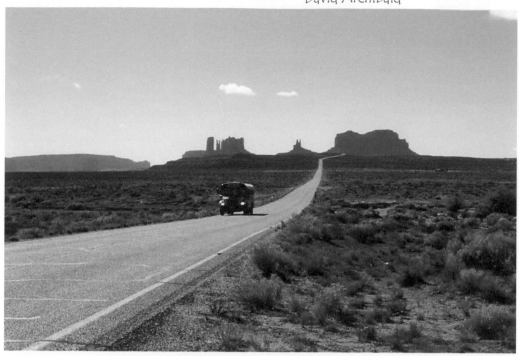

Monument Valley, Arizona

trip and we've traveled with them in Turkey, Hawaii, Costa Rica, Argentina and Chile. Writing about this would probably be another book.

In north eastern Arizona is the Navajo Reservation and Monument Valley. Many international tourists come here because close by is the Grand Canyon and of course an Indian Reservation. They book ahead at the hotels, so beware you might find one with no room available as we once discovered. Its wide open spaces of red and orange offer brilliant statuesque tall majestic formations of rock, resembling monuments.

Room with a View – Oak Creek Canyon

When you go on vacation, a room with a view is nice, a touch of class and elegance. This is similar to being greeted by your host with a wicker tray of two moist hand towels to wipe you face and hands to freshen up. Also on the tray are two glasses of champagne to quench your thirst. While I have had numerous rooms with stunning views the later has only happened once, when Susan and I visited Jerry and Karen's house in Sacramento.

On one of our Visits to our daughter Julie, she arranged to have us stay in the Claremont Hotel in

Berkley. It is only two blocks from her apartment, thus very convenient. Situated on a hill and being on the tenth floor, we had a commanding view of the Bay area. A more recent room with a view was in Arizona's Oak Creek Canyon at the Forest Houses.

Their stated policy… "Forest Houses is for people who enjoy peace and quiet in the crowded world. Please help us keep it this way. Because of its small size, Forest Houses is not suitable for noisy, shouting adults or children. We do not accommodate retreats, family reunions, weddings or any group larger than ten people. Please do not use your house as a daytime base for friends who are camping or staying elsewhere in the area. No more than the stated people are to sleep in each house.

Because of the narrow roads and overhanging roofs and trees: no campers, trailers, boats or other vehicles larger than a passenger car. Please, no weapons or motorcycles. Bicycles are welcome. We reserve the right to refuse reservation to those people who jeopardize the enjoyment of other guests through noise or lack of respect for them, the houses, their contents or the environment."

"I can't hear you, the stream is too loud," says Susan. This idyllic setting is nine miles north of Sedona in Oak Creek Canyon. In late May, with an elevation above five thousand feet, the temperature was cool, in the sixties. We're sitting on a large elevated stone deck of our house surrounded by trees. Everywhere you look, it's green, green. Ten feet away and below us is a rushing stream. It gives off

a roar as it cascades over intermittent sizeable boulders creating small waterfalls. Sitting in the shade we are mesmerized by this paradise of green and Oak Creek in all its glory. Most definitely a room with a view.

Viewing sun light penetrating thru the vegetation I imagine an impressionistic painter trying to capture it all. There is the yellow light producing countless shades or green. There is also a wide variety of

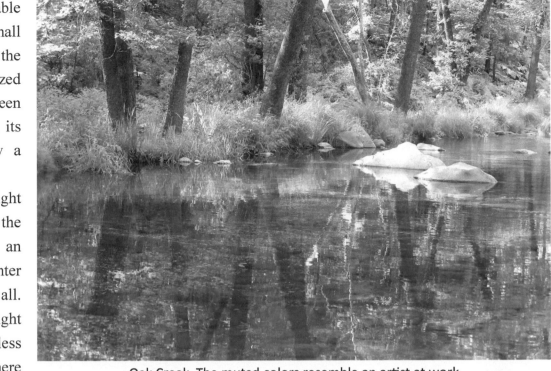

Oak Creek. The muted colors resemble an artist at work

trees present and the shapes of limbs hanging all over create a cocoon of space we inhabit. There is peace and stillness in the air. Time seems to be in another dimension.

I remark to Susan, "Wouldn't it be nice to have our daughters come here?" She replies, "What would they do?" There is no TV at the Forest Houses. I ponder this awhile and conclude that our girls are "City Girls".

To make up for a lost TV, each house has inside a fireplace. "I went to camp and know how to start a fire" says Susan. She gathers small stick and I get two foot sections of wood that lies under a roof just across the street. While we set up a fire and saw smoke coming from other houses, the effects of our champagne left us not needing the atmosphere of an indoor fire.

Our location is isolated. We are a two hour drive from Phoenix traveling north in the direction of Flagstaff. You exit the freeway after Verde Valley and drive ten miles into town. From the town of Sedona you drive nine miles north. You have to keep a keen

eye out to see the sign for Forest Houses on the right side of the road. Making your sharp left hand turn, you enter a narrow road descending to a stream crossing to arrive at Forest Houses. This tucked away feeling adds to the charm of this enchanting refugee.

Forest Houses property was purchased in the 1930's and started out as rentals after WWII. By the 1950's they had expanded to six houses: Rock House; The Studio; Diamond House; Creek House; The Chalet; and Sycamore House. Our Bridge House was built in 1968. They now have fifteen houses on a very narrow road surrounded by a wide variety of trees: giant Ponderosa Pine, several varieties of Oak, Red Maple, Douglas fir, Sycamores, and Walnuts. More at eye level are flowering shrubs, wildflowers, and in the middle a huge green lawn.

Let's go beyond a literal interpretation of a room with a view. Step outside and go on a hike, you see an expanded version. A mile north of our Bridge House was "The West Fork Trail".

The walk was on an easy dirt path, which navigated at the beginning thru a field of green

ferns. You then found yourself looking skyward to huge vertical cliffs of red rock which seem to dwarf sizeable pine trees. Every once in a while the path directed you to cross the small stream. It was nowhere near the force and volume of the one outside our house. At first glance it seemed an easy task, unless you had the lease to our dog. Luckie is strong and has a mind of her own. Added to this was the slipperiness of the rocks. Fortunately Susan and I managed these situations and did not fall in our stream crossings.

The hike was a challenge for a photographer, but I relished the opportunity to capture the beauty before us. It's refreshing to be in such a glorious setting. It's a very big room with a view. With the familiar, we often slip into a mundane frame of mind and look but really don't see what's before us. These few days in Oak Creek Canyon I was able to look and appreciate.

People have told me about a "vortex" existing in the Sedona area. Something to connect you a mysterious extra-terrestrial force field. Guess I'm just not sensitive enough, because I didn't feel it. I did acquire a profound sense of clarity. Of the many pictures I took, one symbolizes this emotion. A picture of small yellow flowers set amongst green ferns with blank black space in-between their arms. A harmony of color and compatibility. Not all art is contained in museums.

Reviewing my recent pictures and deciding, which if any, are worthy of being printed is a heavy decision for me. I get help and Susan's opinion, as I am too close to the subject. The two we select are both of the Oak Creek stream. One has three horizontal presentations: green grass with streaks of brilliant yellow sunlight, then a flat brown surface of the stream, and finally at the top white grey boulders. The second picture catches the reflection in the stream viewing the far bank of trees and green vegetation, resembling an impressionists painting. I hope Julie would be proud.

A Step Back in Time: Bisbee

The town of Bisbee is nestled in a ravine at an elevation of 5300 feet. It was founded in 1880 as a mining community and still retains the charm of being a frontier town. Two and three story brick buildings in the commercial center remind one of the 1920's or 1930's. Victorian houses cling to steep rock walls and seem magically suspended in air. Residents dress in the style of nineteen sixties hippies.

Everything in town is carefully maintained to retain an appealing historical atmosphere. The Copper Queen Hotel opened in 1902 and is the longest continuously operating hotel in Arizona.

The mines transformed Bisbee from a rough camp in the late 1800's to one of the largest and most cultured cities between St Louis and San Francisco by the early 1900's. From the discovery of rich surface deposits in 1877 until 1975 when the last of the underground mines closed Bisbee Mountains yielded more than 8 billion pounds of copper, as well as gold, silver, lead, and zinc representing one the most productive mining districts in the world.

The rich copper ore has played out but you can still visit the underground mine. The tour was led by a retired miner who spoke eloquently about the risks and backbreaking work. Deep in the bowels of the earth, he told everybody to turn off their lamps. I had never felt such powerful darkness. It was frightening! Bringing my finger close to my nose, I could not see it. My imagination ran wild. Trapped underground I would surely die. After twenty seconds we were allowed to switch on our lamps and I breathed a sigh of relief.

Located in southeast Arizona, Bisbee claims to have the best climate in the world. It never gets unbearably hot and avoids chilling winter temperatures. Looking at some statistics I take issue with their claim and offer San Diego as a city that has the better climate. Their big asset is the ocean which

Bisbee Hotel: The Inn at Castle Rock

keeps things cool but not cold. Regardless of temperature claims both are good places to live.

Shopping in town with a tremendous artistic reputation was right up my wife's alley. I patiently tagged along. We passed up the opportunity to buy locally produced olive oil and honey. Bisbee has a plethora of jewelry stores and here Susan studiously examined a lot of gems. I was consulted on the final decision. Walking out of the story we both felt a moonstone ring was a good memento of our visit to Bisbee and her sixty sixth birthday.

Silver Air Stream trailers are a reminder of how many people lived in the 1950's. Susan decided it would be fun to stay in one. I wasn't too keen on the idea at first. The stigma of being low class, "trailer trash" was deeply embedded in my consciousness. However, I am not one to shirk from what might be a unique experience, so I agreed to this adventure.

The Shady Dell does not allow smoking or cooking inside their trailers. Nor does it allow pets or children. The furniture, stove, refrigerator and other knick- knacks inside are not reproductions. They want to preserve the authentic artifacts. Hence our day there was like being in a special museum.

Spartan Aircraft Company saw the end of World War two diminishing the need for their product and they shifted production to help the need for housing. Their sleek silver trailers had elements of art deco in their design resulting in a home on wheels that became the "Cadillac" of the industry. Being inside, I felt as though I was in a hollow log, everything was

wooden curves. The rounded shape outside created an airplane like atmosphere. I waited for the safety announcements and never did find my seat belt.

There was a ten inch TV inside, but it could not show regular programs being only a DVD player. We had a choice of ten movies, all made in the fifties. This heightened our step-back in time. We watched Robert Mitchem in the film, Home from the Hill.

Traveling south from Phoenix you pass though Tombstone before you get to Bisbee. Like Bisbee it was a mining town in the 1880's. This tourist trap lacks Bisbee's charm because their whole focus is on a famous gun fight. They kept their wooden sidewalks in the historic downtown area. Here men dress up as cowboys, answered questions and posed for photographs. We much preferred talking to women in long multi colored dresses in Bisbee. Give me a hippie any day rather than a gunslinger.

Another Trip to Bisbee.

Entering our home Susan says, "Like we've been gone a week, yet it's only been two days." This just reinforces the comment of Ben Franklin, "Travel

slows down time."

We travel 210 miles from Chandler to Bisbee, stopping along the way at: Picacho Peak for wild flowers; Tucson for breakfast; and Saint David for pecans. In the last forty some odd years, this will be our fifth trip to Bisbee. It has incalculable charm. A bumper sticker on a car there read: "There is a little hippie in all of us." Also on the same car "Go where you're celebrated not where you're tolerated."

I was overwhelmed by the history of the place, an old mining town with an elevation of 5,300 sitting in a canyon with houses perched on the hillside and countless steps up to them from the main road. All of the houses differed from one another in size, shape, and color. Porches were present, and they speak of being outside and open in a community. We stayed at The Inn at Castle Rock which dates back to 1895, making it the oldest hotel in town.

Each of the fourteen rooms had a different theme with art work by Jim Babcock who owned the Inn for 38 years. The whole place reeks of creativity, some samples: Far Away Ranch – exotic animals; Pioneer – covered wagons; Return to Paradise – beach; Crying Shame – Paris; Last Chance – oriental; and Down Under –ocean. We stayed in the back. Labeled Tasmania, were awe-struck by a ten foot tall bamboo forest outside our door.

The Inn has no television. You either visit with other guests or read. I did both. Bob Costantino was a professor at the University of Arizona. His house in Tucson has some notoriety. It sits on an acre of land with 75 saguaro cactus and is called, "The Great Ina wall," as it's located on one of Tucson main streets, Ina road. The small book I read was, "Souvenir of Bisbee" by a re-cycled miner Ray Ewing. It contained some interesting stories of the early 19th century.

Previous visits saw us trying to get into Café Roka, one of the few five star restaurants in the state, but it was always closed. This time we planned better, finding out what days of the week it was open, and got a reservation two weeks in advance of our trip. It was fabulous and surprisingly not expensive. Our four course meal only cost 77 dollars. You couldn't help but be impressed by the attention to detail, and the sauce in my pork dish was to die for.

The next day had us scheduled for a two o'clock tour of Kartchner Caverns, an hour drive north west of Bisbee. We slept in at the Inn and drove to Sierra Vista which is next to Fort Huachuca, an army base. Having breakfast at Denny's found us sitting next to a retired army couple. Mentioning Bisbee he remarked, "You know who Charles Manson is…He said if he ever got released from prison he'd go live with his friends in Bisbee." I diplomatically inquired what he thought of Tombstone. He replied, "Watch the wallet in your back pocket." Denny's does have a different crowd than Café Roka.

Sierra Vista had a Farmer's market and its here we met Priscilla and Victor from Utah. I was struck by the back of his T-shirt and asked if I could take a picture of it. He obliged. It read, "After all these years of fishing… my wife is really my best catch." They had been married 48 years, so we had a lot in common. Victor had his girl friend's name tattooed on his arm and while overseas in Thailand during the Vietnam war got a Dear John letter. Returning home he met Priscilla and now has her name on the other arm.

Much to my chagrin, you cannot take pictures inside Kartchner Caverns. It was discovered by two hikers in 1974 and kept secret for many years because they did not want hordes of visitors to spoil it. The state parks department which oversees the large cavern is very sensitive to the environment and you enter through a tunnel which has three air locks and a misting system. Despite no photographic evidence, we were overwhelmed with the haunting beauty and the feeling you received from it once inside the cave. .. Mesmerizing tranquility.

The end of our day saw a hunger to eat somewhere

on our drive home. We chose Casa Grande, the town where I grew up. Of course it has grown, but some parts remain the same and I was able to successfully navigate to BeDillions. It's an old adobe house with a large cactus garden in the back and has been converted into a restaurant. The food was very good and I'm sure it ranks up there with several stars. Seeing people with white hair I strained to recognize some of my classmates from high school. Many have not moved away as I have.

One gentleman with white hair walks around the cactus garden with a camera. Could this be a long lost classmate? Susan encourages me to go check him out. He's not, but a charming man from Michigan. He says I have an interesting face and could he take my picture? I say sure, he snaps away and shows me the result. He's framed the picture well as I stand by an adobe wall.

Leaving the restaurant we are struck by an awesome sunset. The sky's blue canvas is painted with brilliant colors of yellow, orange, and deep red. Deprived of photography inside Kartchner Caverns. I am now rewarded and get a great picture.

Las Cruces, New Mexico

Susan says, "If you're not talking to strangers, I think you might be sick." On our way to New Mexico, our first stop is in Bisbee. Having lunch at the bar in the Copper Queen, I strike up a conversation with an Englishman. Having dinner that night in The Market, a waitress laughs at one of my jokes and gives me one in return. "Do you know about the vegetable band, its lettuce, turnips, and the beets." In Las Cruces, in our B&B, it's BJ who tells a story about an airplane crash in Mexico and its Jamal who once worked at a grocery story on the 48th floor of a Chicago skyscraper. Walking on a boardwalk at White Sands, I talked to a Georgia Tech student who is driving to San Francisco. I asked him where he grew up and he said China. He's been in the United

State just two years.

Bisbee – I could live there. It reeks of history. The town sits in a canyon with houses perched on the sloping hillsides. The town is now a shadow of its former glory yet has transformed itself into a mecca for a thriving artistic community. As a photographer I would fit right in.

We stayed in a small attached row of cabins built in the 1920's and refurbished recently. Not freezing, but a bit chilly, we used the electric heater at night. Earlier I sat in a wicker chair outside, sipping wine, reading a book, and every once in a while looking up at the trees and mountains reveling in this charming place.

On our route to Las Cruces, thirty miles from Bisbee, lies the town of Douglas. The Gadsden Hotel was built in 1907 and features Tiffany stained glass murals. They were stunning, brilliant colors stopping you in your tracks. We also enjoyed a good breakfast.

White Sands National Park New Mexico – a unique experience. The Park lies 50 miles north of Las Cruces. It's not like walking on the beach. The

Susan and Luckie walk in White Sands National Park

brilliant white sand is so soft. I tried to capture the contrasting color of the distant Blue Mountains and the high mounds of white sand and their impressive curvature, but unnoticed bits of very fine sand on my lenses ruined what I believed to be fantastic pictures. Disappointing, still the visit to White Sands stands out as a beautiful trip.

The Lundeen Inn is approximately 100 years old and recently won an award as the best B&B in New Mexico. The three story house has spacious, antique rooms with odd interesting corners. We were surprised to find bidets in the rooms. It's also an art gallery and the week before our arrival hosted an art show. The walls are adorned with countless paintings. Sitting in a plush sofa, it was fun talking to Linda, the owner. She was married to Jerry, an architect who died this past June. One time they hosted the singer Linda Ronstadt and her entourage. We stayed here because it is dog friendly, but there turned out to be a myriad of reasons why I highly recommend it. In all of our travels, it's one of the best places we've stayed.

The driving distances: 200 miles to Bisbee; 240 to Las Cruces; and 390 home to Chandler. Some interesting trivia to follow, as we took our dog to a dog-friendly Inn, I reminded of a song… Three Dog Night – "Jerimiah was a Bull Frog, was a friend of mine, Never understand a word he said, but I helped him drink his wine, and it was a mighty fine wine. Joy to the world, all the boys and girls, joy to the fishes in the deep blue sea, joy to you and me.

Now some facts on the local outlaw of the 19th century. Billy the Kid was a New Mexico legend: 5'7", 135 pounds, blue eyes, and two prominent front teeth slightly protruding like squirrel's teeth. Reportedly he never drank or used any form of tobacco. In personality, he contained good humor with a flaming, hair-trigger temper. Boldness verged on recklessness, and when provoked he could explode in deadly rage that carried no warning. Yet his sunny,

cheerful nature, his openness and generosity and his laugh-studded smile made him well-liked by almost everyone. However, cordial relations did not always restrain Billy from stealing from people he looked on as friends. He boasted a quick mind and superior intelligence and he could read and write. He could speak Spanish. He claimed to make his living as a gambler. Billy had numerous scraps with the law and at the age of twenty one was killed in 1881.

Trains

Since our retirement in 06 we have taken six train trips. They are in no particular order: San Diego to Santa Barbara, California; Vancouver to Jasper, Canada; Minneapolis to Chicago; New York City to Boston; Copenhagen, Denmark to Stockholm, Sweden; and finally The Verde Canyon Railroad in northern Arizona. Not relevant to the subject of this journal entry, I can't help but mention boats and three cruises: Inland Passage of Alaska; Adriatic cruise (southern Europe); and Baltic cruise (northern Europe). Yes we've been busy.

It's a two hour drive from the Phoenix metropolitan area to northern Arizona and the town of Cottonwood. Entering the Verde Valley off in the distance we could see the white shining snow atop Mount Humphrey in Flagstaff. After going through six round-a-bouts we finally arrived in Cottonwood. Shopping in a small bakery and wanting to go to the restroom, I'm told, "Just push on the bookshelf." Much to my amazement when I did, it opened up to a hidden restroom.

We share the trip with lifelong friends Chip and Gail. They live in Prescott and only had to drive an hour to meet us in Cottonwood. The four hour trip is advertised as, "It's not the destination, it's the journey." It starts in nearby Clarkdale and ends in the ghost town of Perkinsville. The reason for the existence of the train in the first place was to move recently mined copper. It follows the Verde River and

The Verde Canyon Railroad is a heritage railroad running between Clarkdale and Perkinsville, Arizona.

now moves tourists. Tis not easy to get a good picture of the canyon and the river below on a moving train, but after countless tries I have a few decent pictures. Capturing the brilliant colors of Green (trees) Red (rock) and Blue(sky) was intriguing.

We greatly enjoyed the scenic ride. To ride first class we were given a small glass of champagne followed by a variety of appetizers during the trip. Unfortunately, you couldn't get more champagne unless you paid for it. However, if you were a veteran, and Chip and I are, you were given a free drink. At the end, Susan wasn't feeling well and we cancelled our planned evening in Prescott with Chip and Gail and headed home to Chandler. A strong recommendation to Roy Sinclair, a lifelong addict of trains, you need to take this trip.

Chapter 24: The Adriatic

Don't wait for the storm to pass, learn to dance in the rain.

Adriatic Adventure

A geography lesson is in order. Imagine the Mediterranean Sea with boot shaped Italy in the middle. The east coast of Italy is called the Adriatic while it still seems like the Mediterranean. We didn't go to Italy on this vacation, but the other side of the Adriatic: Croatia, Montenegro, Albania, and Greece.

I took over two thousand pictures of our vacation. I edited almost every day and reduced the number to 454. The pictures speak of my addiction to trying to capture the atmosphere that makes the location and the people unique.

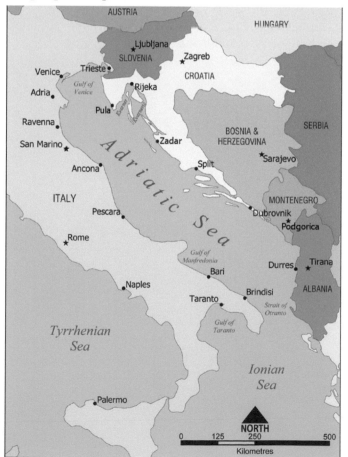

Just as important as seeing new places is meeting new people, our fellow travelers. One of the first things people ask is: "Where are you from? This will then give them some insight as to your personality. When I reply, Arizona, they cringe and say, "But it so hot." My explanation that it is a dry heat and vastly different than the horrid humidity of the east coast doesn't quite satisfy them. It's then that I resort to humor saying, "the Arizona heat is therapeutic…you may not believe this but I'm ninety years old and look like I'm in my sixties."

The twenty-one days includes two long days on airplanes. You just have to grin and bear it. The nineteen days left can either be "a trip" where you are on the go all the time, or "a vacation" where you rest and do things on your own. Surprise, surprise we had a pleasant balance of both worlds.

The Balkans, the Baltic, Yugoslavia, the Adriatic, are all foreign mysterious names to a majority of Americans. The Balkans refers to south east Europe. The Baltic refers to a sea in the north east of Europe. We didn't go there. Yugoslavia was a country formed after world war one and ceased to exist some years after world war two, being broken up into several small countries. It's some of these bits and pieces we went to: Slovenia, Croatia, Montenegro, and Albania. The Adriatic is the arm of the Mediterranean Sea between Italy to the west and the bits and pieces to the east. Yes, we went off the beaten path.

To make easy sense of our travel, I'm presenting my pictures in the following format: the ship, the

people, and exotic lands. Yet to tell the story with words, I'll rely on my journal.

Imagine a football field: our ship would measure from the end zone to the fifty yard line. Comfortable rooms for fifty travelers although we were only forty two. As a well-traveled person, I often judge the quality of a shower. This is an important thing for an eleven day cruise. Aboard the Athena it was very good, roomie enough

Lake Bled is a lake in the Julian Alps of the Upper Carniolan region of northwestern Slovenia

to stand in and the tilt of the floor easily accommodated the water running down to the drain. Last but not the least the ship had an outstanding air-conditioning system. This was very welcome because at the end of the trip it was hot the last three days.

An international crew of twenty seven took very good care of us. They were Indonesian, Indian, Croatian, and Serbian. Darko the chef was outstanding. It was extremely hard to limit yourself at the dining table. The choices you were offered at the breakfast and lunch buffet pleased everybody. Dinner was a sit down affair of four courses and never saw you with an empty wine glass.

People are not all the same. What a boring world this would be if we were all carbon copies of each other. Bill was a calm doctor specializing in kidneys and golf. His wife Sue reminded me of my aunt Jean: freckled face, skinny, and a pleasant demeanor. Their

Our Itinerary

Sunday *Slovenia – Bled, a mountain resort (group of 16)*
Monday *lunch in castle high above Lake Bled*
Tuesday *Visit castle and a very big cave*
Wednesday *Ljubljana in center of capitol city – no cars allowed*
Thursday *Croatia – Zagreb (six join our group, twenty more in another)*
Friday *Varazdin and visit wine cellar before lunch*
Saturday *Plitvice lakes & waterfalls (74 degrees three plus mile walk)*
Sunday *Aboard ship, coastal city of Split*
Monday *Island of Havar (lavender chief crop)*
Tuesday *Island of Korcula (our first swim in the Adriatic)*
Wednesday *Dubrovnik (last coastal city in Croatia)*
Thursday *Montenegro – town of Kotar (here I buy a hat)*
Friday *Swim beach of Kotar and sail to our next destination*
Saturday *Albania (kids shelter, ancient city of Butrint)*
Sunday *Greece – island of Corfu (Sisi's palace)*
Monday *Greece – Delphi (temperature in the low nineties)*
Tuesday *Athens (still hot)*
Wednesday *ten hour flight NYC, five hour layover, arrive Phx midnight*

parents knew each other, consequently they met as very small children in a playpen. Dave and Dottie met at a bowling alley and our first impression saw them as somewhat reserved, yet as days went by we discovered their charm. Bill and Sue live in North Carolina, Dave and Dottie in Ohio.

The 42 people were separated for tours into two groups. The 16 in our group were all in the pre-trip led by Jana. Six more were added to our group in Zagreb and another twenty made up Harry's group. It's in Harry's group we met John and Gracie from Seattle. John is tall and played the role of a tree in our Greek theater play. Gracie is a short bundle of energy from Lebanon. John's passion is poker and the seventeen times he's visited Vegas he's only once come away losing money.

Of the forty-two only six kept to themselves, two couples from Los Angeles and another from San Diego. Three of our sixteen were traveling alone and bonded together. We became friendly with Michael from Hawaii and Lynne from San Diego. The other one was Lisa. She was a stereotype loud mouth Jew who I found ill-mannered and obnoxious. Half way through the trip Lynne, who is 72, became sick. Once at breakfast when Lynne joined us, Lisa with a grating voice shouted out, "You look horrible!" However, Susan liked her, and felt pity for someone traveling alone. I kept my mouth shut. A rare trait for me. Often in port she and Susan were happy fellow shoppers and I lagged behind taking pictures. It all worked out I guess as Susan came home with numerous dresses, tops, and gifts for many of our friends.

Jana was the leader of our group. She is labeled "Program Director" and supervised various local guides and took care of us like a family. Jana is a stunning blond in her early forties and she did an excellent job. She is very personable and charming to be around. Here are two "if's". If Jana was taller she would be a successful fashion model. If I was twenty years younger and single I'd make a move on her.

Nineteen nations in Europe use the "Euro" for money. Croatia is an exception – it's currency is the Kuna. The Kuna is also an animal popular in the country. We did not see this animal, but made generous use of the paper Kuna for our time spent in Croatia. Of our seventeen days in five countries the majority of our time, seven days was spent in Croatia.

My favorite of the Plitvice Lakes pictures I took

Highlights from my Journal…

It's wonderful to lie flat on a good bed after a marathon of cramped quarters in an airline seat. The next morning in my journal…Sizing up a picture and seeking out a stunning landscape or catching people in a candid pose…is like a drug to me.

Visiting the Postojna cave was the only time we needed warm clothes as the temperature inside was 47 degrees. The cave was huge. At the beginning we took a small train ride of fifteen minutes inside the cave. The train sped along a narrow twisting track with the roof of the cave very close to our heads. This would never meet American safety standards. NBA players would not be able to duck down enough to escape disaster. We then had a two mile walk among the stalactites which were highlighted with well-placed lights. Walking with us was Lisa and she exclaimed, "It's a fairyland." The lights were turned off for twenty seconds. Wow it was totally dark so you literally saw nothing not even bringing your finger in front of your face.

Slovenia is nicknamed "little Austria". Mountains and lakes have small charming little towns, two-story houses with window boxes of colorful flowers. There are few fences in the fields and no bars on the windows. It only rained once on our trip and we were cozily inside sipping wine and eating strudel.

Zagreb is the capitol of Croatia and it's here other members of the tour not on the pre-trip join us. The Westin Hotel where we are staying had a big swimming pool of which I took advantage. There was a glass covered one when we stayed in Bled and it was fun swimming there looking at the mountains.

A tourist dresses up to get the feel of what it's like to be a Greek warrior

The Croatian Museum of Naïve Art was very impressive. Painting rural scenes on glass heightens the color. The expression on the people in most of the paintings reflected their humble attitude and the whole effect left you with a brilliant image. I bought a t-shirt in the gift shop as a poignant souvenir of this museum.

Forty thousand live in the town of Varazdin and twenty thousand ride bicycles. One wine bar had a clever name, "The Mea Culpa". However, the town wasn't much but the castle was. It successfully withstood attacks by the Turks. Inside were some impressive artifacts: cannon, swords, and rifles. More to the liking of my photographer's eye some

semi translucent dinnerware and vases with stylishly colored designs captured my attention.

Part of the joy of traveling is the anticipation and planning. I eagerly awaited our visit to Plitvice Lakes. It's a big area of connecting turquoise lakes where you walk on wooden boardwalks to witness the countless breathtaking travertine waterfalls. The temperature for our three plus mile walk was a pleasant 74 degrees. My fear of cloudy skies and rain, a kiss of death to a photographer, quickly vanished. It was a clear sunny day and I felt like I was in heaven. It's the height of tourist season and it was very crowded. Reviewing my pictures that evening I have possibly five outstanding ones I could print and put up on our wall. It will be a difficult decision to pick just one or two.

Enough living out of your suitcase in two hotels. Split is a coastal town in Croatia and where we pick up our ship, the Athena. For eleven days we'll sail along the Dalmatian coast, stopping at two islands in the Adriatic, the town of Dubrovnik, towns in the countries of Montenegro, Albania, and finally Greece. It's now more of a vacation with expanded leisure time. It sort of feels like home, no more packing and unpacking the suitcase.

Continuing my anticipation theme. I early looked forward to swimming in the Adriatic. Susan and I went three times. Our first dip into the water was in Korcula Croatia. Later we swam in the waters of Montenegro and Albania. However, the high drama occurred in our first swim in Croatia. Harry, the other program director, warned us about the danger of getting stung by sea urchins. "Oh you'll see the black creatures in the clear water" he said. The outdoor temperature that day was a high of 83 with a low of 71. It was a rocky beach, not the normal sandy one we're accustomed to in San Diego. I wore my trusty sandals to navigate the rocks. Susan said the water was too cold and just dunked herself. I slowly walked out into the Adriatic intently looking down to avoid stepping on either a black rock or a sea urchin. I really couldn't tell the difference. Out to my waist I plunged into the brisk water and it felt wonderful. The sun was shining and lazily swimming on my back I looked at the ancient town and said to myself, "You're in a different world."

"Which one of three calamities on vacation do you wish to avoid?" I utter under my breath: real hot days, rain, or forest fire. Coming to Montenegro we enter a huge bay with tantalizing inlets. Ninety percent of the country is mountainous. A forest fire is on the slope of a mountain. This obscures the dramatic effect of the towering mountains coming straight down to the water's edge. Picturesque landscape, but one sad view for a photographer who relies on good light. Despite this beginning I really enjoyed Montenegro. The small town was charming, the grey cloud of the fire eventually disappeared, and we enjoyed our second swim in the Adriatic.

Our fourth country on this vacation was Albania. I was shocked to learn from one of our guides that Albania had one of the most repressive governments in recent history (1970-90's). Albania was on a par with North Korea. China was just about the only country in the world community recognizing it, then it disavowed Albania. Absolutely no contact with the outside world was allowed and people were shot if they violated this mind set. Now in 2017, I expected wooden carts and a third world country. This was not so, they have recovered well. Even so we did not stay long, visiting an ancient Greek and Roman settlement and a shelter for homeless kids. Not sure many big Cruise ships stop here.

Is it chicken to order a hamburger when overseas? Yes it is, you should try the local food. Pumpkin seed oil is used as a salad dressing. Soparnik is a very flat cracker pizza filled with a spinach-like vegetable and coated with garlic mixed with butter. In Slovenia Susan was very impressed with the richness of the creamy butter. In Croatia before you had dinner it

was expected of you to drink a shot of grapa. It is a highly fortified wine that certainly gets your attention.

To prepare for our arrival in Greece, Robert the hotel manager, had us participate in a Greek theater play. The night before togas were provided. We were all given a piece of paper with the role you were to assume in the play. Philip, the band director from New York and I were,

Greek play aboard the cruise ship

"scary robbers". His wife, Joan, was "the curtain" dancing in front before and after each act. Susan was "the window" who stood behind the king. Many more roles were involved. Robert then read from the script and when called upon you played your role. Much action took place to involve everybody. However, the general gist of the play saw "the scary robbers" kidnap the princess and the prince rescues her. When the prince rode in on "the white horse", a woman in real life not his wife, everybody roared with laughter.

Afterwards, one of the program directors said they don't always do this play depending on the personalities of the passengers. While six people who usually stayed to themselves, chose to sit on the upper deck, 36 others had a riotously good time. Much of life is enhanced by a positive attitude. Sharing our vacation with like-minded people added to our enjoyment of being off the beaten path.

A Toastmaster challenge

How do I reduce this adventure down to a six to eight minute speech and reduce my pictures from 120 to only 30? Have a powerful opening. "Recently we traveled off the beaten path to Croatia and its neighboring countries". Next use humor. "The Arizona heat is therapeutic. You may not believe it, but I'm ninety years old and look like I'm in my sixties." Let your pictures entertain and tell a story. Have a good close, Socrates said, "I am not a citizen of Athens, I am not a citizen of Greece, I am a citizen of the world." Finally a call for action. Don't sit at home afraid of terrorist, lots of people die in America from crazy people perhaps more than overseas." Travel extends your life, live longer, be a citizen of the world.

After my presentation, Linda Moser asked if she could have a copy of the turquoise waterfall picture. I was flattered and complied. She's a wonderful new age individual and decorates her home with the 'feng shui' guidelines in mind. I'm flattered she feels this photograph fits in well. A waterfall means prosperity and wealth.

Chapter 25: Rotary

"Service Above Self'" Rotary Motto

Rotary Club

My father belonged to Rotary. It's an international organization which helps people. The motto "Service above self" appears on some of their T-shirts. One day I went with neighbor Pam to help sort food at the food bank. It was here I met Rotary Clubs in action. At the close, different groups posed for pictures and neighbor Harry Short motioned me over to be in the picture.

Next week I went on a hike in South Mountain and met other Rotarians in Harry's Club. Hiking is different yet somewhat similar to running. The pace is slower. The up and down of rocky terrain can take a toll on your knees if you are not careful. The early morning light highlights the shape and the riotous subtle color of this pristine desert landscape. Differing shades of brown, yellow and red strike the eye when I pause to see the direction of our hike. There is no gun-metal grey of sidewalks here. Mesquite and Palo Verde trees dot the rolling hills of unregimented rocks and fine sand. Occasionally you see the statuesque Saguaro cactus. Rotary members hike South Mountain twice a week. I can't make the Tuesday hike because it's my Toastmaster morning, but Thursday I do. Because the pace is quite pedestrian there is an easy ebb and flow of conversation.

Part of their routine is to stop and gather at certain junctions. At the first stop, Scott remarked he was cutting the hike short and heading back to the trail head. The next junction saw Harry and Oliver deciding to take the ridge line. Someone asked Oliver

where he went to college. In a humble manner, Olive, a black man in his early 60s, told us he was a Rhodes Scholar. This highly prestigious achievement saw him studying three years in Oxford, England. He studied tropical forestry.

The remaining three of us took the Pima Wash trail. Our group of physically fit men hiking the desert terrain of South Mountain periodically ran into other hikers. None of them could match our age and experience. After about twenty minutes, the three of us looked up to the ridge line and saw Oliver's red jacket and Harry's orange vest. Harry is 77 years old. Doug and Bill, my hiking partners on the Pima Wash were 79 years old. I'm a youngster in comparison, soon to be 73.

Doug is a Canadian and Bill a Hoosier from Indiana. They talked about being six years old during WWII. I was only a wee baby then, but my parents were issued a ration book in my name, so this means I participated in a very small way. Doug's friend stole a packet of cigarettes from some returning soldiers and convinced him to hide out and smoke. Doug passionately told us he got horribly sick and hasn't smoke since. Even today he can't stand to look at a cigarette.

Finishing our two-hour hike in the mountains, Doug and Bill reminded me 73 is a prime number, that can't be divided. My birthday is nice, but I feel undeserving of a lavish party like Ken, a fellow Rotarian recently had on his eightieth birthday.. This summer Doug and Bill are celebrating their eightieth.

Being eighty is a milestone, and hiking at that age every week is impressive.

After the hike, I was invited to a meeting. I was impressed with the humanity of the members and their approach to life. It's lunch on Monday so it doesn't interfere with Toastmaster's Tuesday morning meeting and I joined. Their big fund raiser is a golf tournament and I got to be the official photographer.

Our Rotary Club is involved in a wide variety of activities. Each person has a particular passion for helping. Dave Kline is active in the Guadalupe Boys and Girls Club, coaching youth basketball and soccer. Harry Short travels to other Rotary Clubs telling them about Malaria and how it can be prevented. He recently went to Africa to research the subject. Rob Foster is keen to support "Save the Family". Machel Considine spearheads our Foreign Exchange Student Program. Ken Pollock leads us to a middle school to mentor students in AWIM, "A World in Motion." They learn about gear ratios in the process of making model cars. Ken also edits our award winning web site, which attracts visiting Rotarians to our club meetings.

Then there are activities we all jump into: Habitat for Humanity, building housing for poor people; providing dictionaries to elementary schools and volunteering time at Treasures for Teachers. We do more than "just write the check" as some other Rotary Clubs are known for doing.

The name of our club is The Kyrene Rotary Club in Tempe. We meet at a Japanese restaurant and have guest speakers three times a month. The person responsible for getting these speakers is me. When I joined it seemed a natural with my fourteen years of Toastmaster experience. Club membership gave me leads to various potential speakers and I have had several of my toastmaster friends talk at Rotary. It's a juggling act to keep all this straight and I need to keep better records of who is doing what and when. A highlight for me was meeting and introducing to the club a celebrity newscaster. I have long admired this person on TV and was thrilled meeting her.

Rotary clubs raise money and turn around giving it to those in need. Our fund raising has been a dismal failure. One attempt saw us selling candy in a park while families watched an out-door movie. Then Wally, an avid golfer, convinced us to hold a golf tournament. Many were skeptical as they knew nothing about golf. Wally persisted and the doubters fell in line. I played once or twice with my father, but that was many years ago. Thus I felt it would be fun to play a round of golf.

"There are two important days in your life, the first is the day you are born and the second day is when you find out why" Mark Twain.

The why in my life is certainly not to be a golf pro. When I mentioned to a neighbor that I was going to play golf for the first time in thirty years and needed some advice. Greg Thatcher said to me, "Why don't you play military golf, hit some to the left and then some to the right."

Hitting the small white ball is certainly a challenge. The beauty of the sport is that for every bad shot you make every once in a while there is a beauty and of course this is the one you remember and keeps you coming back week after week. I've been told Phoenix has more golf courses than any other place in the world. It does sound strange for a desert community, but we do indeed have a lot of course drinking up a ton of water.

Bob Covington is a fellow track coach and avid golfer. It was his invitation that brought me out to the links. He lent me his wife's clubs and after hitting some on the practice range we advanced to the first tee. Here we discovered his wife's bag, for some strange reason, did not have a putter. Not to be dismayed, we were flexible. When we were on the green I used Bob's putter. Throughout the nine holes he was very gracious and supportive despite my comic attempts.

At my suggestion, we played the best ball after hitting off the tee. Invariably Bob's drive would be much further. Then I would search for my ball, pick it up, and hit from his spot. However, on one occasion at the eighth hole, I hit the beauty to remember, a 170 drive that actually rose in the air. No military golf here, amazingly it also went straight. My previous drives were "grass cutters" never rising above three inches off the grass. On this hole Bob pulled his drive to the left, out of bounds, and took another drive, which in golf language is called "a mulligan".

There are a lot of things to remember in golf. First and foremost for me was the mantra, "Don't kill the ball". By swinging too hard a lot of bad things happen to the beginning golfer. A good coach, Bob, told me to push my left hand out towards the right in finishing my swing. Good advice when I was able to follow it as my drive then avoided the military and went straight. Since I hadn't played in a long time, and even then very infrequently, getting the ball to rise high in the air was a problem. Time after time I would hit it on the top instead of underneath. The mental image Bob gave me was, "brush the grass and let the club do the work."

A cardinal sin in golf is to pick up your head too soon when striking the ball. There is a natural reaction to see where you hit it. However, this interferes with a proper swing. Of course pros or very rich golfers have a caddie who do this. Amateurs or duffers like me rely on your partner.

Bob picked up golf the same way I did. His father played. It's a touching memory I have of the day my father and two brothers made a foursome and played golf. Being competitive, we kept score. While I don't really remember who won, I think I did pretty well. Playing with Bob we did not keep score. It would have been silly. It was fun and Bob invited me to play next week, but I held off, perhaps once a month is enough torture.

Using an iron for a par 3 you need to hit it over a water feature

Golf Tournament

There is so much planning and anticipation by our Rotary club going into our golf tournament. When it does finally take place, there is an overflowing of joy. I am placed at the 6th hole. A person from one of our sponsors drove me there in a cart. He gets lost several times, but helpful advice from golfers allowed us to arrive at the sixth tee. Being turned around several times, I wondered where the club house really was, perhaps a half mile away, but in what direction? I finally got a score card which acted as a map and have a general idea of the geography and where I am.

With a pop-up tent I had shade from the 97 degree temperature. Near-by was cold water in a small up-right structure. With no port-a-pottie, near-by trees served a good purpose. With a nice chair and my needs taken care of, I was comfortable awaiting the challenge of taking some good pictures. I was there from 12:30 to 6:20 to take pictures of 80 golfers. Earlier, Wally, the driving force behind this event, reminded me not to make much of an interruption to the pace of the golfer's game. Arranging quick group pictures of the foursomes I was not terribly

pleased with the results. The faces appear too dark, whether in the sun or shade. The action pictures are also difficult, as I attempted to capture the club at the precise instance it strikes the ball. I took more pictures than I ever have in my life. I tired different angles and guess some of them will portray the action of what takes place on a golf course.

Phoenix is number one. It has more golf course in the metropolitan area than any other place in the world…185.

My neighbor, Bob Anderson, said what make the tournament enjoyable was the limit of two putts on the green. "Nothing takes more unnecessary time than excessive diddling around, putting on the green."

Susan joins me toward the end and enjoys driving the golf cart. We're not really sure where we are going. The sun is setting and the lush greens make the drive fun. With a few golf carts greeting us, we always ask if we're going in the correct direction for the club house. It's a big course with curvy paths and she says, "It's like being in Disneyland." We finally arrive at the club house and Susan remarks to those in charge of the carts, "Watch out, student driver."

I give the chip in my camera to Ken, a fellow Rotarian who is an accomplished photographer. He puts the pictures on our website and I am pleased with the results. He's lightened up the faces on the shots of the foursomes. Ken then has a slide show of the golfers in action. Interspersed with the

Susan drives a golf cart for the first time

golf swings, I had taken pictures of the faces of the golfers reacting to the flight of the ball, because you can't see them well as their bodies are twisted with their heads down when they are swinging their club. The seventy five pictures turned out better than I

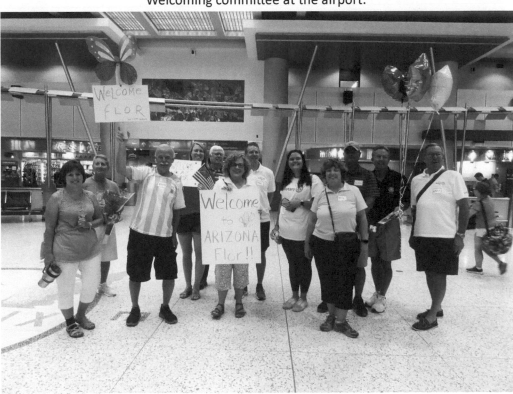
Welcoming committee at the airport.

expected. Fittingly, the last picture in the slide show is one I took of Susan driving the golf cart.

Rotary Speaker

Gayle Langman/Creswick spoke at our Rotary meeting today. Being in charge of who the speakers are, I rely on recommendations other member make, and occasionally use my toastmaster's connections. Gayle was outstanding, and she's not even a toastmaster. Yet she is a talent and has spoken before in a variety of places. She was a director at Friendship Village, a retirement community many of our Rotarians are very familiar with. Gayle writes an advice column for seniors in local newspapers in several western states. She had a fertile audience as we have an absence of young people in our club. Her column is titled, "Ask the old bag" and she responds to letters people write her about their problems. After some time women readers complained about the title, feeling it was demeaning to women and it got changed to, "Gabby Gayle." Here's one letter.

Dear Gabby Gayle: I am writing about my mother who is an 80 year old widow, going on 16. She got this wild idea about joining a dating site and has turned into a teenager. She has met a man five years younger than she; now we think she is sleeping with him. We three daughters are mortified and find it disgusting. I think she reads your column, so please advise. Signed M.G.B. Her reply, Dear MGB: I do not think you are going to like my answer, but first some questions. Do you believe that young people have a corner on happiness? Don't you want happiness for yourself when you are 80? Haven't you read any of the articles that say romance can lengthen your life? If your mother is giddy, like a teenager in love, what is really wrong with that, at any age? Please try to be joyful that your mother is living her life to the fullest. Also, intimacy does not belong just to the young. It is not shameful, it is beautiful. Please do not rain on her parade.

Flor DiBartolo and Havasupai

An upcoming Toastmaster speech has as its title-"What's it like to be a foreign exchange student?" My call for action asks the audience to consider being a host family. You need not be a member of Rotary.

A returning exchange student said the experience is like being born again: new language, new parents, new country with its culture and customs. Those who have done it say, it's one of the most memorable things they've done in their lives. Flor's family has a student from Finland who doesn't speak Spanish or English; they both use a translator application on their phone and after two months, the student is getting better with Spanish.

List of student's Rotary is sponsoring:
Hillary – Peru Carlos – Ecuador
Maci – Venezuela Gabriel – Brazil Jacob,
Elsa – Sweden
Lisa, Tristan – Belgium Lisa, Virginia – Italy
Max – Austria Mayssa: France (next find out what city assigned to)

Sunday: pick up Flor at Margie's and Frank's. Get settled in, dinner goes well and we find out she likes chocolate milk and carrots. Susan will shop tomorrow. She's a charming girl.

Monday: up at 6:30 and just before seven, a fifteen minute drive to Corona Del Sol High School. Pick her up at four and have Mexican dinner. Even though she speaks English, we try out our limited Spanish and learn some new words. Flor has fast thumbs on her phone. Susan takes her to the YMCA and after her workout will take her to a baby- sitting job. Susan will hang out at Megan's and then pick her up. Just got off the phone with Bill about Havasu trip. Tentative plan sees him driving and we will meet at Jacob's house in Scottsdale (Shea and Hayden) and Carlos from Gilbert will also meet us there. Hope this works out as I do not want to drive myself, more fun to car pool.

Tuesday: Flor and I have the same birthday,

Flor DeBartolo.

Flor's home town, Mara del Plata

January 28. Susan drives her to school today because I left early for Toastmasters. I did my Kilimanjaro speech. After school Susan took Flor shopping and got her a jacket. During dinner we used our halting Spanish to talk with her parents. You could see their faces in her cell phone. Later we watched pictures of our 2006 trip to Argentina and Chile. Can Flor dance the tango? It's the signature dance of her country. Checking my emails, I find out Bill has room for me in his van.

Wednesday: I pre-pack my duffle bag for upcoming Havasu trip. Mexican cuisine for Flor, dinner at Rosita's, one of our favorite restaurants.

Thursday: We drive four and a half miles in fifteen minutes to take Flor to Corona Del Sol High School. Just before we get to school, there is a crush of humanity and a line of cars getting into the parking lot. One drives very slow and keeps a keen eye out for any student who might dart out in front of traffic. Flor goes to dinner at another Rotary Club. She is driven home by somebody I had met at the Rotary camp in Heber last spring.

Friday: Finally packing of duffel bags for Havasu trip. We are advised to stuff our clothes and equipment in large plastic garbage bags inside the duffel because of a forecast of thunderstorms in the area. Nobody wants to put on wet clothes. For dinner I cook my signature dish of fried potatoes and an omelet. Flor's dad's specialty is pizza. I drive her back to school for the football game and dance afterwards. A friend drives her home just before midnight.

Rob Foster and Flor work on a Rotary Service Project, Treasure for Teachers

Four days at Havasu

Saturday is a day of preparation for the hike which is in northern Arizona. Carlos, an Ecuadorian who lives in Gilbert, comes to our house and I drive him and Flor to Scottsdale for Jacob from Sweden. Bill, a veteran of the Havasu trip, drives from Fountain Hills to where Jacob is living to pick up the four of us. We will be joining 76 other people on this adventure.

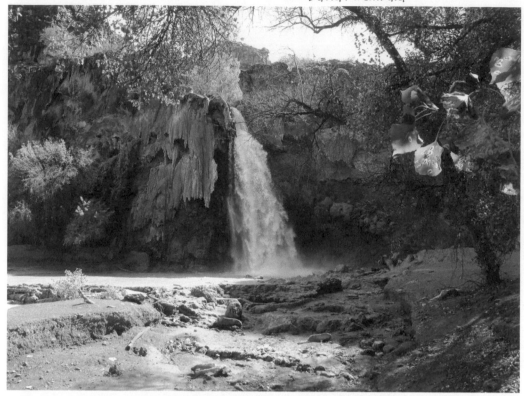
Havasu Falls is within Havasupai tribal lands.

We arrive in Prescott for dinner. After Cajun chicken over a bed of noodles and a buzz of conversation in a crowded room, we're off to Seligman. Here Chuck, our leader, has reservations for us in three different motels. T-shirts are given out with a stunning photograph of Havasu Falls on them.

This wilderness area of red rock canyons is a unique area highly coveted by tourists from all over the world. Reservations are extremely hard to get. Chuck Flint, the brainchild of this expedition, has been doing this for over twenty years. He has a good working relationship with the local Indians, who live in a village nine miles from the trailhead. The pristine white waterfalls descend from great heights into blue green pools. It is truly breath-taking, especially considering the arduous hike of ten miles you endure to get there.

Sunday saw us drive almost two hours from Seligman to the trailhead. Rain causes us a problem before we even started. The trip was in jeopardy because there weren't enough horses to take down our 91 duffel bags. Plus there was the ever- present

danger of a flash flood. We were also told a bridge was wiped out and a half mile of the trail was covered in water. This last bit of information proved to be untrue. The threat of not going hung over us for two hours. Chuck worked out a compromise and had half of the bags delivered to our campsite by helicopter, so we got a late start at ten thirty.

Having been on the hike before I was familiar with the terrain: the vertical switch-backs taking you down 2,500 feet; the long hike traversed a twisting, rocky, sandy dry river bed; and then you leave the dry river bed and walk alongside a small stream and dense bushes and trees until you come to the village. I consider myself to be in relatively good shape. I can still run two miles without stopping. However, to be a good hiker you need balance. It was not a race, I was reminded, but I came in last place. I was slow, oh so slow, but I did not fall. Due to my poor balance, it took me five hours to reach the village. It was here Gerard, a veteran of the trip and Chuck's right hand man, was of tremendous encouragement and help. He was the sweeper, looking after those who struggled and I was certainly one of them. Gerard arranged a drive in a small open air all-terrain vehicle at the village to take us both the mile and a half to our campsite. My aching legs were very grateful.

People saw my almost paralyzed legs and two rushed over and graciously helped me set up my tent next to Bill's. After a dinner of rice and chicken, I asked Chuck if I could ride a horse out on Tuesday.

The helicopter was not an option. Chuck said yes, and I was over joyed with relief. To those of a curious mind, the horseback ride cost $140.00, but the value proved to be much more for me.

Bill gave me some Ibuprofen and after some wine and a good night's sleep listening to rain hit the roof of my small tent, I felt like a new man on Monday.

A profile of our group of eighty one: twenty adults were from Tucson. There were sixteen foreign exchange students from ten different countries: Venezuela, Ecuador, Peru, Brazil, Argentina, Sweden, Belgium, France, Austria, and Italy. They were spending one year at schools in: Lake Havasu, Sedona, Prescott, Anthem, Phoenix, Tucson and Nogales. The youngest of the group was Milo. He was ten years old and not an exchange student. His family was hosting one. Then there was Jeff who flew into Las Vegas from Portland, drove to Kingman where he met his friend John and they continued the journey to Seligman.

The students slept in two big tents: 9 girls in one and 7 boys in the other. They kept pretty much to themselves, apart from the adults, and had a tremendous "esprit-de-corps." Chuck, Gerard, and Cindy (the cook) gave them jobs to do around camp and they were good workers. I saw Flor only occasionally and she had a smile on her face; she was obviously greatly enjoying herself.

It rained twice when were in camp and Cindy had some plastic to put over the food. Can you imagine cooking for 81 people? The rain turned

the waterfalls chocolate brown, instead of their signature crystal clear, a big disappointment. Yet, the boys did go swimming and everybody enjoyed the area. Our camp was situated in a narrow slot canyon with towering vertical reddish brown rock walls… very impressive, giving one a sense of reverence to be in such a majestic place.

Sitting on a bench at the edge of the camp, I was joined by a woman who said, "My name is Susan." I replied "That's easy to remember, because my wife's name is Susan." Susan then said, "My husband's name was David and we live in Tucson." She smiled when I told her my name was also David." The couple was intelligent, interesting, and laughed at my jokes. We had a dentist and a doctor. There was a couple who were lawyers in Tucson and another couple from Lebanon… and many others that my foggy memory can't recall. The tenor of conversation enveloped you into a feeling of enjoyable togetherness, something the students were also feeling.

After hiking in on Sunday, Monday saw us with a free day. My camera did not work this day. I was at

Rotary foreign exchange students display their flags at Havasupai trail head.

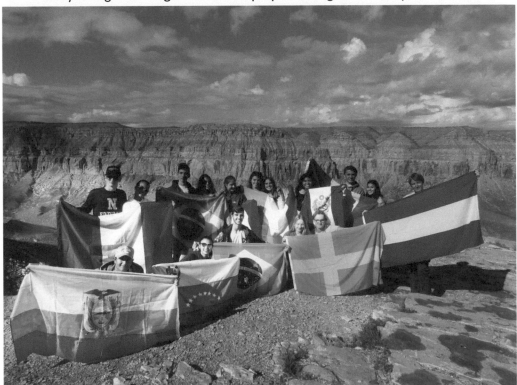

183

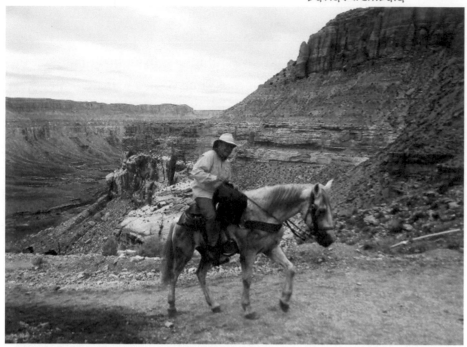

I am one tired cowboy. I can barely keep my seat.

It has been some twenty plus years since I've ridden a horse and this was certainly one of the highlights of the Havasu adventure for me. I'm stiff and not very flexible so even getting up on Blu, my horse, required help from Ted, the wrangler who was to accompany us. Our group included: Chuck, Tucson David, Debbie from Fountain Hills and her son Milo.

You see things differently atop a horse once you get used to the rhythm of his gait. What used to be Navajo Falls was destroyed in one of the flash floods and in its place were several separated smaller falls. Surprise, surprise, the water is now clear and the pools at the bottom of the falls are their spectacular blue green.

On the ride I saw a fox racing alongside a rock wall with something in its mouth. Then there was a father with his small child perched atop his backpack. Of course we encountered hikers coming in, one with a dog wearing sun glasses, and passed hikers going out. They noticed us on the horses and smiled. As we rode along, Ted occasionally let out a hypnotic whistle. We were never told why as he seldom talked, but assumed it was comforting to the horses and kept them disciplined.

The long hike in the dry sandy river bed saw us meet Gerard, the sweeper, with Hillary (from Peru). Something was wrong with her ankle. "She can't walk" said Gerard." There was a pregnant pause from our group and then it was agreed she would ride with Ted, the wrangler, on his horse. Hillary wasn't very big.

Now came the challenging part of the ride for me. Chuck and I moved ahead and separated from David, Debbie, Milo, Ted, and Hillary. Chuck wanted to be

first frustrated, but then plenty of others had cameras. Chris, who had recently moved from Kansas, took a nice group picture of the students and Rotarians. Susan took a good picture of me in front of Havasu Falls and Christy captured me riding the horse as I entered the finish line at the trail head.

We get our water from a faucet. Yet, I have always been fascinated by water that comes straight out of the ground, a spring. On the east wall bordering the campsite is Fern Springs. The clear water you can drink just gushes right out of the reddish brown rock. To me this just reeks of the joy of nature. On two previous trips to Havasu, for some reason, I did not take a picture of this. Now I did, the first day in camp, before my camera died on me.

We had to get out early as we faced a long ride home. Therefore we got up at five in the morning. With headlamps on our foreheads it was fun to watch our camp slowly shrink as tents went down and boxes of supplies were put in duffel bags. Ever mindful Chuck counted 97 bags and would re-check the number again back up at the trailhead. Two loaves of bread were left on the picnic table for the next campers.

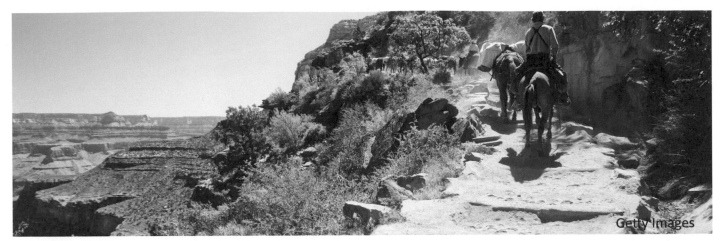

up at the trailhead organizing things and on open areas of the trail with no boulders or rocks to navigate Chuck used a rope to get his horse into a gallop. Blu, not wanting to be left behind, also galloped. Wow, you're bouncing up and down, up and down pressing your thighs into the side of the horse and holding onto the pommel for dear life. After about a football field Chuck would slow to a walk. From my days as a coach, it seemed to me we were doing a series of wind sprints. I stayed on, but at times wondered how.

Finally we came to the switchbacks and no more gallops as the horses slowed down considerably and went into their climbing mode. Did I mention I was afraid of heights? Somehow I overcame this feeling and blocked it out of my mind. Blu was thirteen years old and during the three hour ride stumbled twice. I trusted his decision as to where he was placing his legs when we stepped around large rocks and which trail to take when there was a choice, but I was nervous we might fall as we ascended the steep narrow trail up and up to the trailhead. Yet we made it, greeted by cheers from a small crowd of earlier arrived hikers.

Getting off Blu, with legs that seemed frozen, required some help from a nearby Indian. Painfully, I slowly slung my right leg over. He held my shoulders and said, "Just fall down on me, I got you." As I hobbled over bowlegged to Bill's car, he saw me and laughed.

Having left an hour or more before us Flor, the other students and many adults were already at the trailhead when Chuck and I arrived. Half an hour later Hillary and company arrived safely. We now had to wait for the horses carrying the back packs. Slowly, I took off my hiking boots to put on my more comfortable sandals and discovered a blister on my left foot. Hiking shoes really not recommended for riding a horse, especially one who gallops requiring you to stand tall in the stirrups.

Our six hour ride home was done mostly in the rain, and outside Prescott we saw a beautiful rainbow. Flor got a nice picture. We were tired and to keep us occupied in the car, Flor had us listen to some Latin music and then the Beatles from England. Next she had us play a word game, a subject was announced and you had to mention something about the subject… such as "ships" and a person would say "sails" and the next person would say "lifeboats" and so on until somebody couldn't come up with a reply. We were tired but it kept us in good spirits as we came closer and closer to Phoenix and home. Flor was a good entertainer. Bill was a good driver, and Carlos, Jacob and I happy campers. Glad when the rain stopped, as we entered Scottsdale. The four days were not a trip, but an adventure we will never forget.

Wednesday our eleven days with Flor came to an end as we transferred sponsorship over to Kelly. The experience has enriched our lives.

The four days of Havasu put us in touch with our ancestors. They lived close to nature as we camped and, of course, they rode horses.

Chapter 26: Politics

He who follows the beaten path seldom gets lost...but leads a boring life

Politics with Jennifer Samuels

A former student/athlete, Jennifer Samuels, is running for the Arizona Legislature. Two days before the election and one day before her 39th birthday I knocked on doors of residents in District 15 in north Phoenix with her.

This is called a canvass and was very high tech. Accompanying us in her van was a fellow teacher. Deidre, a math teacher, sat in the passenger seat up front and texted on her cell-phone the address we were seeking. On her phone was a list of Democratic voters who had not mailed in their ballots and were thus eligible to vote in two days. Not only did we have their address, but their names and ages. Very low tech, I sat in the backseat and alternated with Deidre in going up to various houses. Jennifer told us three people approaching somebody's door appears threatening and is a definite no-no in the political game.

Saturday morning many people were not home. Then Jennifer scribbled a short note on her large post card information and inserted it in the screen door or by the floor mat. She started her campaign four months ago and figures she's knocked on three to four thousand doors. Probably half have dogs and she was surprised at the number of people she did talk to who were high.

The general population offers a wide range of personalities. But most everybody is considerate. Some we talked to didn't really want to and you could sense they were only being polite and wanted

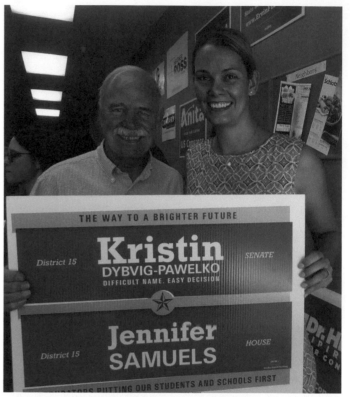

Jennifer Samuels and me.

you gone quickly. One man remarked, "I've heard of you and you have my vote." Another man asked if we wanted a bottle of water. We said, "Yes" and returning to our van with a chilled bottle of water we knew he'd made a special effort and would remember to vote for Jennifer. Jennifer is one of three Democratic candidates and only two advance onto the general election to face the Republican candidates. The Republicans have a numerical advantage in her district. Hopefully she can reach across the divide and get their votes, if she survives the primary.

Taniyah Williamson was the cameraman from channel 8, who earlier at campaign headquarters,

was recording volunteers receiving their canvassing instructions. She followed us in the neighborhood for a couple of stops. Before she left she said to me, "You've taken a good number of pictures, let me take one of you with Jennifer." I gave her my camera and being the professional she is, she took a nice picture of us.

There is a confusion of colors. Traditionally Republicans are red and Democrats blue. Jennifer was motivated to run for office because of the teacher walk-out in the spring. It acquired the slogan, "Red for Ed" and all the teachers and their supporters at the capitol wore red shirts. Jennifer teaches English to 7th and 8th graders in a middle school and got swept up in the movement to improve education in Arizona. To do more than sit outside the capitol building she decided to run for office. But, you say Jennifer is a Democrat. Yes she is, wearing two shirts, depending on the circumstances.

Arizona needs change; it ranks lowest in the country for teacher pay, and has the highest student counselor ratio in the country. Jennifer says she routinely has over thirty-five students in her English classes. The publicity of the teacher strike reached across the ocean and an Irish journalist interviewed Jennifer for an article in her country... Even more publicity followed, as Jennifer appeared in the Arizona Republic newspaper (August 26 2018) a day after I went knocking on doors with her. This might be more helpful than the Irish newspaper.

September 8th I finally reached Jennifer and she told me, "I won by only 73 votes, now it's on to the general election in November." Jennifer Samuels 7977 (34.5%) Julie Gunnigle 7904 (34.2%) Tonya Macbeth 7189 (31.1%) She now faces the daunting tasks of convincing Republicans and Independents. They have a big advantage in numbers. The Republican primary saw Nancy Barton receive 19190 votes and John Allen 17164. So four candidates are running for two seats in the Arizona House of Representatives. Can Jennifer reach a sizeable number of independents? Can she convince some Republicans to vote for an educator instead of stagnant incumbents? Can Jennifer ride the red wave of anger teachers are stirring up in the state?

September 22 I drove from Chandler up to Scottsdale to the northern reaches of the metropolitan area and the Saddlecreek Coffee Shop in Cave Creek. It's time for another canvass, driving about a neighborhood and stopping at targeted houses. Jennifer has taken a leave of absence from teaching and is devoting herself full time to the campaign. Jennifer paired me up with Donna Johnson and off we went in her fancy jeep.

Donna is a banker who works out of her house and lives in the neighborhood we are canvassing, so she is very familiar with the street signs. Saturday morning many are not home, so we leave a cluster of campaign material and a short hand-written note. Most of our selected people are Independents or Democrats who failed to vote in the primary. Jennifer's full time campaign manager has worked this all out and Donna reads it from her cell phone. Two people actually invited us inside and only one was rather brisk allowing us only a few hurried words of wisdom. One young woman had just given birth two weeks ago and her husband was inside feeding his new son.

I enjoy talking to people and showed them the New York Times article about rebellious teachers in Arizona. I remind people, the eyes of the nation are on us, so vote for my former student who is now a dedicated teacher wanting her voice in the legislature to make some needed changes. Donna and I returned to the café at 11:30. I was surprised Jennifer had only read the New York article and didn't have a copy. Of course I gave her mine and received a nice good-bye hug.

A lot of interesting people attended Jennifer Samuel's post-election party. They have a wonderful

David Archibald, Former Teacher and Coach, Endorses Samuals for Superintendent

"I endorse Jennifer Samuels for Maricopa County School Superintendent. As her high school coach, I saw determination and courage. She continues to balance many roles with intelligence and poise. Jennifer will undoubtedly improve education in the state of Arizona."

David Archibald
Former Teacher and Coach of Jennifer Samuals

July 17, 2019

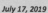

https://samuels2020.com/endorsements-2/

house spacious enough to host some fifty people who worked on the campaign. Everybody knew the odds were against her as the Republicans greatly outnumber the Democrats in her District, yet the mood was very upbeat and positive. There was a strong showing compared to previous elections in the district. Nancy (R) 29% 35,572 votes; John(R)28% 34,393; Jennifer 21% (D) 25,894; and Julie(D)21% 25,072. Only the top two were elected to the Arizona House of Representatives. I reminded Jennifer a lot of famous politicians didn't win their first election, among them Abraham Lincoln.

Jennifer is a good listener and several month later decides to run for another political office to help teachers. I attend Jennifer's kick-off event for her campaign to become the Maricopa County Superintendent of Public Education. It's held in a park. I am one of three speakers talking in front of a crowd of fifty people. My introduction:

He's run the Boston marathon and climbed Kilimanjaro. He was a high school history teacher and track coach for 30 years. He's currently a member of the Kyrene Rotary Club in Tempe and Park Central Toastmasters. Of the many students and athletes he's been in contact with, David Archibald is here to talk about just one, Jennifer Samuels.

My speech…

Jennifer ran cross country and track at Coronado High school. She did the demanding high hurdles and excelled at the triple jump. Over four years I got to know her very well. You lose contact with most teenagers after they graduate, but some are special and you keep in touch… Steve and Lindsay Castro have hosted me and my wife Susan in Chicago… and Jennifer had us at her wedding in Sedona. We've visited her in California when she was first married. And there have been a few times we've connected by running on the track.

What makes her special, well, she's taller than average, but seriously she's compassionate, a good decision maker, a mother to three daughters, a supportive wife to her husband's career, and a teacher in her own right at Desert Shadows Middle school.

She balances so many things. I worked on her last campaign, running for a seat in the Arizona House of Representatives. I live in Chandler and couldn't vote for her, but this time I can because Chandler is in Maricopa county. In our community we need to do more than read the newspaper, and vote. We need to be actively involved, know the issues, and volunteer with the countless things a successful campaign needs. We need to touch the lives of parents who have children in school and enlighten them about Jennifer Samuels. A woman who can oversee and manage education and improve the life of teachers so our children can grow into happy responsible citizens.

Chapter 27: Reunion

"Isn't it funny how day by day nothing changes, but when you look back everything is different?" C.S. Lewis

High School Reunion

A forty minute drive from Chandler to the site of my reunion, Casa Grande. Friday night if I'm going to drink a glass of wine with my fellow classmates makes driving back in the dark perhaps a bit risky. If I stay in town and sleep at a friend's house I'm being safe and smart. Bill Stout hasn't seen me since the last reunion, but he's happy to talk to me on the telephone. Unfortunately, he has no extra room as grandchildren are temporarily in residence. When I mentioned another classmate, Jack Foster, he said 'I occasionally run into him having coffee downtown.' Here's another possibility. Bill is excited about the reunion and it will be good to see him even though he can't host me. I feel a close relationship with some of those I shared the high school experience… in a sense they are family.

Six days before the reunion I sent nine emails to fellow classmates. Two have replied. I chalk this up to Facebook practice where it is not customary to reply to every post made, still a bit bothersome. Then again perhaps the recipients are not as interested as I am in the reunion.

John Love lives in Las Vegas and can't make the reunion. It was nice of him to reply as we had spent two years somewhat together at college in Flagstaff. Steve Hudson was Mr. Everything in high school, class president, state champion in the mile, and boyfriend of a girl I had a crush on. He lives in Tennessee and isn't going to be coming to Casa Grande. Steve did send two pictures. His wife plays the harp and he poses with his dog. In high school Steve always had his hair in a sweeping style plastered down with nary a strand out of place. Now his hair is grey and messed up, apparently a satisfied man.

Perhaps the other seven people I've sent emails to will attend the reunion and feel it's not necessary

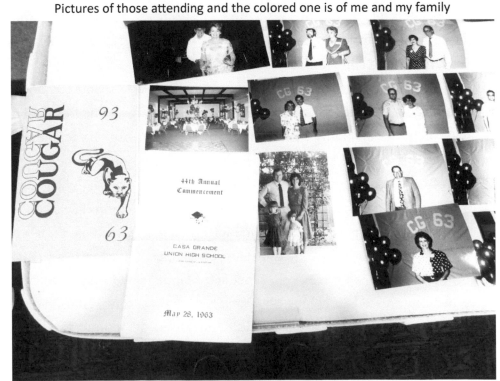

Pictures of those attending and the colored one is of me and my family

Margie Heinle, Me, and Ray Bingham

Friday night's activity at BeDillions restaurant and patio is an activity I've decided to pass on. Driving home in the dark two nights in a row doesn't seem like a good idea. The reunion for me will now be one day: Saturday's lunch at Little Sombrero and the evening dinner/dance at the Holiday Inn. Should be enough as most of the people I will meet are in reality strangers…but I'm a person who enjoys good company. And the reason they are good company is they've decided their high school years were a good time in their life. Sad but not everybody feels that way, seeing it as a challengingly stressful time.

Oregon, San Francisco, Colorado, and Flagstaff were the places my classmates came from for our 55th high school reunion. Enedina Araiza helped me compile some of the history of our class: 120 graduated, 35 are now dead. An ethnic breakdown reveals: six blacks, seven Indians, thirty-six Hispanics, which leaves us with seventy-one whites.

The forty minute drive to Casa Grande in the rain saw the reunion kick-off with a small gathering for lunch at the Little Sombrero. In spite of the weather, I wish I had remembered to bring a jacket as an umbrella was not enough. I saw a few familiar faces. One person who never attends reunions yet still lives in Casa Grande is Larry Burrell. Enedina told me Larry doesn't live very far from where we are. Steve Hudson once went to his house and was rudely rebuffed. I was not to be denied and she agreed to take me there after lunch. Overhearing this conversation Judy Keltner seemed interested and I convinced her

to reply. I'm fairly confident Juan Martinez who now goes by "Johnny" will attend. He lives in Atlanta but has family in Casa Grande. Johnny had some health issues at our fiftieth reunion so it's possible he might not attend. I have his phone number and will give him a call.

Spoke with Johnny and this is the first he's heard of the reunion. Apparently his wife handles all the emails and didn't tell him. He wished she would have. He says he's in good health, but then remarked he's going blind and can no longer drive a car. More reliance on his wife. Johnny was in good spirits when we spoke and I told him I would get back to him with details of how the reunion went.

I sent three emails to girls: Janet Price, my date to the junior/senior prom; Margie Heinle, my date in my senior year to the prom; and Patty Cooper, a fellow actor who I had a crush on. Janet and Margie have been to previous reunions but Patty has never attended. I believe she lives someplace in Texas. It was at least nice seeing her name on the list of emails, which means she's at least alive.

to come along with us.

Larry was a big man on campus, a football star with an engaging personality. He worked as a plumber and while never married lived with a woman for a good while until she died. I brought my school yearbook and on page 181 is an iconic picture of four football players after a thrilling game where we upset Coolidge to end our season. Three of the players in the picture are now dead, leaving

Adrienne Rose, Tom Rose, Stella Kehias, and Judy Keltner

Larry the sole survivor. One of the three was our quarterback, Freddy Dominquez. His nickname was "Chopo" because he was short. Freddy was one of Judy's four husbands.

Arriving at the house we could see a man sitting in the carport. Enedina said, "that's Larry." Not seeing him in 55 years, it was thrilling to get out of the car with my yearbook, hoping he would sign the picture, and I would not be angrily turned away. Larry was glad to see me and after a few words was pleased to sign the picture. Judy then came over and she and Larry talked a bit about Freddy. We told him we valued his friendship and hoped he would come to the reunion at the Holiday Inn. Of course Larry didn't come, yet I felt seeing him, however briefly and making a small connection was very uplifting.

During the interlude between the Little Sombrero and the banquet room in the Holiday Inn in the lobby I met a group that was the class of 1978. Donald Thompson now teaches science at the high school and is the girl's basketball coach. In college he high jumped seven feet three inches.

Al Nader was assistant principal at the High School in 1963. He moved up the ranks to become principal and later Superintendent of Schools. Today Al is 93 years old and he came to the reunion. During the dinner portion of the program I sat with Al. I love basketball but was not a very talented player and got cut my junior year trying out for the varsity team. A year earlier, my sophomore year, I was on the Junior Varsity team and Al was my coach. I primarily sat on the bench and occasionally got some playing time. I thanked him for his patience with me.

He told me about surviving the depression and his service as a 17 year old during world war two in the Pacific. I then asked him what his proudest athletic achievement was…not as a coach, but as a player. In 1941 Miami High School won the basketball state championship. It was a small school and it was quite an upset to beat the bigger schools in Tucson and Phoenix. Al was a sophomore and 5'7. He took great pride in his defense. A Tucson player who stood 6'2 averaged twenty points a game, Al held him to five.

There are bits and pieces filtering through my

One of the tremendous reunion
organizers, Enedina Araiza

Casa Grande is between Phoenix and Tucson

While I am class of 63, brother Bob and his
wife Nancy are class of 64

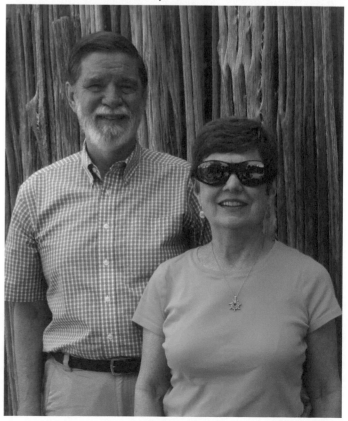

mind of conversations with others: A Vietnam veteran who walked point on jungle patrols; Ray Bingham has five children and nineteen grandchildren; and Ken Mangum as a judge has had my lawyer whistleblower friend Jack Lavine appear before his court. Ken now lives in Maricopa and is recently married. Talking to him I couldn't help but notice he held hands with his young wife.

The reunion is hard to summarize. I've lost contact with some, and some I'm in contact with didn't bother to come, but those who do all enjoyed a wonderful time. My hat's off to Velma Linley, Enedina Araiza and others on the reunion committee. My only regret is not dancing with Margie Heinle who was my date to the prom...oh well there's always the sixtieth.

Chapter 28: Diary

"One advantage in keeping a diary is that you become aware with reassuring clarity of the changes which you constantly suffer." Franz Kafka

Dear Diary

January 1: I go for a run. It's the New Year, my knees feel good and I want to work up a good sweat. As I cross a street to enter my familiar green belt, I sense motion behind me. It's a runner… a woman. Earlier I was thinking about how far I was going to run and the route I was going to take. But what the heck why not run with this other person.

We head north, a familiar direction, and her pace is a touch faster than I'm accustomed to. Should I really run with this person who might be better than me? When you're running side by side you really can't tell much about your running companion. Since I consider myself slow compared with other runners, I ask her how old she is. Dorothy's answer stuns me. She's 81, from Canada, and started running when she was 70. Wow. With my macho pride I decide to stay with her. It has me breathing harder, but I can handle this for a while.

How far is Dorothy going to run? I tell her of some upcoming options on the greenbelt. She tells me "I just follow my path. Once I got lost running here." We make it to Ray Road and she turns left to go around the lake and head back. This is a route I don't normally take, but I tell myself I can continue at this punishing pace from an eighty year old. She says you should run until you can't anymore. It seems like a race, but it isn't, more a challenge and a test of will power.

Approaching the end of the lake loop I decide to part company and slow down, but not stop running.

Luckie

I tell her of my decision. So I see her a bit ahead of me heading home but feel no regret. A humbling experience. My knees held up, I worked up a very good sweat, and had a special run not in my normal routine. Thank you Dorothy.

February 9: There's a painful absence in the house, we put Luckie down. Actually it was Susan who took her away, as I wasn't strong enough. Luckie was in pain with an infected growth on her foreleg. The quality of her life reduced… so we agreed to do the humane thing…but it hurts, Luckie had so much personality and was a vital part of our lives, we will sorely miss her. There is something special about the bond you have with your dog. It's almost love but not quite because they can't talk, except in their special way with those eyes staring at you they communicate. Luckie 14 years old, 40 pounds, a chick magnet.

February 12: Toastmasters Five speakers were called up to the front of the room for table topics, the topic was "love." I was one of the five and read what

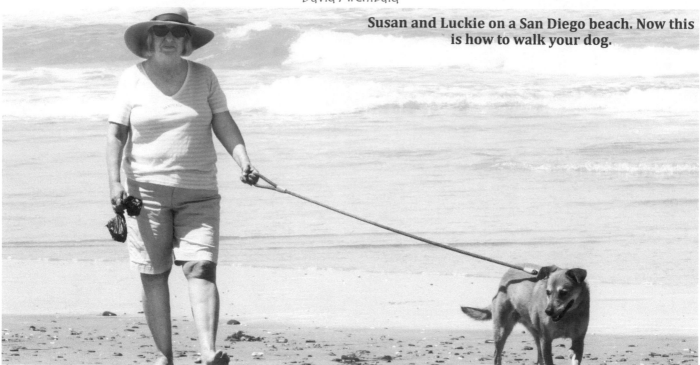

Susan and Luckie on a San Diego beach. Now this is how to walk your dog.

I had written about our dog Luckie. When the ballots were counted, I won best speaker. Being emotional helps with the voters, and I was. Afterwards, Kathleen, a dog person, consoled me with the comment, "You gave her a good life." Sitting on a shelf in our living room there is a picture of Susan and Luckie on a San Diego beach looking out at the ocean, taken December 2018. I placed the Toastmaster ribbon I won, "Best Table Topics" right next to the picture.

March 23: Neighbors Bob and Margo hold their annual Chicago Cubs baseball party. I take three things across the street to their house: a bottle of wine; my camera; and a cigar box with some of my baseball cards. It's nice not to drive to a party so I can have more than one glass of wine.

Two pictures turn out very well. Bob off to the side beside an old black and white picture of two baseball stars, Ernie Banks and Willie Mays. They were on opposite teams yet posed together with crossed bats before a game. Bob got them to autograph the photo

Daisy Explosion

and in my picture of the picture Bob has a big grin on his face.

The second picture is of Margo. She has a photograph of a catcher and a pitcher. The pitcher is a good friend, Lee Smith, who I met in a previous party. The catcher, Terry Williams, usually doesn't attend these parties, but this night he shows up. Terry lives in our community, is a major scout for the Cubs, and travels a lot. I asked Terry if he enjoyed traveling and he replied, "No… I'm only two years away from retirement and don't want to die in a Marriott Hotel." Terry said the photograph of him and Lee was taken in 1983. I got a good picture of him autographing the photo with Margo standing alongside.

Along with my baseball cards I had a few football cards. A guest at the party was looking through them and surprisingly said to me, "Oh my gosh, I know Stan Jones, he lives in Scottsdale." To me this Chicago Bear football player was a "common card" not worth much. Now I know better, the guest told me Stan Jones is in the hall of fame. The back of his card reads, "Big and rough, Stan throws blocks with unerring accuracy. He has the ability to rip an opposing forward wall to shreds and allow the Bears' back to scamper through."

March 27: Landscape. This time of the year in Arizona it's nice to be outside. Reading outside in my backyard, "Virgil Wander" by Leif Enger, I look up and marvel at the nearby towering trees.

Our community of 84 homes has 280 trees. They are beautiful. The book is intriguing. It's about a man in norther Minnesota who lives in a small town where everybody knows everybody. He is recovering from a concussion and looking for some charitable women. My mind wanders from the novel and I look up at the trees and enjoy the early morning.

At noon Bob and I walk over to the Hungry Monk, a restaurant just outside our complex. It's our weekly Wednesday get together. Joining us is Greg. Being on the board of our HOA Greg is able to tell me the type of trees that are in our neighborhood. You may be familiar with some of the fourteen: pine, sissoo, fichus, live oak, Texas Laura, lemon, eucalyptus, mesquite, tippo, red bush, magic, Arizona Ash, Australian Bottle, and palo verde.

March 29: I get published. Page two of the Arizona Republic newspaper has the weather report and in the lower right section a small landscape photograph taken by a loyal reader. This time of the year brilliant sunsets are popular and sometimes flowers. The caption to my picture read, "Daisies burst forth with color in the Chandler backyard of David Archibald." Susan took a picture of it and put it on Facebook so I don't have to hustle around the neighborhood for copies of the newspaper. Even so I got John's, Jim's, and Rick's. It leaves a warm glow in my heart since I love taking pictures and getting some recognition is a nice pat on the back.

Chapter 29: Denmark

"Happiness is a state of mind. It's all according to how you look at things."
Walt Disney

Copenhagen

Chronology is loosely followed in this book. Up next is a flashback. Last summer, a milestone birthday for Susan, was shared with our daughters overseas in the charming city of Copenhagen Denmark.

Six months ago at Thanksgiving in San Diego with our daughters, Susan got them to agree to spend her 70th birthday at Tivoli Gardens in Copenhagen. Susan did the planning and research for the trip. Four days in the city and three in the countryside were wonderful. Sharing the adventure of exploring a charming foreign city with our daughters was a priceless bonding experience for the four of us. Next Lisa flew home, Julie went to Germany and we went on a cruise where everything is taken care of.

Little Mermaid, Copenhagen

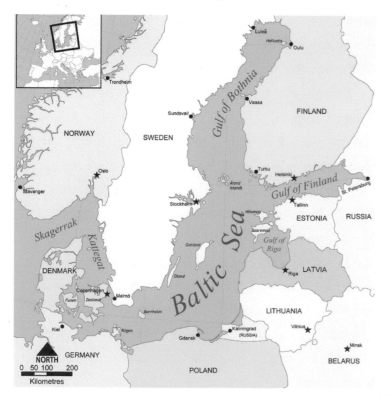

Ten nationalities take care of eighty-four Americans on our cruise ship. Indonesia had eighteen, the largest contingent, followed by: India with twelve; Ukraine with ten; Croatia with nine; and a smattering of other countries represented by one or two. Besides Able Seamen, Housekeepers and Cooks, there was a Russian musician. Dmitry Krivonosov's performance of Chopin on the piano one evening was mesmerizing. We also had a masseuse and a doctor on board. With nine ports of call we sailed around the Baltic Sea visiting seven countries and two islands. Only two nights presented us with rocky seas. Lying in bed I just thought to myself, "Imagine you are a baby and being rocked to sleep." This mantra served me well, and neither Susan nor I had any trouble.

Julie, Susan, & Lisa

seeing her walking fast towards us. I saw her first, filling me with joy. Julie flew from San Francisco to Helsinki and arrived in Copenhagen before us. Cell phone texting informed us she would meet us at Starbucks outside the baggage pick-up. Again I felt a feeling of pride upon seeing her. Not sure who said it, "This is the Archibald's first European vacation." Indeed it was, because while all of us had been to Europe independently, this was indeed "a great family first." I'm not a very emotional person but this touched me tremendously.

Returning to the week we spent in Denmark with Julie and Lisa. Getting there does involve some suspense and excitement. Susan and I arrived in London several hours before Lisa was to arrive and we would then be on the same flight to Copenhagen. Getting through to the correct terminal, security and checkpoints can be time consuming and frustrating with the long lines. Sitting at our gate hoping Lisa would make it, there was a tremendous sense of relief

Some of the highlights of our week in Denmark: four of us drinking "Moscow mules" at an outdoor café; walking the city streets of a charming foreign city and discovering it's geography; the girls presenting Susan with a paper crown to wear on her head when we celebrated her birthday at Tivoli Gardens; renting a car to explore the countryside, Julie and I sitting in the back seat and with Lisa driving and Susan navigating (I keep my mouth shut) staying at two different farm houses that both have chickens; and the view of the verdant fields from the second farm house on the second floor. Susan says, "This puts the Leety's view in Colorado to shame." While this is possibly inaccurate, the emotion reflects the deep feeling of love we have at sharing this travel experience of adventure with our daughters. They are both quite different people and the inter-play of how they got along was interesting. We always have Thanksgiving get-to-gathers to reunite, but the memory of Denmark was priceless.

Estonia

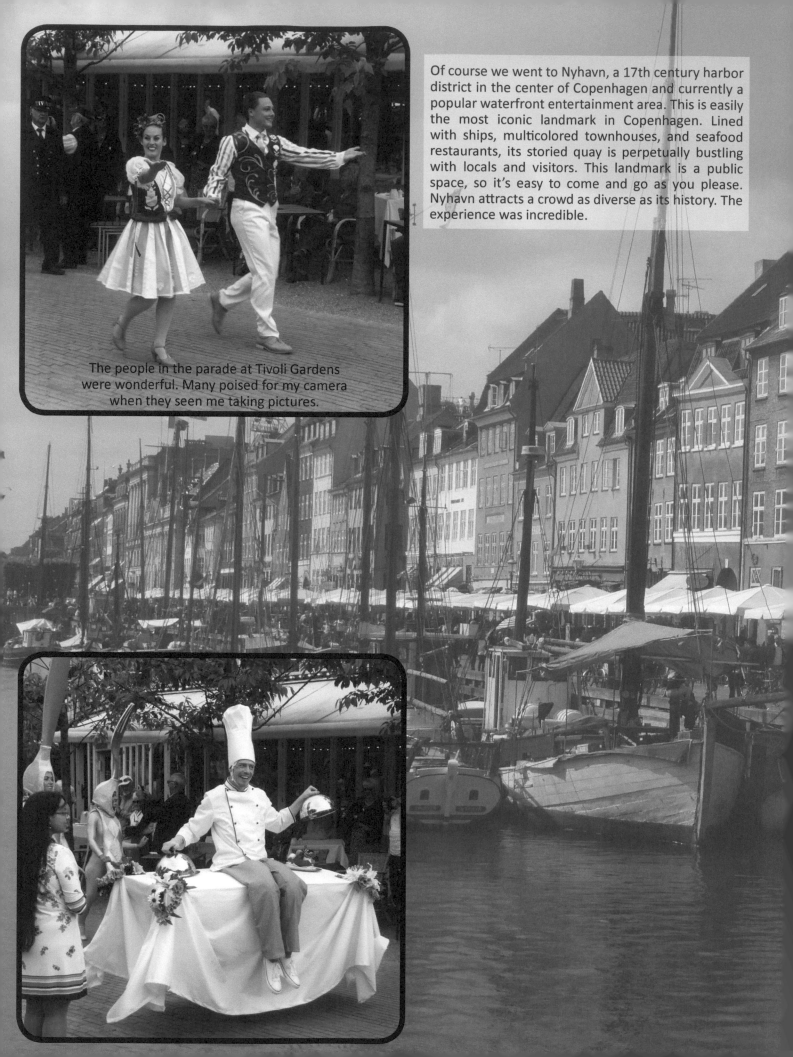

Of course we went to Nyhavn, a 17th century harbor district in the center of Copenhagen and currently a popular waterfront entertainment area. This is easily the most iconic landmark in Copenhagen. Lined with ships, multicolored townhouses, and seafood restaurants, its storied quay is perpetually bustling with locals and visitors. This landmark is a public space, so it's easy to come and go as you please. Nyhavn attracts a crowd as diverse as its history. The experience was incredible.

The people in the parade at Tivoli Gardens were wonderful. Many poised for my camera when they seen me taking pictures.

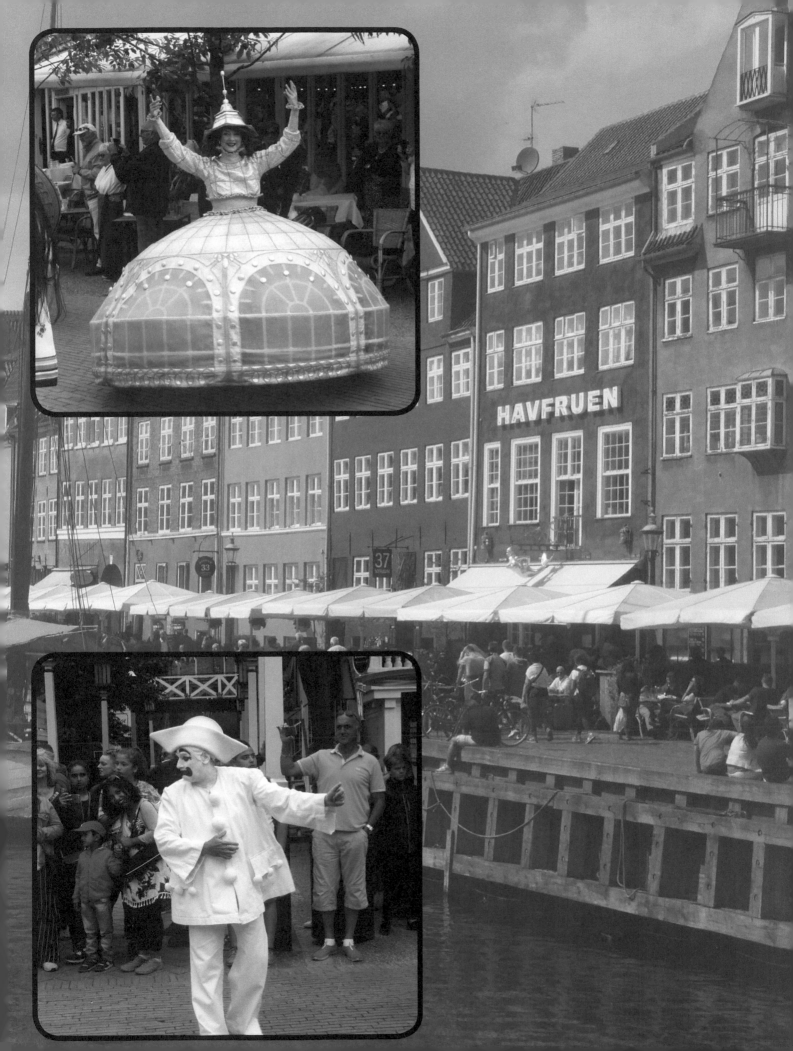

Chapter 30: Italy

Veni (I came)
Vidi (I saw)
Vici (I conquered)

Julius Caesar

Rome

In Rome we tried not to follow the tourist footprint. We wanted to experiencing life of the locals. After four days we joined a tour group for sixteen days and our mode of transportation was the bus. Once arriving at a town we did a lot of walking. At time my knees gave me problems especially when going downhill. However, as we progressed I felt I was getting stronger and the last days my legs held up very well. Susan did well throughout the trip, and was boosted by recovery naps in the afternoon.

Twenty Day Itinerary

- **Four Days in Rome Trastevere neighborhood**
- **Four Days in Sorento**
- **Included Pompeii**
- **Amalfi**
- **Scala**
- **To Tuscany**
- **Vico nel Lazio**
- **Three Days in Chianciano**
- **Included Pienza**
- **Cortona**
- **Siena**
- **Five Days in Montecatini**
- **Included Florence**
- **Vinci**
- **Ferrara**
- **Four Days in Venice**

Flying in an airplane is magic. It takes you across the continent and then across the Atlantic Ocean in less than a day. We flew Phoenix to Philadelphia and then on to Rome. Two hundred years ago you would cross the continent by horse for a month or more. Then to cross the ocean you would be on a ship powered by the wind and another long time of travel. Those early travelers were tough people.

This was our 14th trip to Europe. Exiting from the womb of the air plane after eight hours we entered a new land. Actually it's an ancient one, but new to me. Technically I've been to Italy before, just touching the northern part of the country twenty years ago.

Our Trip

Susan has more mastery of the country having toured Europe after graduating from college forty-nine years ago. She traveled with her friend Pocket and spent three weeks visiting Italy. They hit all the tourist highlights. Therefore she didn't feel we had to see the Colosseum or some of the famous fountains. Since we had four days on our own before joining the tour, Susan became my guide for our exploration of Rome. I once asked her, "Are we ever going to get Pepperone on our pizza? "Susan replied, "No, that's an American thing."

After two days my camera broke and I lost all the pictures I had taken. I was upset and felt like I had lost my right arm. Fortunately Susan's cell phone takes excellent pictures and we were saved.

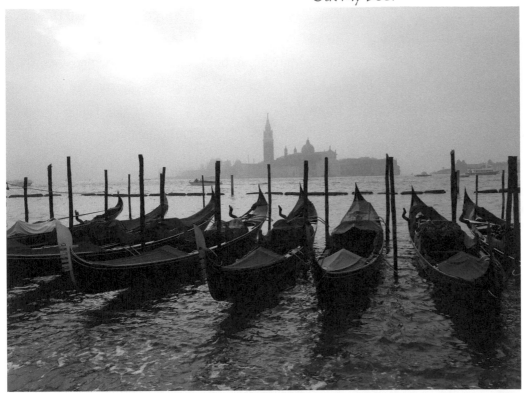

Italian Gondolas

English. We naturally ordered wine, and the waiter opened the bottle and sat it down on the table. All other times in Italy when we ordered wine it was only a glass. This particular time we drank the whole bottle.

Joining the Grand Circle tour, we had an enthusiastic guide. Julia was in her thirties, spoke seven languages, was from Siena, Italy, and in addition to having a good singing voice was a classical Indian dancer. She confessed that she does not watch TV; she threw hers out twelve years ago. At the orientation people

The morale of this experience is I need to sharpen my writing skills in capturing our travel experience instead of over relying on a camera.

There are, of course, major sites all tourists must see. We did see the Vatican, but did not wait four hours in line to go inside. We also saw the Spanish Steps, St. Maria Square, the Jewish Ghetto and had a drink in Harry's Bar. We walked a lot, but to get to the Vatican some two miles away we took a local bus. You know you're old when you get on a crowded bus and two people get up from their seats to give you theirs.

Following the advice of good friend Pat, we stayed in Trastevere, the south-west corner of the city which was off the beaten path. Our B&B was certainly not average. We were on the third floor, and our window overlooked a stunning garden in the back complete with tropical plants and flowers. We ate breakfast here every day. Our host told us how to ride the bus, first getting a ticket at the tobacco shop. One evening eating dinner in a side-walk café, we conversed with a young Italian couple who spoke

Taken at Montecatini Terme in Tuscany, Italy

introduced themselves. Including us there were nine other married couples, twenty seven women, and one man.

Fred was 83 years old and had outlived his two wives. We sat by Stewart and Judy Cohen who were New Yorkers, and we bonded with them right off the bat. Bob and Dianne Mason were from Phoenix, but being a large city we did not know them. They are involved in "Friendship Force" It was started by Jimmy Carter and facilitates international visits. Something we should investigate, kinda like foreign exchange students for adults. It took me awhile to learn all the men's names and I never learned the names of all the women.

Ron listed his name in the program as James, but liked to be called Ron. It took me awhile to catch on to this but we became fast friends. He was from Tennessee but recently moved to Maine. When hearing about my busted camera, he said, "I'm not using my back-up camera, you can use it." Not sure it would take my chip, I was pleasantly surprised when it did. Now I did not have to rely on Susan's cell phone and could be an independent photographer. This made me very happy.

In Amalfi it rained and Keith's wife did not make it back to the bus on time. After an agonizing twenty minutes or so, Julia our guide and Keith managed to find her waiting at a church.

Ron bought a beautiful leather back pack. Storing it in a compartment underneath the bus, the driver tossed it rather hard. Inside the backpack was a bottle of Limoncello. It broke. What a mess Ron had to deal with when he discovered this in his room.

What are the odds of having a troublesome complainer in a group of thirty-eight. Margaret who liked to be called Liz was a slow walker, and she vehemently did not like our young guide, who I thought was doing a fine job.

One person who clearly was doing an excellent job was Anthony, our driver. On twisting narrow roads on-coming traffic often was scooters which would be in our lane riding straight at us and at the last minute nip in between cars in the other lane. This didn't seem to faze Anthony as he was used to it. I knew in advance from our daughter Julie, who had traveled there, of the small roads high up steep cliffs when we were to go to the Amalfi coast. It made me nervous, and then I reminded myself we have an experienced driver and not to worry.

Just north of the town of Amalfi was our base, the small town of Sorrento. It's south of the large city of Naples. Our hotel was excellent. Atop on the sixth floor was outdoor café and swimming pool. I swam there almost every day we were there. The hotel offered a very good selection of food for breakfast. The waiters were dressed in fancy white jackets.

Tuesday evening we had a lecture on the Mafia. They are quite active and account for ten percent of Italy's GNP. In the evening we took a taxi to the beach and had a fish dinner. The restaurant was on a boardwalk jutting out over the water. I was the only man present and enjoyed being surrounded by nine women. The fish was also good. One woman present told me she was advised not to go to Italy because all the men pinch you. She said this hasn't happened yet. She did appear a touch disappointed.

From Sorrento we went by bus to the ancient town of Pompeii. The restoration of this ancient Roman town destroyed by volcanic ash is amazing. I learned on the bus ride there the meaning of a sign that read, "Piano." It was posted on tight curves and means, slow. Now I was getting proficient with Ron's camera and it made me feel good. I always seemed to mess up using Susan's cell phone.

Always present on a Grand Circle trip is a home hosted meal allowing you to meet the local people. On our trip to Spain the host spoke no English, and we managed with our limited Spanish. This particular Thursday it rained, the first they had since May. Picked up at our hotel in the evening we were driven

up the hillside to a house. How the man quickly drove in the dark on such narrow twisting roads in the rain was a wonder. We enjoyed the meal, and the daughter of the host mother spoke English.

After four days in southern Italy we have a long bus ride north. Our three hundred mile journey to Tuscany is broken up with restroom stops and a two hour visit to Vico nel Lazio. The area of Tuscany is northwest of Rome. This village atop a hill dates back to the 5th century. There's not much in my diary about this visit and probably should check my pictures to see if I recorded anything of significance. I will, however, report restrooms in Italy are called, "toilets" and in England are referred to as "the W.C." (water closet)

Our base for three days is the town of Chianciano. We have a two hour five course dinner at our hotel, the Grand Excelsior. So many forks in front of me. Three to start with, the one in front of the plate is only to be used for desert. Two on the left and a knife are whisked away and at one point replaced with fresh silverware. Can't remember what we ate.

The days kinda of blend together when on vacation. But today is Sunday and the bus takes us to Pienza. This is not the town of the leaning tower. Susan buys a purse here. Outside town we visit a cheese factory. For lunch are 8 different kinds of cheese on a paper plate to taste and evaluate. We chose number five which had some pepper in it, and we bought a block of it. The cheese lasted for several days as we took bits every evening in our room with a glass of wine.

The next day we visited another hill side town, Cortona. To get to the town the bus parks below it, and we have to walk up a long very steep narrow road to get to the center square of this small town. Going up was no problem for me, but when we left going downhill it killed my knees. Looking back at our twenty days in Italy, this was the most difficult walking I had done.

I now know the names of all the men in the trip. We visit a winery and are only given small sips. This is the first day I do not wear shorts. It's a jacket and long pants day. While I was standing next to a town wall a gust of wind blows my hat off. Sad to lose it. I spy it in some greenery and point it out to others. It's in a seemingly difficult spot, but our guide Julia is determined to try and retrieve it. And she does. People applaud her effort and the event is recorded by several cell phone pictures. I give her a big hug and later get her to autograph the inside band of the hat.

Montecatini

Tuesday we traveled to another part of Tuscany, the town of Montecatini. This was our base for five days. Midway in our ride we visit Julia's home town, Siena. The town is famous for twice each year having a passionate horse race in the large city square. It's crowded with spectators as each section of the city sponsors a rider and horse in the race. We did not see the race, but I've seen videos of it. At our lunch I sat next to Julia's father, who spoke no English. He did understand some of my limited Spanish as the Italian is similar.

Wednesday we toured the town of Montecatini. With the sun shining, Tettirccio Spa is a visual paradise for the avid photographer. There are tall

The spa at Montecatini

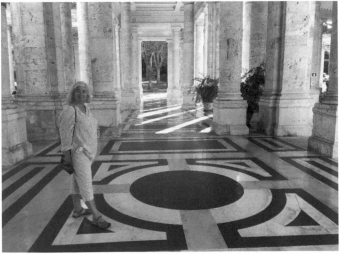

stately marble columns; dazzling intricate patterns on the marble floor; a reflecting pool of water; and countless intriguing paintings. A woman at a piano was singing some classic love songs and this just underscored a fantastic visit. I got some of my best pictures of our Italian vacation here. The evening's visit to a winery, Julia promised us Rivers of wine. She wasn't wrong at dinner our glass was seldom empty. I was the last person to get on the bus for the ride back to the hotel. As I boarded the bus clutching a bottle I had bought everybody roared with laughter. It didn't bother me because by now everybody was very friendly and it was an electric moment.

There are no normal days on our Italian vacation as everything seems to be a peak experience. Last evening I continued taking some quality pictures of people in action. I became a hunter with my zoom lens to capture people with a raised glass of wine, tilted to their waiting lips. The next day I showed Ken a

Susan is enjoying the spa

picture of him in action and he rewarded me by saying, "I'd really like a copy of that."

Thursday we're off to Firenze, which Americans and the English call Florence. We took a train into the big city. It is crowded and this is why we are staying in Montecatini which is not far away. Twelve million people a year visit this popular city. Naturally I

Southern Town of Ravello

had to pose in front of a copy of the famous statue of David.

Friday we passed on the opportunity to visit Pisa and its leaning tower and spent the day on our own. Not too far from our hotel we saw a huge white screen off on a side street and a small crowd of people. It looked like an outdoor movie set, and it was. We crept closer and silently watched a scene being shot three different times. Whispering to somebody what was happening, I was told it's an Italian movie entitled, "18 Presents" starring the famous actress Vittoria Puccini. Using a zoom lens, I got a passable picture of her.

Before we went out to dinner on our own we heard a lecture at our hotel entitled, "Human trafficking or prostitution." It seems Montecatini deals with this subject a lot. The speaker was okay, but I thought he could have at least dressed better. He had the unshaven look and wore plain unkempt wrinkled shirt and pants.

That evening we had one our best dinners. Osteria di Poneta was an old charming restaurant with nooks and crannies providing some privacy. Susan had some kind of pasta and I had an Italian hamburger. It was superbly cooked, sort of crunchy on the outside,

and moist but not rare on the inside. And of course the wine was excellent.

We visited the town of Vinci where Leonardo grew up. They have a nice museum showing many of his inventions. Missing was the art as it is priceless and resides in different well known museums

Just before our farewell dinner I organized a group picture. It's difficult to get twenty-seven women together. We were supposed to meet in the hotel lobby at six and then walk to the town square and the restaurant. Many arrived a bit early and I started getting things set up with eight chairs and having those right behind them standing side by side posting themselves turned towards each other so we could cram as many bodies together and see everybody's face. Well some got antsy and called out "take the picture." Not everybody was present, we were missing some. A few stragglers arrived and were put in place. It was six o'clock and we're still missing two. "Take the picture" was again called out, so the men started shooting. The second group picture that of eleven men, was easier to take. Sigrid arrive and was mad she wasn't included and I apologized to her.

Margaret, our slow walker and complainer, who

Map of Venice, note in the center the grand canal, the red arrow points to our hotel

was in the picture, was upset Julia the guide was clowning around in the picture. Somebody heard her say, "It is just not dignified." She did not make the walk to the farewell dinner so I did not have to talk to this sour-puss. Instead at the dinner somebody approached me and said because of my toastmaster experience, perhaps you should make some comments showing our appreciation for the great job Julia has done. And I did it. Afterwards Bob, who has also been in toastmasters congratulated me for giving a short concise quality speech.

Not everybody was doing the post trip to Venice, so our numbers were reduced from thirty-eight to fourteen. This made a big difference. Stefania, a resident of Venice, was our new tour guide. While our sixteen day tour of Italy has had many memorable moments, the end in Venice was without question a highlight. The city is so unique. I did, however, have to give Ron his camera and now only relied on Susan's cell phone. Taking so many pictures, it was here I got the masterpiece. It's a picture of several unoccupied gondolas bobbing up and down in blue water and in the distance a Moorish Temple.

Freeways in Italy are excellent. Driving from Montecatini to Venice we had to go through the Atlas Mountains. Not only did we have smooth roads, we also had a lot of tunnels. One tunnel was five miles long. Out the window the scenery was breath-taking.

One of the best rides I've ever been on, it rivals the Canadian Rocky Mountains and Glenwood Canyon in Colorado.

Our four hour ride was broken up with a restroom stop and later the town of Ferrara. Entering Venice was dramatic. With the ocean surrounding us, we drove on a narrow causeway and then took a water taxi into the city. Stefania told us for every resident in Venice there are seventeen tourists. The population of the city varies, thirty thousand full time residents, but many rich people have a place in the city where they occasionally reside, raising the total to fifty thousand. There are no cars or bicycles in the city, over four-hundred bridges, numerous canals, and narrow streets for pedestrians. There is no grid system, and it's easy to get lost in the maze of streets that twist and turn in among four to five story homes.

The Una Hotel was close to the heart of the city but remodeled from the noise. It dates back to the 15th century but was remolded 8 years ago. We had a nice room with a small canal outside the window. But the shower was tall and cramped you into such a tiny space. A fat person certainly could not use it. Relaxing in our room I have a glass of wine, drawing a caustic comment from Susan, "Enough with the wine." I reply, "But we're in Italy."

Before we embark on our second day in Venice we are gathered in the lobby. I am putting my credit card in my sock nestling in close to my shoe and I tell Keith, "Pick-pockets have a well-deserved reputation here." He replies, "I keep my wallet in my front pocket." I counter, "My friend Chip did too and he got it stolen." Clever with a comeback Keith says, "Well I'll just have to not wear underwear and be sensitive."

We have a guided tour of famous St Marks Square. We enter a massive Gothic church where photography is not allowed. You stretch your neck, gazing upward at gilded art work on the walls and ceiling, very humbling. Given time on our own we

visit a restroom in the oldest bar right next to the square. Returning to our hotel we get lost in the maze of streets. I recognize some stores from our earlier guided walk but we make a wrong turn. We end up beside the Grand Canal, which looks like a major river and find ourselves by a famous bridge, the Rialto. Turning to take a picture I bump into Dana, a member of our tour. It's nice to see a friendly face. We sit with her, have a drink, and watch the river traffic. We forgot our city map, but Dana has one and together we safely navigate our way back to our hotel. Susan buys a cute watch today.

This is an expensive city, everything brought in by boat. Conversely everything is brought out by boat, ie trash every day. Yet despite the huge crowds of tourists, a charming city. It's located on the north end of the Adriatic Sea. From the 10th to 15th centuries it rose to a major maritime power, conquered the Greek Islands and ruled the Mediterranean as "queen of the seas." It joined other city states in 1861 to become the country of Italy.

At six o'clock our hotel hosted white wine with nibbles of sandwiches. Here I meet Polly Pilkington and Joanne Parnell. They are from Liverpool and on a three day bicycle tour of Italy. Sadly they have had their stuff stolen. It included their passports, thus they are trying to contact officials so they can go home. They are upbeat and Polly tells me she was knighted by Prince Charles ten years ago. She then shows me a picture on her cell phone and I take a copy of this... wow.

We took several water taxis but primarily did a lot of walking, exploring the city with our excellent guide Stefania. We did pass on a gondola ride. She guided us to the fish market, the Jewish Ghetto, and the home of the most famous Venicean, Marco Polo. In the 13th century he traveled to China and brought spices back to Europe. When used correctly they preserve food, prevent it from spoiling acting like refrigerators.

The most dramatic ride we took was the day we left. In the early morning darkness a water taxi took us to the airport. It was surrealistic as the boat skimmed along the water navigating various small canals. We pass by close to wooden upright poles and vertical ancient walls. When we arrive at the airport, a young girl working for our tour company meets us and directs us to the correct spot in the airport. Porters take care of our heavy suitcases. From the time we left the lobby of our hotel in the dark, it was all first class. I was very impressed.

Our short two hour flight to London was pleasant. What was not, the five hour lay-over in London, until our direct flight of ten hours to Phoenix. I drank a British beer and watched all the variety of people in the airport.

After returning home, I gave a toastmaster speech on our Italian trip. Here's the introduction I typed up, "We have a really big show this evening... from the movie 'Roman Holiday' starring Audrey Hepburn and David Archibald. He's just returned from shooting on location in Italy. Let's give a big Toastmaster welcome to the actor David Archibald."

The first word out of my mouth was the Italian greeting, "bon jour o". I then repeated the often heard phrases, "All roads lead to Rome" and "when in Rome do as the Romans do." And then gave them some Latin from Julius Caesar "Veni vidi vici" – I came, I saw, I conquered the cobblestones streets of Rome. The speech goes on as I hit some amusing highlights. For me the most difficult part of a speech is the close. After I had practiced it a few times it finally came to me - return to what was said in the beginning giving the audience a hint you are ready to finish. My close, "If you haven't seen Roman Holiday, watch for me."

Editing my pictures is something I look forward to every evening of the vacation. It goes like this, "delete, delete, okay, delete, yea this is a definite keeper, delete." Susan looks over my shoulder and

says, "Do you really want to keep that statute of a naked lady?" I say, "Of course, the lights right and it's a great shot." Sigrid says she has three thousands picture and likes to seem them on the big screen at home before she edits hers. Coming home I probably have around four-hundred pictures and the next task is to arrange them in a show. Of course nobody wants to see that many pictures so I make two shows, one of about ninety and another one of twenty-five.

Growing up I was fascinated by the exotic Italian film star Sophia Loren. She's still alive today and at age 86 lives somewhere on the Amalfi Coast. In Sorrento a member of our group pointed out a poster of her outside a museum, and I had a picture taken standing next to her. Five days later in Montecatini outside another museum was a poster of four young women in a beauty contest wearing bathing suits. The third teenager going from left to right was Sophia Loren. Finally in a restaurant in Venice there was a large framed picture of a mature Sophia pushing up her lush hair and a twinkle in her eye. I have all three pictures in my show, one at the beginning, the

Bathing beauty contest, Sophia, a teenager is third from the right

bathing suits in the middle catching the audience by surprise, and finally the restaurant picture in the close of my show. Sophia is an Icon of Elegance and Italy is a fascinating place to visit.

Wall outside a school in San Diego sends a powerful message to our next generation

Geographic Order

Thirty Countries Twelve States

Thirty Countries		Twelve States
Tanzania	Russia	Alaska
Morocco	Estonia	Hawaii
	Latvia	
Turkey	Poland	Arizona
Greece		California
Albania	Chile	Colorado
Montenegro	Argentina	New Mexico
Croatia	Uruguay	Utah
Slovenia	Peru	
Italy	Mexico	Minnesota
Spain	Canada	Illinois
France		
Portugal	New Zealand	New York
Belgium		Pennsylvania
Netherlands		Massachusetts
England		
Ireland		
Denmark		
Norway		
Sweden		
Finland		

The End

the INFLUENCE of a good TEACHER can NEVER be erased

CPSIA information can be obtained
at www.ICGtesting.com
Printed in the USA
BVHW020818240220
573108BV00001B/1